The Complete Book of
PAINTING
TECHNIQUES

Maurice Prendergast, *Summer, New England*. Oil on canvas.
(Courtesy, National Museum of American Art, Smithsonian Institution)

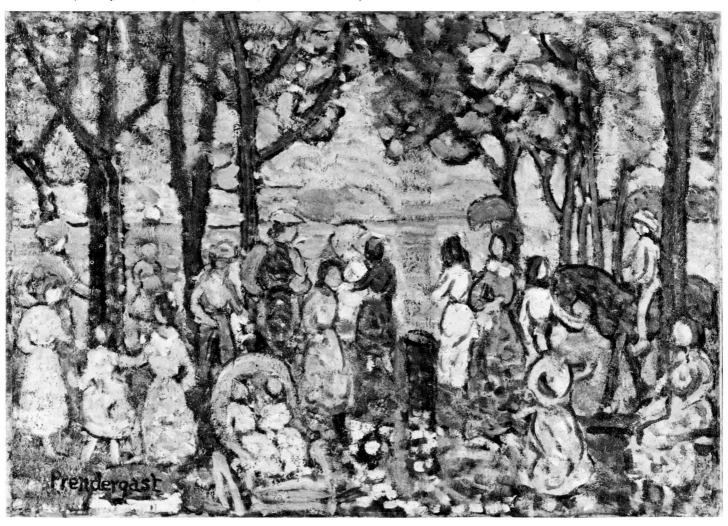

The Complete Book of

PAINTING
TECHNIQUES

Oils ◇ Watercolors ◇ Pastels
Acrylics ◇ Collage ◇ Mixed Media

by Lucia A. Salemme

THE FREE PRESS
A DIVISION OF MACMILLAN PUBLISHING CO., INC.
NEW YORK
Collier Macmillan Publishers, London

The Free Press
A Division of Macmillan Publishing Co., Inc.
866 Third Avenue, New York, N.Y. 10022

Collier Macmillan Canada, Inc.

Library of Congress Catalog Card Number: 82-48450

Printed in the United States of America

printing number
1 2 3 4 5 6 7 8 9 10

LIBRARY OF CONGRESS CATALOGING IN PUBLICATION DATA
Salemme, Lucia A.
 The complete book of painting techniques.
 Includes index.
 1. Painting—Technique. I. Title.
ND1500.S22 1982 751.4 82-48450
ISBN 0-02-927910-0

The publisher and the author thank the persons, institutions,
 and companies who cooperated so kindly in giving
 permission to reproduce pictures in this book. Credit is
 given under the caption title appearing next to the
 illustration. We have made every effort to give
 appropriate acknowledgment. Any error or omission is
 unintentional and will be rectified, upon notification, by
 the author and the publisher in the next printing.

PRODUCTION NOTE

Sidney Solomon, of Publishers Creative Services, New York,
 designed the book and supervised the production.

Trufont Typographers set the type and produced the
 mechanicals. The text is set in Primer, captions in
 Helvetica, and display in Weiss #3 Initials.

Algen Press printed the color section and the jacket.

Murray Printing Company printed the black-and-white portion
 of the book and did the binding.

Lindenmeyr Paper Company supplied the paper: Warren's
 Lustro Dull.

To Lawrence
whose love of fine art
only equals my own

CONTENTS

COLOR
ILLUSTRATIONS

BLACK-AND-WHITE ILLUSTRATIONS

FOREWORD

The unique quality of this book by Lucia A. Salemme, a member of the distinguished faculty of the Art Students League, is that it provides in one volume, and in the greatest detail, all the information needed for the proper handling of painting techniques. *The Complete Book of Painting Techniques* embodies the universality of artistic expression. It includes and explains the special requirements of oils, watercolors, pastels, acrylics, collage, and mixed media.

Lucia A. Salemme presents each of the technique methods as an individual project. These projects are clearly described and are illustrated by the works of a variety of painters from the Old Masters to contemporary artists, without favoring any particular school of painting. She reminds the reader that solid training in the skills of handling each technique is necessary before one can turn out work that expresses inspired feelings. This is an element without which a painting can never be effective. I consider her book a major contribution to art education, and one that is very much needed by art students and instructors.

There are as many methods of teaching art as there are art teachers. However, the breadth and depth of its presentation qualify *The Complete Book of Painting Techniques* as a valuable tool in all the wide variety of teaching methods in use at schools, studios, and colleges throughout the country.

I have known Lucia A. Salemme for most of her painting career, and the important point I can make about this book is that she brings to it her extraordinary abilities both as a creative painter and as a teacher. At all times she demonstrates her respect for the artistic originality of her students by helping them to create work that skillfully brings out poetic ideas of their own.

R. A. Florio
EXECUTIVE DIRECTOR, ART STUDENTS LEAGUE

ACKNOWLEDGMENTS

I extend my deepest gratitude to Sidney Solomon for his sustaining encouragement during the course of my writing this book and for his fine work as editor, designer, and production director. To Evelyn Tucker for her excellent work in preparing the index and assisting with the proofs. To Charles Smith, vice president of the Macmillan Publishing Company, who assisted in many ways.

I am especially indebted to the Acquavella Galleries in New York: Thomas M. Messer and Louise Averill Svendsen of the Solomon R. Guggenheim Museum in New York; Joshua C. Taylor and Adelyn D. Breeskin of the Smithsonian's National Museum of American Art in Washington, D.C.; David Scott at the National Gallery of Art, Washington, D.C.; and Agnes Mongen of Harvard University's Fogg Museum, Cambridge, Massachusetts, for their generosity in supplying me with the many reproductions of the fine paintings used in the book.

My thanks to Victor D'Amico and Daniel Dickerson who read the manuscript in its early stages and gave helpful advice. My thanks also to Ida Fleischer who was responsible for much of the typing of my manuscript; to photographer Lee Sievan for her lovely portrait of me; to Fred A. Hamel, for his invaluable photographs used throughout the entire book.

A very special appreciation to my friends Louisa Calder, Walter Gidaly, Helen Rosenthal, and Ruth Wassell for their constant interest in my book. To the numerous painters, instructors, art galleries, and collectors who graciously allowed me to reproduce their paintings, to my sons Vincent and Lawrence whose opinions were most gratefully listened to; and to my many students for whom most of the projects were first written.

Lucia A. Salemme

INTRODUCTION

Our current interest in painting techniques coincides with the vastly expanded participation in painting by larger groups of new artists, both amateur and professional. Today new materials and procedures are constantly being perfected and made available to creative painters wishing to develop and enhance their skills. Since all types of superior paints are on today's market, you need no longer concern yourself with the grinding of colors with mortar and pestle in order to make your own paint. As for the actual techniques of painting, no taboo is attached to any method: you are free to apply paints with traditional brushes; to use rags or sponges; to stain, pour, drip, or pat the paint on with a knife. On the other hand, if you expect to have your work survive the ravages of time, it is advisable that you understand how to use your tools and materials properly so that they do the work they were designed for. The technique should determine where and which tool is to be used. In short, the knife should scrape, pat, scratch, and extend paint; and the brush should smooth and stroke. Proficiency in a craft is essential to every artist and you will save a great deal of time and energy once you have learned what techniques to use in order to achieve the lasting effects that all true craftsmen aim for. Each project you undertake will be made easier if you set up your tools and materials beforehand, so that you will not have to interrupt the flow of creative energies in hunting for colors while in the throes of painting. I have therefore provided a list of necessary tools and materials needed for each project.

Although many painters may use the same techniques, the individual's style is usually determined by his personal touch or "handwriting." It develops only with much practice and experimentation. The aim of this book is to help you to eventually have a style of painting distinctly your own by learning how to choose successfully among the different painting techniques of the past and of the present. The time-tested as well as the newer methods of painting are presented here along with specific project assignments that put the techniques to the test. Reproductions of works by master painters accompany many projects with the aim of demonstrating the main characteristics of the technique being discussed. These works should be studied in this book and of course galleries and museums should be visited frequently.

Learning the methods and techniques of painting is a study involving much time and

effort. Therefore, before you start to paint, it is advisable to have adequate training in drawing. Since such a solid background is necessary for carrying out the exercises presented in this book, I have included an entire section on the techniques of drawing.

The way you use your materials will have a strong effect on the color qualities you achieve. When you feel that you have mastered the painting methods with some degree of competence, you can begin to use them singly or in combination and in any situation appropriate for expressing your ideas.

Keep in mind that successful results can be expected only with practice. Therefore after completing each project, it is necessary to plan to do other versions of the same project idea. The lessons of this book are a guide for your own development as painter.

Part One

EARLY PAINTING TECHNIQUES

Painting techniques have varied through the ages as new media have been developed and new ways of seeing and portraying objects have become popular, but the basic underlying principles—the use of color, perspective, composition, and the like—remain the same.

In this book we first study these principles, then apply what we have learned in the various media—pastels, watercolors, oils, acrylics, and mixed media—through technique projects.

But first, let us take a brief look at the early methods of painting and trace how the Old Masters presented their world.

ENCAUSTIC

In the twelfth century in the Netherlands, France, and Italy, artists used the Byzantine *encaustic* method of painting, a technique which had come to them from the Greeks. Encaustic was a mixture of powdered pigments, melted wax, and glue. It was commonly known to the Italians as *cerra-colle*. The encaustic technique had disappeared when the Byzantine Empire went into decline. A few individual artists continued to use this method of painting, but their technical expression was limited, because the pigments lacked a pliable solvent. This may account for the lack of progress and the primitive quality of the drawing and painting of the period.

FRESCO

Fresco, introduced by Giotto in Florence, was the next painting technique to gain popularity. This method involves painting on a freshly laid gesso ground (gesso is the Italian word for plaster) while the gesso is still wet. Egg-tempera colors, made by mixing together egg yolks, colored pigments in powder form,

3

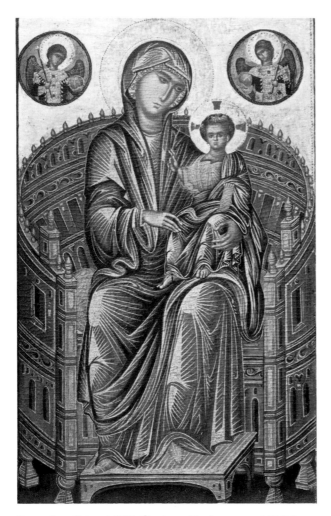

Byzantine School, 13th Century, *Madonna and Child on a Curved Throne.* Wood.
(National Gallery of Art, Washington, D.C., Andrew W. Mellon Collection.)

The encaustic technique. Encaustic was the painting of the Greeks. Most work done in the encaustic technique was distinguished by a linear quality, stylized facial features, and figures in a formal rigid design. There was no interest in three-dimensional rendering. The oldest existing encaustic paintings are those in Pompei, which are Roman copies of much earlier Greek works, and portraits painted in Fayam, Egypt.

water, and glue, were painted onto the moist gesso-covered wood panels or walls by such artists as Giotto, Fra Angelico, and Michelangelo.

True fresco is the most exacting of all painting forms, because it reveals all of an artist's shortcomings. The painter, working with pure pigments and using no binders, with nothing but water for a medium, paints directly onto a freshly laid, still-wet gesso ground. The work of painting must therefore be carefully done in stages, one passage at a time. If the panel is too wet, it rejects the pigments from the brush. If the gesso is too dry, the pigment will not be absorbed, powdering off the panel when dry. Furthermore, the work must be completed during the few hours when the surface is just dry enough to absorb the pigment and just wet enough to combine its own moisture with the water contained in the pigment. Only then will the plaster absorb the color into a fraction of an inch below its surface, and after drying, hold it there permanently.

OIL PAINTING AND TEMPERA TOGETHER: THE TRANSITIONAL PERIOD

Oil painting had been introduced by the twelfth-century monk Theophilus, who described the method and at the same time condemned it. He wrote, "Take the colors you wish to use, grind them carefully with oil without any water and make mixtures of colors for painting the figures and draperies as you did before with water; but every time you have to apply a color, you will not be able to lay on a second one until the first is dry and this in pictures is too long and wearisome." Painting in oils continued to be an inconvenient process until well into the fourteenth century, and artists were constantly seeking a solvent that would make their colors more pliable and faster drying. The method of painting during the thirteenth century had involved using *tempera* on some parts of the picture and *oils* in other areas of the same picture.

When *Cennino Cennini* (1365–1440) wrote his famous treatise on art "Trattato della Pittura," he recommended the laying on of glazes made with transparent oil colors *over* areas that had previously been modeled with tempera. He used tempera colors wherever subtle effects and quick drying were needed, usually in the drapery, architectural, and flesh-tone areas. The oil glazes were then painted over the dry tempera surfaces. When the entire painting was completely dry, a coat of varnish was applied to cover and protect it. The varnishes (which were made of mixtures of ani-

mal and vegetable gelatins) could easily be damaged by humidity. Furthermore, the varnishes were of a deep brown color, the patina of which seriously altered the harmony of the pictures they covered.

This by no means was the complete process of pure oil painting, since it was still combined with tempera, but it was the important *transitional* method widely adopted in Italy.

THE TRECENTO

The characteristic look of the trecento period was dark and muddy, as the thirteenth-century masters basically used the (cerra-colle) encaustic method of painting originated by the Byzantine school. This dark muddy look was the result, first of the incorrect preparation of the panel supports made with glossy mixtures of lye, wax, and glue, the painting work done in the egg-tempera technique, and lastly an excessive use of varnishes.

EGG TEMPERA

Giovanni Cimabue (1240–1302), the Florentine Master, was the first to introduce the egg-tempera technique of the Greeks into Italy. He taught it to his famous pupil *Giotto* (1266–1337), who in turn taught it to other Italian painters, liberating them as he had been from the rigid cerra-colle technique. *Cennino Cennini* (1365–1440) gave an account of the egg-tempera process in his treatise "Trattato della Pittura," and it made a profound impression on all who read it. Giotto's panels had been painted with stunning luminous colors, and the free movement of his draped figures and landscaped backgrounds was rendered with astonishing realism. Cennini's description of Giotto's technique is as follows: For his easel pictures Giotto painted on seasoned poplar wood panels that had taken two years in which to dry. The panels were selected carefully, only those that were totally free from any grease were chosen, then they were given two thin coats of carefully prepared gesso grounds. The first coat was called gesso-grosso, very rough in texture (its modern equivalent is plaster of Paris). Upon drying, it was scraped down with a long flat-blade knife until the surface was level. Then a second coat was applied, this time with *gesso sotile*, which when dry produced a very smooth, silky surface.

The final step was to scrape the now brilliant white panel until much of the oil was re-

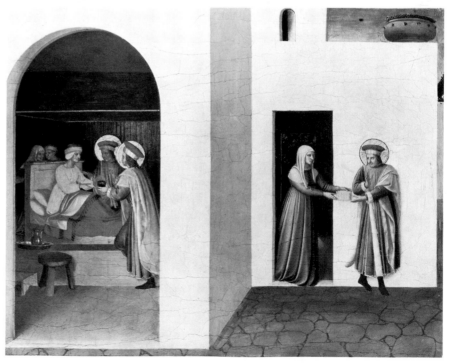

Fra Angelico, *The Healing of Palladia by St. Cosmos and St. Damian.* Wood panel. (National Gallery of Art, Washington, D.C., Samuel H. Kress Collection.)

Fresco. After encaustic, fresco painting was the next technique to gain popularity. The painters worked their colors on gesso-covered poplar wood panels.

moved, making the panel surface smooth enough to be painted on. It was extremely well suited for doing work requiring sharp contrasting color.

There are many myths revolving around the methods of the Masters, and many artists believe that Giovanni Cimabue and Giotto used the following formula with which to prime their wood panels.

INGREDIENTS
 1 small hen egg (fresh)
 Linseed oil
 Slate-lime in powder form (gesso)
 Glue size
 1 quart-size jar with a secure lid
 Pane of glass to use as a palette
 Spatula for mixing

The egg was broken into the jar and shaken for about one minute. An equal quantity of linseed oil was then added and shaken well for ten minutes by the clock. Then an equal quantity of glue size was added and shaken well for an additional ten minutes. (The proportions would be ¼ egg mixture, ¼ linseed oil and ½ glue size.) A suitable quantity of the gesso was poured onto the glass palette and the liquid from the jar was slowly dripped into the center of the gesso, while being stirred well with the spatula until the mixture became the consistency of cream.

The absorbency of this priming could be lessened by the addition of a higher percentage of liquid glue. The best glue was made from the skin of a rabbit.

Hubert van Eyck (1366–1426)
Jan van Eyck (1370–1440)

True oil painting began when the Flemish Van Eyck brothers perfected their method of painting and introduced it to the world in 1410. The monumental works produced during this period, both in the Netherlands and in Italy, have not as yet been affected by the ravages of time, and today, almost five centuries later, they still remain in superb condition. Their preservation is primarily due to the Van Eycks' innovative technique, a method which combined the use of boiled linseed or nut oil with pigments that had previously been diluted in a tempura emulsion. The Van Eycks' discovery of a new painting medium with which to make glazes opened up new possibilities to painters in the early fifteenth century. Their principal improvement in painting technique was that their medium dried quickly. When the liquid varnish medium was applied along with and mixed into each pigment as it was needed, painters were able to achieve subtle tonalities and shading that had never before been possible. The medium also *preserved forever* the solidity and limpidity of the painted surface by leaving a thin residue that, when dry, gave the appearance of a brittle varnish that protected the picture against any decay.

THE VAN EYCKS' FORMULA

Many artists have believed that the ingredients that these brothers used in making their medium, which later came to be known as "Van Eyck's Varnish," are the following: linseed or nut oil, pulverized glass, and powdered calcined bone. The *powdered glass* served to mechanically facilitate the oxidation of the oil and the *bone* slightly thickened it by the action of the calcine salts that the bone contained. When these ingredients were cooked for several hours at a high temperature, the fattiness of the oil was reduced by the evaporation of the pulverized glass compound (glycerine). This produced a very thick black oil, perfect for mixing with colors. When this oil was applied to lean surfaces, such as paper or tempera grounds, it did not diffuse. News of this medium was gratefully received in the printing trades. In order to make colors ready for painting the pictures, artists first thinned down the boiled oil with turpentine, then mixed in dry powdered pigments. The next step was to dilute the colors in an emulsion that was made by adding one spoonful of egg-yolk (beaten until it liquified) to one spoonful of the previously made boiled oil varnish. This

mixture was shaken thoroughly in a jar until it was well mixed and then one part water was added a little at a time. The result was a liquid emulsion that could be kept for several days. This now was the complete medium, which the Van Eycks are believed to have used to make their luminous glazes.

The Van Eycks' medium was universally used; painters in Germany and France also began using the Van Eyck method, conscientiously adhering to the rigid precautions initiated by the Flemish Masters. The painting process was done in many stages. Light-value toned colors were built up first with an application of white paint, and then numerous glazes were superimposed in sequences until the desired color was reached. The process became popular, finding its way onto panels, canvases, and walls. It enabled painters to execute works of large dimensions inside their own studios rather than directly on the walls of the buildings for which they had been commissioned. Colors formed a homogeneous body with the surfaces of the panels, and a picture painted in the Van Eyck method was bound to last indefinitely.

The Van Eyck method of work is believed to have been very nearly as follows:

Using pen and ink, the artist drew his composition onto a gesso-covered panel, indicating the shadow areas with cross-hatching. When the ink was dry, he would apply a coat of his varnish over the section of the drawing he was going to paint in. He would paint the color onto the wet varnish just applied. First the local color tones were mixed and diluted with emulsion and laid evenly in place. Then while they were still wet, he added more of the white emulsion to do the modeling. He modeled the paints with a dry brush, fusing them with the oily varnish in a way not possible with a tempera medium, as tempera would have dried before any blending could be done. After several days, when the first layer was dry, he would begin again, using the same medium, the areas that had already been painted, repeating the process as often as was necessary.

An overall coat of varnish was given when the painting was finished. The coat of varnish that had been applied when the painting was first begun served as a wet couch to make blending possible, but in the final coat, its function was to pick up any matte area and to equalize the surface lustre of the painting.

In brief, the Van Eycks' technique may be described as a process of working a tempera emulsion into a fresh coat of an oil varnish. The brothers kept their perfected technique of oil glazing a secret until it was introduced to Italy in the early fifteenth century by Antonello da Messina, whereupon the Italian masters also used it. Later, Da Messina developed a formula of his own that was used widely and was found to be just as useful as the Van Eycks'.

The break with medieval culture and tradition had become complete by the end of the fifteenth century. It was the Van Eycks who had brought about the first advance in the technique of painting, but their contribution was only the beginning. Subsequent painters were looking for new methods that would free them from the limitations of the oil technique.

THE FIRST LEAD VARNISH

Antonello da Messina (1410–1479)

Antonello da Messina introduced the next radical change. Discarding the last vestiges of the tempera painters, he produced the first lead medium for painting with a technique based entirely on the use of oil. Although the Van Eycks' method survived them for only about 150 years, Antonello's technical innovations and advances formed the basis of methods used for the next three centuries. Until the end of the 1700s, the most illustrious artists of the Renaissance followed his technique. Rubens could not have arrived at the formula for his own medium without Antonello's discovery. According to Vasari, the epitaph on Antonello's tombstone reads: "Not only was he revered for the excellence of his pictures, but also because by mixing colors in oil, he was the first who gave splendor and permanence to Italian painting."

The Van Eycks had been the first to use linseed oil that had been boiled as a solvent for glazing colors over others which had been diluted in a tempera emulsion; whereas Antonello was the first to dilute all *pigments with a lead varnish oil solvent*.

Antonello's formula is said to have been lead varnish, a paste-like preparation resembling honey, that was made by cooking over a slow fire a mixture of walnut oil along with a high proportion of litharge (fused form of powdered lead ore). He came to his discovery knowing that from the earliest times of oil painting, artists had used white lead on their palettes because of its great drying power when mixed with their paints. Antonello's lead varnish was completely resistant to water. It had a quality of fluency that made it possible to blend colors perfectly, making painting a *direct process* that allowed the artist to achieve results in a few sessions. This was a distinct improvement over the Van Eycks' laborious process, which had to proceed by many stages, first in the building up of light tone areas with white, and later by covering them with numerous glazes applied in light toward dark sequences. Antonello da Messina, on the other hand, used his paste medium to dilute the colors that had been previously ground in raw linseed oil. It was the direct contact of lead with the colors that enhanced the tone and brilliance of his pictures.

Leonardo da Vinci (1452–1519)

Leonardo invented the second lead medium, by adding water during the cooking stage of Da Messina's process. The addition of the water had the effect of lightening the color of the oil medium. The procedure was dangerous unless carefully executed. Leonardo improved it later by adding beeswax, which made it possible to cover larger surfaces.

Giorgione (Giorgio Barbarelli) (1478–1511)

Giorgione made the next contribution. He converted Leonardo's medium into what is referred to as Giorgione's black oil. He used it along with beeswax to create the first successful large-scale oil painting. He was also able to control the matte, gloss, and impasto aspects of the new medium; consequently he could control the painting process better than any artist had ever done before.

Titian (Tiziano Vecello) (1477–1576)
Tintoretto (Jacopo Robusti) (1518–1594)

Titian and Tintoretto each developed variations of his own. Titian used velatura, the semi-opaque tones and half pastes which were glazes containing white paint diluted into the varnish.

Tintoretto, on the other hand, used more beeswax in his painting medium so that he could paint very large areas, and his method came to be known as the *medium of the Venetians*.

Flemish painters used the Van Eyck method until the time of Peter Paul Rubens (1577–1640). The Italians used it until Da Messina popularized his own formula because it was much easier to use than fresco. These two methods were used continuously for over 300 years.

Because oils were less stubborn than fresco, they permitted the painter more freedom in retouching and correcting. As a result, painters were tempted to relax in keeping to the discipline of the proper use of the medium. In time, the original methods used by the Van Eycks and Da Messina were forgotten. The chief mistake of many artists was to paint on an oil-primed canvas, using thick impastos of paints and applying final coats of varnishes. These layers dried at different periods of time, preventing the painting from acting as a unit while the contraction and expansion caused by variations in each substance took place, i.e., canvas support or panel, paints, and varnishes along with different room temperatures. As a result, most paintings developed cracks and their preservation was greatly hampered.

But the real decline of oil painting began with the improper use of varnishes, with unstable colors, and by unhappy experiments with poor painting techniques. Many masterpieces by great artists deteriorated because their creators had found the Van Eycks' and Da Messina's methods too confining.

Peter Paul Rubens (1577–1640)

Many methods of painting are questionably attributed to Rubens. A great number of artists who are guided by myths of the past strongly believe that the following is the process that Rubens used. Whether it is accurate or not, it does give us some insight into his methods. But be that as it may, there can be no question that Rubens created a revival of the old standards when he perfected his oil painting medium, which was a mixture of powdered lead carbonate and mastic varnish added to Giorgione's black oil. By mixing his wax-like mastic varnish medium into his paints, he was able to produce a luminosity, a transparency, and an impasto quality never before achieved. This medium made the facile, visible, and versatile brushwork of his alla-prima method of painting possible. (Alla-prima means covering the canvas surface with a color and, while the color is still wet, working in additional colors using visible brush strokes.)

After many experiments Rubens discovered that when he combined a black oil (boiled wal-

Peter Paul Rubens, *The Meeting of Abraham and Melchezedek.* Wood.
(National Gallery of Art, Washington, D.C., gift of Syma Busiel.)

Rubens' oil painting medium. There can be no question that Rubens created a revival of the Old Master guild standards when he perfected his own painting medium. His formula is believed to be a mixture of powdered lead carbonate, mastic varnish, and boiled walnut oil (black oil). This medium made possible the versatile impasto brushwork of his alla-prima method of painting.

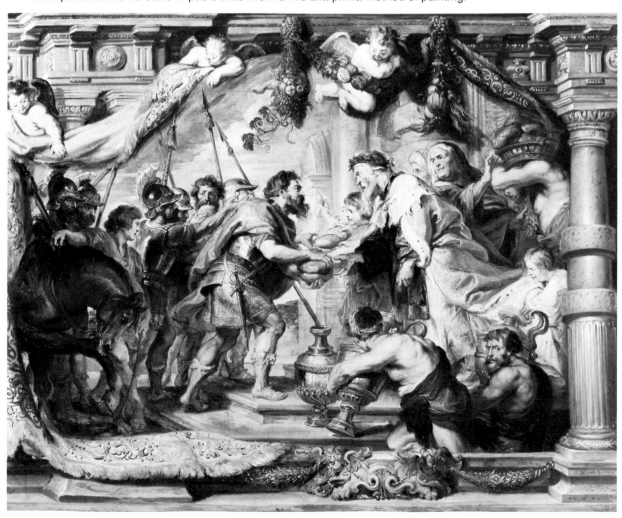

nut oil), powdered carbonate of lead, and a solution of mastic varnish mixed with essence of turpentine, he produced a wax-like jelly. Its strength was in direct proportion to the amount of lead in the oil. The jelly could not be obtained without the turpentine, a necessary ingredient. Although the turpentine evaporated, it could not be replaced with anything else. During the process of painting, the amber-colored jelly was used to dilute the colors on the palette. The effect was as though liquid glass had been injected into the colors. Since Rubens' jelly medium was so heavy, he often had to wet his brush in essence of turpentine to soften it before continuing with the painting. He could modify the force of the jelly by increasing the lead in the black oil so that it would take on more body and transparency. By the addition of a few drops of boiled oil, a tenacity would be produced in the medium, causing the brush stroke to pull slightly as it moved across the canvas. This medium made possible almost incredible gains in turning out work with great speed of execution.

In choosing the proper support for his grounds, Rubens made a distinction between those that were to be used for small paintings where he usually used the alla-prima technique in painting them, and those used for paintings of large dimensions requiring long, drawn out work in which his pupils assisted. For small paintings he used panels of hardwood, oak, or walnut. When the last layer of priming was dry, he colored it a light brown-toned bistre, which had been diluted with the jelly medium until it was almost a glaze. He also used the wax-like jelly medium for glazing, as he found it to be an ideal vehicle for this technique.

Sir Anthony Van Dyck (1599–1641), one of Rubens' pupils, used much the same medium, except that he used a much lighter black oil made with less varnish.

The Dutch artist Jan Vermeer (1632–1675) used Rubens' formula but without the wax, because he wished to have a smooth, polished, untextured surface in the small pictures he painted.

Rembrandt van Ryn (1606–1669) used Rubens' medium with the maximum amount of wax to produce his heavy impasto effects. Like Rubens and Van Dyck, he sketched in and painted his pictures in the alla-prima technique, but he would *rework* the entire canvas after it had dried. The transparency of his medium, when applied in layers, made it possible to create the most lustrous and lasting atmospheric effects of great depth which is characteristic of most of his work.

El Greco (Domenkos Theotoculis) (1541–1614)
Diego Velazquez (1599–1660)

Finally, the last but by far not the least version of the use of the Venetian medium took place in Spain, first by El Greco and then by Velazquez. In later years, great contributions have been made by the French Impressionists, the Post-Impressionists, the Fauves, the Cubists, the Surrealists, the Nonobjectivists, and the Precisionists. But no matter what the individual styles in painting and pictorial ideas were, they utilized the same procedures initiated by the Old Masters.

Today, painting has reached a point where difficulties of technique no longer stand in the way of artistic expression. With the scientific advances and discoveries made, artists need have no concern about the durability of their work. They have at their disposal countless, time-tested paint products and colors, varnishes, and painting surfaces of high quality and permanence.

These advances have freed painters to devote themselves completely to the execution of their inspired motivations, assured that their work not only will be preserved but may even outlast the great masters of the past. They are free to concentrate on the many ways to apply the paint to canvas, panel, or board with palette knife, brushes, sponge, or rag, using whatever method suits the immediate need.

Part Two

COLOR

In the study of painting, it is difficult to understand color unless we first acquaint ourselves with tonal values. By asking the question, "What is the value of a color?" we are really asking, "How light or how dark is it?" In other words, we are seeking a way to distinguish the lightness or darkness of given colors when comparing them to others. In painting parlance this is often referred to as *value distinction*.

Before starting to use color it is necessary to learn to distinguish the different tonal values in the black-and-white scale. The first step toward gaining the ability to recognize values is to grade tones in degrees of darkness (or light) from pure white to intense black. When the tone has been made light by the addition of white, we refer to it as a *high-key value*, and when it has been made dark by the addition of black, as a *low-key value*. We use white to raise a tone's value and black to lower it.

It is easier to recognize value in gray tones than in colors, because the stimulation pro-duced in our eyes when we look at colors is likely to deceive us in judging how much light there is in a color. A valuable first color exercise, therefore, is one that mixes only black and white to produce a variety of grays.

With a clean palette, mix seven different grays, using only white and black paint. Add small amounts of black to small amounts of white to get the desired values. First mix two light grays, then three middle-tone grays, and finally two dark grays. Place these seven grays, along with pure white and black, in sequence from dark toward light onto the upper edge of your clean painting palette. You now have nine mounds of paint to work with.

In the following project we will be involved with the first concern of the painter: the distinguishing of different tonal values.

To understand the light and dark values of a tone, we will do a painting using forms that have curved contours. These will be a great help not only in studying different tonalities but in seeing how their three-dimensional qualities can be rendered when they are modeled with graded-scale-blended tones that go from light toward dark.

Value scale showing nine different grays. To produce a variety of grays of different tonal values, start with a large amount of white paint. Gradually add small amounts of black to make successive mixtures of darker toned grays, until you have at least nine different ones, ranging from pure white toward the black. It is easier to recognize values with gray tones rather than in colors because the colors are likely to distort our judgment of intensity of light or dark.

Project: VALUE DISTINCTION

SUBJECT: Still life, with low-key and high-key
 values

ILLUSTRATION REFERENCE: Cezanne, *Still Life:
 Flask, Glass and Jug*

TOOLS AND MATERIALS
 Smooth-surface canvas, 20″ × 24″
 Bristle brushes, assorted sizes of flats
 Flake white
 Ivory black

Oil painting medium
Turpentine
Two medium cups
Palette knife, flat blade for mixing
Two palettes

Allow yourself plenty of time for preparing
your palette with as many grays as you can
mix before you start to paint your picture.

We all know mixing black and white to-
gether produces a basic gray. The question is,

Paul Cézanne, *Still Life: Flask, Glass and Jug*. Oil on Canvas.
(The Justin K. Thannhauser Collection, The Solomon R. Guggenheim Foundation, New York)

Value distinction. When you mix a color with another darker or lighter color, you
change its tonal value. The greatest change occurs in the simple shapes and in
small quantities such as in a small square or strip.

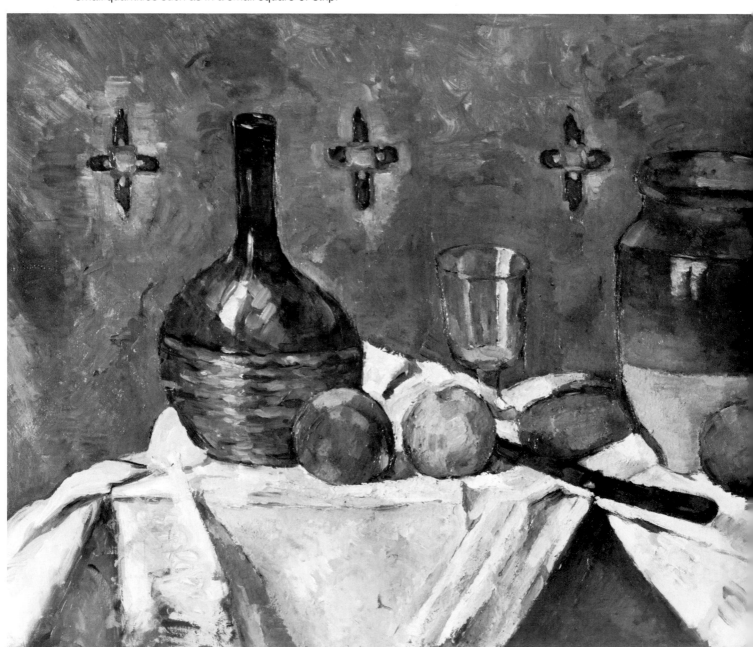

just how many grays are you capable of mixing? Quite a few, provided that your patience holds out. You should come up with at least seven clear-cut gradations of gray by simply adding a little more black to the white for each successive gray.

Using one of the clean palettes, individually mix the following grays, one at a time:

Two light grays

Three different, middle-tone grays

Two dark grays

Transfer them all onto your clean palette, placing them in sequence from dark toward light.

Set up a still life of several objects that have curved edges, such as an orange, a grapefruit, a lemon, and a large round bowl or dish standing upright behind them. Place them on a table so that they are silhouetted against a dark-gray wall or draped cloth. A bright light should come from the side so that you can get a definite source of light shooting onto the objects. The variation of grays on each form and the sharp shadows made by the objects create excellent areas of distinct tonal values, giving you the opportunity to paint in graded tonal values. *Still lifes* are suitable as subjects because you are able to take as much time as you like to study their tonal nuances and variations before you start to paint.

1. First, select one of the middle-value grays. Thin it with a little turpentine, and sketch the still-life composition onto the canvas.

2. Next, block in the key dark areas, using pure black paint applied with smooth brush strokes.

3. Use the darkest of your grays for the background space, covering the entire area with it. Dip your brush in the medium before each brush stroke.

4. Determine where your source of light is, and then paint in all the light areas with pure white.

5. Follow by painting in all the different middle grays, always referring to the actual objects in your still-life setup. Work from light toward dark values. Place each tone next to

the others so that the edges touch. When you have finished, you will have little trouble identifying each of the different grays, noting how each differs from the one it is next to.

6. Lastly, using a clean, dry brush, systematically rework the gradations (that is, where one value ends and another one begins) of the areas you have just painted. Work the brush back and forth so that the painted wet areas are blended together and softened. In this way a gentler and more subtle appearance is achieved.

Project: MONOCHROMATIC PAINTING

SUBJECT: Still life with green drapery

ILLUSTRATION REFERENCE: L. Salemme, *Windows* (color section, page 18)

TOOLS AND MATERIALS

 A large piece of solid green fabric, about 1
 square yard
 Viridian green
 Ivory black
 Titanium white
 20″ × 24″ stretched canvas
 Sable-hair flat brushes, assorted sizes
 Flat-blade palette knife for mixing
 Clean palette

In this exercise you will be studying the effects achieved when you work with only one color (green) added to a series of seven grays that have been made with small amounts of black and white mixed together (see preceding exercise).

Your subject is to be a still life of draped fabric painted in tones of one color. I write in terms of green, because it is a favorite of mine, but you can use any color you wish.

1. First, mix a series of seven different grays, and place them in a row on your clean palette. Then squeeze out a generous amount of the viridian green alongside the grays.

2. Drape the fabric so that it flows gracefully over the back of a chair and onto the seat, over the edge, and toward the floor. Place the whole setup in the path of light coming from a win-

dow or other light source. Arrange it so that you get interesting shadow areas throughout.

3. Make a thin wash of one of the grays by mixing some turpentine into the paint. Then sketch in your drapery and its folds. This is a very important step, because success depends on a good start. Aim for an interesting composition of your subject. Decide where all your dark and light areas are to be and where the light is coming from—sharp contrasts created by the distributed darks and lights will make the composition more interesting. And now to paint.

4. Using a good-sized brush, paint in all the largest areas first, using all the middle-value grays.

5. Next paint in all the dark areas with black.

6. Now paint in all the white areas in the remaining blank spots.

7. The next step is to apply the green. Simply pick up the color with a clean brush and work it into the wet grays that you have just painted. Apply the paint so that the wet undercolor (gray) blends with the green you are adding. Work carefully, preferably with small brushes, so that you do not blur the edges of your original sketch.

8. The last step is to carefully paint in all the details and highlights with more green, black, or white, depending on what the subject calls for. The finished picture should be a fine example of a painting done in tones of green.

COLOR QUALITY

The three qualities that colors possess are hue, intensity, and value. In the painter's language *hue* means the name of the color. *Intensity* means how one color differs from another. *Value* means the different degrees of darks and lights of a color.

Of the three, hue is the most important term. Depending on what colors you mix together, you can produce innumerable hues. For example, if you mix red paint with yellow paint, you produce orange paint, which is a change of hue. (And you will, of course, get variations of hue, depending on what proportions of red and yellow are used.)

Because some colors are strong and some are weak, the quality by which we tell them apart is called *intensity*. Painters mean the same thing by *saturation* and *chroma*. You can change the intensity of your color without changing its value or its hue by adding a neutral gray of equal value to it.

Many painters prefer the word *brilliance* to the word *value*, but either word indicates that we are able to see the difference between the light or the dark tones of the same color.

A midtone is a middle value or a grayed-down version of a color. When a little black is mixed into a pure color, the resulting subdued version of the color is referred to as midtone of whatever original color was used. Because working with midtones is vital to your understanding of color values, do a practice painting exclusively in midtones.

After you have studied the tonal values of the black-and-white scale, you can venture into the dazzling world of pure color. (See color section, page 18.) It is a good idea to give color values identifying titles. They fall into three categories, the mass tone, the top tone, and the midtone.

The *mass tone* is the color as it looks when first squeezed from the tube. An essential practice exercise is to paint a small picture in which you explore all the top tones. It will prove to be most valuable in demonstrating how much light a given color is capable of projecting naturally, how dark a color can be, and what a tremendous impact each pure color has when placed next to another. Note that yellow has the most light, red is a middle-value color, and blue casts the least light of all. You can easily do all this by filling up the picture space with nonobjective forms in an all-over pattern, painting each shape with the color right out of the tube. The finished painting will project a mood of dynamic excitement.

The *top tone* is the color after it has been mixed with white, and this is the way most

artists prefer to study the intensities of colors. Do a practice exercise using only your undertone colors and note what a cheerful light-hearted array of tonalities you have achieved.

The *midtone* is the toned-down version of a color, after it has been mixed with a little raw umber, with black, or with its complementary color. (Complementary colors are directly opposite to each other on the color wheel.) Do a practice exercise using the same composition you have used for the undertone and top-tone paintings and see how subdued and serious a mood you can create with a palette composed solely of midtone colors.

There are as many different labels for each of the colors as there are companies manufacturing them. When making a selection, it is best to refer to the powdered pigments made by suppliers of dry colors for artists. Here is a list of recommended colors. This list refers to the pigment in its powdered stage, the purest stage of all. When buying your paints, select from the manufacturer's color chart only the colors that resemble these:

Cobalt blue	Ultramarine blue
Cobalt green	Vermilions
Cobalt violet	Chrome oxide
Cerulean blue	Umbers
Genuine aureoline	Siennas
Emerald green	Ivory black
Emauraude green	Titanium white
Cadmium yellows	Zinc white
Cadmium reds	Flake white
All oxides	

THE PRIMARY COLORS

The primary colors are red, yellow, and blue. All the other colors in your paint kit are derived from a combination of these three. Before venturing on to work with other colors, do a practice exercise exploring just these three. Squeeze ample amounts of cadmium red, cadmium yellow, and cobalt blue onto your palette. Using a large brush, transfer the paints in this pure state onto your canvas or paper. Then place a blob of pure white next to each color and allow the white to fuse slightly into the color. Brush it out so that each color almost touches the other. Finally, enclose each color area with a bold, direct brush stroke of black paint. Note how the black outline gives added vibrancy to the color.

If you mix all three colors together on the palette, you will get a beautiful and interesting gray.

COMPLEMENTARY COLORS

When we refer to complementary colors, we mean colors that are opposite in character in the sense that they appear opposite to each other on the color wheel. For example, starting with the basic colors, the complement of red is green, the complement of blue is orange, and the complement of yellow is violet.

For a warm-up exercise, paint square splotches of complementary colors on a canvas or paper. To facilitate matters, use the following list of primary colors and their matching complementary partners. Arrange them in the order listed to view the colors against their partners.

COLOR CHART

Primaries	*Complements*
Lemon yellow	Cobalt violet light
Cadmium yellow	Cobalt violet
Yellow ochre	Cobalt violet deep
Cadmium red or vermilion	Yellow green or permanent green light
Cadmium red medium	Viridian
Alizarin crimson	Chrome green
Cerulean blue	Cadmium yellow deep
Cobalt blue	Cadmium orange
Ultramarine blue	Cadmium orange deep
Prussian blue	Cadmium orange light

Even though certain colors are opposite one another on the color wheel, they can nevertheless harmonize. This is a fascinating contradiction of terms, one you should remember. You have to experiment with color combinations in different proportions on the canvas to learn what will harmonize and what will not. There is also a substantial element of personal feeling here. Keep your practice canvases around and refer to them from time to time so that you can study the different combinations.

Project: EARTH COLORS AND PRIMARIES TOGETHER

SUBJECT: A landscape with figures

ILLUSTRATION REFERENCE: V. Salemme, Pacific Shore (color section, page 19)

TOOLS AND MATERIALS:
 Oil colors: Cadmium yellow
 Yellow ochre
 Cadmium orange
 Raw umber
 Cobalt blue
 Burnt umber
 Cadmium red
 Burnt sienna
 Indian red
 Viridian green
 Green earth
 Titanium white
 Bristle brushes, assorted sizes (flats)
 Oil painting medium
 Turpentine
 Two medium cups
 Flat-blade palette knife
 Clean palette

In a landscape painting your composition will hang together harmoniously (no matter how many shapes you include) if you use visible brush strokes. By visible brush strokes we mean that the strokes go in the direction of the shape being painted. Clouds in the sky will be painted in circular rhythms, architectural features in whatever direction the perspective calls for, and grasses in short vertical brush strokes. Simply change the direction of your brush strokes with each shape you paint, varying it from the direction used in neighboring areas.

By painting earth colors and primaries side by side you enhance the unity of the composition. Note how the whole color scheme in a painting flows together when you use visible brush strokes and place an earth color next to a bright color. Since most earth colors are dark in value, you might use them mixed with a little white to bring out their top tones.

Paint a practice exercise of juxtaposed earth colors and their primaries. By painting an earth color next to its corresponding primary, you will reduce the brilliance of the primary. For example, to reduce the brilliance of cadmium red use Indian red, and to reduce the brilliance of blue use raw umber or burnt umber. (You may go on to include the complementaries in your experiment. Place a light veridian green next to green earth, place violet next to raw sienna, and orange next to raw umber.)

When you wish to get more subdued effects, be more generous in your use of the earth colors. For instance, you can substitute an earth color for any of the brilliantly hued colors—thus instead of cadmium yellow, you can substitute yellow ochre; instead of any of the blues, substitute a sienna or an umber; and with your cadmium red the substitute would be Indian red.

Now put this information to the test by painting an autumn landscape, because earth colors do suggest that time of year.

1. First block in your composition, including the features you think suggest a rural scene in autumn, such as hills, fields, barns, houses, and trees. If you include figures, have them engaged in some activity that will correspond to some of the other elements in the composition.

2. Plan a definite source of light from which you can logically expect shadow areas. Shadows not only add drama to a composition but also serve to tie the different parts of the painting together.

(Continued on page 41)

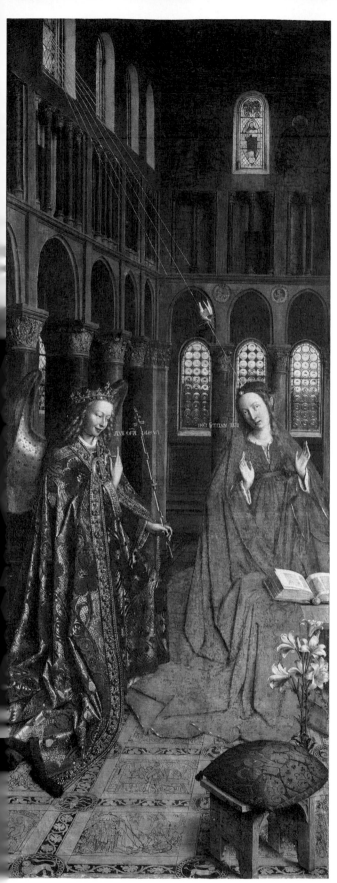

Jan Van Eyck, *The Annunciation*. Transferred from wood to canvas.
(National Gallery of Art, Washington, D.C.)
Oil painting. The Van Eyck brothers discovered a new medium, oil paints, to use for painting lustrous and luminous glazes. These were applied in many stages, first building up all the light-toned areas with a layer of white. Later, numerous color glazes were applied in sequences, going from the light toward the dark tonalities until the desired color was reached.

Antonello Da Messina, *Madonna and Child*.
(National Gallery of Art, Washington, D.C.)
The first lead varnish medium. Antonello Da Messina discovered the first lead varnish medium. This medium had a quality of fluency that made it possible to blend colors perfectly, making painting the **direct process** that allowed the painter to achieve results in a few sessions. This discovery led the way to all further developments in oil painting techniques.

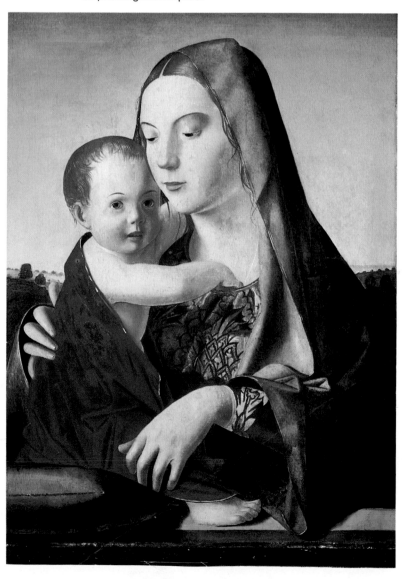

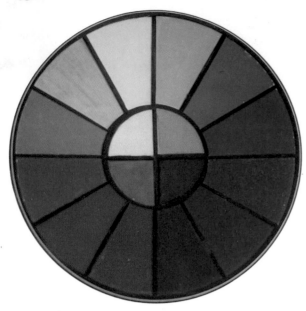

The color wheel. This is the traditional synchronized spectral circle or color wheel, which is the basic one used by most artists. All these colors may be multiplied by varying the amount of light or dark of each. These colors have different names depending on which paint company manufactures them.

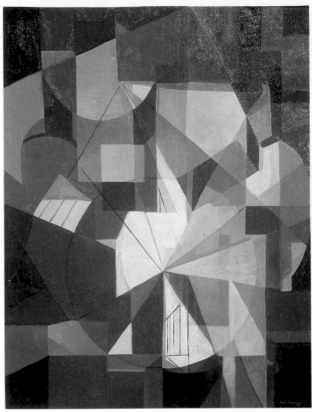

Lucia Salemme, *Windows*. Oil on canvas.
Monochromatic painting. Even when dealing with one color, a variety of tonal nuances can be achieved with additions of black and white. By using different value variations of the blues along with a dramatic treatment of some areas of pure black and white placed in key spots, a poetic aspect of an otherwise severe architectural idea is achieved.

Lucia Salemme, *Between the Moon and the Sun*. Oil on canvas.
Harmony with the primaries. This large canvas is divided into three sections, each painted in the family of one primary color—yellow, blue, and red. The sections are fields on which both the color and the pictorial images are dealt with as units, providing a series of "one-color-at-a-time" images.

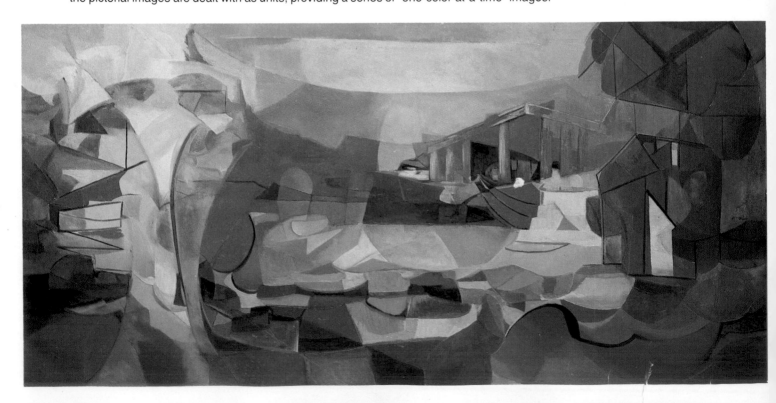

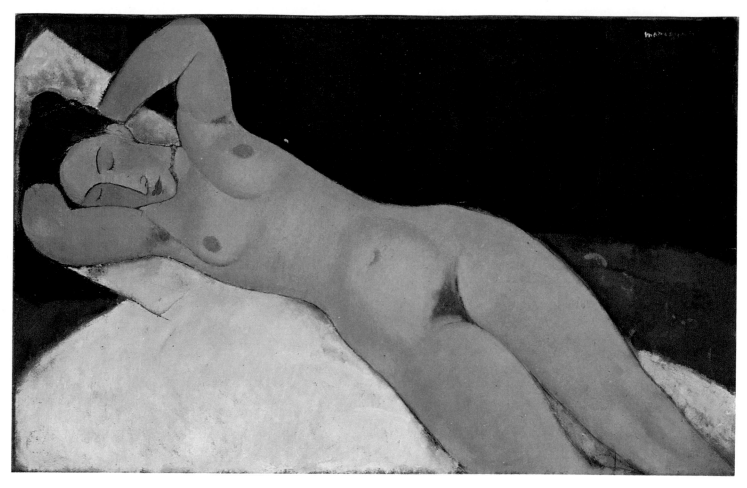

Amedeo Modigliani, *Nude*. Oil on canvas.
(The Solomon R. Guggenheim Museum, New York)
The **positive space** in the composition is the area making the statement. In this case it is the figure of a reclining nude. The negative space is the area surrounding the solid forms.

Vincent Salemme, *Pacific Shore*. Oil on canvas board.
Painting with earths and a primary, using visible brush strokes. An intense blue primary can be toned down when you place an earth color next to it, making the composition hang together in a flow of harmonious rhythm. In addition colors can be made to appear more vibrant when brush strokes go vigorously in the natural direction of the form being painted and the background spaces can be made to recede delicately when painted with faintly distinct brush work.

Georges Braque, *Landscape Near Antwerp*. Oil on canvas.
(The Justin K. Thannhauser Collection, The Solomon R. Guggenheim Foundation, New York)
The hot colors. The basic hot colors are the cadmiums, yellows, reds, orange, and flake white—along with their derivatives. Even if the compositional arrangement in the picture is peaceful, when these colors are used in the painting, flashes of glowing warmth will emanate from an otherwise calm picture.

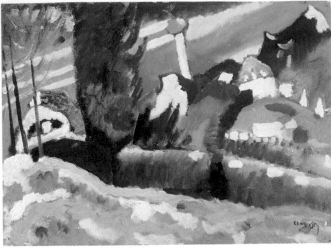

Wasily Kandinsky, *Winter Study with Church*. Oil on board.
(The Solomon R. Guggenheim Museum, New York)
The cool colors. The basic colors are blue, gray, viridian green, and zinc white. Some of the other colors, like lemon yellow or alizarin crimson, will also project a cold image when placed next to traditionally cold colors.

Color Mingling Experiments

In the first two columns, colors are made to vibrate by mingling white on the upper area of each frame. On the lower part of the same frame the color is mingled with black producing a muted version of the area. The third and fourth columns illustrate the mingling of complementary colors to produce additional intermediate hues. The last two columns show the mingling of triads where exciting effects are achieved when all three primaries are combined.

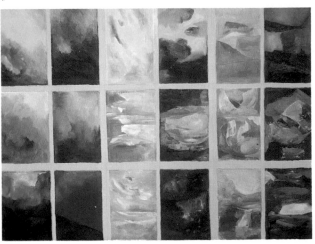

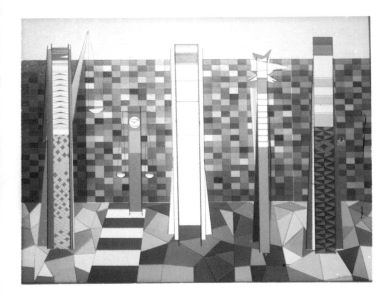

Attilio Salemme, *The Sacrifice*. Oil on canvas.
Monochromatic harmonies. Some colors recede, some advance. Ten or twelve different reds are used in this painting. Each one is different because it was mixed separately, as were the grays. The reds have a strange quality: they blush with the light sometimes in a deep crimson toward purple and at other times toward the orange. When the painting is seen up close, the wall flattens the figures to it, but at the proper distance the space between and behind the figures is strongly alive.

Lucia Salemme, *As Light Sweeps Across the Sea*. Oil on canvas..
Velatura. A dry, matte surface texture with veil-like ephemeral atmospheric color is the characteristic of the velatura technique. It is achieved by adding glazing medium to the color until it is of a paste-like consistency, halfway between impasto and glaze. Painting on a gesso-covered canvas is recommended.

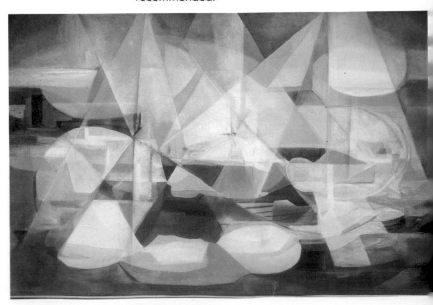

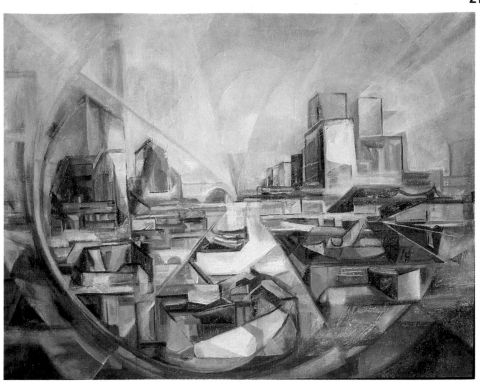

Lucia Salemme, *Blue Landing*. Oil on canvas.
Glazing. Use stand oil with a touch of copal
drier thinned with rectified turpentine when
glazing or overpainting, as these mediums do
not yellow or crack. When dry, they produce an
enamel-like finish that enhances the tone values
of your painting and promotes the fusion of
colors. The medium also permits frequent
overpainting without impairing permanence.

Achieving Depths with Color

Block in all the large areas with color masses of faintly
distinct light value tones in the far-distance spaces,
muted midtoned colors for the middle-distance spaces,
and vigorous, dramatic in-focus colors for the
foreground.

While the paint is still wet put in the details with
applications of thick paint. Then, using a clean brush,
gently work the edge of each of the areas so that they
blend together, transforming the raw color patches into
delicate variations of the images each represents. The
softened edges help eliminate an awareness of shape.

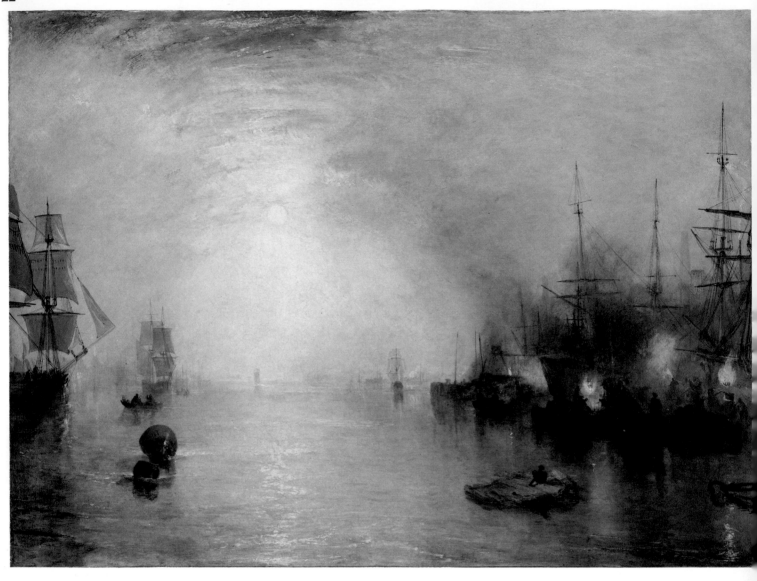

Joseph Mallord William Turner, *Keelman Heaving in Coals by Moonlight*. Oil on canvas.
(National Gallery of Art, Washington, D.C., Widener Collection)
Wet-In-Wet. In this technique color brilliance is obtained from the color itself, a quality which is either emphasized or subdued by direct blending while all the colors are still wet. You can blend additional colors into color already on the canvas.

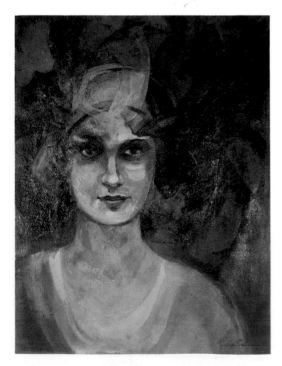

Lucia Salemme, *Ariadne*. Oil on canvas.
Luminous glazes are achieved in stages by first painting the lighter toned colors over which darker glazes are applied in sequences until the desired color value is reached.

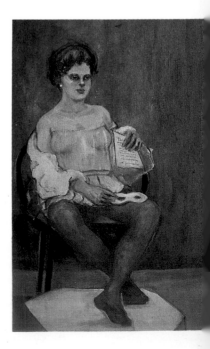

Lucia Salemme, *Backstage Girl in Red Tights.* Oil on canvas.
The posed model as a subject painted with smooth brush work. The colors are carefully planned to emphasize the mood of the person being portrayed.

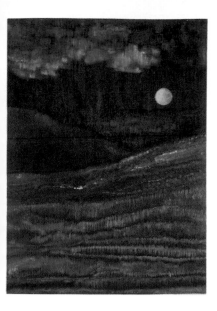

Vincent Salemme, *The Shore At Night*. Oil on canvas.
Rough textures include such objects as rock formations, tree bark, seeds and nuts, pine cones, fields, hills, and skies. Do several paintings of such subjects so that the different texture of each is clearly defined.

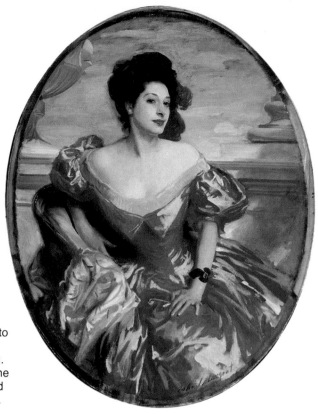

John Singer Sargent, *Betty Wertheimer*. (National Museum of American Art, Smithsonian Institution, Washington, D.C.)
Lustrous effects. You will be called upon to paint lustrous effects when rendering skin tones and the tones of the model's clothing. Often the color of the garment as well as the background and skin tones will be reflected back and forth throughout the composition.

Stages in painting a portrait. Start with a black-and-white sketch. Then proceed to the painting. Apply the actual color, beginning with the light-toned ones, then the midtone colors, and gradually darken the values with suitable shades as you proceed toward the last stage. Emphasize the direction of the light source where the sharp contrasts of light areas against the darks are seen. This is done by applying the paint in the light areas with thick brush strokes, but take care not to disturb the values already established in the underpainting. Finish off by painting in the various colors where they are needed in the background or drapery details. You can mix a basic skin tone by combining titanium white, Naples yellow and a touch of alizarin crimson, and finishing off by blending in touches of the adjacent colors that surround the model.

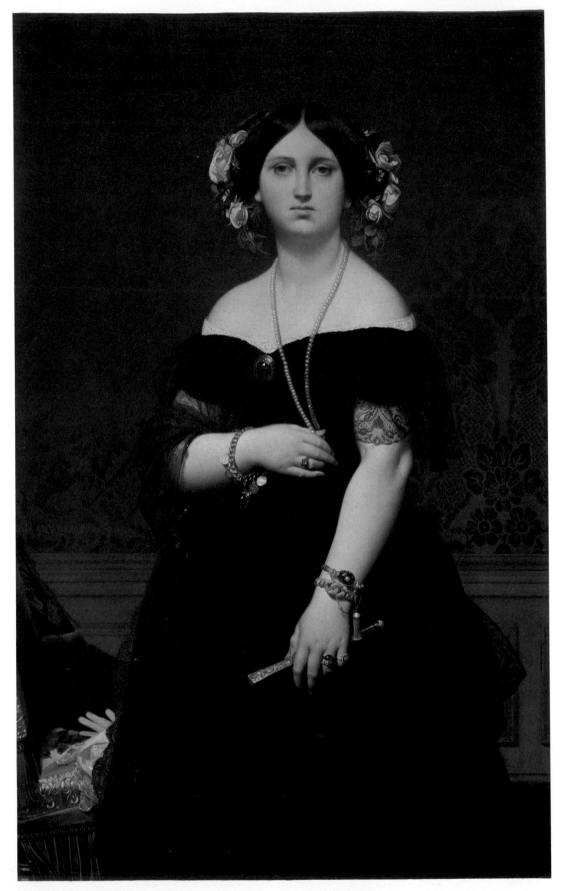

Jean Auguste Dominique Ingrès, *Madame Moitessier*. Oil on canvas.
(National Gallery of Art, Washington, D.C., Samuel H. Kress Collection)

Smooth textures. Do some small paintings of smooth surfaces of real things. Make a collection of objects with smooth textures, like sea shells, fabrics, flowers, feathers, pebbles, and pearls. Place them in still-life set-ups and then paint them.

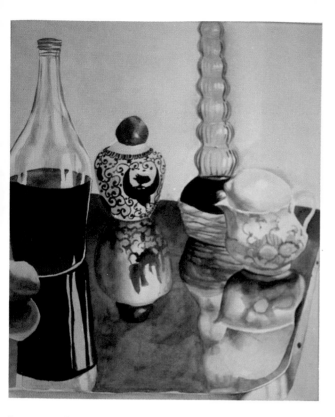

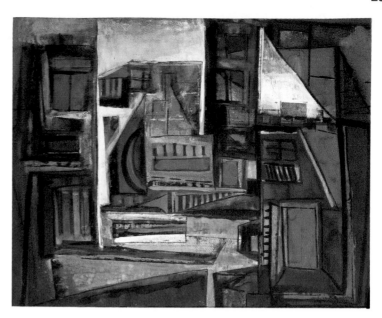

Lucia Salemme, *Night in the Clairvoyant City*
(Permanent Collection Whitney Museum of American Art, New York)
Gouache painting on toned paper. For greater freedom in achieving textural effects quickly, thick applications of bright gouache colors over dark toned papers are recommended.

Lawrence Salemme, *Reflections*. Watercolor on paper.
Omitting edges: There are several techniqes for omitting edges. One of them is not to put any paint in the areas that are to remain light.

Lucia Salemme, *Laguna Beach Garden*. Watercolor on paper.
By allowing the paper to remain white, the different forms in a clustered landscape can be identified.

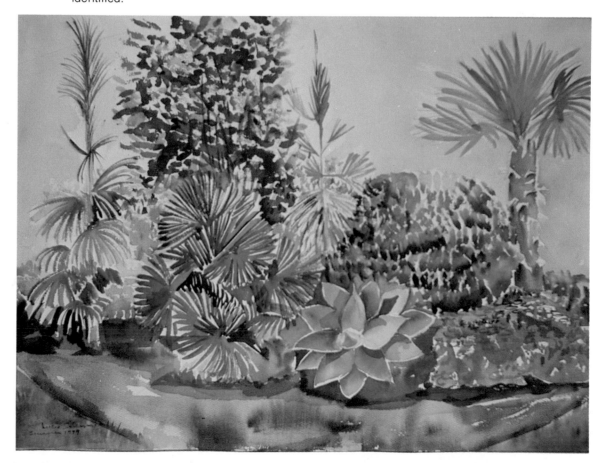

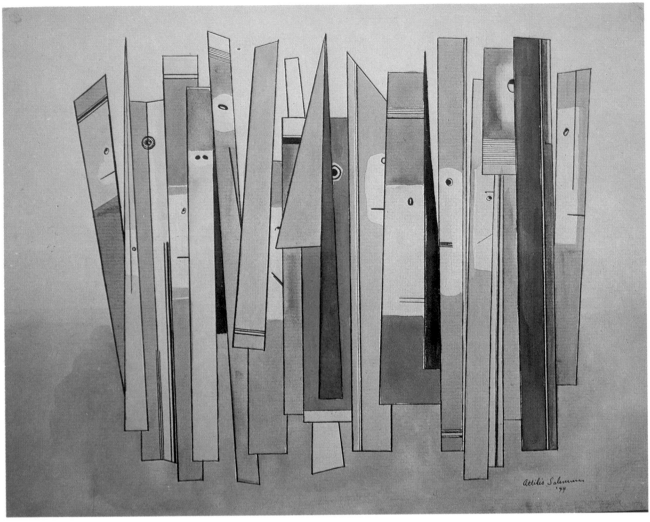

Attilio Salemme, *The Crowd*. Watercolor on paper.
Transparency with flat washes. The flat wash is ideal when you wish to paint an architectural
subject, especially the flat light and dark sides of buildings in a traditional scene, or when
painting flat planes of pure color in an abstract composition.

Vincent Salemme, *Celebration 1976*. Felt
tip pens on paper.
An overall pattern-like effect is achieved by
using an assortment of colored felt tip pens
in a linear composition.

Lawrence Salemme, *The Chinese Poster.* Watercolor on
paper.
When leaving **blank spaces** or open areas in the places
that you wish to appear white, working on smooth, hot-
press watercolor paper will help you achieve clean, sharp
edges.

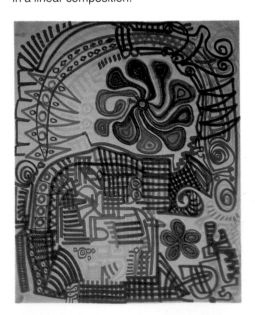

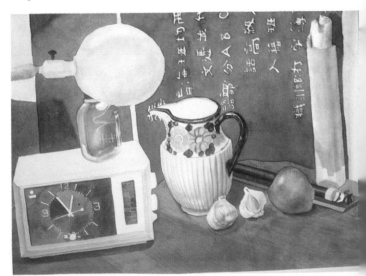

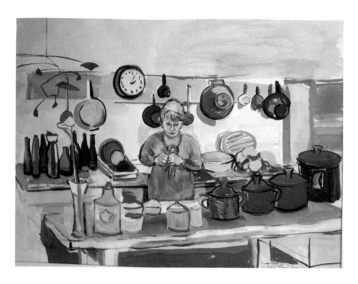

Lucia Salemme, *Potrait of Louisa Calder in Saché Kitchen.* Gouache on paper.
(Privately Owned)

Flat opaque effects. Plan to paint your flat gouache picture so that it is finished in one sitting. Do not allow it to dry over as you rework it, because as the paint hardens it will not absorb any fresh paint, and can flake off as it dries. It is best to keep working while the colors are wet.

Andrew Wyeth, *Dodge's Ridge.* Tempera.
(National Museum of American Art, Smithsonian Institution, Washington, D.C.)

Tempera. The linear quality is the characteristic look of an egg tempera painting. The tones are created through the buildup of individual, close-together brush strokes which permit the creation of sharp clear edges and details. These are especially evident in the completed picture.

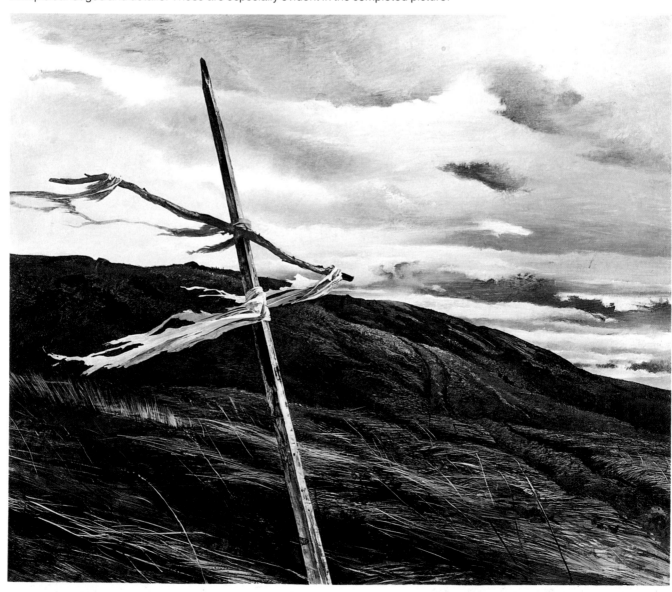

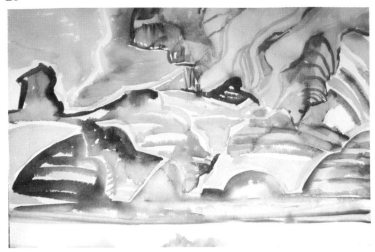

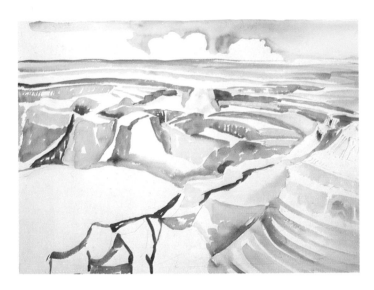

Lucia Salemme, *Early Morning Light at the Grand Canyon*. Watercolor.
Alla prima technique in a landscape painting.
Three steps leading to final oil. First two steps in watercolor, using watercolors that were painted on location where the play of light at different times of day were studied.

Mid-day Light: Grand Canyon. Watercolor.

Grand Canyon Afternoon. Oil on canvas.
The oil version painted in the studio using the alla prima technique.
The two watercolors served as the frame of reference.

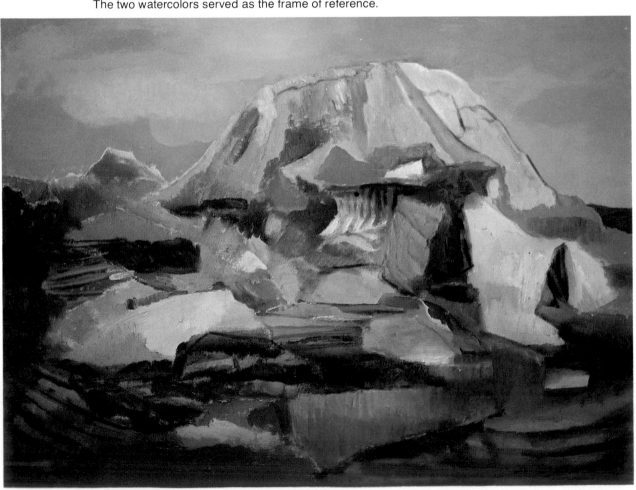

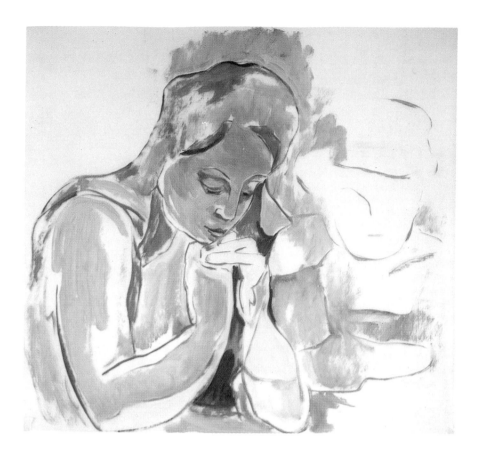

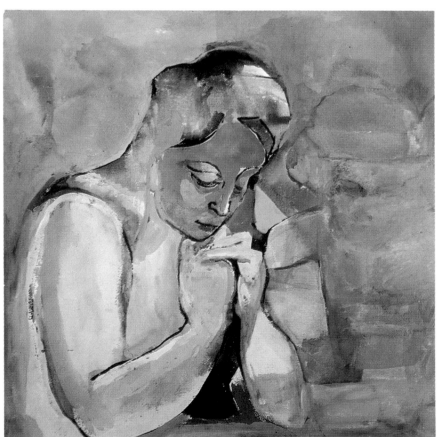

Lucia Salemme, *Contemplation*. Gouache on paper.
Blended opaque effects are achieved gradually. Build up the opaque quality with a series of color washes superimposed over each other. All blending is done at this stage while colors are in a wet state. You are free to overpaint, as an opaque quality is the characteristic look of a gouache. Small objects are painted in last.

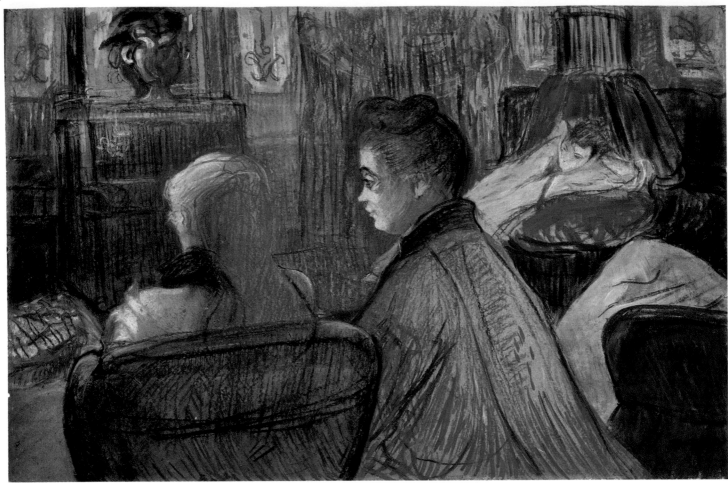

Henri de Toulouse-Lautrec, *Au Salon*. Pastel, gouache, pencil on cardboard.
(The Justin K. Thannhauser Collection, The Solomon R. Guggenheim Foundation, New York)
Sharp edges and linear strokes. Both soft and hard pastels are used in this technique. A touch of
color is first applied with the soft pastels and the linear strokes are superimposed with the hard sticks
of pastels.

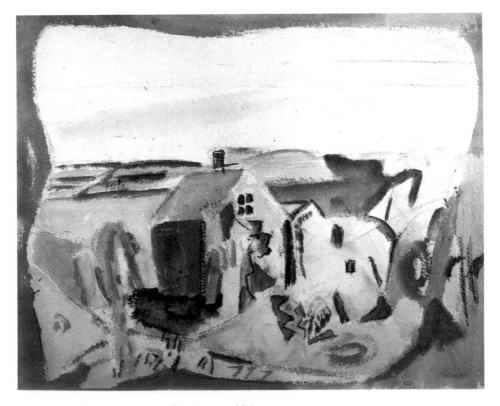

John Marin, *The Little House, Stonington, Maine.*
(Privately owned)
Dry-brush. This technique is useful when rendering different textural effects, such as
in rocky hillsides, weather-beaten barns, or for different marine effects.

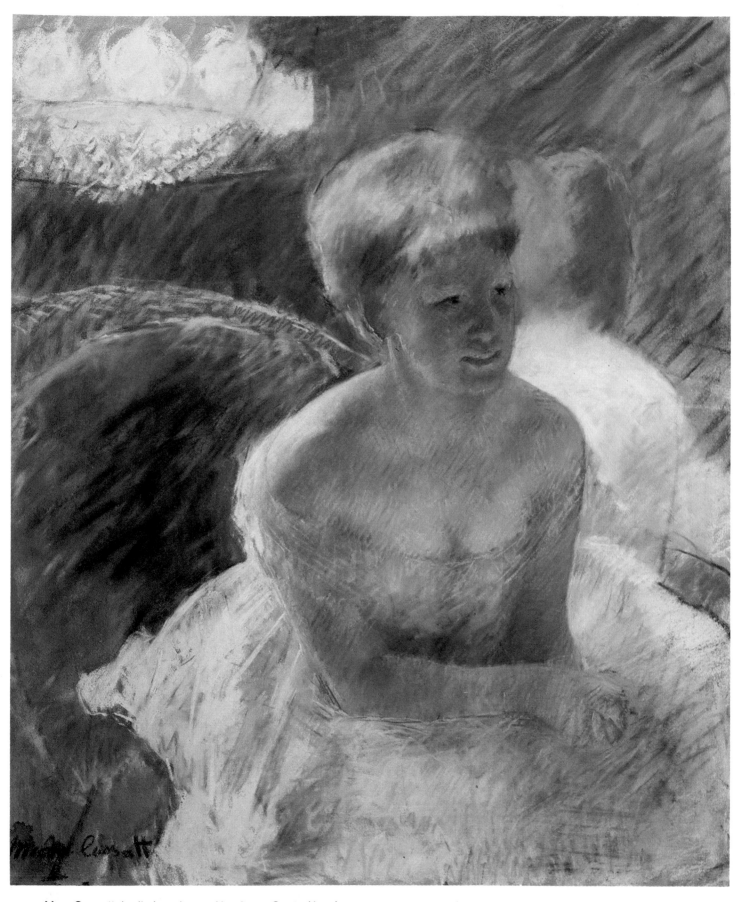

Mary Cassatt, *Lydia Leaning on Her Arms, Seated in a Loge*.
(Nelson Gallery, Atkins Museum, Kansas City, Mo.)
Cross hatching is an ideal medium when doing speedy work. You can produce both values and textures simultaneously by increasing or decreasing the number of strokes and by controlling the width of the spacing between them.

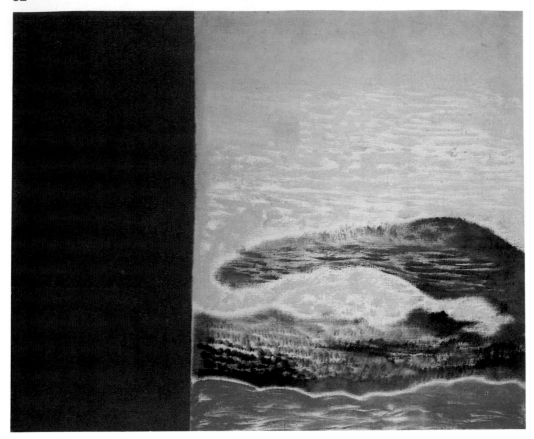

Vincent Salemme, *Yellow Lagoon*. Acrylic on canvas. The quick drying of acrylic paints permits you to model the forms and shapes of your picture simply by stroking paint so that its direction matches the natural movement of the form being worked on.

Lucia Salemme, *The Farewell*.
Glazing. Transparent glazes, made by using acrylic mediums, which come in gloss, matte, or gel, can be applied one over the other. Start with light colors and finish with darks.

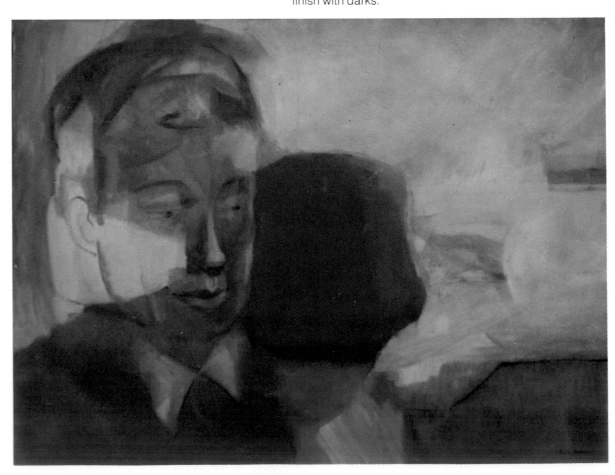

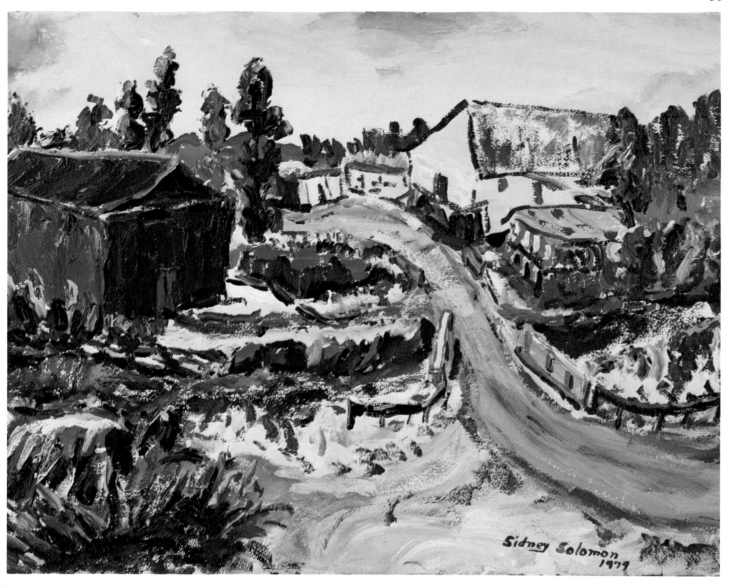

Sidney Solomon, *Village Road in Lamoille Country, Vermont*. Acrylic on 300 lb. *Papier d'Arches*.
(Courtesy of the artist)

Light tones underneath. The artist here departs from the common practice of first sketching or outlining in pencil or charcoal. In this colorful scene he first laid down, in light wet tones, the broad areas of color: sky, foliage, road, stream, buildings, etc. Then he refined the composition with strong lines and patches of color, using less water. Finally he overpainted in sharp, heavy brush strokes, with ample layers of thick acrylic, to refine perspective and shape. For some of the colors he also used designers gouache, especially where subtler tones were needed.

Frances Avery Penney, *Jivation*. Acrylic on canvas.
Impasto for three-dimensional effects. All sorts of dimensional effects are possible with acrylics, especially when modeling paste is worked into the gesso ground while the gesso is still wet. Heavily raised impastos are created by building up the paint levels with modeling paste, and relief effects can be achieved by scooping out the modeled paint layers. Painting on a rigid surface is a must when using modeling paste. Doing a mural on a plaster wall or outdoors on a cement wall presents no problems as they are sufficiently rigid.

The Pointillist Principle. Optical mixing is the basic principle underlying the Pointillist technique. For an orange color use alternate groupings of yellow and red dots. For a green effect, use alternate small yellow and blue dots and to get the effect of purple use a series of red and blue dots. Intersperse these colors with dots of white to lighten and black to darken.

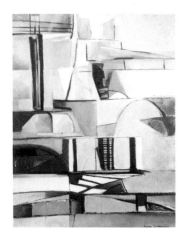

Lucia Salemme. *City Panel.*
(Mosaic mural, in lobby of residential building 220 Central Park South, New York.)
Pointillist mosaic mural. An example of how the pointillist principle has been utilized in executing a mural where a great variety of colored tiles (*terrazi*) were used instead of colored dots and daubs of paint. The principle is of course the creation of an illusion. (Preliminary sketch above, mosaic mural below.)

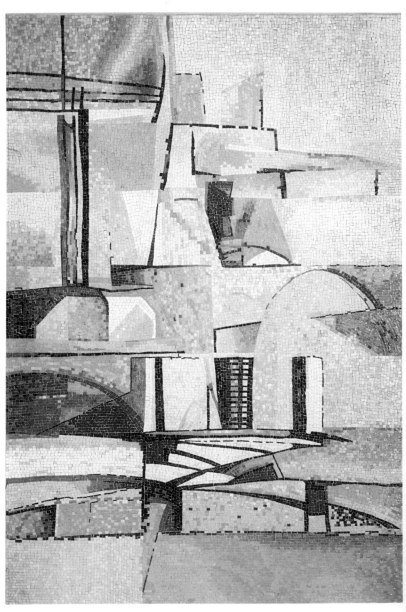

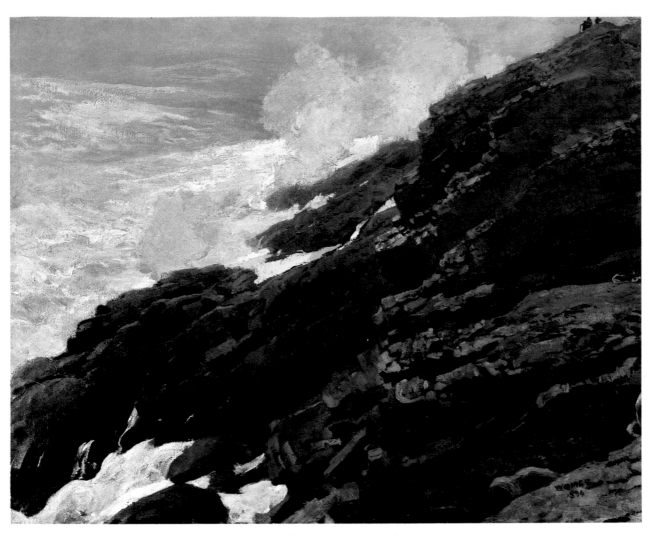

Winslow Homer, *High Cliff, Coast of Maine*. Oil on canvas.
(National Museum of American Art, Smithsonian Institution, Washington, D.C.)
Visible brush strokes. No overpainting is required when using a visible brush stroke. The procedure is to load the brush with color and apply it a little at a time, having the stroke go in the natural direction of the form being painted. Generous amounts of paint are used, as a thick paint load is what creates the visible brush stroke.

Albert Pinkham Ryder, *Jonah*. Oil on canvas
(National Museum of American Art, Smithsonian Institution,
Washington, D.C. Gift of John Gellatly)
Scumbling is done over a dry painting. The paint must be dry **underneath** so as to reveal the dry color. When a brushful of new color is dragged over the dried old one and is allowed to show through, a beautiful archaic effect is produced. Scumbling can be useful in rendering the textural quality of rocky hillsides or wild ocean waves.

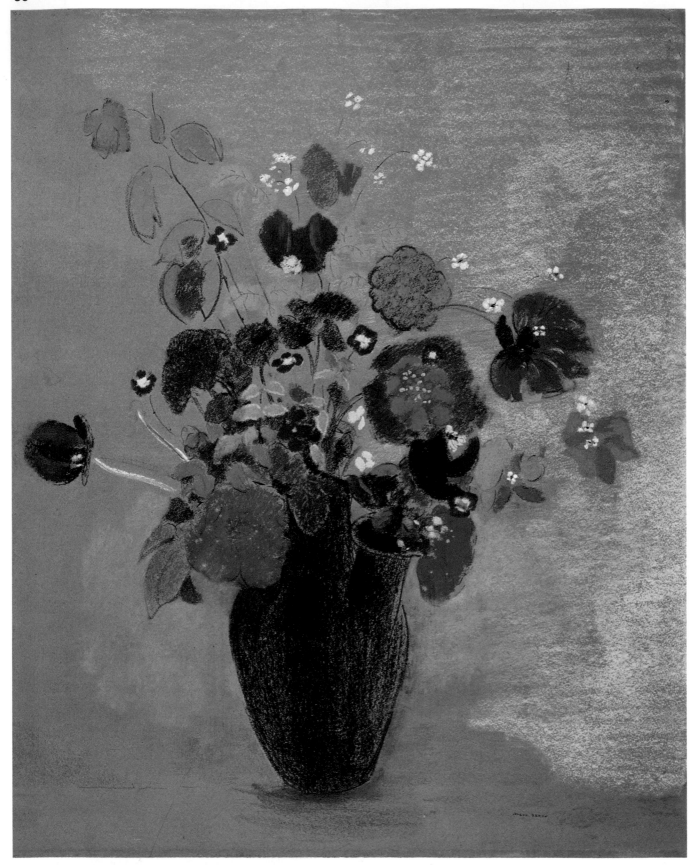

Odilon Redon, *Vase de Fleurs*. c. 1914. Pastel on paper.
(Courtesy Aquavella Galleries, Inc., New York)

Soft and hard pastels together. The natural tool for creating visible strokes is a stick of hard pastel that has been sharpened to a blunt point. The quality of lines and strokes produced by it depends largely on the amount of pressure exerted, on the angle at which it is held, and on the surface texture of the paper being used. Heavy pressure produces sharp edges, and light pressure results in showing the character of the paper. Darker-hued hard pastels may be used to accentuate details. These visible hard strokes are usually applied over layers of color made with soft pastel after being sprayed with fixative.

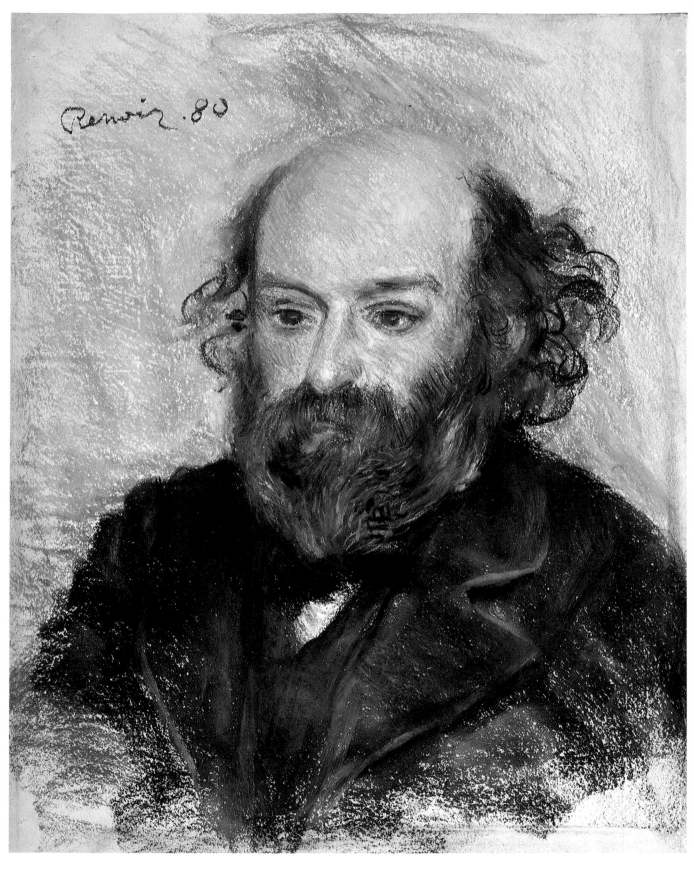

Pierre Auguste Renoir, *Portrait of Cezanne*.
(Courtesy Acquavella Galleries, Inc., New York)

Soft and hard pastels together. The natural tool for creating visible strokes is a stick of hard pastel that has been sharpened to a blunt point. The quality of lines and strokes produced by it depends largely on the amount of pressure exerted, on the angle at which it is held, and on the surface texture of the paper being used. Heavy pressure produces sharp edges, and light pressure results in showing the character of the paper. Darker-hued hard pastels may be used to accentuate details. These visible hard strokes are usually applied over layers of color made with soft pastel after being sprayed with fixative.

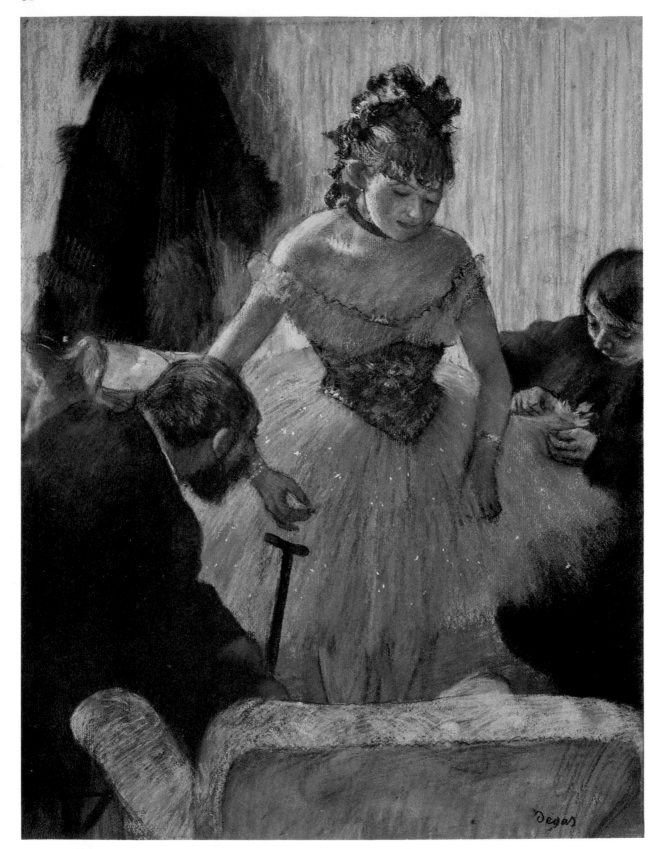

Hilaire Germain Edgar Degas, *Avant L'Entree en Scene. (La Loge de Danseuse)* c. 1878-1879. Pastel on paper.
(Courtesy Acquevella Galleries, Inc., New York)
Blended soft strokes with sharp edges. The soft strokes are blocked into the larger areas first and later are accented with the sharper edges of the same sticks of soft pastels.

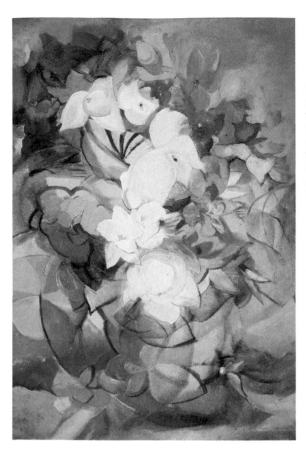

Lucia Salemme, *My Garden*. Acrylic on canvas..
Glazing. Acrylic paints are a perfect medium for the glazing technique. You can apply transparent glazes by thinning the paint with water or with the acrylic mediums, which come in gloss, matte, or gel. As you apply the varnish after each one of the glazes, one glaze is built up over the other, like layers of colored cellophane. The clear varnish will separate each glaze and build up a film of thick paint so that the effect not unlike flickering light is captured.

Will Barnet, *The Three Brothers*. Acrylic on illustration board.
Certain painting techniques are best suited to acrylics, especially flat-paint application with no surface textures. In addition, the fast-drying quality of acrylic makes the spontaneous capture of a fleeting moment all the more possible.

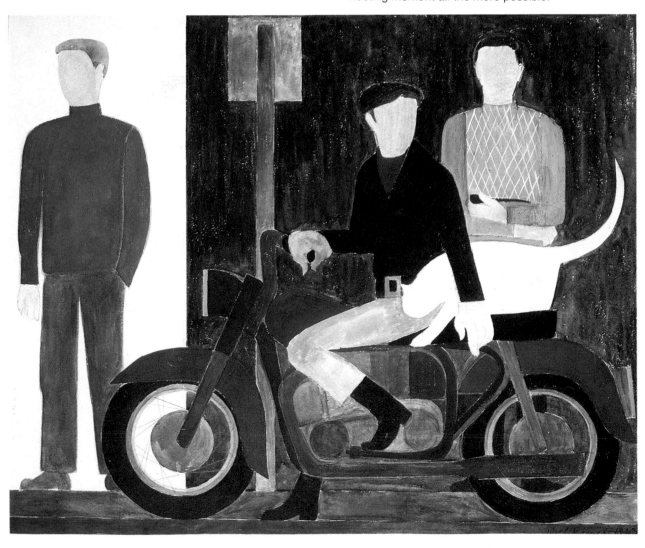

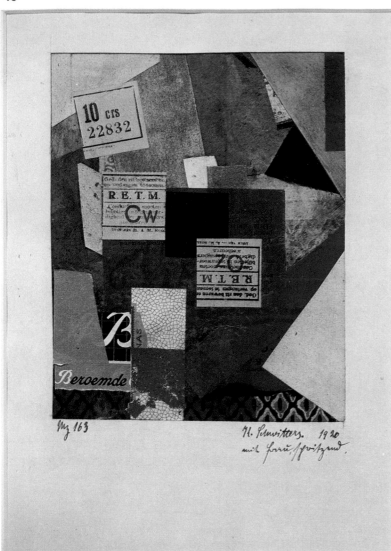

Kurt Schwitters, *Merz 163, with Woman Sweating*. Paper and cloth collage
(The Solomon R. Guggenheim Museum, New York)
Three-dimensional effects. A three-dimensional collage looks best on a small scale, where objects used may be seen close-up without much trouble. Choose materials you like and plan the composition so that the objects themselves are the subject of the panel, with pictorial ideas playing a subordinate role.

Leo Manso, *Summer's Day 1968*. Collage on board.
A textured surface is made with all sorts of textured fabrics. The artist has used acrylic-stained cloth, rice paper, painted gesso on rice paper and Elmer's glue on board.

(*Continued from page 16*)

3. Paint in the large areas first, using broad, visible strokes in applying the thick paint. Proceed to the smaller areas, with your brush strokes going in the natural direction of each shape you are painting. This will help you achieve the many different textures needed in this composition.

4. As for the choice of color, be guided by the work you did in the practice exercise. A primary concern will be the texture of your paint and how thickly you can apply it with your brush to achieve a distinct brush stroke.

If you match an earth color with its corresponding bright color and place the two near each other, you can develop an effective feeling of unity over the entire picture surface.

COLOR TEMPERATURE

When we describe colors as *warm* and *cool*, we are obviously referring not to their physical but rather to their esthetic qualities. You can understand this point by thinking what the words *warm* and *cool* suggest. For example, when you utter the word *fire*, the colors that come to mind would be the reds, yellows, and perhaps purples. Similarly, the colors that come to mind at the mention of a *cool ocean wave* would be Prussian blue mixed with white, greens, and grays. Moreover, the degree of warmth and coldness of colors depends not only on their inherent quality but on two other factors as well: how you place them alongside each other and what you mix them with when you modify or accent their temperatures.

The colors you will be using fall into categories of hot and cold, warm and cool. Here is a list of how they fall:

Hot: Flake white, cadmium yellow, cadmium orange, cadmium red, yellow ochre, burnt sienna, permanent green light, ultramarine blue

Warm: Titanium white, Naples yellow, raw sienna, cadmium yellow medium, cadmium red, rose madder, Venetian red, cobalt violet, cerulean blue, viridian burnt umber, lamp black

Cool: Zinc white, lemon yellow, alizarin crimson, gray, thalo blue, thalo green, raw umber, ivory black

Cold: Zinc white, Prussian blue, blue violet (both dark and light), mars black.

Getting to Know the Hot Colors

The basic hot colors are cadmium yellows, the cadmium reds, and their derivatives. However, even within this range you will find cool colors, depending on how you mix them and next to what color you place them. Because these colors change through mixture and placement, by experimenting you will be better able to see what happens. (See color section, page 19.)

Experiment by first squeezing out the colors—cadmium yellows, reds, yellow-greens, ultramarine blue, alizarin crimson, lemon yellow, viridian green, and Prussian blue—so that they are in a horizontal row on the upper edge of your palette. Apply the paint to the canvas in the following order: Put cadmium red next to cadmium yellow, then mix some of each together, and you will have a hot orange. Place this mixture alongside the red and yellow. Take a cool lemon yellow and place a patch of it next to cadmium yellow. Note how hot cadmium yellow seems when seen next to lemon yellow! Now take lemon yellow and place it alongside a mixture of white and Prussian blue and notice how lemon yellow now appears warm. Mix alizarin crimson with white (which gives you a warm pink) and place it next to a light cadmium red mixed with white. The pink will appear cool next to the peach tone of the cadmium red.

This exercise will act as a springboard to get you started in seeing temperatures and may help you to overcome the feeling of helplessness when confronted by a clean blank canvas!

Now try a few more color mixings. Cadmium red mixed with white becomes a soft

warm, peachy red, but cadmium red mixed with a little black produces a dark, hot brown. You can also get a brown—but a warmer and more vibrant brown—by mixing green with your red. Try mixing orange with blue, yellow with violet. This is only a sample of mixtures you can try. Also, see what subtle shades and hues you get when to each of these combinations is added some white paint.

Make your colors change as many times as possible by the amount of mixing and inter-mixing you feel like doing, and when you're done with each mixture place all the dabs in systematic rows on your palette so that you can identify them without getting confused. Then, using a clean brush for each one of the colors, paint them onto a small canvas so that you can have a color chart for your future reference. You can even go a step farther (that is, if you have the patience) and write down under each one how much of each color (and white) went into the mixing of it. You'll notice that the color content of each is either multiplied or diminished by the varying amount of light or dark colors you add. The differences will be clearly visible for you to memorize.

Getting to Know the Cold Colors

Just as you learned about the hot colors, you will now learn that within the cold family the relationships also depend on the influence one color has on another. Some cool colors will appear either warm or cool, depending on what you mix them with and their relationship to adjacent colors. Your cool and cold colors are zinc white, lemon yellow, alizarin crimson, gray, thalo blue, thalo green, raw unber, Prussian blue, violet, and mars and ivory black. (See color section, page 20.)

With all color mixing it is a good idea to start with a weaker color and gradually add small amounts of the stronger one, until you get the desired color. Your mixtures depend on the different proportions added together. The exact shade you require is up to how patiently you do the mixing. For example, place a dab of white on the canvas with your palette knife. After cleaning the knife, add a little ultra-marine blue to part of the dab, mixing it into the white. Use zinc white in the mixtures of your cold colors, because this white makes your colors incline a little more toward violet, giving you clearer tints. Clean your knife and add the Prussian blue to a dab of white. Study these two colors, and you will see that the ultramarine will glow with warmth when compared to your icy-cold Prussian blue. Make another dab of white, and now add your cool viridian green. Cobalt blue is a cooler, purer blue, as you will see when you place it along-side cerulean blue, a blue that has a warm, greenish cast.

Do another practice exercise, this time of an abstract composition, breaking up the picture space with as many shapes as you have colors. Systematically paint each with a different cold color. You can set aside the resulting painting for future reference and study.

THE PRIMARIES AND COMPLEMENTARIES TOGETHER

Colors Vibrate

When you place a primary color next to its complement, you will find that both colors suddenly come alive. The stress of interaction is what creates this tingling, scintillating effect. For example, when you place a red along-side a green, a blue next to an orange, or a yellow near violet, you will achieve a mood that vibrates with life in your canvas. According to some color theorists, this happens because a strong color tends to throw its complementary on the adjacent area. (See color section, page 20.)

I suggest you do a practice exercise, again using abstract shapes, filling up the canvas with as many forms as you have colors and their respective complements, placing them near each other. Apply each color in broad, flat

strokes, taking care to keep the edges of each form crisp and clean. Place the colors so that they appear as partners—next to, above, or below one another. In other words, place red near green, yellow near violet, and blue with orange. Do this until you have used all your colors. The finished picture will produce the marvelously vibrant array of colors that artists call *plastic quality* in a painting, the vibrations caused by the primaries juxtaposed with their complements.

Monochromatic Harmonies

Pure colors change when they are mixed with a complement, resulting in a neutralized version of the original color. The following practice exercises should be done in sequence. You should stay with your work from start to finish, without any interruptions. The exercises should take about a week to do, at the end of which time you will have completed a series of five studies, starting with the family of one color with its corresponding complementary color. (See color section, page 20.)

1. All the blues with orange.
2. All the reds with green.
3. All the yellows with purple.
4. All the grays with red, blue, and yellow.
5. Riot of colors day!

For subject matter, I recommend the use of abstract shapes whenever possible, because this provides the best opportunity for breaking up the picture surface many times, thus giving you a valid reason for using up the numerous mixtures of colors. By painting in these colors next to each other, you can readily see how the primary colors have been affected by the addition to their complements.

To achieve harmony with these colors, the complementary should be in the same temperature scale as its primary color. Remember this rule: *warm for warm, and cool for cool.* For example, for warm cadmium red, the complement is warm yellow-green; for a cool lemon yellow, the complement is a cool pinkish violet; for warm cerulean blue, the com-

plement is a warm yellow-orange. But try your own combinations. Just remember the rule: to achieve harmony with mixing your complementary colors, use warm with warm and cool with cool.

1. All the Blues with Orange. When one color is mixed with its complement, the result is a neutralized or calmed-down version of the original. The purpose here is to see what happens when each blue color in its pure state is mixed with its complement, orange.

Do a practice exercise using all your blues and orange. Squeeze out a little of each blue in a row on the upper edge of your palette, and under these put some of the cadmium orange and a little yellow and red, plus some raw umber, titanium white, and ivory black. Your blues are cerulean, cobalt, ultramarine, and Prussian.

Taking the blues one at a time, mix each with a little of the orange. Add a little more yellow when you want your orange to warm up, a little red when you want to temper it down. Another combination to try is a blue plus orange and a little black; still another is blue plus raw umbar and orange. White added to any of these combinations will give you lighter values. You will be amazed at some of the beautiful grays you get! You will see that the resulting values will be mostly muted gray-blues. First paint in all your pure blues; next to each pure area place some of the blue that has had orange added. Do this until you have used up all your colors. The resulting chart should be an array of gentle, calmed-down blues.

2. All the Reds with Green. Proceed next to using red with its complement, green. You will find that the quality obtained is entirely different from the effects in the last exercise. Your reds are vermilion, cadmium red, both light and medium, and alizarin crimson. The greens are viridian and permanent green light and the two colors that make green, yellow and blue.

To explore the many color variations you

will be mixing, fill your canvas with an abundance of spaces and shapes, so that you have as many forms as you have colors. Remember, you want to use all the pure colors as well as those already mixed with the complementary color. Paint by systematically applying first the pure red and then the same red mixed with its complementary green. Do this until you have familiarized yourself with the different values produced with the reds and their complementary partner.

3. *All the Yellows with Violet.* Now try an exercise using the next set of complementary colors, yellow and violet. Your yellow colors are lemon yellow, cadmium yellow medium, cadmium yellow deep, yellow ochre, raw umber, complemented by cobalt violet light and cobalt violet deep, and the two colors that make violet, red and blue. You add either white or black to change their values further.

Study the different yellows, planning where you will use them, and follow the same procedure you used with the blues and reds. Paint until you have used up all the yellow mixtures in monochormatic harmonies. It is surprising what an infinite number of harmonies you can produce simply by altering the proportions of your complementary color and white and black.

4. *The Grays with Red, Yellow, and Black.* The misleading thing about the term "all the grays" is the tendency to regard gray in terms of black-and-white mixtures. However, simply by adding red to this mixture you can get a red-gray and so on. In other words, the variety of *grays* are produced simply from the *basic gray and the addition of any one of the bright colors.* Do a painting using all your grays, but use grays that complement each other. Next to a shape that you have painted in a green-gray, place a reddish gray. Next to a yellow-gray, try a violet-gray. Next to a blue-gray, try an orange-gray. Finally, if your feel it necessary, accent certain areas with a pure primary color.

5. *Riot of Colors Day!—Pointillism and the Impressionists.* In this exercise, follow the example of the Impressionists, who simulated the illusion of light by juxtaposing tiny dots of bright colors alongside their complementary ones. When viewed from a distance, the tiny dots fuse, the eyes of the beholder doing the mixing. These daubs of pure color placed next to each other produce fresh and vibrant values unsurpassed by many other methods of painting. (See color section, page 24.)

Use all the colors in the paint box. Squeeze out daubs of each of your colors. It is a good idea to put all the yellows together, all the reds together, and so forth, to avoid confusion.

Sketch in your design, briefly indicating where the light is coming from. You might experiment by doing an imaginary landscape. In the throes of painting, do not lose track of the source of light. Remember, you need not confine yourself to painting tiny dots. You may want to pat on dabs of colors about half an inch in size. For example, when painting a red area, you can paint the entire space by patting on vermilion dots, interspersed with some orange and white on the light side. On the dark side, pat in some yellow-green, or blue and yellow, the two colors that make green, alongside the vermilion areas. Use all the colors in their pure states. When you view your painting from a short distance, you will discover that these colors have blended because your eye is doing the mixing for you. Follow the same procedure with all the other colors. It would be a good idea to consult your list of complementaries here.

After completing all the exercises in this chapter, you should have a feeling for the power of complementary colors: how they can be used to invigorate a painting, how they can be used to subdue a painting. This will be very valuable to you in later exercises, where you will be called on to use this knowledge to produce specific effects.

The Earth Colors

Although earth colors themselves are lovely to look at, they also serve a most useful pur-

pose when it is necessary to reduce the brilliance of the brighter colors in a composition. You accomplish this by placing an earth color of the same hue next to or mixed into the bright color. The whole color scheme in a painting becomes muted when an earth color is substituted for a pure color. For example:

1. Place yellow ochre next to cadmium yellow light.

2. Use raw sienna next to any one of the blues.

3. Put burnt sienna next to cadmium red light or Indian red.

4. Place chrome green or green earth alongside viridian green.

To create more subtle effects in your paintings, use the earth colors sparingly. Use them in place of primary colors just to try out this theory. For example:

1. Instead of cadmium yellow use yellow ochre, raw sienna, or raw umber.

2. Instead of viridian green use chrome green or green earth.

3. Instead of any of the blues, use raw umber with a little of the color mixed into it.

For supplementary color accents in the light areas, use a color you have not yet used in the picture. For instance, if your earth color combinations do not contain a bright yellow, use one for an accent color. Keep in mind that you use the earth colors primarily when you wish a painting to hang together harmoniously—this is where their real function rests.

Harmonies

Analogous colors are those that fall into color families. The analogous yellows are lemon yellow, cadmium yellow, cadmium yellow light, cadmium yellow medium, orange, and yellow-green. The red family colors are cadmium red light, cadmium red medium, vermilion, alizarin crimson, orange, and red-violet. All the blues are cerulean blue, cobalt blue, Prussian blue, cobalt-violet, and blue-green. And of course the earth color family includes Naples yellow, yellow ochre, raw umber, burnt umber, raw sienna, Indian red, Venetian red, burnt sienna, and black.

There are all sorts of variations and gradations you can make with each family of colors, depending on how little or how much of the adjacent colors you mix with them.

Analogous colors will harmonize and blend pleasantly into one another, because they are of the same family. Colors that have all blues in their mixture—blue-green, blue-violet, for example—are analogous. Likewise, colors that all contain yellow—such as yellow ochre, orange, yellow-green—are analogous. Because of this close relationship, you'll find that working in analogous colors presents no conflict.

OPTICAL ILLUSIONS

Color Perspective

In dealing with two- and three-dimensional problems, you will often be called on to create optical illusions with color alone.

The term two-dimensional refers to the length and width of your flat painting surface. The third dimension refers to the illusion of space or depth created by the way you use color in your composition. Understanding which colors recede and which come forward to create the illusion of depth poses a problem that you must solve. (See color section, page 21.)

Here are a few hints to guide you when you wish to express the illusion of depth with color. To paint forms in the far distance areas use as base colors the grays, purples, and all the neutralized primary colors. Paint the areas in the foreground in sharp, clear, top-tone colors, with lighter variations such as brilliant pinks, pastel oranges, yellows, reds, and greens.

The size as well as the color of an object will help you achieve the effect of spatial depth in a picture. You can readily see what I mean if you place a piece of white tissue paper over the area you wish to show as being at distance.

These areas will appear hazy and softer in hue; in short, they will seem to recede.

By painting the outline of distant shapes in vague, indistinct colors and also by reducing their natural size, you will add to the feeling of deep space. Use the reverse of this method when you want objects to advance; for example, bolder, dramatic, and focused colors.

Obviously, at the very outset of your painting session, you must determine the time of day or source of light you wish to depict. If it is early morning or late afternoon, the light will most likely not be sharp and clear. This calls for a palette of light greens, blues, reds, and yellows—all of which can be considerably neutralized when you paint them in the far distance areas of the composition.

Weights and Balances

The best way to evaluate the problem of weights and balances is to study how a paint-ing of an apple will look when compared with others of similar size but of a different color. Let your eye be the judge.

First take three sheets of 24″ × 18″ drawing paper and fold them in half. (Hold the paper upright.) On the upper portion of each sheet, lightly draw a contour sketch of the apple. On the lower half of each paper, draw the same apple exactly as you did above. Repeat this drawing on the remaining two sheets, so that you have six pictures of the same apple on three separate sheets of paper. Paint the ap-ples, using red for one sheet, yellow on the second, and blue on the third. Then pin the three sheets on a wall, so that they can be viewed from a distance. You will see that al-though the two objects on each page are actu-ally the same size and the same color, the one on the upper portion of each sheet of paper will have greater visual weight than the one in the lower half. How then can you balance the two so that they are equal in weight? By making the color on the upper portion of your painting a slightly lighter hue than the one on the lower half.

Color Affects Shape

Sizes of shapes change, depending on the colors they are painted. Because yellow has a tendency to reflect more light than the other colors, yellow shapes seem larger than the same shapes of another color. Yellow gives the illusion of enlarging itself. For this reason yel-low is referred to as the *expanding color*. Place a dab of yellow next to a spot of blue and you will readily see what is meant. When blue is by itself, it is a receding color; it calms and at the same time remains still. When next to yel-low or any other hot color, blue seems to re-duce itself, but its hue becomes more brilliant at the same time. Red is a staccato color; it excites and pulsates with life, hopping all over

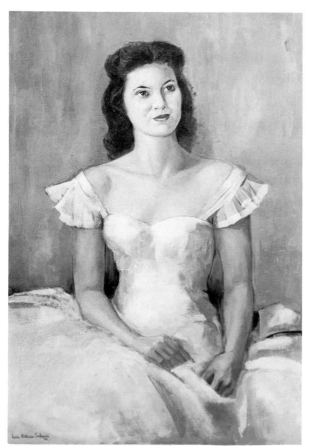

Lucia Salemme, *Portrait of Claire*. Oil on canvas.
(Collection of Mr. & Mrs. Sam Polk, New York.)

Color affects shape. Shapes change size depending on the color. Large shapes appear larger in a light color, and the smaller areas much smaller when painted in a dark color. The overall effect is one of constant motion as the eye shifts back and forth over the canvas.

the canvas. However, when a spot of green is placed alongside red, the red quiets down immediately, not much, but enough to warrant attention.

To see how these different colors affect one another, do the following exercise. You will see that when you paint a *small* yellow area next to a *large* blue one, the small space will support, or balance, the large one. You will see that a small black spot will support or balance a large red. A small red spot will balance a large yellow. A large blue area next to a small yellow will look smaller; a large blue will support a small red.

You will be able to handle the exercise more effectively if you have a variety of shapes to work with. Think of triangular pears, crescent-shaped bananas, moonshaped oranges, rectangular bunches of grapes, circular bowls, and so on.

Draw an imaginary still life. You don't have to make the picture true to life in this exercise, because your drawing will identify the shapes of each object, leaving you free to select your colors according to how you wish the color to affect their shapes.

Next, plan your color scheme. Apply the colors in stark primaries, in flat poster-like brush strokes, bringing each color to meet its adjoining one.

If you wish to have the banana appear to recede, you can paint it blue; if you want the orange to look bigger, paint it yellow, and paint the watermelon violet, just to see how it changes next to the others. And don't forget black and white! Do you see how color can work for you in composing a representational painting from memory?

Flesh Tones in a Portrait Subject

There really is no such thing as a flesh tone, because the color of your subject depends first on the type—be it blond, brunette, white, oriental, or black. Also bear in mind that the flesh tones depend largely on what sort of light or atmosphere surrounds the model.

A basic general flesh tone color for a blond, light-skinned model is a mixture of titanium white, rose madder, and Naples yellow. By adding a touch of cobalt violet or cerulean blue to some of this mixture you will have a gentle midtone color for modeling the facial features, and a little raw umber added will provide you with the proper color for the deep shadows.

For a brunette type use titanium white, yellow ochre, and cadmium red mixed together. By adding ultramarine blue to some of this mixture, you will arrive at a good shadow area.

When painting a black person, a mixture of yellow ochre, burnt sienna, alizarin crimson, and a small amount of titanium white is a good basic flesh tone. With a little ultramarine blue added, you will have the proper shadow area color.

For oriental types, use raw sienna, alizarin crimson added to some titanium white plus

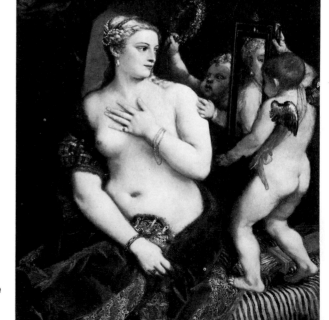

Titian, *Venus with a Mirror.* Oil on canvas.
(Mellon Collection, National Gallery of Art, Washington, D.C.)

Flesh tones. There is really no such thing as a flesh tone. The flesh color of the subject depends, first, on the type—blonde, brunette, white, oriental, or black; then, on the light and atmosphere surrounding the model. If the model is outdoors, the facial coloring will not be the same as in an indoor setting.

some violet or ultramarine blue for shadow areas, and the basic flesh tone is arrived at.

You can be as imaginative as you like in your choice of colors, because the realism is carried out in the drawing. But let me warn you, however, not to be too extreme. Be very selective in how your use your tonal values. Not only are there many shades of each, but the effects vary according to the surroundings, especially according to the adjacent colors and the light.

Local color and atmosphere refer to the colors immediately surrounding your subject. The choice of colors depends on the type of light illuminating your subject. For example, in a portrait your choice of colors is determined by the weather and the time of day when the subject is exposed. Therefore, if your model is outdoors, the atmospheric colors will be quite different from the ones you would use indoors. Because portrait and figure painting requires a knowledge of anatomy, only the more advanced students with drawing skills should try it.

In a portrait or figure painting, your composition will hang together harmoniously (no matter how many small shapes you include) if you use visible juxtaposed brush strokes going in the natural direction of the shape being painted. Clouds in the sky will be painted in circular rhythms, architectural features in whatever direction the perspective calls for, and grasses in short vertical brush strokes. The same theory applies to the facial features of the model (hair, eyes, nose, mouth) as well as the body (arms, neck, breasts, torso, legs, and drapery). Simply change the direction of your brush strokes with each shape you paint, varying it from the direction used in a neighboring one. This method of applying your colors will help you to achieve a three-dimensional quality to the different anatomical planes of the human face and figure.

Part Three

COMPOSITION

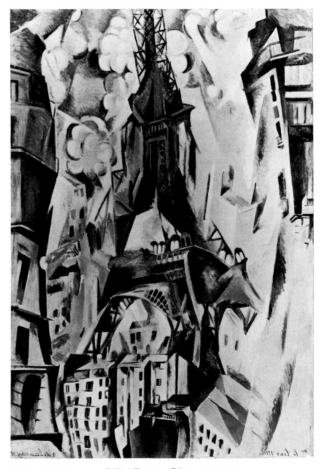

Robert Delaunay, *Eiffel Tower*. Oil on canvas.
(The Solomon R. Guggenheim Museum, New York.)
Compositional basics. The basic shapes in the composition are the circle, square, and triangle used in a singularly imaginative and creative arrangement.

Although composition is intrinsically intuitive, you can learn many skills involved in making a good composition. These basic compositional elements provide the structure necessary to bring to life your graphic concepts.

Good composition is achieved by the patterning of shapes and colors next to one another in a structured unity. This unity reinforces your initial ideas and is often the first thing we react to in a work of art. Of course, your emotional response to a subject is crucial; without it, the structure would be a mere mechanical display of skill. But inspired motivation, combined with skill, is what makes a good composition possible.

Pictorial art is a universal language. Anyone, of any background, can comprehend it. As the composer must learn the rudiments of theory and harmony before getting to counterpoint, so must you, the painter, master the basics of drawing and color. You must know how to begin, how to develop a theme, how to

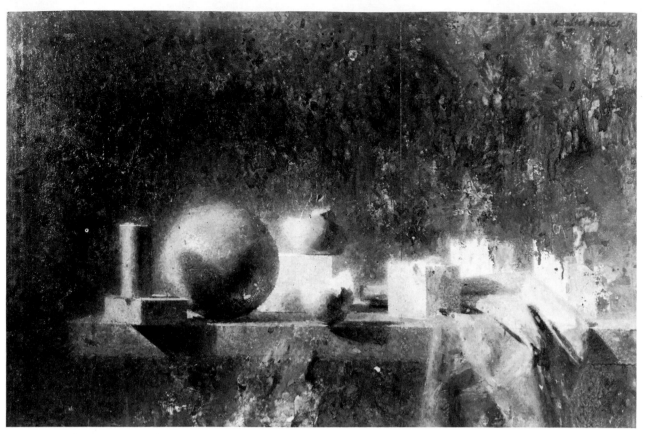

Walter Murch, *Fragments*. Oil on canvas.
(Collection of Helen Mary Harding, New York.)

A group of geometric shapes set up as still life objects and arranged on a table so
that the light, middle, and dark values are clearly made visible.

isolate, how to combine, how to blend and how to end. You must also know how to understate and how to expand, whether you should paint a *single canvas* or a *series* to carry out your ideas.

When you are settled in a studio and working on your own, you will need the knowledge and experience with the fundamentals that will allow you to give mature expression to your work. Carrying out the exercises in this book can help provide these skills. Although you can do these on your own, it may be helpful to work out this program in a classroom setting.

BASIC COMPOSITIONAL SHAPES:
The Circle, the Square, and the Triangle

We all know that by correctly mixing the three primary colors you can create every color in the rainbow. Similarly, you can invent almost any shape in creation when you com-

bine the circle, the square, and the triangle, the basic geometric shapes, as is seen in the uncluttered work of nonobjective painters such as Alexander Calder, Wasily Kandinsky, and Piet Mondrian. These modern masters excelled in using shapes that have no direct reference to real objects, their creation being solely in the imaginative beauty of their own invented shapes.

Try doing a few compositions that have these geometric shapes as sole subject material. Do one using shapes that have only rounded contours, then do one with forms that have a straight edge, and last do one that has shapes with both round and straight contours. Besides using these basics, you may also wish to try a simple divisioning of the canvas into either symmetrical or uneven areas of space.

When painting a picture, be it nonobjective, with natural forms, a portrait, or buildings, the important first step is to plan the composi-

tion by sectioning the paper into circular or rectangular areas. For example, you may see the subject of a portrait as circular forms within a triangle; distant hills as one large triangle or a series of small triangles; and landscape forms in both vertical and horizontal shapes, such as circular clouds, cubelike buildings, and triangular trees. By thinking in these nonobjective terms you may find that putting together your pictorial elements will prove to be less of a problem and a much more exciting and rewarding experience. This procedure helps to simplify things and will work for you if you give it a chance. In other words, do not start with details; they will come as you progress with the picture.

VOLUME AND DIMENSION

When the flat circle, square, and triangular shapes are rendered three-dimensionally, the circle becomes a sphere, the triangle becomes a pyramid, and the square becomes a cube. The works of the early cubists, Georges Braque, Pablo Picasso, and Kasimir Malevich, clearly illustrate this principle. The cubist point of view can be a great help when rendering the more traditional subjects such as portraits, still-life compositions, and cityscapes, landscapes, and seascapes.

1. A good first exercise in rendering the three-dimensional quality of forms on the flat surface of a canvas is to work from a group of geometric shapes in the form of children's blocks. Set them up just as you would a still life arranged on a table. Place a strong light as the only direct source of illumination. This will make it easier to see the three-dimensionality of your objects.

2. With soft charcoal, render each object by first sketching in the sharp darks in the shadow areas, followed by careful modeling of all the other forms with at least five different grays. Blend the light, middle, and dark tones

Alexander Calder, *Composition*. Oil on canvas.
(Privately owned)
Geometric forms rendered three-dimensionally. The circle becomes a sphere and the triangle a pyramid.

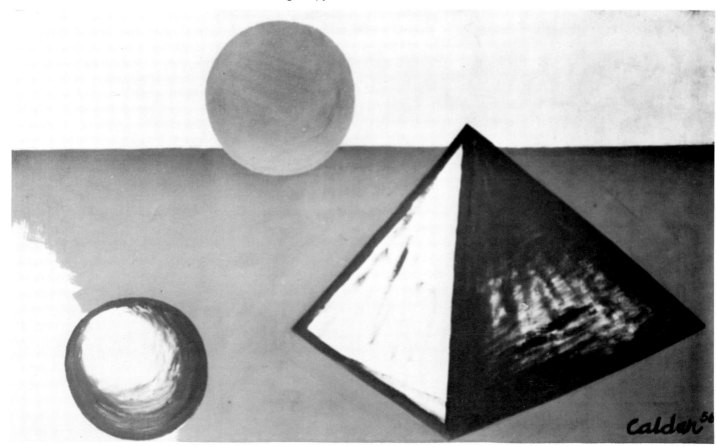

in gradual transitions. In this connection it is useful to study the value rendering of the Old Masters.

Now do a modeled drawing of still-life objects such as apples, pears, grapefruit, peaches, and oranges. With tonal blending, the three-dimensional quality of each of these round forms may be established without much effort. Try it and see.

1. Place the fruits on a table where they will receive direct lighting either from above or from only one side.

2. With hard charcoal, sketch the fruits as if they were cubes and spheres, depending on how you yourself see them. Then with soft charcoal, render the tonal values of each fruit, indicating where the shadows are.

3. Go back to the hard charcoal, and use it to build up tonal gradations of the different val-

Kasimir Malevich, *Morning in the Village after Snowstorm*. Oil on canvas.
(The Solomon R. Guggenheim Museum, New York)

Geometric shapes abstracted in a landscape composition. In this abstract version of a landscape the artist has modified the volumes of the nature forms and transformed them into the basic geometric shape that each one resembles: the sphere, the square, and pyramid.

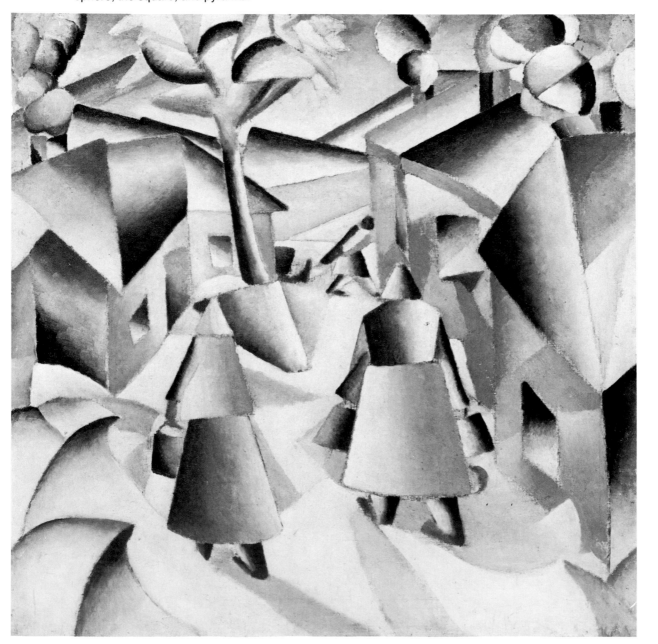

ues. Leave the white paper untouched for the lightest surfaces, and use the darkest tone for the deepest cast shadows. The shadows will be more pronounced as the surface of the sphere-shaped fruits moves away from the source of light. In modeling forms in volume note especially the lights, highlights, cast shadows, core of the shadows, and reflected shadows.

After doing as many of these renderings as you can, you should proceed to working from the posed model, concentrating mostly on figure work.

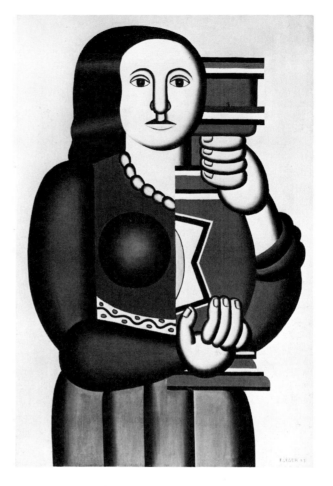

Fernard Leger, *Woman Holding a Vase*. Oil on canvas.
(The Solomon R. Guggenheim Museum, New York)

Volume and dimension abstracted in a figure composition.

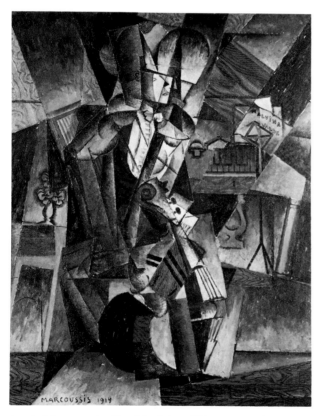

Louis Marcoussis, *The Musician*. Oil on canvas.
(National Gallery of Art, The Chester Dale Collection, Washington, D.C.)

An abstracted version of a many faceted musical instrument and figure vibrates with movement in this intricate painting.

Jacques Villon, *Portrait of the Artist's Father*. Oil on canvas.
(The Solomon R. Guggenheim Museum, New York)

Planes and masses in a cubist portrait.

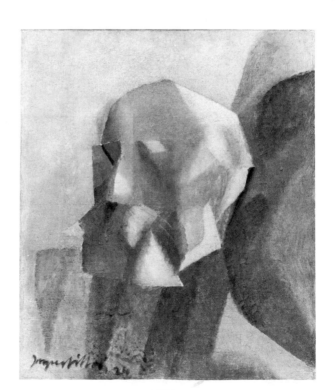

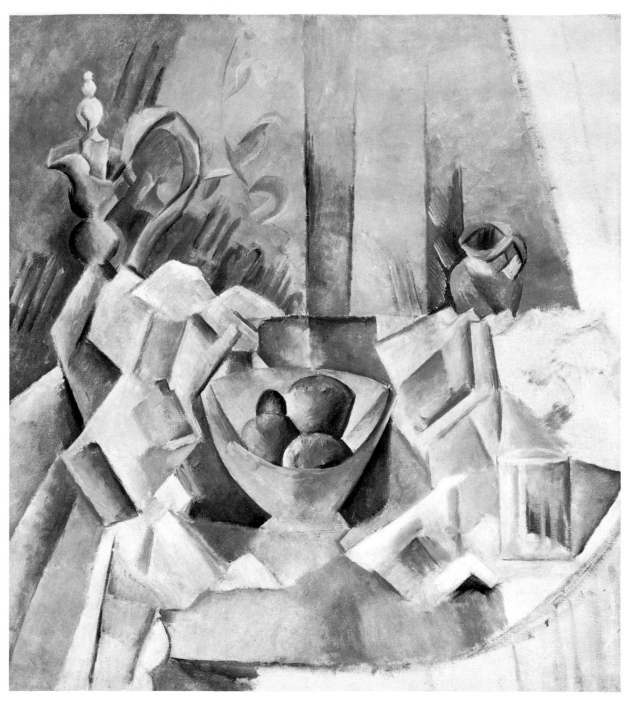

Pablo Picasso, *Carafe, Jug and Fruit Bowl*. Oil on canvas.
(The Solomon R. Guggenheim Museum, New York)

Abstract still life. Cubist planes and masses in a still-life subject painted by the man who invented cubism.

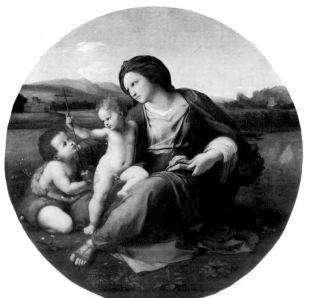

Raphael, *The Alba Madonna*.
(National Gallery of Art, Washington, D.C., Andrew W. Mellon Collection.)

Modeled forms. The three-dimensional quality of volumes beautifully rendered in a circular composition.

BASICS OF PERSPECTIVE

Perspective is the grammar of art. It can help you draw correctly just as the grammar of language helps you to speak and write coherently.

The first aspect of drawing is to learn to see and measure proportions. This is accomplished by the age-old method of facing the object being drawn and holding a ruler or pencil up at arm's length at your own eye level. By closing one eye you concentrate your vision, seeing one object minus all its distracting surroundings. Close one eye and measure from one end of the ruler or pencil to the thumb; then swing the hand at arm's length (with the elbow straight, the arm extended to its greatest length) and compare the measurement with another portion of the same object. Look at your drawing. Its proportions should agree with those of your subject.

You measure so that you do not make the nose too short or the house too tall in comparison with the apple tree. You also measure lines that run parallel with your eyes, such as the top of a roof, table, wall, box, or building.

For vertical upright lines, as in doorways, window frames, and the side of a wall, you use the plumb line, one of man's oldest tools, which always finds the true perpendicular.

Objects Become Smaller as They Recede

A good rule of perspective is to try to make objects in a drawing appear to be either advancing or receding. When you make them small as they approach the horizon line, they will appear to recede, because they occupy less space in the field of vision. To create a further feeling of depth in a composition, make the foreground shapes or objects largest, those in the middle distance smaller, and those in the far distance smaller still. Test this by going out of doors and studying the view of the sky meeting the land. The junction where the two meet is called the *horizon line*; it is the line that follows and is parallel with your eye.

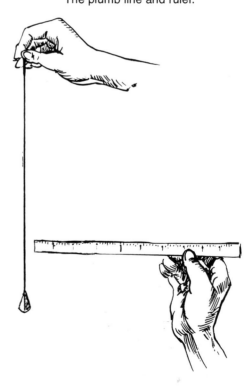

The plumb line and ruler.

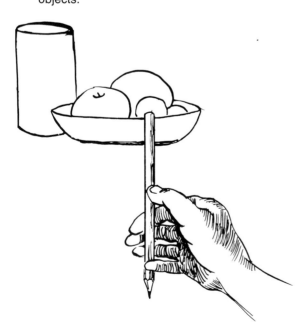

Comparing and measuring different sizes of objects.

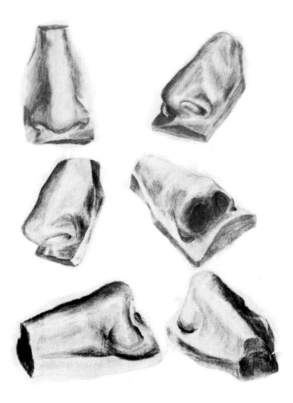

James Misho, **The Nose,** charcoal on paper.
As seen from different angles.

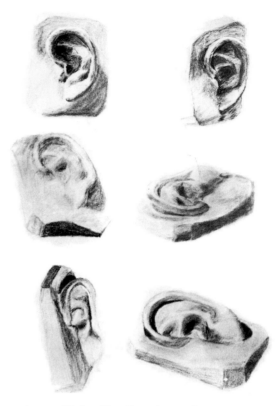

James Misho, **The Ear,** charcoal on paper.
As seen from different angles.

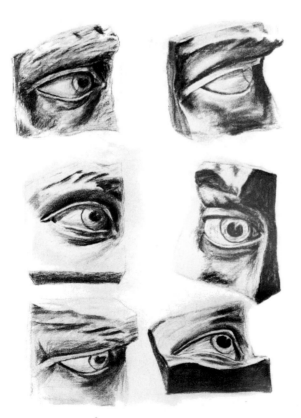

James Misho, **The Eye,** charcoal on paper.
As seen from different angles.

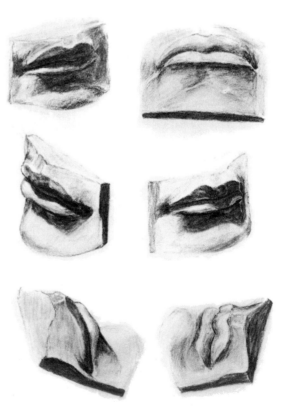

James Misho, **The Mouth,** charcoal on
paper.
As seen from different angles.

The Horizon Line

The horizon line, by definition, is always at eye level. It is not always visible because of intervening objects such as treetops or houses blocking your view; nevertheless, it is there.

The Vanishing Point

All parallel horizontal lines converge and seem finally to disappear at the same point on the horizon line. We call this imaginary point or dot the *vanishing point*. It is where all receding lines meet. A picture may have as many as four vanishing points, depending on the shape of the landscape.

To go further on into exploring visual perspective, architectural subjects will invariably have several vanishing points, sometimes as many as six, depending on whether the subject is a landspace with an uneven terrain with many houses and barns, all placed in different positions and levels. In all cases, a horizontal line must be established, along with vanishing points to accommodate each building.

One-Point Perspective

Perspective is an optical illusion. It is a means of giving the illusion of deep space on the flat surface of a paper or canvas.

A good way to render a scene in one-point perspective is to start with a horizontal line, or horizon, across the canvas. (Remember, this horizon line is the imaginary line in space that is on a level with the viewer's eye.) Then place a dot, the vanishing point, anywhere on the

Follower of Caneletto, *The Courtyard, Doge's Palace with a Procession of the Papal Legate*. Oil.
(Gift of Mrs. Barbara Hutton, National Gallery of Art, Washington, D.C.)

Below-eye-level view. Objects become smaller as they recede into the compositional distance.

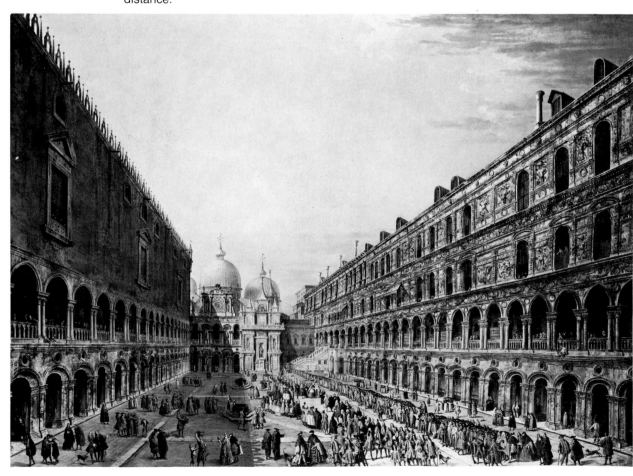

horizon line. This device is aptly called one-point perspective.

As an exercise, do a *street scene* showing an unbroken view of an avenue with buildings of different heights lining both sides of the street. Plan on including whatever features you consider to be characteristic of a street scene: lampposts, shop windows, people, and the like.

1. First, sketch your horizon line, placing it a trifle higher than the center of your canvas. Then, place a clearly defined dot, or pinpoint, somewhere on this horizon line, preferably a little off center.

Master of the Barberini Panels, *The Annunciation.* Wood.
(National Gallery of Art, Samuel H. Kress Collection, 1939, Washington, D.C.)

One-point perspective. All horizontal lines that lie parallel, converge to the same point on the horizon. This imaginary place is called the vanishing point, where all receding lines meet.

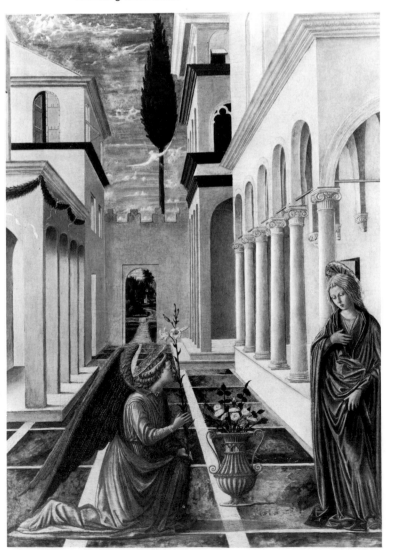

2. To indicate the street, start by the bottom edge of the canvas and sketch two diagonal lines, about 4 to 6 inches apart, converging toward and ending at the vanishing point. For more accuracy, you can use a ruler. These two lines represent the street.

3. About an inch away, on either side of the lines you have just sketched, draw two more lines. These, too, should also converge toward the vanishing point. These lines indicate the sidewalk.

4. Next, show where the building line is by drawing the bottom edges of the buildings about an inch away from the sidewalk lines you have already drawn. You should now have a series of six lines, all starting at the bottom edge of the canvas and stopping at the vanishing point.

5. To get the perspective of a building, you must begin by drawing its basic shape, be it square, rectangular, or whatever. Be sure that all vertical lines are perfectly straight, not leaning to a side (they represent the height of your buildings). If the vertical lines are not straight, everything will be off balance, and your buildings may seem to be collapsing. To get its perspective, draw guide lines that go from its corners and ending at the vanishing point. Visualize the buildings as if they were cubes, sketching the sides as if they were directly facing you (*this side will not be in perspective*). Then draw the guide lines that begin at each of its corners and end at the vanishing point.

6. Erase these guide lines to trim the building down to whatever size you wish it to be. Remove the lines at the point where the building ends.

7. The buildings should look like a succession of cubes and rectangles of various sizes, getting smaller as they approach the vanishing point.

8. Any ornamentation on windows and doorways must also be in perspective. People in the street should be larger in the foreground and smaller as they get closer to the vanishing point. It is especially important to keep clean, sharp edges on the forms, because the slight-

est variation in the angle of a line can throw compositional balance off.

9. The last step is to establish a definite source of light. The direction of the light will determine which sides of your buildings will be in the light and which will be in shadow.

Below-Eye-Level Views

The term *below-eye-level* means that anything placed below the horizon line will appear to be beneath the viewer's center of vi-

sion; he will see the tops of whatever is being rendered.

As an experiment, think of a view that shows rooftops, chimneys, watertanks, and windows with awnings as seen from above. A below-eye-level view is suggested because the scene is often more interesting when viewed from a higher level.

1. Begin your drawing by sketching your horizon line a quarter of the way down from the top edge of the paper or canvas.

2. Place a dot on the extreme right side of this line as your vanishing point. The objects get smaller the closer they approach this point.

Helen Oh, *Empty Street.* Ink drawing.
One-point perspective, street scene. An unbroken view of an avenue of buildings of different heights lining both sides of a street.

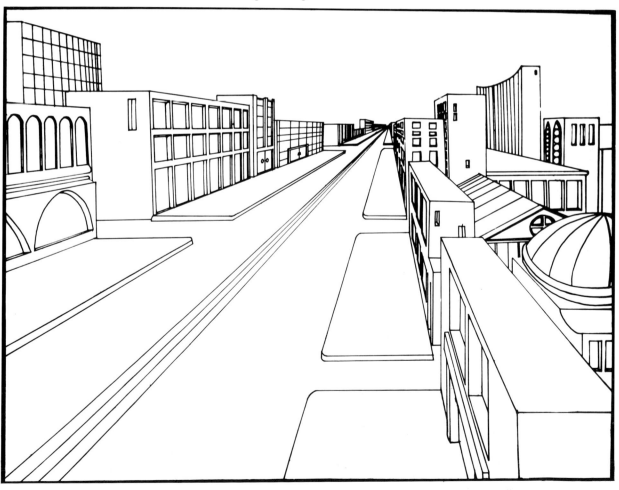

Lucia Salemme, *Under the Highway*. Oil on canvas. Here is an abstract version of one-point perspective.

Helen Oh, *Room Interior*.
A below-eye-level view of a room.

3. Draw a series of lines that point directly onto the vanishing point. These will be your guides in sketching in the different features of your composition.

4. Remember, the closer to the vanishing point your shapes get, the closer together they will appear to be; for example, railroad tracks receding into the distance.

You will have a less complicated composition if you confine yourself to the rendering of two rooftops, with a chimney or a watertank and perhaps several people walking. Since this is a *below-eye-level* study, you will be seeing the tops of all the features in the picture.

Above-Eye-Level Views

In rendering above-eye-level views, the horizon line is placed closer to the bottom edge of the canvas, say, about three-quarters of the way down from the top of the paper. Above-

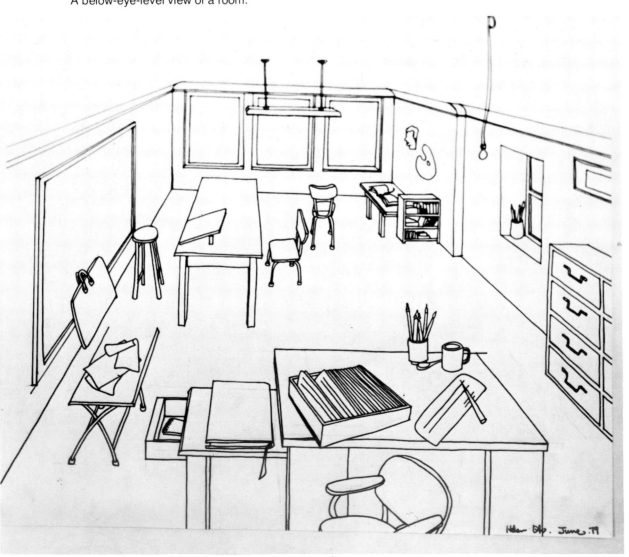

eye-level is what you see when you are looking up—at the sky or the ceiling, say. Place a vanishing point on the horizon line and experiment. Think of airplanes, clouds, or UFO's.

Foreshortening

When doing direct-eye-level drawings, the horizon line is placed in the very center or halfway down from the top edge of the paper or canvas, with the vanishing point placed directly in the middle of the line.

Here are a few hints to help you render a direct-eye-level picture of your own. Imagine lying on your stomach on a beach and looking at the figure of a companion sunning himself, lying with the back of his head facing you. You would probably see a very large cranium, with shoulders and chest next in size, and the re-

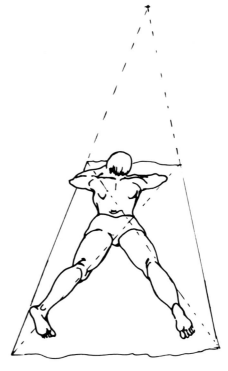

Foreshortening is most apparent whenever the human figure is part of the composition. From this angle, the forms closest to you appear much larger than those further away, creating an illusion of startling distortion.

Room Interior. Normal vanishing point seen at eye level.

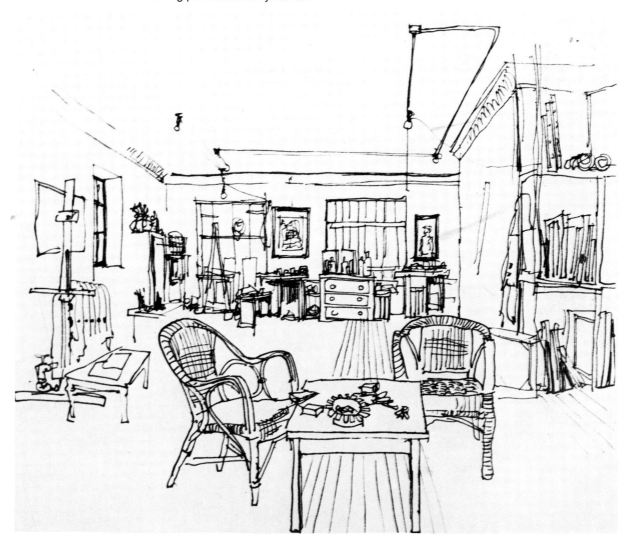

ceding hands, legs, and feet getting progressively smaller the farther back they go. Experiment on your own and choose any subject that will help you explore the idea of foreshortening.

Foreshortening is the depicting of objects as they seem to the eye when viewed obliquely and drawing them so that the forms overlap and partially obstruct whatever forms they are in front of, thus creating a series of overlapping shapes, the one that is closest to the viewer being the largest in size. The essence of foreshortening is overlapping; that is, one form partially covering the form behind it. The progression into depth is made in steps, from one form in front to the one behind it and to another behind that, and so on. It is one of the basic problems of perspective and is most ap-

parent whenever the human figure is part of the composition. The first thing to observe in foreshortening is that your view of the subject should always be at direct eye level, because this is where you will be able to note that the forms closest to you appear to be much larger than those behind, creating illusions of distortion.

SPATIAL RELATIONSHIPS

Positive and Negative Spaces in a Composition

Positive space in a picture is the subject or the area in the composition that makes the statement, such as the face in a portrait, the

A picture may have many vanishing points but only one horizon line.

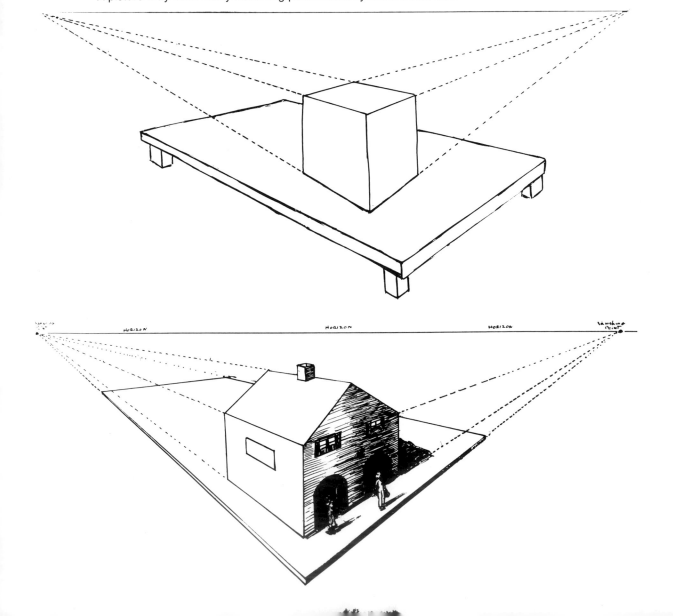

fruits in the still life, the boats in a seascape, the trees and hills in a landscape.

The negative space is the area surrounding the solid forms of the face, figure, or other tangible objects.

It is important to understand that you cannot possibly see positive space unless there is also negative space. Since the positive space is solid, it goes without saying that the negative spaces should have an "ethereal" quality. Usually the images in the background areas are negative, and they must be carefully drawn so as not to conflict with the main subject.

You will find that the ethereal negative spaces and the solid positive spaces complement each other, while at the same time emphasizing the specific qualities of each.

Visual Weight and Balance

When you render shapes that have the same size, the effect can be one of monotony. However, you can change this by rendering each shape in a contrasting value or color. Experiment by making a few nonobjective sketches using forms based on the circle, square, and triangle. The varied tonalities of each form will determine whether the form will seem rigid or flexible, heavy or light, no matter what its size may be, balancing and supporting each other without much effort.

Put this idea to the test by arranging five shapes of the same size, along with one that is much larger. Place the shapes so that they are not touching one another. You can achieve a feeling of subtle movement simply by limiting your colors to the three primaries (red, yellow, and blue) along with black and white.

Do another sketch with the forms, so that the large shape is the center of interest. Choose the colors that best express a specific mood: white, yellow, and orange for a happy mood; blue-green, violet, and gray for an introspective mood. The shapes you paint in very dark value colors invariably suggest immobility; as you progress toward lighter-hued

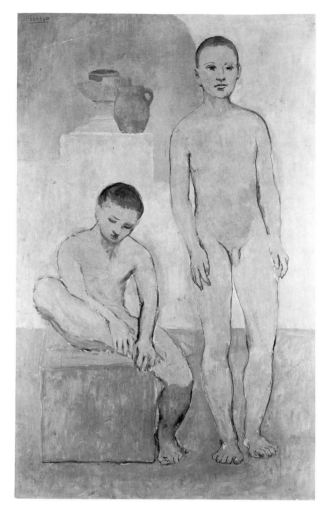

Pablo Picasso, *Two Youths*. Oil on canvas. (National Gallery of Art, Washington, D.C., Chester Dale Collection, 1967)

Foreshortening is achieved when one form or shape partially covers the form behind it as shown in the seated figure.

colors, airier and more flexible forms appear. A balanced compostion is one in which all the forms you have included are essential and from which none can be eliminated. You will also discover that any form painted in black or a very dark color will seem to be larger and heavier than a light-hued one, no matter what size either of them is.

Chiaroscuro: Sharp Contrasts for Dynamic Effects

The term *chiaroscuro* literally means light-dark. This sharp contrast of tonal values is a device many artists resort to when they wish to express dramatic atmospheric effects.

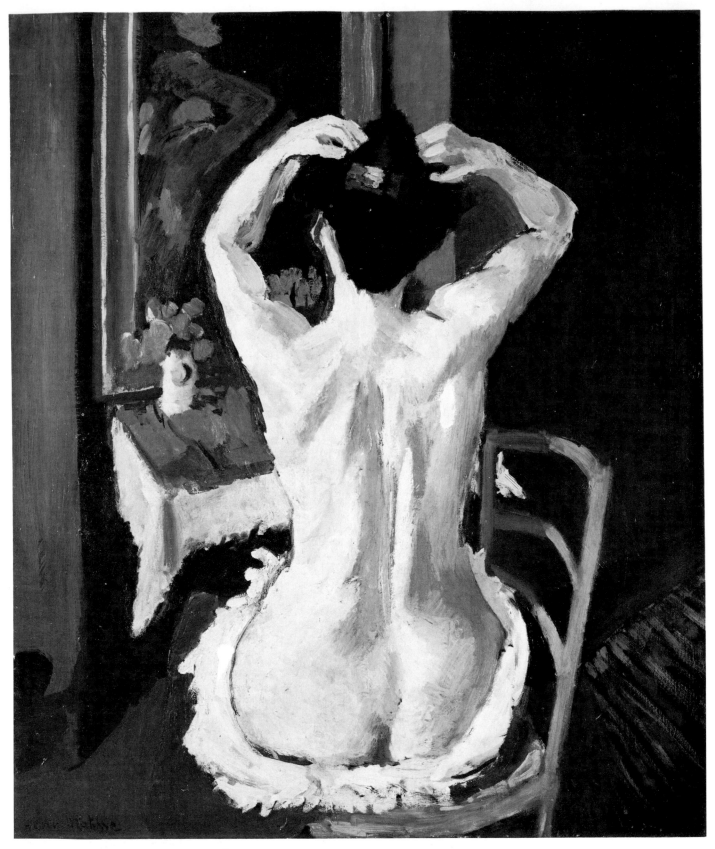

Henri Matisse, *La Coiffure*. Oil on canvas.
(Washington, D.C., Chester Dale Collection, National Gallery of Art.)

Weight and visual balance. The feeling is achieved by painting areas in an
abundant variety of tonal values. Because the model is placed in the very center of
the canvas, she becomes the core to which all the other pictorial elements must
relate, thus establishing a logical feeling of balance.

In planning a chiaroscuro painting first think of a definite dramatic idea. An ominous and foreboding mood can be expressed, first, with the gestures the figures make, and second, by a dramatic placement of darks and lights.

For a good subject, think of a group of figures watching a burning building, or people standing on a rocky shore during a storm. Limit your palette to black and white. Decide where your center of interest is to be, and use it as a focal point around which the other forms revolve. Arrange the figures so that they create a continuous motion that leads to the climactic point, whether it is a burning building or a stormy sky. Work in tonal sequences that start with the light areas around the center of interest, going darker toward the edges of the canvas. It is important to place each figure so that each form picks up where the other leaves off. This will create the continuous motion that leads to the climactic area in the composition.

Movement in a Composition for Expressing Moods

The following project contains work where you will be using different action and change of direction linear brushwork to express a classic poetic mood. After experimenting with the lines alone, do a series of brush paintings, using each one as the basis for a pictorial subject of your own choosing.

Pablo Picasso, *Le Moulin De La Galette*. Oil on canvas.
(The Solomon R. Guggenheim Foundation, New York, The Justin K. Thannhauser Collection.)

In rendering forms of the same size, the effect can be monotonous. But this can be changed when you paint each shape in bright contrasting color.

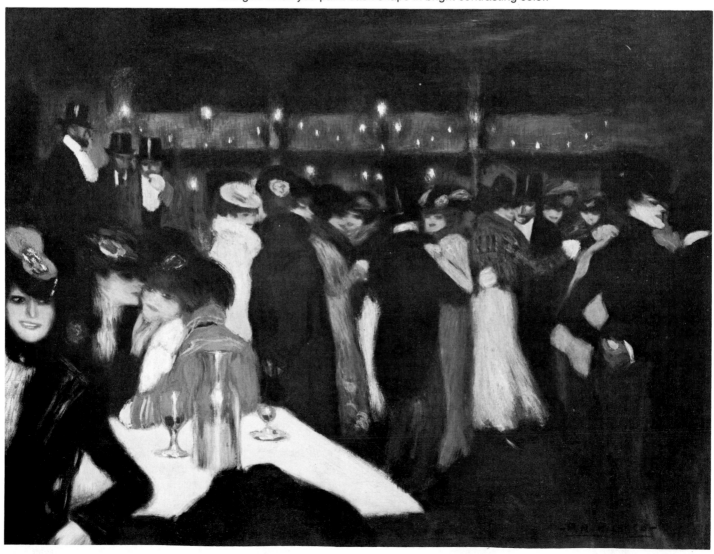

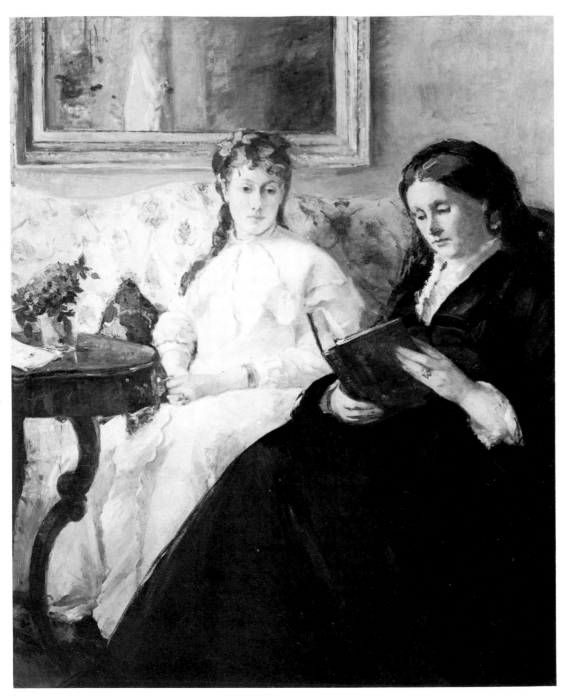

Berthé Morisot, *The Mother and Sister of the Artist*. Oil on canvas.
(National Gallery of Art, Washington, D.C., Chester Dale Collection, 1962)

Chiaroscuro. Dynamic effects and sharp contrasts of tonal values in a painting are often referred to as chiaroscuro.

Peter Hopkins, *Lunch hour*. Oil on canvas. (Opposite page)
(Collection of James N. West, New York)

Circular action in a figure composition. Because each figure is placed next to a related form, a series is created because each form anticipates and moves into the next. Thus a feeling of flowing, continual motion is achieved.

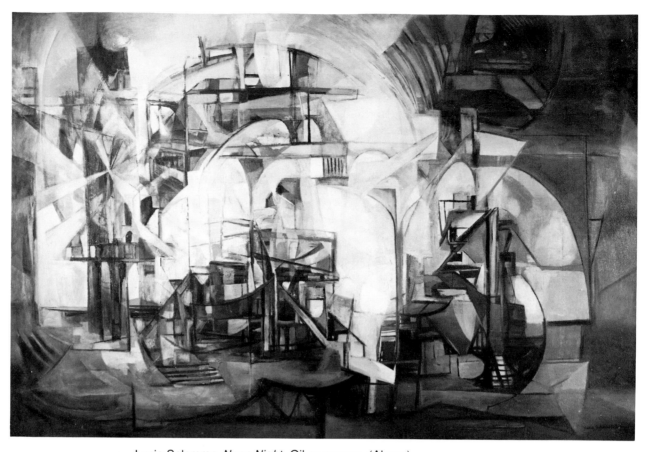

Lucia Salemme, *Neon Night*. Oil on canvas. (Above)

Circular action in an architectural composition. The framework of the buildings has been exposed, revealing tense whirlwind forces in movement.

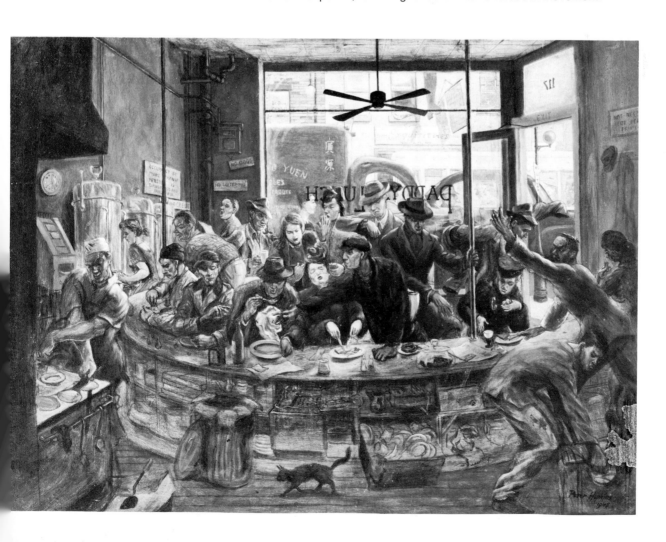

ACTION LINES FOR EXPRESSING DIFFERENT MOODS
Do a series of paintings using each linear movement as the basis for a pictorial subject of your own choosing.

Zigzag movement is expressive of excitement. This movement is often delineated with figure subjects, such as people in action on a crowded dance floor or gesturing spectators at a sports event, or in nature subjects such as lightning and trees in a storm.

Dots and dashes in a cluster impart a mood of excitement; a staccato rhythm is created with a display of fireworks or a cluster of small buildings in a large landscape.

Flowing lines express a langorous mood, as is evidenced in studying forms in nature—a sweep of sand dunes, the undulations of the sea, patterns made by drapery folds, or the flow of long hair.

Counterpoint forms in movement, like dancing figures, ocean waves, or clouds.

Pointed forms as in a mountain range, jagged rock formations and figures in triangular compositional arrangements express alert tension.

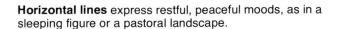

Flowing lines express a sensuous mood, as with a figure gracefully reclining in a soft, low arm chair.

Broken lines express a mood of nervousness and insecurity.

Horizontal lines express restful, peaceful moods, as in a sleeping figure or a pastoral landscape.

The arch conveys a feeling of harmony, buoyancy, and strength. It is also a symbol for spiritual contemplation.

Verticals express a mood of great dignity, austerity, and stability.

The oblique line for dynamism and speed. A sensation of powerful movement is created in whatever direction the line inclines.

Spray shaped lines in the fountain spray motif evoke a gracious, lighthearted mood.

The spiral is a symbol for energy. It is a fundamental nature rhythm—best observed in seashells, flowers, or rocky hillsides. It can also convey a mood of conflict as in a whirlpool and hurricane.

Spheres are symbols for luxuriance and well-being.

The Curved Line Expresses a Graceful Mood

Undulating, waving, and curving forms create a feeling of graceful motion in a composition. The images that immediately come to mind are those we associate with the world of nature: rolling hills, cloud formations, linear gestures of the human body, ocean waves. Combine one of these undulating forms with a rigid solitary shape and you will create a feeling of grace and energy. Undulating motion is expressed in continuous curved contours, as with dancers, bathers, or splashing waves. Plan the color scheme so that it supports the movement already established by the forms. They will enhance one another when in strong contrasts, such as colorful modulations for the large undulating areas next to powerful flat colors for any rigid shapes. The larger expanses of undulating shapes will help tie the composition together.

Overlapping Forms Create Continuous Movement

An excellent way to express continuous movement is to use human figures in an action composition. Think of a group of people in a sports event, dancers in a ballet, or a nonobjective composition using overlapping curved shapes.

Start by placing your main figure or shape in the center. Have all the other elements revolving in a circular action around this central form. This will assure you of a forceful feeling of motion. Keep any background action quiet to calm down the turbulence created by the movement of the figures. If you are doing a nonobjective composition, the concept should be kept simple: it is best to use overlapping, rounded shapes only. If, on the other hand, you are using human figures, a knowledge of anatomy is necessary. Study models in action to get the correct poses.

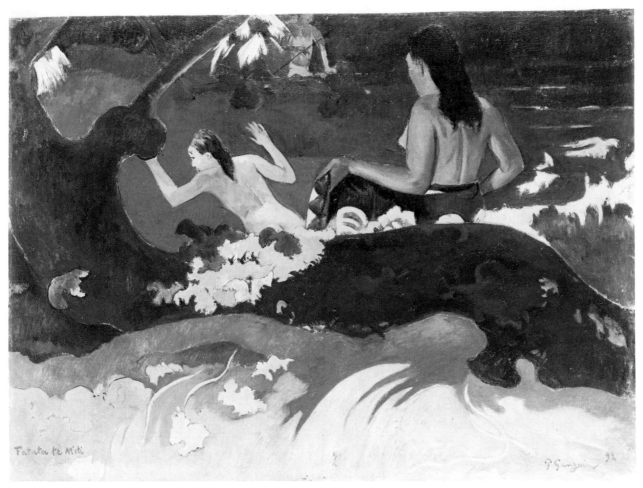

Paul Gauguin, *Fatata Te Miti*. Oil on canvas.
(National Gallery of Art, Washington, D.C., Chester Dale Collection, 1962)

Undulating forms create a feeling of motion such as rolling hills,
ocean waves, and linear gestures.

French School, XVIII Century, *The Rape of the Sabine Women*.
Oil on canvas.
(National Gallery of Art, Washington, D.C., Widener Collection, 1942)

Overlapping forms create continuous movement.

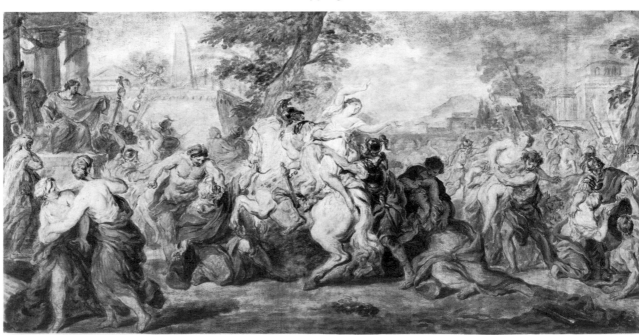

Horizontal Forms Express a Restful and Peaceful Mood

All subjects with a horizontal action in their structure appear peaceful. This is evident if you look at the flat plains in the desert landscape, a city skyline silhouetted against a spread-out sky, or a sleeping figure. Decide for yourself the kind of subject that will best express a peaceful mood in your painting.

A pastoral landscape is always suitable, with a distant horizon line, spread-out horizontal rows of trees and pasture with a few animals grazing in a field. You can also include cloud formations that stretch clear across the canvas in a totally horizontal action or any other features typical of a pastoral setting, always keeping in mind that they should be predominantly horizontal.

Select a muted palette of colors, always with horizontally applied brush strokes.

Vertical Action for Majesty and Dignity

A mood of majesty and dignity can be suggested when vertical shapes dominate the composition. For your painting you may wish to use different vertical subject ideas such as a purely nonobjective study made up of long vertical shapes alone. Or you could do a full-figure portrait of a person standing upright in the very center of the canvas. Whichever you wish to do, plan the composition so that the spaces behind your main vertical shape assume the vertical movement. This placement will add to the feeling of height already projected by the pose. Use middle-value colors in the background sections, saving the more dramatically accented values for the main subject. Use fairly visible brush strokes that take a vertical direction in the painting.

Oblique Action Forms for Dynamism and Speed

The illusion of powerful movement is created by using shapes that have diagonal oblique actions. When oblique forms dominate

the design, they create a sensation of powerful movement in the direction toward which they incline. I suggest you use a canvas with long dimensions, that is, one that is much longer than it is high, so that you will be able to repeat your motif. Repetition helps create the feeling of uninterrupted motion. As a subject for this project think of a figure pushing a heavy object, a row of trees being bent by stormy winds, or some other violent action. Reduce all the forms in the composition to their basic shapes. To express dynamic motion, make sure that all the forms incline sharply in the same direction. Sharp value contrasts in the selection of colors you use can add greatly to the feeling of speed and dynamism already established by the forms.

Honore Daumier, *Advice to a Young Artist*. Oil on canvas. (National Gallery of Art, Washington, D.C. Gift of Duncan Phillips 1944.)

Perpendicular forms are often symbols for dignity and austerity.

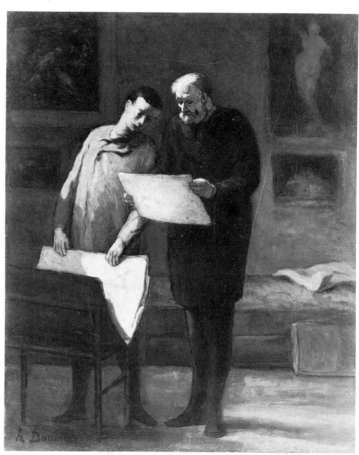

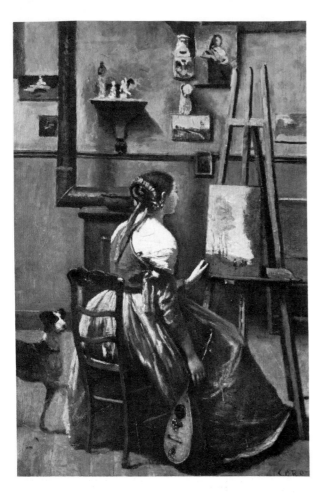

Jean Baptiste-Camille Corot, *The Artist's Studio*. Panel.
(National Gallery of Art, Washington, D.C. Widener Collection, 1942.)

Diagonal lines accent the main idea of the composition.

Spray Shapes Create Cheerful and Graceful Movements: For Expressing a Lighthearted Mood

Unlike other action lines, the fountain spray motif is a form that suggests a gay and graceful movement. To express a lighthearted mood, therefore, think of some delightful happening you have witnessed: a bouquet of flowers, fountains in full spray, or fireworks during a celebration. Any carefree event will do, so long as the main image has an upward and downward spray motion. Your choice of colors will help immensely in rendering these moods. I suggest the use of light versions of all the primaries: pale yellows, pinks, and light blues to brighten your already delightful shapes.

Broken and Fragmented Lines Express Desolation

Occasionally an artist may wish to express a feeling of desolation in a painting, and there are times when this mood can be most poetic. In this project, plan a composition of an unde-

Alexander Calder, *Homage à Salemme*. Oil on canvas.
(Perls Gallery, N.Y.)

Zigzag actions express excitement.

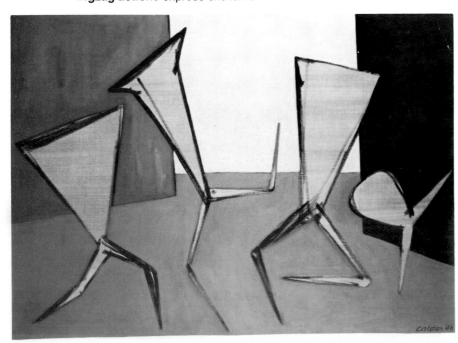

tailed landscape, with an erratic pattern of hills and roads. Over this pattern superimpose smaller forms, spotting the different images so that they are isolated, that is, not touching each other. Trees and plants, with their foliage outlines, stems, and branches, provide ideal forms for this. You can also include people or animals, depending on your personal feelings. Inclusion of linear forms next to amorphic nature forms accentuates the desolate mood. Superimpose sections of fences or telephone poles to help create the nervous effect that broken lines will produce. The use of subdued colors such as grays, blues, and ochres will reinforce the sad mood.

Spiral and Twisting Actions Express Energy

The spiral is a fundamental rhythm found in nature, best observed in the writhing and twisting shapes of old trees, root formations, rocky hillsides, and turbulent sea waves. A tree without its leaves is a good subject to study. Keep in mind that the shape of the trunk and the direction of the branches represent its journey through life, its struggle with the elements—storms, rainless summers, heat, frost—and its survival amid all these hardships. Therefore, you can be as vigorous as you like in twisting the trunk and churning the branches, leaving the spiraling action for rendering the textures of the bark. Vincent Van Gogh is a painter who used the spiral action frequently in many of his paintings.

Zigzag Movement to Express Excitement

Excitement is best rendered with such subjects as moving trains, automobiles, crowds hurrying, groups dancing in a disco ballroom, or a landscape showing a group of windswept trees in a storm in front of tall, jagged mountains. Any subject, if shown in staccato-like fragmented compositional arrangement (even architectural subjects, if placed in a zigzag haphazard manner on the canvas), can express excitement and animation. Select a subject that suggests these moods and then carry out the idea in a painting of your own. Remember, your subject should require the use of zigzag linear forms.

Diagonal Direction Lines Accent the Main Idea

The diagonal line in a composition is used to suggest movement. Several diagonals, however, act as directional signals toward any spot in the composition to which you may wish to call attention.

Think of a landscape using diagonals to accent the center of interest. Include mountains, each a different height. Have a series of roads or ski slopes starting at the corners of the canvas and leading diagonally up the mountains to something interesting at the top:

Pierre Bonnard, *Bouquet of Flowers*.
Oil on canvas.
(National Gallery of Art, Washington, D.C., Ailsa Mellon Bruce Collection.)

Graceful and gay mood with a spray-shaped bouquet.

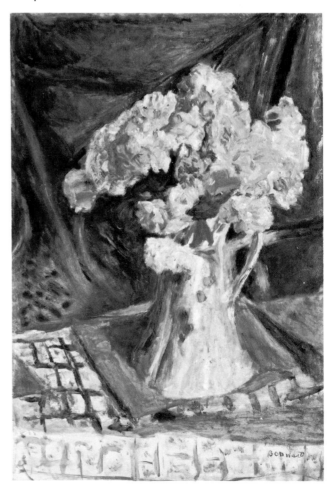

a strange or beautiful house, the sun or moon, unusual cloud formations as in a sunrise or sunset. The point of interest does not matter, so long as the diagonals point toward it. These lines will not only create the movement, they will act as direction signals that will focus on your main idea. There are many kinds of brush strokes, but remember that diagonal-action strokes will speed the movement toward the climactic area of your picture.

The Classic Arch for Harmony and Strength

The arched-line movement is one that binds the shapes in a composition close together, expressing harmonious strength through its heavily swinging action. Therefore, when you wish to paint a subject suggesting a serious and introspective mood, use shapes that form an arched design. There are situations in which the classic-arch motif can be used, for instance, a seated figure holding a child in the lap or a row of heavy-leafed trees that form an arch over a country road or street.

In conclusion, in planning the color scheme with which to paint your different mood subjects, select colors that suggest the feeling of the mood to be rendered. For example, for quiet and subdued subjects you might use darkened version of your colors, and for the gayer and more carefree ideas use pastel tints of the colors.

If both the forms and the colors work together, your composition will be an ensemble of forces perfectly in order, neither too strong nor too weak, with even tonal values that pull the composition together into one harmonious and unified whole.

Artists often change their minds.
Attilio Salemme, *The Family* (first stage).
Oil on canvas.
Originally the artist kept the background area uncluttered so as not to distract from his main theme.

Attilio Salemme, *The Family* (final stage).
But in this final stage of the painting, he decided to include a few diversionary elements in order to create a more playful and light-hearted mood.

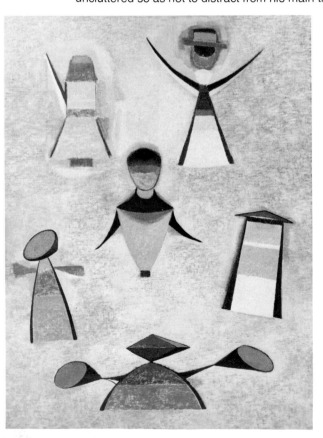

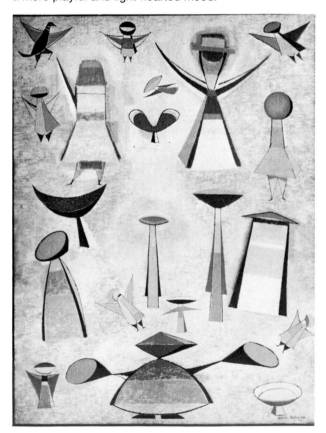

Part Four

DRAWING

We are all aware that drawings, aside from the practical uses to which artists put them, have a charm and beauty of their own. Indeed, the drawings of many artists have lived through the ages. Literally, the act of drawing means to run a pen or other tool over a surface, leaving behind a mark or line. To draw is to delineate and render an idea either with contour outlines, light and shade values, in chiaroscuro, or simply a line.

Drawing is the foundation on which all your future work in painting depends, and eventually you will use your drawings as preliminary studies for your more elaborate paintings. Through drawing you will make the spontaneous statements that evidence how your ideas and visions are transformed into tangible realities. The techniques best suited to drawing are those that lend themselves to the useful notation of *your* ideas. These ideas can either be rendered carefully, with much attention to detail, or be spontaneously splashed onto paper with carefree lines or brushwork. Each method is valid and belongs to the time-honored field of draftsmanship.

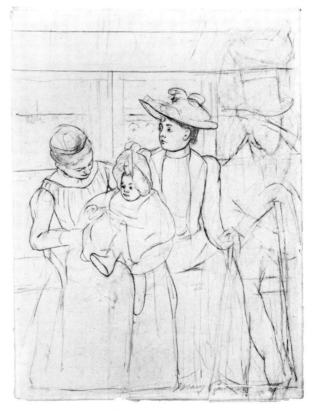

Mary Cassatt, *The Tramway* (*In the Omnibus*). Lead pencil.
(National Gallery of Art, Washington, D.C., Rosenwald Collection.)

After the initial sketch is made, the line is made darker by putting pressure on the pencil, thus creating more variety and accents throughout the drawing.

75

The proper handling of both styles should be mastered before you learn to paint.

Nine basic techniques used in drawing are presented in this section. Reproductions of works by master artists accompany each project, demonstrating the use of good draftsmanship and the unique quality that distinguishes each technique from the others.

A list of the necessary tools and materials is included with each project. After your introduction to each drawing method, it is important to keep in mind that when doing your own creative renderings, you work with the materials that you like and the tools that meet the needs of the moment. Only when you work in a relaxed manner can your inspired ideas be expressed naturally. The techniques presented in this book are just a starting point, not hard-and-fast rules. Gradually your own techniques will take over.

TOOL AND DRAWING MATERIALS:
COMPLETE LIST FOR ALL PROJECTS
 All-purpose drawing paper pad 18″ × 24″
 Charcoal paper pad spiral bound 18″ × 24″
 Smooth-surface bond paper pad 12″ × 16″ or
 15″ × 19″
 Watercolor paper block 16″ × 20″ semi-rough
 surface
 30″ × 40″ sheet of untextured rice paper (can
 be cut down to smaller sizes)
 Gesso-covered scratchboard paper 20″ × 30″
 Bristol board 30″ × 40″
 Illustration board 30″ × 40″
 All sizes of toned pastel papers, subdued
 colors of gray, brown, ochre, red
 Drawing board (wood) 20″ × 28″
 Charcoal—soft, hard, medium, both in stick and
 pencil form
 Pencils—graphite or carbon, *medium* 2B, Hb;
 soft 4B, 5B, 6B; *hard* 2H
 Conté crayons—sticks come in hard, medium,
 and soft; white, black, sanguine
 Pastel chalks—white, flesh, ivory, terra cotta,
 terra verte
 Colored pencils—black, sepia, dark brown, raw
 sienna, terra cotta, white, ivory, flesh
 India ink
 Ink—black, sepia, all colors
 Sumi carbon ink—tablet or stick
 Shallow ceramic block for mixing Sumi with
 water
 Tempera or poster paint—white and black
 Gillott pen points (assorted sizes) and pen
 holders

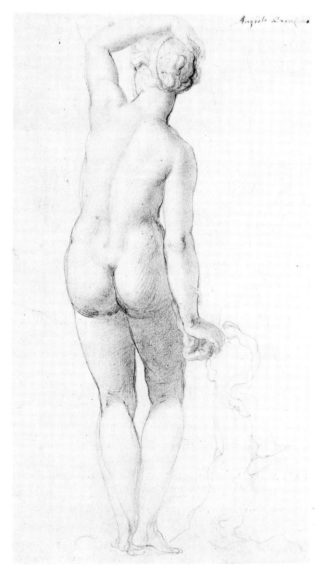

Bronzino, Copy after Bandinelli's *Cleopatra*. Black chalk on white paper.
(Fogg Art Museum, Harvard University, Cambridge, Mass., Charles A. Loeser, Esq. Bequest.)

Delicate modeling is done only in the shadow areas with black chalk.

Pelikan 120 fountainpen
Stylist pens, thick and thin felt-tip pens—all
 colors
Rapidigraph pens with very thin and medium-
 width points
Metal stylus with holder for scratchboard work
Paper stumps, blenders assorted sizes
Sandpaper block
Blotters
Grooved palette
Sponge
Masking tape
Clips to support and hold paper to drawing
 board
Thumbtacks or pins
Erasers—kneaded and gum
Single-edge razor blades (do not use
 double-edged blades, because they are
 dangerous)
Can of spray fixative
Flat-hair 1-inch watercolor brush (student
 grade)
Japanese brushes, bamboo handle—#4, #6,
 #8
Portfolio or carrying case, 19″ × 26″
Empty jar to hold clean water

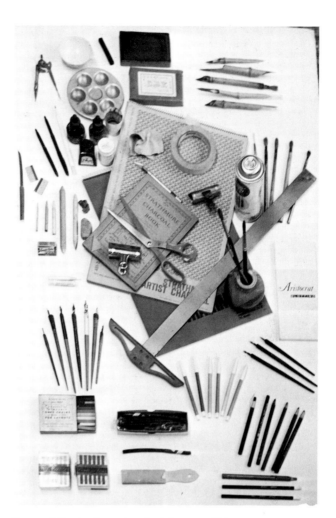

Some of the tools and materials you will be
using in carrying out the drawing projects.

Project: CONTOUR DRAWING—The Continuous Line

ILLUSTRATION REFERENCE: V. Salemme, *The Trap*

TOOLS AND MATERIALS:
 15″ × 19″ smooth white drawing paper
 Pen and ink
 Charcoal pencil
 Thick and thin felt-tip pens
 Lead pencil—soft
 Conté crayon pencil

Contour drawing specifically means draw-ing a continuous line that reproduces the outer edge of the form or shape of an object. The best results are accomplished when using subjects that have rounded contours such as fruits, vegetables, flowers, people, clothing such as old hats or shoes, large forms in a landscape or a street scene, animals.

The true contour drawing is one that is done *without looking at the paper* by visually fol-lowing the edge of the shape being drawn while the hand holding the drawing imple-ment is doing the actual work of drawing on the paper.

For warm-up exercises, take out your tools and practice drawing with them. Draw only a series of single objects at first, making one continuous line going in the different direc-tions your subject calls for. Try to put down as simply as possible only the outside edge of what you are seeing. Next, when you feel more confident, proceed to doing a more com-plete contour drawing, in which you draw

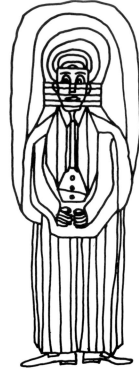

Vincent Salemme, *The Trap*. Pen and ink on paper.
The continuous line following the direction of the outside edges of the subject makes for a clear, uncluttered expression of an introverted mood.

several objects together and use a different tool each time.

Understatement is the keynote of a good contour drawing. At first glance your finished drawing may seem to be greatly out of proportion, but this can also be its charm. Do not try to correct it! You are not supposed to have even glanced at what was happening on the paper, except when you felt it was absolutely necessary to get your bearings.

Do not be discouraged if your drawing seems to be out of proportion; it is the sensitively drawn edge rather than "even proportion" that produces the characteristic look of a good contour drawing.

Project: THE CONTINUOUS LINE

SUBJECT: Still Life

ILLUSTRATION REFERENCE: Calder, *Head*

TOOLS AND MATERIALS:
 Still-life objects: Any three curved vegetables, such as beets, eggplant, squash, banana, pear, or any other three-dimensional round object you find interesting
 18″ × 24″ all-purpose white drawing paper
 Graphite lead pencils #4B and #6B, crayons, thick and thin felt-tip pens, pencils—conté crayon or charcoal

1. Before touching the paper, study the object: let your eye rest on the form closest to you, and then move your eye along, looking only at the outer edges. Use only one object for your first try, then arrange the objects in groups of two or three for other drawings.

2. Place your drawing tool on the paper and, without glancing back, move your hand in unison with your eye movement, looking at your drawing only when it is absolutely necessary to find your bearings. Avoid moving your eye faster than your hand. Have hand and eye move at the same pace.

3. Match the movement of your hand to each indentation and bulge of the edge of the shape your eye is following.

4. For a still life, set up two or more objects together. When the surface you are drawing changes direction, stop! Take a look at your picture and then continue to draw at whatever place is next to the spot where you stopped.

5. When your outline is completed, study what you have drawn and see how it compares with the subject. Add whatever details you think are needed to complete the drawing, being careful that it retains the contour quality at all times.

6. Move the object around to form a different arrangement. Make several drawings of it, as you did in step 4. You will then have several compositions.

7. Alternate by drawing with different tools for each new drawing.

8. Then do contour drawings of other objects such as lopsided pillows, an old hat, a shoe, or any other curved three-dimensional object that strikes your fancy. Try putting them in groups, coming out of a bag or a basket. *Do not try to work from live models until you*

have mastered a great many still-life subjects. Establish the habit of looking at the subject rather than at your drawing, and draw all around each part of the form without looking at your hand. From time to time, practice doing lots of drawings of subjects that are near you wherever you happen to be. Keep a small sketchbook with you.

Contour drawing dates back to the time of early man, who cut lines that corresponded to the contours of designs and images onto bone and later on the stone wall of cave shelters. The tools were only sharpened stones! These unique and spirited representations of animals and hunters, the earliest drawings known to us, are clear examples of the contour-drawing method of rendering ideas. Today's artists have an unlimited supply of tools with which to achieve contour effects in their drawing; they can select from pencils, crayons, felt-tip pens, other pens, and all types of inks.

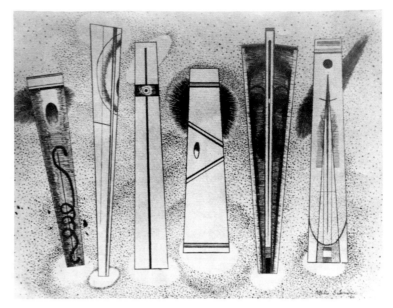

Attilio Salemme, *Successful Characters*. Ink on gray paper.
(Permanent Collection: The University of Iowa.)

A surprising number of textural effects can be produced with stippling, which is done by drawing a series of broken lines or numerous close-together dots.

Project: PEN AND INK—The Varied Line Drawing

SUBJECT: Thick and thin lines with pen and ink

ILLUSTRATION REFERENCE: V. Salemme,
 Dunes; V. Salemme, *The Big Tree*;
 L. Salemme, *Under the Bridge*; A. Salemme,
 Successful Characters

TOOLS AND MATERIALS:
 14″ × 18″ smooth bond paper
 Gillot penpoints and penholder—assorted sizes
 Bottle of black India ink

Today's artists render linear work mainly with pen and ink and pencils, but most prefer the flexibility of the penpoint, because beautiful effects can be achieved simply by varying the width of lines. You can produce a variety of sensitive and poetic effects simply by alternating between light and heavy pressure on the pen. The degree of pressure not only determines how thin or wide a line will be produced, but also how light or dark the impression will be.

By varying the width of your lines, you will be able to emphasize what you think is important in your drawing. This requires that you have continuous reference to your model, looking back and forth from the drawing to the

Alexander Calder, *Head*. Ink on paper.
(Collection Mr. & Mrs. Klaus G. Perls)

Contour drawing is the technique of drawing lines that go in the natural direction called for by the subject and putting down as simply as possible only the "outside edge" of what you see.

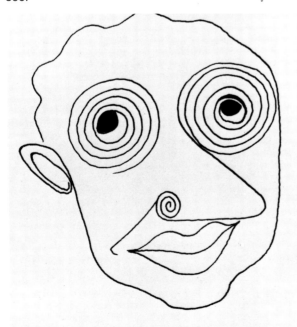

subject as often as you feel it necessary. For inspiration, study the exquisitely clean outlines of human figures that distinguish the work of the ancient Greeks. Most of our knowledge of their drawing is derived from the figures displayed on their classic vases, because most of their wall paintings have vanished.

In doing a varied line drawing from life, have the model take a relaxed pose in a reclining position. This will give you the opportunity to use flowing lines. If you like, you can first make a light pencil sketch of the model to use as a base, later going over the pencil lines with pen and ink. Then when the ink has dried, you can erase the pencil sketch, leaving your ink drawing intact. Drawing directly with pen and ink is for advanced students only.

Wide-width lines are achieved by pressing down on your penpoint, and fine, thin lines by releasing the pressure of your hand on the pen holder. The thinness and width of your lines are dependent on how much control you have on the pressure you place on the pen.

Do a series of exercises where you practice making lines. Make several renditions of each type of line, then try variations of your own.

To create modified graded values, use more complex linear work, such as clustered lines and crosshatching. Clustered lines are drawn in a parallel action, with the lines all going in the natural direction of the shape being rendered. Use close-together lines for rendering dark values, and use far-apart lines to render the lighter values.

Varied Lines made with flexible pen points and black ink. This, and the next four drawings illustrate pen & ink work.

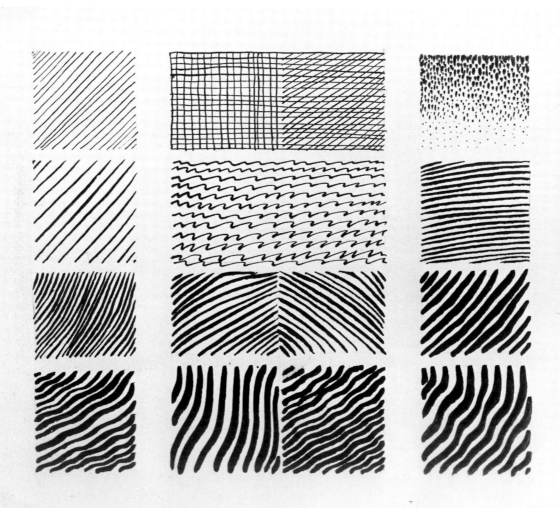

Vincent Salemme, *Ferocious Beast*. Ink drawing.
All lines going in the natural direction of the form being modeled.

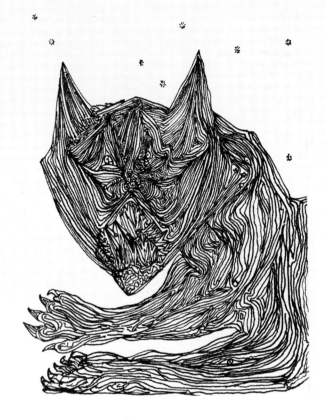

Linear work done with flexible pen points and black ink.

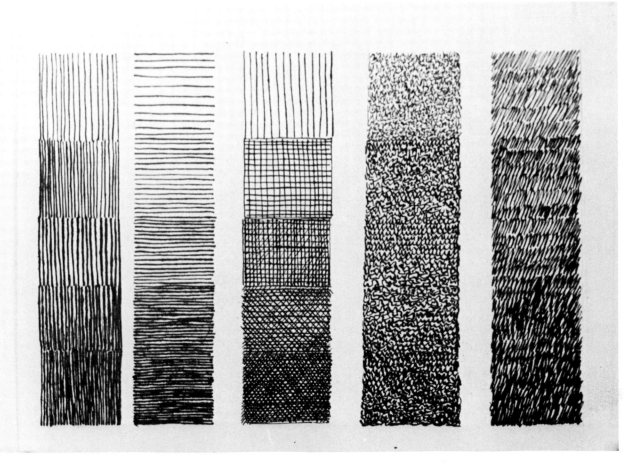

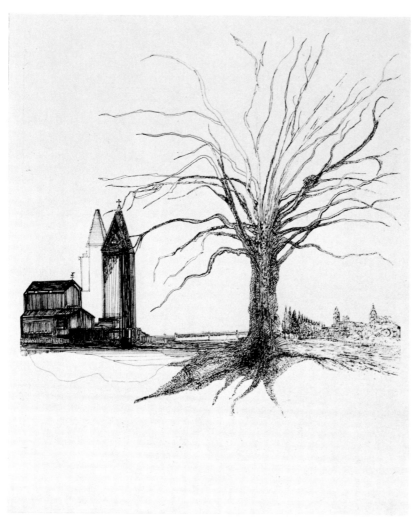

Vincent Salemme, *The Big Tree*. Ink drawing.
A variety of landscape textures are rendered with rigid
pen points of different sizes.

Lawrence Salemme, *Under the Bridge*. Ink on paper.
Varied textures are rendered in an architectural setting
with a ballpoint pen.

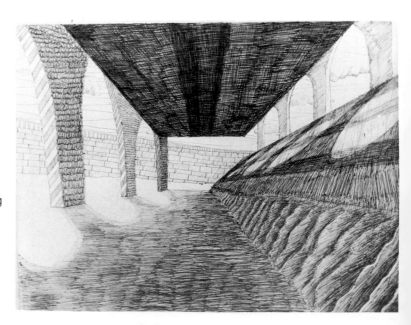

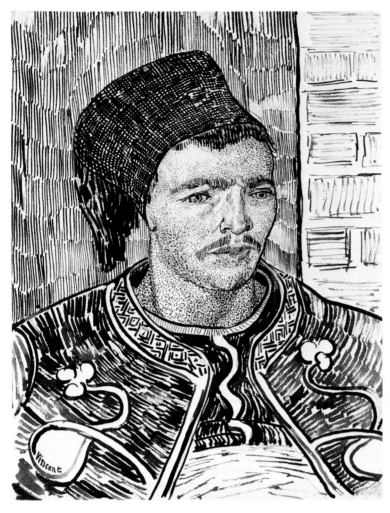

Vincent Van Gogh, *The Zouave*. Ink on wove paper.
(The Justin K. Thannhauser Collection, The Solomon R. Guggenheim Foundation, New York)

Thick and thin lines are produced with a small, pointed sable-hair brush, and for making the finer lines, with a blunt-point pen.

Project: **MODELED LINE DRAWING WITH PEN AND INK**

SUBJECT: Posed model—gestures and action

ILLUSTRATION REFERENCE: A. Salemme,
 Seated Nude

TOOLS AND MATERIALS:
 Smooth-surfaced bond paper 15″ × 19″
 India ink
 Gillot penpoints, assorted sizes
 Several pen holders

Because the human eye is incapable of registering instantaneous movement, you must study the movement, the gradual transition from one attitude to another, that is characteristic of all life. To render a movement, you should select the *most characteristic* position. Skillful selection will give the impression of life. Photographic rendering is to be avoided, because it produces only a deadly frozen posture. When drawing from a model where you use varied line with pen and ink, be guided by these steps:

1. First, make a light pencil sketch of the pose, accenting the flowing lines of the figure and drapery.

2. Using the sketch as a base, go over your pencil lines with ink lines of different widths to render variations of values and undulating movement.

3. While drawing, indicate forms that overlap or change direction with either thick or thin lines.

4. Use dark, heavy lines for shaded areas, hair-thin lines for light areas.

5. Complete the drawing with very sharp dark lines for accents and details. If you wish, you can create some modified, graded values by using more complex linear work such as clustered lines and a little crosshatching.

Project: PENCIL—Modeling Done with Pencils

ILLUSTRATION REFERENCES: L. Salemme, *Neal*; Picasso, *Dinard—Summer 1922*

TOOLS AND MATERIALS:
 18″ × 24″ or 9″ × 12″ medium-rough textured papers, white or different light tones
 Graphite lead pencils—4B, 5B, and 6B
 Charcoal pencils
 Conté crayon pencils
 White chalk, white pastel stick
 Conté pencils—white, sanguine, black
 Sandpaper block
 Small can of spray fixative

To achieve graded value effects with lines alone, pencils that are kept well sharpened at all times are the basic tools to use. These include charcoal, all sorts of colored crayons, as well as the lead graphite pencils we are all familiar with. The drawing method is the same with each. The line each one makes varies slightly, and by experimenting with them you will find that:

Conté crayon is a semihard chalk of a fine texture. It has a sufficiently oily binder that makes it adhere readily to smooth paper.

Lead pencils are pleasant to work with, because strong contrasting effects can be achieved quickly.

Charcoal pencils have somewhat the same characteristics as the lead, but the finished drawing requires fixative.

Graphite lead and conté crayon pencils are sufficiently hard so that the drawing does not dust off the paper, and they do not have to be sprayed with fixative.

When crayon pencils are used on the flat side against the paper, they make broad strokes of graded tones, while the corners make elegant sharp-edged lines. Because you cannot erase, only advanced students should work with it. But before doing a finished detailed drawing, fill up a practice sheet and experiment with all types of pencils to test the quality of line they make, always keeping in mind that there is to be no erasing!

Try carrying a small sketch pad and a pencil or two of different colors to use when you are at a concert, the beach, or a sports event. Here you can make spontaneous drawings and sketch in your free moments where you need not concentrate on any one subject. Rather, watch many people and capture details from a number of figures in succession. The idea is to render the essence of the action with quick notation. Don't be afraid to exaggerate the gesture.

To become adept in the use of your different pencils, fill up two sheets of medium-rough, gray, pastel paper with a series of thin and thick lines:

a. Draw horizontal lines, both close together and far apart.

b. Add vertical close-together and far-apart lines.

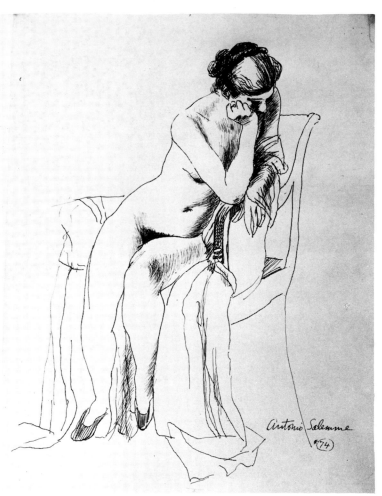

Antonio Salemme, *Seated Nude.* Ink on paper. Because the human eye is incapable of registering instantaneous movement, a study of the gradual transitions from one attitude to another is a must. To suggest movement, lines are drawn with a flexible pen point that makes both thick and thin impressions. The thick lines to indicate changes of direction, hair-thin lines for areas catching the light, and more complex linear work for the modeled areas.

Lucia Salemme, *Neal.* Pencil on white paper. Graphite lead pencils are pleasant to work with because a variety of strong and contrasting effects can be achieved quickly.

Pablo Picasso, *Dinard—Summer 1922*. Pencil on wove paper.
(The Justin K. Thannhauser Collection, The Solomon R. Guggenheim Foundation, New York)

Drawing in outline is the important first step on which all the other steps depend.

c. Next, draw close-together and far-apart curved lines.

d. Draw clustered lines, some short, some long, all going in the same direction, both close together and far apart.

e. Crosshatching. First, draw lines going in one diagonal direction and then superimpose additional lines in an opposite direction.

f. Stippling may be done by placing groups of dots or bunches of short lines close to each other or far apart.

After practicing different strokes, do a series of single-object still-life drawings of fruits, using the pencil you enjoy working with best and putting in highlights with the white chalk as the final step.

When you feel you have practiced enough, you should be ready to do portrait and figure studies where you use a posed model.

VALUE RENDERING

You can make different grays by varying the values with pencil in a series of parallel lines moving either vertically, horizontally, or diagonally, and with slight modifications of direction, suggest the surface movement of three-dimensional forms. You can also achieve advancing and receding effects with the use of values. For example, you can work from *very dark toward light* in a picture if you keep this technique throughout the composition. In another picture you can work the reverse, that is, from *very light toward dark.*

Experiment by drawing two separate circles, and use both types of value rendering to note how you can change the look of a surface. For example, model one circle by drawing from a *light center* toward a dark periphery, and it will look like a dish. In a second circle reverse the procedure by starting with a *dark center* and get lighter toward the edges. This will make the circle look like a ball. When you darken the background around the toned circle, its edges will appear lighter. And if you make the background lighter than the toned circle, its edges will appear darker. Try it and see!

SOURCE OF LIGHT ON THE SUBJECT

It is important in all modeling to have a definite source of light on the object being rendered. Experiment by drawing a circle and have your source of light coming from directly in front. Note how the light-value areas seem to advance, whereas the dark ones recede. Draw another circle, and have the light source directly behind—it will give the opposite effect. The dark area comes forward, and the light area goes back.

As an additional exercise, try modeling an object as if the light were coming from only one side. Place an egg or a white ball on a piece of white paper, and light it from above or from one side. Do a modeled drawing of what you see.

You can use changes-of-direction lines both to capture the gesture and to do your modeling. The outline is the important first step, on which all the other steps depend. With a good basic outline, careful handling of your pencil will develop the modeling of the forms in the drawing. In doing a carefully modeled drawing, first draw the outline, then do the modeling with the following methods.

To scribble you keep the pencil constantly on the paper. Draw rapidly, without lifting the pencil, until you have captured the light-and-shade variations as well as the different surface texture.

Another method is to model with a series of short broken lines (a type of stippling) placed various distances from each other, all going in the same direction.

A third method is *crosshatching,* in which lines are drawn over others going in the opposite direction.

The loveliest of all is the classic, carefully modeled drawing in which juxtaposed fine parallel lines go in the natural direction of the form being modeled.

Project: MODELING WITH PENCILS

Graphite soft-lead pencils—4B, 6B
Graphite hard-lead pencils—2H, 3B
15″ × 19″ semirough surface paper

In rendering the human figure, the aim is to model the anatomical plan in a way that establishes the figure's three-dimensional quality. This is accomplished by using light-and-shade values related to the anatomy of the model. Make four separate drawings of the posed model. Use charcoal pencil for the first one, then hard-lead pencil for the next, soft-lead pencil for the third, saving the pen and ink for the last one. Use the same technique for all four.

1. Have the model take a simple standing pose, one that can be held for several hours (with 5-minute rest periods at intervals of 20 minutes).

2. Make a lightly sketched contour drawing of the pose.

3. Study the subject and note where the source of light is and where the dark areas, the middle tone areas, and the extreme light areas are.

4. Working from dark toward light, draw close-together parallel lines, going in the natural direction of the shape being rendered so as to fill in the darkest areas.

5. For each successive light value, place the parallel lines farther and farther apart. You can make different tones by varying the thickness of the strokes (depending on their direction) to suggest the surface movement of the shape being modeled. This, of course, is a slow process, but the effort is well worth your trouble.

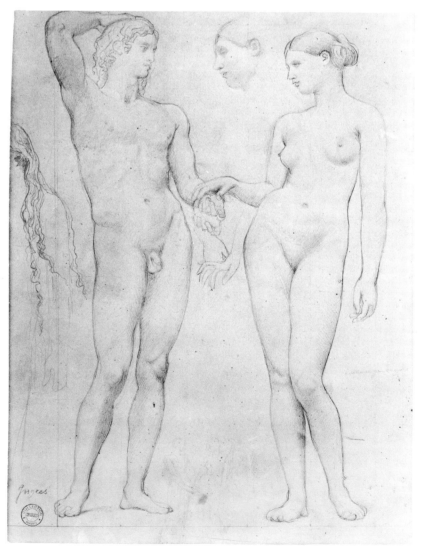

Jean Auguste Dominique Ingrès, *Two Nudes Study for L'Age D'Or.*
(Fogg Art Museum, Cambridge, Mass.)

When aiming for subtle rendering of three-dimensional forms, use parallel graded lines juxtaposed to the initial drawing you made of the subject.

Project: CONTÉ PENCIL—Light and Shade with Line

SUBJECT: Portrait—head and shoulders only

ILLUSTRATION REFERENCE: Cenci, *Lucy as a Young Girl*; Mondrian, *Chrysanthemum*; School of Lorenzo de Credi, *Drapery Study*

TOOLS AND MATERIALS:
Medium-rough gray pastel paper
White pastel stick
Conté pencil, sanguine or black
All-purpose drawing paper pad, 9″ × 12″

In doing a portrait, notice that the eyes and lips have a mobility of expression that animates the human face. To make this face appear alive on paper you must seize the maximum expressions from several moments and combine them to capture the essence. You accomplish this by rendering the unique characteristics of your model. You have to make choices. Each feature must be selected, simplified, and emphasized. Eliminate all nonessentials. To express form, the lines of a drawing must be well placed and all shadowed areas dramatically shown and accented. Here are a few steps to help you get started:

1. Seat the model directly underneath a strong light (a spotlight is best).

2. Study your subject, noting what shapes interest you the most. Then proceed to sketch very lightly the outline of the head and shoulders.

3. The simplest way to develop modeling is to start with the strong shadow areas. Carefully draw a series of close-together lines with your conté pencil. (Be sure it has a good point.) You must know enough about anatomy to visualize the facial structure with sufficient accuracy.

4. To create graded values, use more complex linear work such as clustered lines, scribbling, crosshatching, and stippling.

5. Use parallel graded lines juxtaposed to the original outline for the rendering of subtle three-dimensional modeling.

6. Organize the planes and volumes of the face to indicate clearly its light and shadow

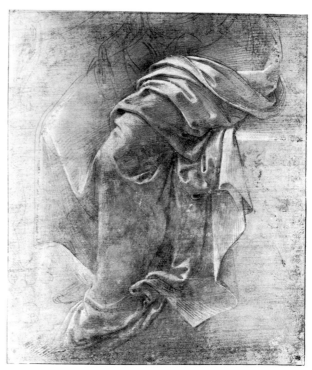

School of Lorenzo di Credi, *Drapery Study*. Pencil with white chalk on toned paper.
(Fogg Art Museum, Cambridge, Mass. Bequest of Charles A. Loeser.)

In this drawing the drapery is delicately outlined with light graphite lead pencil work on a toned paper. The dramatic highlights are rendered with white chalk.

Piet Mondrian, *Chrysanthemum*. Charcoal.
(The Solomon R. Guggenheim Museum, New York)

Modeling that is done with charcoal pencils using short broken lines, produces sharp and contrasting effects.

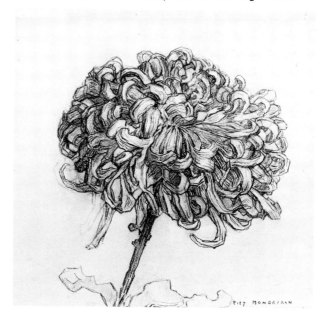

areas. You can have lines all going in the same direction or add crosshatching or stippling.

7. When the lines are close together, the area appears darker and has more depth. When the lines are farther apart, the area appears lighter and seems to advance.

8. The last step is to use the white chalk to pick up the highlights and reflection.

9. Change your position to give you a different view of the model's facial planes and do a second drawing, following the same procedure as in your previous drawing.

Gustavo Cenci, *Lucy as a Young Girl.* Conté pencil with while chalk highlights.
The simplest way to develop modeling is to begin by toning all the darkest shadow areas and then putting the highlights in last with white chalk.

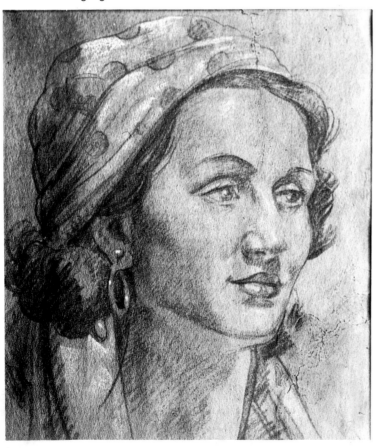

Project: CHARCOAL: Modeling Tonal Values

TOOLS AND MATERIALS:
 Tortillons or blenders, small and large
 White charcoal-paper pad, 18″ × 24″,
 assorted types
 One dozen sticks of charcoal—soft vine,
 semisoft, hard, and compressed
 Kneaded eraser
 Can of spray fixative
 Sandpaper block

Charcoal is the traditional medium that artists use when first learning to see values. It is popular because it is easy to control, and mistakes can be erased. It is well adapted both to small, carefully executed work and to large-scale studies, in which different tonal values are to be quickly applied. Both sharpness of detail and delicate gradations of tone can be achieved. This quality is especially useful when drawing three-dimensional forms in portrait, figure, still-life, and landscape subjects, and when rendering different surface textures. Painters began using charcoal from the time of the Renaissance and have continued doing so to the present day.

Charcoals differ in texture, depending on what binder is used in their manufacture. The blackest is compressed charcoal, and the lightest in tone is the soft vine charcoal. Semisoft is the most versatile and is used in all charcoal work in which blending and fusing are to be done. The hard charcoal is used whenever detailed linear modeling is required. Try them all and test them for yourself with some practice exercises. The subjects are optional, because charcoal is a medium suitable to all figurative ideas.

Practice the rendering of both light and dark tonal values by drawing a set of cubes and spherical shapes in different tonalities, depending on what sort of a light is being directed on them. Select objects such as a set of children's building blocks (blocks should be painted white before setting them up in a still-life arrangement). Place them so that

they will receive a strong direct light from above or from one side only. Study and observe their shadows carefully before beginning to draw. Then gradually begin to build up the different tones by applying coats of the hard charcoal, leaving the white of the paper untouched for the lightest area and the darkest tone for the deep-cast shadow areas.

1. In rendering the tonal values of solid forms, the elements to observe carefully are where the light, highlights, cast shadows, core of the shadow, reflected shadows, and reflected highlights lie.

2. After careful observation of the above, do a fused, blended drawing of the forms of the geometric building blocks.

For a second practice exercise, set up a still life made up of rounded forms such as apples, grapefruits, melons, or squash.

1. Study each one carefully, draw each in outline, and note their different proportions.

2. Since they are all sphere-shaped forms, study carefully the fused blending of the tonalities, going from extreme dark to middle-tone to light areas. Note how much more pronounced the surface of the sphere is as it moves away from the source of light. The most important point in the drawing is the place where light and shadow meet.

3. Next, seek out the place where reflected light is cast into shadow areas from the nearby light-value surfaces.

4. The last step is to draw the corner where the form turns out of the light into the dark. The "now in focus" texture of the different surfaces of the sphere-shaped fruits you have been rendering is clearly visible.

FUSED AND BLENDED DRAWING

Semisoft charcoal is used in doing fused and blended work. You need a well-pointed charcoal stick that has been made so by rubbing it across the sandpaper block. To build up all the delicate tonal gradations, put in even layers of grays with lightly applied parallel lines. Fusing and blending are done by gently rubbing the area with either your fingertips or a tortillon.

To make richer tonalities, you can superimpose a second set of lines, which you fuse together by rubbing and then spraying the area with fixative; repeat until a tone of the desired value is established. To achieve even

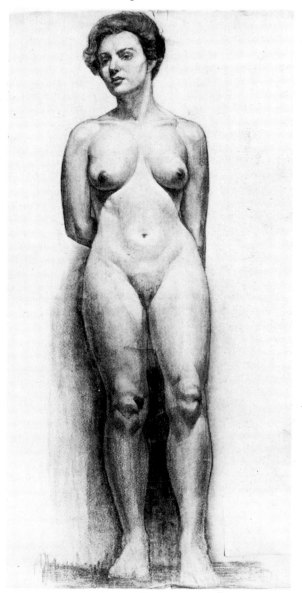

Lucie Autorino, *Standing Nude.* Soft charcoal. Soft charcoal is popular because it is easy to control and where necessary, can be blended and fused with tortillons or with the fingers.

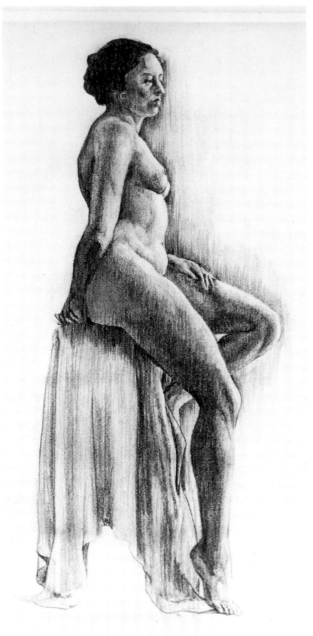

Lucie Autorino, *Seated Nude With Drapery*. Hard charcoal pencil.
In drawing anatomical forms, the place in the picture **where light and shadows meet** is important. For this you need to work with a hard, sharply pointed charcoal pencil in order to draw the parallel lines necessary in achieving the desired modeling effects.

smoother gradations from white to black, finish off with more gentle blending with the tortillon or paper stump.

When tonal values have to be quickly applied, usually in large-scale drawings, soft charcoal is frequently used. Both the point and the side of the charcoal stick can be used freely for rendering these tonalities.

The most important final step in all charcoal work is to spray the finished drawing with fixative. This is best done by placing the drawing in an upright position in a well-ventilated room and holding the spray can at least 18 inches away from the drawing. Spray it by using a circular movement until the entire surface has been evenly covered. Do not spray too much, or you run the risk of staining the paper.

With the other subjects, take special notice of the textures at the point where light and shadow meet. Is the transition sharp or gradual? It will vary according to what sort of light is being directed over it. If you like, do an additional picture, this time composed of large, simply formed fruits, pots, bowls, vases,

or a plaster cast of a head. It will help if the objects are light in color because these make it easier for you to see the tonal values.

These observations also apply to working from a posed draped model, especially when you wish to render textures. Here you concentrate on the basic large planes of the anatomical forms, rendering textures (only at the point where light and shadow meet) of the model's clothing. But first render the anatomical structure, superimposing the drapery of the model's garments over it, then fusing and blending with your finger or tortillon to render more graded tonalities.

1. Pose your model to receive a dramatic, strong light that creates sharp light-and-shadow effects.

2. Because a figure subject is elaborate and complex, place a simple background behind the model so that the cast shadows are easily visible. The shadows will transform the simple space into an additional exciting pictorial element.

3. Make a light sketch of the pose, and then systematically proceed to develop the different tonalities of each form.

4. Study the shapes of the shadows and model them as carefully as the actual forms. The shadows are vital, because they provide pattern elements equal in importance to the solid forms of the actual figure.

5. The traditional method for rendering gray tones and values is to draw a series of *graduated parallel lines* in either a vertical or a horizontal direction with the very sharp point of a hard charcoal stick. This method is best used when doing rather small drawings.

6. When drawing larger pictures, you may blend the different tonal areas either with a finger or with the tortillon. Rub gently, applying additional layers with a softer charcoal, spraying with fixative between layers, until you arrive at the desired tonality.

7. On completion of the drawing, spray it with fixative. This will protect it from rubbing off.

CONTÉ CRAYON

A. Tonal Areas, Superimposed One Over Another

The characteristic look of conté crayon work is fresh and spontaneous. No part of the picture appears reworked.

Conté crayons, in both hard and soft consistencies, come in black, white, sanguine, and brown. They can be used in the same manner as pencils in linear work. In addition, there is a method that is unique to conté, in which different tonal effects are achieved by overlapping several layers of conté crayon applications.

The first layer is applied with the flat side of the stick. Then additional tonal areas are built up by using the sharp edge of the crayon to draw lines for creating darker tonal values, until the forms are built up within the forms that are already there.

By continually drawing with the flat side of the conté stick, pressing harder on the areas that are to recede in the composition and releasing the pressure for the areas that advance, you will achieve a three-dimensional illusion. (The principle to keep in mind is that usually light areas come forward in a composition, and darker areas recede.)

B. Linear and Value Effects Achieved Simultaneously

In this method you both outline your subject and develop modeling at the same time. Placing the flat side of the conté crayon on the paper, press hard on one edge only, then make an outline drawing of the subject. The body of the crayon will tone the inside part of each form, creating the tonal modeling as the crayon is dragged along. Before starting to work on the projects involving these methods, do a series of simple practice exercises in which you experiment with each one.

Project: **OVERLAPPING TONAL AREAS WITH CONTÉ CRAYON**

SUBJECT: Posed model, 20-minute poses

ILLUSTRATION REFERENCE: Munch, *The Lovers*

TOOLS AND MATERIALS:
 18″ × 24″ smooth-surface drawing paper
 Soft conté crayon stick, black
 Hard lead pencil—2H

To develop overlapping with values in a modeled drawing, lay one tonal value over another. The first layer is done with a flat, even application of a light-gray tone of your conté crayon.

1. Have the model take a 20-minute pose (a simple frontal pose is best), and make a quick, light outline sketch.

2. Using the sharp edge of the crayon, lightly go over the pencil lines so that they are barely visible. Fill the page with the entire figure.

3. Now go back and firmly put in the first part of all-over gray tone inside the shape you

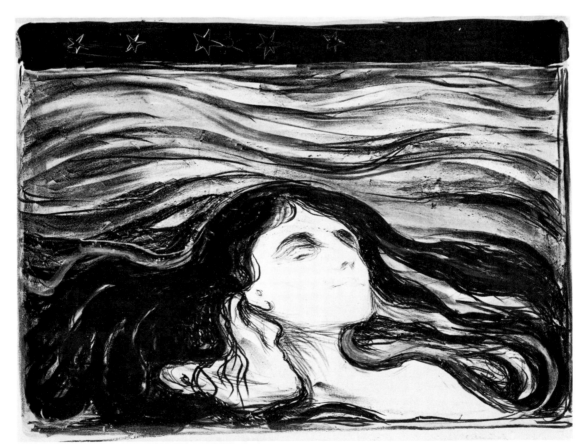

Edvard Munch, *The Lovers*. Color lithograph.
(The Solomon R. Guggenheim Museum, New York)

Overlapping tonal areas are done by building up even-toned, light-gray layers. The first layer is applied by stroking the paper with the flat edge of the lithograph pencil. The process is repeated pressing harder on the litho to make darker accents until the forms are built up to the desired value.

have just made, so that it looks like a gray silhouette.

4. Now superimpose darker layers, so that the forms are built up within the form already there. Use the side of the crayon, pressing fairly hard on it.

5. Again using the flat side of the conté crayon, lay it down on your paper, redraw the figure, and model the forms to develop the three-dimensional quality.

6. Continue to draw with the flat side of the conté stick. Pass it back and forth over the surface, pressing harder on the forms that are to advance. Variations in the perspective will depend on the sizes and shapes of the different anotomical forms. Your own judgment on which form is to be accented will come into play here.

Project: LINEAR AND TONAL EFFECTS ACHIEVED SIMULTANEOUSLY

SUBJECT: Figures in action; the modeled form with line and tonal values rendered simultaneously

ILLUSTRATION REFERENCE: L. Salemme, *Shaded Nude*

TOOLS AND MATERIALS:
Conté crayon, 2 sticks each of black, sanguine, brown, and white, hard and soft
Small sketch pad of any smooth paper 15″ × 19″
Pad of smooth bond paper, 18″ × 24″

This is the fast way to develop modeling. In this method you use half a conté crayon, place the flat part of the paper, and both draw and shade with one stroke. This technique is ideal when doing fast work in which a quick capturing of the gesture and tonal values are your main concern. Because you rarely have to go back to do any shading, this simultaneous rendering of both line and tone is a skill you should master. It is especially helpful when the model is taking extremely short poses of 2 to 5 minutes' duration.

1. Study the pose briefly but carefully, and plan what spacing the figure is to have on your paper.

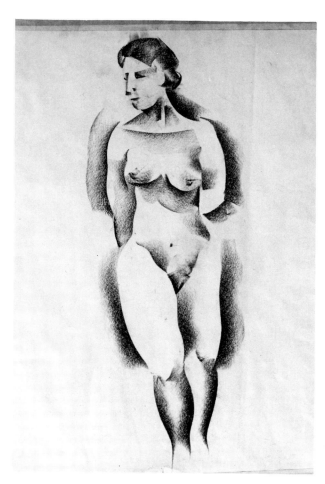

Lucia Salemme, *Shaded Nude*. Soft conté crayon on smooth paper.
Linear and tonal effects can be done simultaneously by placing the flat side of the conté stick to the paper and pressing down on one end to do the drawing so that the flat side of the stick strokes the paper, automatically shading the forms as you concentrate on drawing edges and outlines. The amount of pressure you exert when you place the conté stick to your paper is what determines tonal variations. Soft conté crayon is the best type for producing line and shade with the same stroke.

2. Using the flat side of the crayon, lay it on your paper and press hard on one edge only, drawing as if you were doing a contour or outline drawing. Concentrate on the outside edge of the crayon. The body of the conté crayon will tone the inside part of each form, creating the tonal modeling as it is dragged along.

3. Do not go over an area once it is done, because that could lose the fresh, spontaneous look that is characteristic of the conté crayon technique.

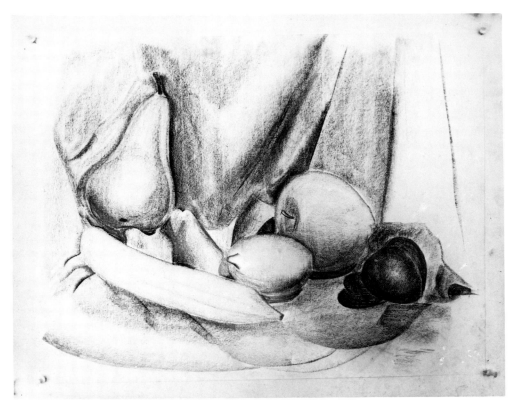

James Misho, *Fresh Fruit*. Hand conté crayon.
A variety of pressures on the paper with conté stick creates shading with depth.

Project: CALLIGRAPHY

SUBJECT: Linear brushwork

ILLUSTRATION REFERENCE: V. Salemme,
 Landscape

TOOLS AND MATERIALS:
 30″ × 40″ sheet of untextured rice paper, cut to
 smaller sizes
 15″ × 19″ smooth-surface bond paper
 Bristle hair brushes
 Japan brush #6—bamboo handle
 Blotters
 India ink
 Sumi (carbon ink stick)
 Shallow ceramic block for mixing
 Ceramic palette or saucer
 Jar of clean water

Calligraphy literally means beautiful penmanship. In the pictorial arts, however, the beauty is obtained by the brush stroke.

Because you cannot erase mistakes, a certain amount of self-assurance is required when using this technique. Most brush-and-ink drawings are done quickly. It is a spontaneous medium in which precision and elaborate detail are not required. If you use a variety of brushes and papers, the results can be exciting. Calligraphy differs from other linear work in that both full and thin lines can be achieved simultaneously with a single brush stroke. Oriental artists invented this technique, and their drawings made with bamboo brushes led to the spontaneous, free method of watercolor painting that is commonly used today.

Chinese painters have for centuries used the same basic tools—inks and brushes. The ink tablets or sticks are made in a variety of colors, but black is the most popular. Black is made by pressing pine soot and graphite with gum arabic into blocks. The ink is then diluted with water as it is needed. It is known as sumi, which is placed in a shallow ceramic block and ground with water, thus producing different tones of dense blacks.

These blacks can be controlled by mixing different quantities of water with the inks. Pictures are painted on absorbent rice paper with a very flexible bamboo brush.

Handling the Brush:

There are many ways of handling the brush: with the tip alone, on its side, and by combining very thin watery ink in the full part of the brush with heavy black ink on its tip, which makes varied brush strokes. Many diverse effects are possible when painting on a variety of paper surfaces. For instance, to make economical washes, you can use ordinary India ink and a saucer of water. Because there is no substitute for good paper, always use the best.

Practice using different brushes and papers. Strive to achieve both hairline thin lines and bold, strong masses of dark and light areas with all the brushes.

Different brushes produce different effects:

a. Bristle brushes produce sharp, angular strokes.

b. Lettering brushes produce lines of different widths.

c. Long, very pointed Japanese brushes produce flexible brush strokes of all sizes.

Try as many of these techniques and brushes as you can:

1. Practice making heavy lines by pressing down on the bristles.

2. Thin lines are made by releasing the pressure.

3. Graduated lines are made by alternating degrees of pressure.

4. Stiff-bristle brushes produce lines that are harsh and angular, often with dry, fuzzy edges.

5. Flat-tipped lettering brushes produce lines with pronounced different widths.

6. Long, very pointed Japanese brushes with bamboo handles can produce either wide or very fine lines, depending on how much pressure is placed on the brush by the hand.

7. If you use brushes without much ink or with washes (by running a loaded brush

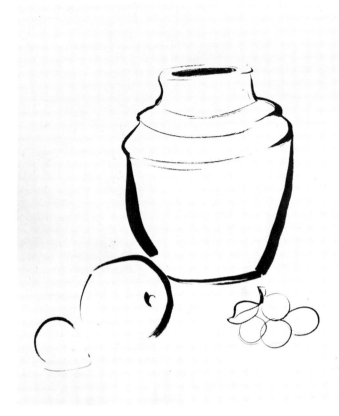

Calligraphy calls for linear work; therefore, select the proper brushes to work with. This brush and ink drawing of a vase is done with thick and thin brush strokes to make flowing and rhythmic lines.

across a blotter), you can achieve unusual dry-brush textural effects. For the dry-brush technique, the use of a blotter is a must. After dipping your brush in the ink, gently run it across the blotter, eliminating excess ink, and then rub the side of the brush across the area to be covered. Try to keep the texture of the paper exposed.

8. When finished, be sure to wash brushes thoroughly with soap and water, because India ink will greatly damage them.

Different papers also determine what quality of line you produce. Soft paper, such as rice paper, absorbs the ink immediately, giving you soft-edged brush strokes. Hard-surfaced paper, like bristol board, gives you

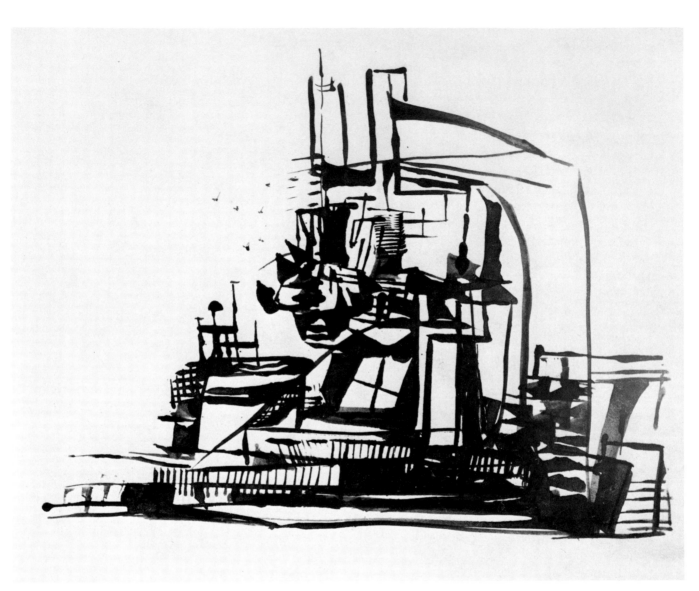

Line drawing of a cluster of buildings is done with brushes and black India ink.

Vincent Salemme, *Landscape*.
Dry-brush work in a landscape drawing. The effect is created by running the brush (that has first been dipped in India ink) across a blotter, before touching the drawing paper.

smooth, continuous, clean-edged lines. Rough-textured paper is fine for the dry-brush technique.

Project: DRY BRUSH

SUBJECT: Landscape in summer

TOOLS AND MATERIALS:
 30″ × 40″ sheet of untextured rice paper—cut down to small and large sizes as needed
 18″ × 24″ smooth-surface bond paper
 16″ × 20″ thin bristol board
 16″ × 20″ rough-surface drawing paper
 Lettering brushes, 3 assorted sizes—small, medium, and large
 Ox-hair brushes, 3 assorted sizes
 Japanese brushes—3 assorted sizes
 Blotters
 India ink
 Sumi (carbon ink stick)
 Shallow ceramic block for mixing
 Ceramic palette or saucer
 Jar of water

For this project plan to do a very large picture, 18″ × 24″ or even larger, where you can utilize all the linear work you have practiced on.

1. Do several preliminary drawings of a landscape, with clouds, distant mountains, rock formations, fields of grain, trees, houses, and a figure or two. Select the one you like best and redraw it onto your good paper.

2. Calligraphy calls for linear work, so you should select the proper brush for rendering each feature in your landscape.

a. Use the long, painted Japanese brush to produce wide or thin lines in rock formations.

b. Use the same brush without much ink for dry-brush textural effects on houses or rock formations.

c. Use a middle-size ox-hair brush to paint in any flat or graded washes in sky area, clouds, bodies of water, and fields.

d. Use the lettering brushes of assorted sizes for rendering trees and leaves. Proceed to use all the tools in this one drawing to test how many different textures and lines you can suitably put in your picture of a summer landscape.

WASH DRAWING

Project: WASH DRAWING

SUBJECT: Flat washes and graded washes

ILLUSTRATION REFERENCE: Davidson, *Florida Sunset*

TOOLS AND MATERIALS:
 12″ × 18″ all-purpose drawing paper
 Masking tape
 Thumbtacks
 India ink
 Sepia ink
 Sponge
 Blotters
 Japanese brush #6
 Single-edge razor blade
 White tempera paint
 Saucer (flat) for mixing
 Jar of clean water

A wash drawing is a combination of a drawing and a watercolor painting. It is usually done in a monotone of either sepia or black ink made light by dilution with water. This technique has been a favorite with artists, who often use it for making preliminary drawings for future oil paintings or murals.

You can use absorbent rice paper, watercolor paper, or illustration board as well

A **wash** is usually done by diluting the inks with water so as to paint monotones on paper with flat-textured surfaces.

Mingled washes are produced by first wetting the paper and then loading the brush with ink and carefully letting the ink mingle on the moisturized surface of the paper.

as ordinary drawing paper. There are two ways of doing a wash drawing. The best is the free, spontaneous handling. In the more systematic method the composition is carefully sketched in with firm outlines of pencil or pen and ink before the washes are added. In either method the pure white of the paper is left untouched to create light areas.

The flat wash, unlike the free and spontaneous handling traditionally associated with watercolor painting, requires a rather careful application of the tinted, watery tone. The first step is to outline firmly the area to be covered. Put a little water in your palette (or a small saucer), and add enough ink or paint to make a light gray. Load your brush with it and spread it across the area, going from left to right. Then quickly reload your brush, and gently place the tip directly under your first stroke, so that the tip mingles with your first stroke. Repeat this procedure until the area is covered. If you wish to give a second coat to your wash, wait until the first is completely dry. If it is not dry it will produce an unpleasant mottled effect.

Project: FLAT WASH DRAWING

SUBJECT: Landscape

ILLUSTRATION REFERENCE: Guencino, *A Man Sitting at a Table Reading*

TOOLS AND MATERIALS:
　　16″ × 20″ smooth watercolor paper
　　Ink
　　Water
　　Cup
　　#7 watercolor pointed brush

1. Make a careful pencil sketch of a landscape. Include all the details. Render the tonal values by applying flat washes to all enclosed shapes.

2. Put some water in your saucer, and add enough ink to make a light gray.

3. Spread it over all the areas except those you plan to leave white.

4. When the wash has dried, add a second, darker wash, and continue painting until you have worked down to your darkest area.

5. Never try to lay a wash over a wet area, because this produces an unpleasant, spotty effect.

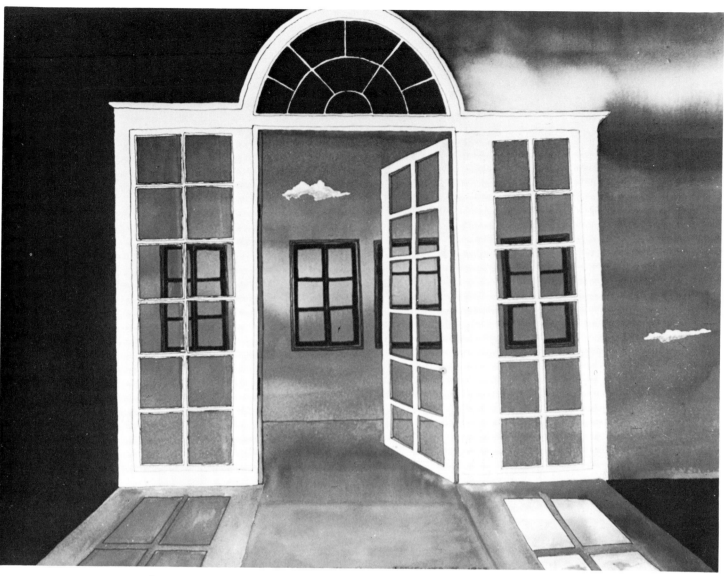

Sandra Calder Davidson, *Florida Sunset*. Wash and ink.
(Private Collection.)

Colored washes in combination with pen and ink. The linear work delineates the
subject and the wash is used to create a poetic mood.

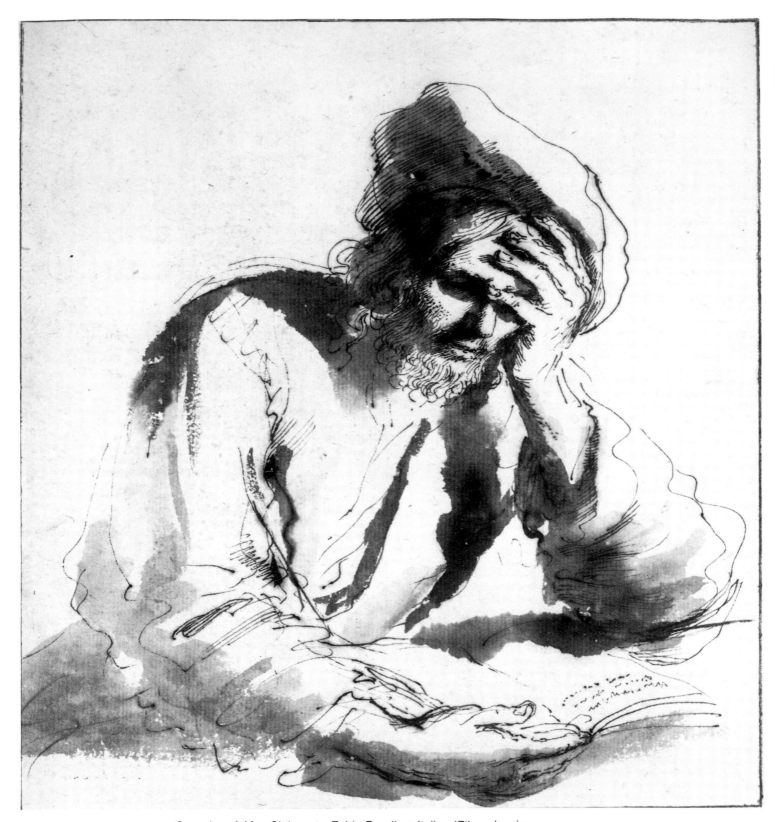

Guencino, *A Man Sitting at a Table Reading.* Italian 17th c. drawing.
(Fogg Art Museum, Cambridge, Mass.)

Wash drawings are a favorite with artists, who often use this technique in studies for future oil paintings or murals. The subject is usually sketched in with outlines of pencil or pen-and-ink before the washes are added. The pure white of the paper is left untouched to create light areas.

Washes Alone:

When you desire more spontaneous and loose effects in your work, both flat and graded washes may be used for value rendering. However, you must remember that to achieve the apparently simple, free, brushed-in wash typical of this technique, there can be no retouching! Many artists also use this technique in combination with pen and ink.

Project: THE GRADED WASH DRAWING

SUBJECT: Draped figure

ILLUSTRATION REFERENCE: L. Salemme, *Maine Landscape*

TOOLS AND MATERIALS:
 16″ × 20″ semirough watercolor papers
 Blotters
 Single-edge razor blade
 Sponge
 India ink
 Sepia ink
 White tempera paint
 Japanese brushes #4 and #8
 Cup or saucer for mixing
 Jar of water

Graded washes are suitable for rendering subjects such as landscapes, still lifes, and drawings from life.

1. The first step is to make a loose drawing of the subject in either pen and ink or pencil.
2. Plan the value pattern, and leave the white of the paper for your light areas.
3. Mix half a cupful of medium gray by mixing black ink into the water.
4. Proceed to paint, adding more water to your medium gray when you want a lighter tone and more black ink or paint when you want darker tones.
5. Permit the brush strokes to show. Do not try to blend them together. Save blending for doing flat washes.
6. Allow surfaces to dry completely before adding more washes or black ink for the final accenting.
7. If you lose your light areas, they can be recovered by either using white tempera paint, wetting the area, and then blotting it up or waiting for the picture to dry thoroughly (overnight is best) and then scratching out lights with a razor blade.

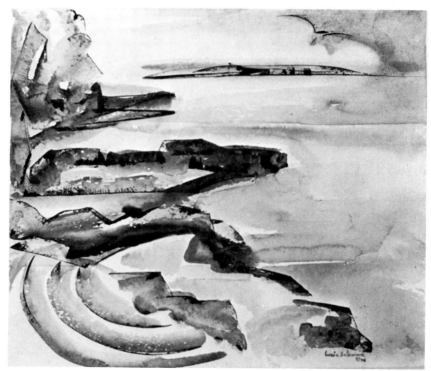

Lucia Salemme, *Maine Landscape*. Study for large oil. The graded wash drawing is a method of brushing in tints when free and spontaneous effects are needed. The equipment is brush, ink or watercolor, sponge, blotter, and clear water. Use dry paper for more controlled effects.

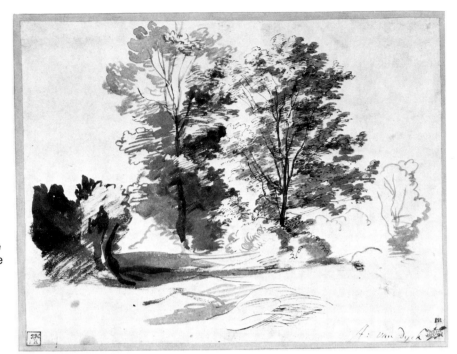

Sir Anthony van Dyck, *Edge of the Wood*. Sepia ink drawing. (National Gallery of Art, Washington, D.C., Syma Busiel Fund.)

The pen is used to sketch in the trees, and the other areas of the landscape are spontaneously painted with a variety of tonal washes.

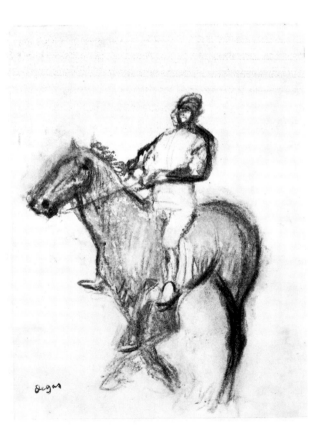

Edgar Degas, *Le Jockey*. (National Gallery of Art, Washington, D.C., Gift of Mrs. Jane C. Carey as an addition to the Addie Burr Clark Memorial Collection.)

While the drawing of the figure and horse are spontaneously rendered in charcoal the large massive area of the horse is carefully painted with a soft dark wash. This helps to intensify the feeling of solidity in the body of the prancing horse.

GRADED AND MINGLED WASHES

The graded wash is a method of painting in tints when free and spontaneous effects are needed.

The paper should be absorbent, with a slightly rough texture. Using your sponge, first wet the paper, then place the paper flat on the table until the water has been absorbed. Fasten the edges down with tape. Allow the paper to dry until the buckling is gone. The tape holds the paper flat, keeps it from swelling, and prevents your washes from drying irregularly.

The intermediate values of grays are achieved by diluting the ink or paint with water. An unusual variety of lines, values, and textures can be achieved with washes. Since a wash drawing is really a painted drawing, it can be useful as the transitional step toward a painting.

DRY BRUSH

With a rough-textured paper a dry-brush effect is easily achieved and must be used when this effect is required. In doing dry-brush work many artists prefer to use tempera, oil paint, or even printer's ink because of the thickness of each medium. One can alternate, of course, by using thicker media when rendering textures in dry-brush areas and the thin inks when doing more linear renderings. (See color section, page 28.)

There are many variations of the drawing techniques described in this book, and you can use them all or in combination, depending on the subject that you are rendering and your ingenuity. New methods and approaches are bound to materialize after you complete many experiments of your own. Think of the possibilities—there really is no limit to what you can do. Any drawing method adaptable to paper work is acceptable. The Old Masters often combined an initial drawing of charcoal or chalk with a colored wash. Later, to intensify darks, they used ink and then added white tempera for highlights. For the final touches, colored chalks were used.

For your own pictorial subject in using combined techniques, look through some of your old landscape drawings and see if there is one you would like to elaborate on with another medium. Keep in the same family. For example, use colored pastel chalks, charcoal, and conté crayon together. Ink washes, pastel, and tempera go with a pencil drawing. You can vary this by using unorthodox methods of applying washes, inks, and tempera. Use a sponge, heavily textured rags, combs, or anything else you can think of. Your own imagination is now your chief guide.

Part Five

PASTELS

Artists have always loved pastels. With this medium a finished picture retains all the fresh color it had when it was first rendered. Basically, pastel is pigment in the raw. To make the pigment workable the manufacturer mixes it with a gum tragananth and water until the mixture reaches a doughy consistency. White chalk is then added to make the light tints, and black pigment is added to make the darker shades. These mixtures are then kneaded into sticks and cut to the desired working sizes. When dry, they provide a large variety of colors. Pastel sticks are combined with talcum or chalk (both pure ingredients) so that they can be more easily extended while the rubbing and friction of drawing are taking place.

The traditional method of pastel painting, from which all other methods stem, is superimposing one layer of pastel over another, working mostly from the light colors toward the darker ones, building as you go along textures that have a velvety smoothness.

Pastel lends itself to reworking areas to produce slight variations of a line or an edge. You can tone down a bright area that is not effective simply by "breathing" a film of another color over it. By the slight touch of a finger you can immediately soften a hard line. This is possible with pastels but not with any other medium.

The chief advantage of working with pastels is that they require no drying time, because they contain no oil binders. The finished picture will not yellow or crack, as often happens with paintings done with oils and watercolors that have to be combined with varnishes and binders, additives that eventually may change their color qualities. An added advantage is knowing that no setting-up time is required before you begin to work with pastels, because you do not have to prepare a palette of paint. The colors are ready and waiting for you in all their dazzling glory.

One of the chief characteristics of a pastel painting is its dry and surface texture, in which all the nuances and subtle tonalities are lasting. The distinctive color quality is due to this dryness.

Opaque tonal effects are permanently retained after the finished picture has been sprayed with fixative, matted, framed, and mounted under glass.

EQUIPMENT

The Easel

Since working with pastels involves much spreading of chalk dust, it is advisable to work in a room where you need not be concerned about keeping the area clean. A long, knee-length smock or apron is also a "must." It is best to work in a standing position, at an easel whenever possible, so that you do not smudge or rub the picture with your hands or sleeves. In pastel painting your paper is firmly clipped onto a drawing board that is placed onto the adjustable bar of an easel. It is advisable to have a firm-based, sturdy easel, because pressing down on the pastel is an important part of the technique. The easel itself must not shift or skid while you are at work. The type of easel with a sliding ratchet bar that holds the top of the drawing board firmly in place is the best.

The Drawing Board

The drawing board or support board is your most important piece of equipment, because it will not only be supporting your good, expensive papers but must be firm enough to withstand the constant pressure of your hand and arm as you work. The wooden drawing boards available in art stores are normally acceptable. If you are also planning to paint large pictures, get the lighter-weight wallboards and hardboards available in lumberyards. When buying support boards, make sure they are not too thick for your clips and will easily fit into your easel.

The surface of the board should be smooth, to afford an even base for your papers. Buy a board at least 1 inch larger all around than your paper, because a 1-inch border makes it easier to clip the paper to the board. This extra space is also needed to protect the paper from damage when you anchor the board to the easel. You should have a board for each different size of paper you plan to use.

The Work Table or Taborette

All your materials should be placed on a work table, or taborette. Make it big enough to hold all your pastels, along with additional materials you may need while painting. Stripping that is tacked along the edges of the table will prevent the pastels from rolling off and breaking.

In setting up the table, place all your soft pastels in the center of the table, leaving them in the grooves of the boxes they come in (pastel boxes usually feature removable grooved trays that separate the sticks from one another). Most pastels are packed according to color, with all the greens together, all the reds, and so on. Try to keep them in this order, returning each stick to its proper groove after each use. If you do not, you will have a confusing disarray of chalks. All your other tools—pencils, erasers, single-edged razor blades, charcoal, fixative, mahl stick—should surround the pastels, in a convenient array.

Paper

The best papers for pastel work are those that have a 100% rag content, because they are the most durable. They come in a variety of surfaces and tones which are pleasant to the touch while being worked on.

Surfaces. Papers come in smooth, medium-smooth, medium, and rough surfaces. When we speak of the tooth of the paper, we mean the texture of the surface.

Smooth papers have less tooth than the rough ones. You can build color layers more rapidly on smooth paper, because the pastels lie closer to the surface of the paper.

Additional applications are more difficult, however, because the pastel stick tends to slip over the evenly built-up surface. Smooth paper is best suited to rendering subjects that have sharp and linear characteristics, such as finely detailed architectural subjects or room interiors.

Rough papers have a wider tooth than the smooth papers, which shaves off more of the pastel granules as you work. Because the granules build up more slowly on a rough surface, it is possible to work many pastel layers over an area. Pastels adhere more firmly to papers with a rough tooth, giving you the soft, grainy, scintillating quality that is the unique "pastel look" distinguishing it from all other techniques.

Some pastel and charcoal papers come in pads. Their surfaces will not "pick" or "lift" under repeated blending with stumps or layers of color. Sanded papers and boards for pastel painting come in smooth and rough surfaces. They provide the proper tooth for the transfer of pigment from stick to paper. The mounted papers come mounted on backing board. Velour-surface pastel paper has a uniform velvety surface that provides an excellent tooth for portrait painting. It comes in medium and heavier weights, unmounted and mounted.

Tones. The most popular toned papers are made by M. Grumbacher Inc., and Canson Mi-Teintes by Morilla Paper Co. It is easier to match values and colors in a pastel picture rendered on toned paper, because the lighter pastel colors are difficult to see unless they are surrounded by dark colors. If you use a toned or colored paper, you need not color in a background to create a progression from darks to lights.

Most papers come in three basic tones—light, middle, and dark—of all the colors. Select the tone that suits your subject. For example, use a light-toned paper when the subject is dark. Light-toned papers allow you to use a wide selection of darker colors with which to render the dark areas of the subject. The light-toned grays, pale green, and blue-grays are fine in painting a dark subject.

The middle-toned papers are the most practical of all the colored papers. They suit all subjects, allowing you to proceed from the lightest to the darkest limits of the pastel color range. They come in medium gray, warm gray, cool gray, and ochre.

Dark-toned papers are used when you wish to render dramatic, contrasting effects or to call particular attention to a special area in your composition. You may use a large assortment of the dark-toned pastel colors here, because they always seem to be much lighter when used on dark paper. The dark papers come in brown, green, blue, and maroon.

Pastels

Pastel is raw pigment that has been mixed with a binder. When a stronger binding solution has been added, hard pastel sticks are formed. Hard pastels are used when very little blending is to be done. Eberhard Faber makes a set of 12 sticks of hard pastels called Nupastel. Soft pastels have just enough binder mixed with the pigment to prevent the stick from crumbling when applied to paper and to keep the color from being rubbed away.

Brands vary from one manufacturer to another, usually in their degree of softness, according to the binding formula used. M. Grumbacher Inc. and Rembrandt make the hardest pastels, whereas those of Lefranc-Giroult are softer. You can experiment on your own with each brand. Test them by exerting pressure on each to discover the particular degree of hardness and softness you prefer.

Your basic pastels should be soft. If you are going to work seriously in this technique, you should buy the largest set available, which contains some 300 sticks. As a beginner, however, you may want a much smaller set that you can add to when you wish. You can start with a set of 50 sticks, buying refills of the colors you use most frequently. When you buy an additional set of pastels, get one made by another manufacturer, because it may have colors that your first set lacks. If you keep each

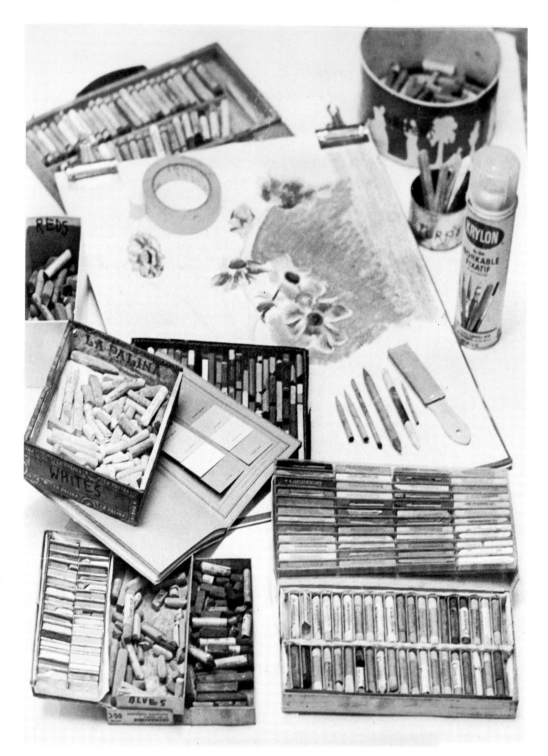

Some of the **Tools and Materials** needed to carry out a pastel painting project are shown in this picture. Artists love pastels because colors always remain fresh, for the pigment is in its purest state. The chief characteristic of pastel painting is its dry surface texture in which all the nuances and subtle tonalities are permanent.

set orderly and don't mix up the brands as you work, you will know what to reorder as you run out of colors. Try to keep to a system. Work from the lightest to the darkest, from the richest to the brightest colors, and from the very softest sticks to the hardest.

Additional Materials

Soft charcoal is used in the preliminary drawing, because it does not leave a thick residue and can easily be erased. It can also be used with the pastels to darken the other colors.

Pastel fixative is a thinly diluted varnish that is sprayed or blown onto the pastel surface. It has many uses, mainly to secure the chalk particles to the paper surface before the painting is reworked in other colors. While the fixative spray is still wet on the paper, dip the pastel stick into it, and you will find that the pastel spreads more thickly and plastically. When the picture is finished, spray it again with fixative, let dry for an hour or so, and then it is ready for framing.

The proper spraying procedure is to leave the paper in place on the board, stand about 3 feet away, and aim the spray to the edge of the picture, gradually moving it onto the picture area. To control the spread of the spray, move the spray in a circular motion while maintaining a steady pressure, so that no part of the painting receives too much fixative. When you notice an area darkening, it is time to stop. If too much fixative is sprayed onto the picture it will stain the paper.

The mouth atomizer is used with bottled fixative when spraying details on very small areas. To prevent the atomizer from clogging, pass a piece of picture wire through its hole immediately after using it. Both bottles and cans of spray fixative are available in all art stores. Grumbacher Tuffilm Spray Fixative and Weber Pastel Fixative are both good.

For erasing, a single-edge razor blade and a kneaded eraser are needed. A good method of removing a mistake is to scrape the edge of the razor blade once or twice across the surface to be erased. Then use the clean eraser to remove the pigment, working only on the scraped area, because any unscraped area will smear. After erasing, spray some fixative on lightly, then rework.

Both spring and clamp clips are needed to attach your pastel papers to the support board. Pushpins or thumbtacks can also be used to attach paper to softer boards such as Celotex or Homosote.

Masking tape is useful when transporting unframed pastel paintings with cardboard sandwiched between them, taping only the boards. It is also good for marking floor positions of models or still-life objects.

Stumps (or tortillons) are tools made of soft, gray paper felt-rolled into narrow tubes. They are used to fuse or blend tones. They are easily kept pointed with a sandpaper block. The larger ones are double-ended. Keep such blending down to a minimum, because you really get a much fresher quality with careful modeling.

A mahl stick provides a steady brace for your painting hand, to keep you from touching the painting surface. It is a stick of wood or metal with a soft tip at one end that is leaned either on the painting or on the easel near the painting. The other end is held in your free hand.

A good light is important. Whatever lighting you use, whether artificial or natural, it is important that the light come over your left shoulder if you are right-handed, (or over your right shoulder if you are left-handed). In this way your painting hand will not cast shadows onto your picture. Natural north light from either a skylight or a high window is most desirable for lighting up your subject, because it remains constant throughout the day. This single light from one source makes it easier to see the light, middle, and dark tones and the shadows on your subject. Additional light sources only tend to complicate things. A single light source also clearly illuminates the forms, clarifying their natural, three-dimensional qualities. If you must turn to

artificial light, use a single light source, angled from above rather than from the side. Use a strong bulb, about 200 watts, or a spotlight set up high. Arrange the room so that both you and the subject are receiving light from the same source. Artificial light that tends to cast sharp, harsh shadows is ideal for drawing or quick gesture studies.

Project: BLENDING WITH SOFT PASTELS

SUBJECT: Dancing figures

ILLUSTRATION REFERENCE: Degas, *Dancers in Green and Yellow*

TOOLS AND MATERIALS:
 Set of soft pastels
 Medium-rough pastel paper, light tone (pale gray), 18″ × 24″
 Tortillons
 Spray fixative
 Drawing board
 Clips

When working with soft pastels you are using the chalks in the classic manner, which is the basis of all the other pastel methods. The technique is one of superimposing one layer of pure-colored powdered pigment over another, with much blending of each layer as it is applied. The lighter colors are laid on first, working toward the darker ones, building up textures as you go along that have a velvety, peach-skin smoothness. The chief characteristic of soft pastel is its dry, opaque, tonal effect, which is permanently retained after you spray the finished picture with fixative.

Try this exercise:

1. Secure the pastel paper firmly onto the board, with clips or pins.

2. Sketch in your subject, a group of about five figures dancing on a ballroom floor. Draw with charcoal or a neutral-colored pastel stick. Place the figures in the composition so that they are in a series of graceful positions, being careful to treat the negative space around them with interest.

3. Decide on a definite source of light, and plan the distribution of light and shadow areas.

4. Apply a coat of white to each of the flesh-tone areas.

5. Apply the next layer of colors, working from the lighter colors toward the darker ones, using stumps to blend each layer of color smoothly into the one beneath it. Once an area has been blended to the desired tone, it should be immediately sprayed with fixative before a new layer is put over it.

6. Apply all remaining colors needed over other parts of the picture, keeping control of your values at all times so that they remain clear and light. Use stumps to blend each new color layer, before you work another color over it.

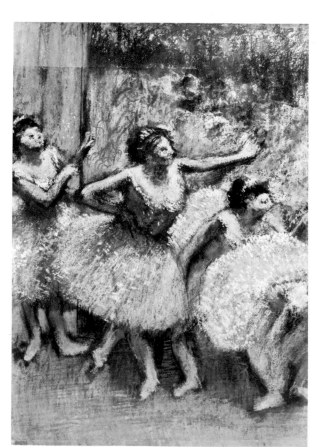

Edgar Dégas, *Dancers in Green and Yellow*
Pastel on paper.
The Justin K. Thannhauser Collection, The Solomon R. Guggenheim Foundation, New York.)

Blending with soft pastels involves working layers of colors one over the other, with much blending of each layer in between each application.

7. Apply the colors in the background area as the last step, using them to delineate your images and to accent key pictorial ideas.

8. Spray the finished picture with fixative.

Project: BUILDING UP LAYERS OF COLOR WITH HARD PASTELS

SUBJECT: Posed model in a darkened room

ILLUSTRATION REFERENCE: Munch, *Sketch of Model Posing*

TOOLS AND MATERIALS:
Canson Mi-Teintes light-toned (pale green) paper
Set of hard pastels
Kneaded eraser
Spray fixative
Drawing board
Clips or pins

Because you will be stressing dark values, use most of the dark-colored sticks in your set. Most pastel colors are darker than the light tone of your paper, allowing for a wider selection of all the dark colors. (Nupastel color sticks are stronger than the average pastels, making them easier to use in modeling tonal areas.)

1. Fasten the paper firmly onto the drawing board.

2. Lightly sketch in your subject, carefully rendering all the features in the composition, including the draped folds of the model's garments and details of the hat. Draw with a sharp-edged drawing pencil or the corner of a yellow ochre pastel stick.

3. With the flat side of the pastel sticks, lay in all the larger color areas in bold strokes.

4. Put in the highlights, the middle tones, and the darker shadow areas, using sharp, visible marks of the pastel sticks. Work from lighter to darker colors.

5. Add all the necessary background colors, again working from the lighter colors toward the darker. If you like, you can blend these with your fingers, to fuse the background.

6. As a final step, use the edge or the corner of the pastel sticks to add any sharp accents or details. Clean any smudged areas with the kneaded eraser.

7. Spray the finished picture with fixative.

Project: THE SIDE STROKE—Hard and Soft Pastels Together

SUBJECT: Portrait in vignette

ILLUSTRATION REFERENCE: Renoir, *Portrait of Cezanne* (color section, page 35)

TOOLS AND MATERIALS:
Rough-surface pastel paper, tan, 18″ × 24″
Set of hard pastels
Set of soft pastels
Kneaded eraser
Clips or pins
Drawing board
Spray fixative

The side stroke is ideal when you wish to do a fast pastel portrait study in vignette with the head not enclosed by a definite border or a background.

A tan paper is best. Because this paper will remain untouched, the tan color will combine softly with the delicate flesh tones of the subject.

1. Pose your model in a soft light.

2. Make a careful sketch of the model with the Van Dyck brown stick.

3. Apply an even coat of white pastel to the facial area.

4. Use the light-colored soft pastels for creating a couch of basic color for the different compositional areas. Starting at the top and working down to avoid smudging, apply in sequence over the white ground, first yellow, then beige, and then a reddish brown. Use a minimal amount of each color. Holding the sticks on their sides, make repeated strokes, pressing hard on the sticks to produce an even stroke without much graininess. In applying the different colors, keep control of your values at all times so that they remain clear and light in tonality.

5. To establish the final highlights, textural effects, and dark values, make sharp, crisp rectangular strokes with the hard pastels, by

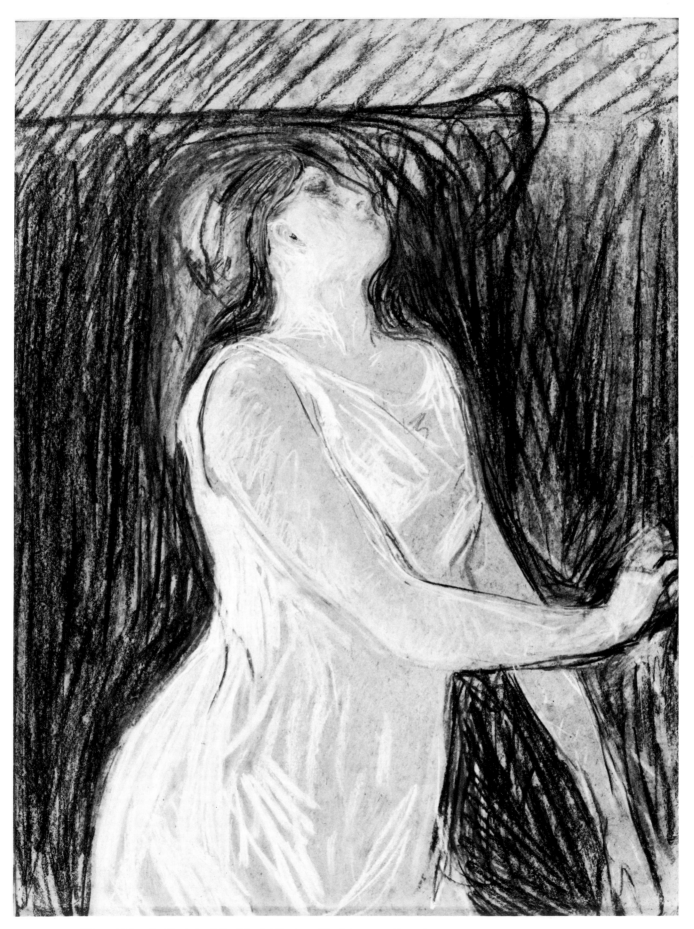

Edvard Munch, *Sketch of the Model Posing*. Pastel on cardboard.
(The Solomon R. Guggenheim Museum, N.Y.)

Blending done with Hard Pastels. The side-stroke is applied with soft pastel and is
ideal when rendering quick effects of either action poses or portrait vignettes.

holding each stick on its side and exerting a medium pressure. These strokes will delineate the features and accents of your vignette portrait.

6. Spray the finished picture before matting and framing it under glass.

Project: **LINEAR STROKES**

SUBJECT: Model with many textured garments

ILLUSTRATION REFERENCE: Toulouse-Lautrec, *Au Salon* (color section, page 32)

TOOLS AND MATERIALS:
 Smooth, close-tooth paper, pale green,
 21″ × 29″
 Soft and hard pastels
 Stumps or tortillons
 Drawing board
 Clips
 Spray fixative
 Kneaded eraser

For a painting in which you wish to render sharp edges and linear strokes, you need to use both soft and hard pastels. Use the sharp edges of the top or bottom of a new soft pastel stick to produce an impasto for the linear work that is to follow. Soft pastels will create a bed onto which you can superimpose the linear work needed to render the fine, sketchy textures that are the characteristic look of this technique.

Hard pastel sticks can be sharpened to a good point with a sharp knife or single-edge razor blade. They produce the finest lines on the smooth-surfaced papers. Sharp edges of a pastel stick can be made with medium or hard pressure to the paper. This method of using your chalks is ideal when you wish to achieve a spontaneous, "unfinished" effect while still making a complete pictorial statement.

You can accent facial details by building up the tonal layers many times with as many applications of colors as you like, using soft pastels which leave the paper smooth and untextured. Do all the linear work with hard pastels to render the different textures of your model's clothing. Be sure to spray the color layers periodically before you do the linear stroking.

Project: **CROSSHATCHING**

SUBJECT: Figure of a child at play

ILLUSTRATION REFERENCE: Cassatt, *Lydia Leaning on Her Arms* (color section, page 33)

TOOLS AND MATERIALS:
 Smooth paper, pale rose color, 21″ × 29″
 Pastel pencils, assorted colors
 Hard pastels
 Drawing board
 Clips
 Spray fixative

Painting under stress to complete a picture quickly is a problem that can be solved by working in the crosshatching technique. Work with hard layers over soft. The soft layer not only gives body to your picture surface but makes it possible to do the crosshatching quickly. After you have posed your model, use a sharpened hard pastel pencil that is slightly darker in color than the toned paper. Sketch with a light touch and roughly indicate the facial proportions and the other compositional areas. Next, switch to a slightly darker pastel and refine your drawing. You can repeat this procedure many times, always with a darker and sharper color, until you are ready to do the modeling with the crosshatching technique.

Subjects that come to mind for using crosshatching with success are compositions dealing with any subject in action: animals, birds, figures engaged in a sports activity, and portraits of children.

When doing a portrait of a child, you must expect many changes in the pose. As quickly as possible you must record in a drawing what you wish to capture of the pose. Pastel is an ideal medium for such speedy work, because it affords a vast choice of colors, textures, and thicknesses of line. Once you have made a good beginning on the drawing of the child, you can finish it off at your leisure, when you can fully concentrate on the technical aspects of the work involved. Pastel work combines elements of both drawing and painting, and as such, it is an ideal medium for work in which rapid rendering is a must.

In the crosshatching technique you create different tonalities through the use of overlapping horizontal and vertical lines. By increasing or decreasing the number of strokes and by controlling the width of the spacing between them, you can build up and develop tonal masses. The natural tool for this technique is a hard pastel sharpened to a blunt point or a set of pastel pencils.

The quality of the lines and strokes produced by various types of pastels depends largely on the amount of pressure exerted, on the angle at which they are held in your hand, and on the surface of the paper. Heavy pressure produces the crisp strokes you use in accenting details and for the highlight areas. Medium pressure results in sharp edges. Light pressure produces the grainy textures that most clearly show the character of the paper you are working on.

It is often advisable to break a stick when you want to produce an extra-sharp edge to your lines.

Project: BLENDING SOFT AND HARD PASTELS

SUBJECT: Landscape

ILLUSTRATION REFERENCE: Degas, *Avant L'Entree en Scene* (color section, page 36)

TOOLS AND MATERIALS:
Fiberboard, 15″× 20″
Set of soft pastels
Drawing board
Clips
Marble dust
Spray fixative
Bottled fixative
Stumps or tortillons

1. In doing a landscape subject with pastels, select a scene that does not have too many details. Also, the time of day you intend to depict is important—sunrise or sunset is best, because each provides an opportunity to use glowing colors. Include in your composition an uncluttered sky, far-distant hills, a broad field or water, and foreground foliage with either a tree or a figure as a focal point.

2. After you have carefully sketched in the composition, plan the distribution of your light-and-shadow areas.

3. Start by first applying all the major light-toned areas, blocking them in with broad applications of the sides of your pastels.

4. Spray the base color with fixative to isolate it and to retain some of the tooth of the paper.

5. Do not start to blend until you have first developed the color quality you want, retaining the texture of the paper as long as possible.

The best method for blending is to use your finger, but be sure it is completely clean and dry. You can also use a tortillon. These tools act like brushes in that they spread the layers of pastel evenly; they require that you use thicker layers of pastel to avoid picking up too much pigment. The thicker the pastel layer and the smoother the surface, the more easily will you be able to blend the pastels.

James Misho, *Flower Studies—Anemones.* Pastel on paper.
Layers of blended soft pastels superimposed produces a soft, poetic rendition of the flower still life.

Once an area has been blended to the desired tone, it should be immediately sprayed with fixative. The proper buildup requires that you do not fill up the tooth of your paper too soon. On smooth papers, just a few layers will fill up the tooth. On the rougher surfaces more layers are possible. If you are planning to use a great many layers of color to produce the various surface textures always desirable in pastel painting, keep working in progressively softer pastels, starting with the hardest and ending up with the softest. Spray each color layer with fixative to isolate it and also to retain some of the tooth of the paper.

Exert heavy pressure on the edge of a soft stick when you want to deposit a thick amount of pastel pigment to the paper. To render all the accents of darks and lights in the finished picture dip the pastel in bottled fixative and apply it wet.

In the last step, when you wish to add texture to the paper surface, you can sprinkle some marble dust over the painting, spraying it heavily with fixative.

Project: SCUMBLING

SUBJECT: Flower still life

ILLUSTRATION REFERENCE: Redon, *Vase de Fleurs* (color section, page 34)

TOOLS AND MATERIALS:
Very rough, dark paper (select from brown, green, blue, or maroon), 21″ × 29″
Set of dark-colored soft pastels
Stumps or tortillons
Drawing board
Clips
Spray fixative
Atomizer
Bottled fixative

It is easier to match values and colors when you use a darktoned paper, because the light value colors of your pastels are difficult to see unless they are surrounded by darks. You use a colored paper to avoid having to color in a background. For a flower subject, this practice is especially useful, because it eliminates the need to color around the edges of leaves and flower petals in the background space. You can achieve dramatic contrasting effects with ease, and you can use a large assortment of your darker pastels, because they always seem much lighter on dark paper.

A still life composed mostly of flowers affords the artist many varieties of colors and shapes, along with an appropriate opportunity to use the scumbling technique with the pastels.

1. Place the flowers in a light-colored vase with light shining on it from above. This dramatic type of light will create a variety of interesting shadow shapes and textures on the leaves and flowers.

2. In sketching in the forms of the composition, devote the largest area to the flowers, setting the base of the vase about 2 inches from the bottom edge of the paper. Make a careful drawing with one of the light-toned pastel sticks.

3. Block in all the light-and-shade areas in flat tones with black and white pastels.

4. Proceed to apply the other colors. Work from dark to light and from hard to soft, the reverse of how you use pastels in the other methods. This procedure facilitates any additional scumbling you may wish to do later with lighter colors. Spray the area with fixative each time you intend to add a new layer of color.

When you skim a pastel stick over a dark paper or over a darker layer of pastel so that the color underneath shows through in an irregular texture, you will be using the *scumbling technique*. Very rough paper is used for scumbling, because the greater irregularity of the tooth allows more pigment to be held. You work first with soft pastels, because they deposit much more pigment onto the paper. Spray the area with fixative, allow it to dry, then go over the area with whatever darker-hued color you choose to use, making sure it is of a harder consistency than what was used previously. You can keep on doing this over and over until you achieve an effect that pleases you. This is when your picture is finished.

Part Six

WATERCOLORS

The unique qualities and characteristics of paintings executed in the watercolor technique and the methods and materials needed to produce them are what will concern us here. Some of the advantages of using watercolors are the fact that they lend themselves to quick handling of the paint, the spontaneity made possible by this medium, and the comparatively low cost of the paints. They are used extensively in schools, for commercial illustration, and in the fine arts.

Learning from and being inspired by masters will help enhance the personal qualities you bring to your work. Reproductions of master watercolorists are included to illustrate each major technique, because all great painters have derived inspiration from their predecessors. In addition, keep in mind that in the long run your artistic individuality in the work you produce will depend on your own feelings, your imagination, your daring, and how you use your tools, and not on the painters who have influenced you.

Remember that there is craft and there is imagination in art. This chapter is geared to help you learn how to use both.

BRIEF HISTORY

Prior to the nineteenth century, artists and critics did not consider watercolor painting too seriously, claiming that it was not a permanent medium. Since then its progress has been considerable, because of a better understanding of watercolor materials and a proper concern for the methods used in working with them.

In years past watercolor painting was known as the sketcher's medium and was used mainly to record color notes for more elaborate works the painter planned to execute later in oils. Although there are numerous fine examples of watercolor paintings done by the Old Masters, it was not until the early 1800s that great watercolorists like J. M. W. Turner started to use this medium seriously. Later, the French Impressionists really began to explore its possibilities.

After you have experimented with and studied your modern water-based paints, if you have properly painted your pictures on rag-content watercolor papers and placed them either in frames or in airtight envelopes to protect them from temperature and humidity changes, there is no reason that the pictures should not last a long time.

119

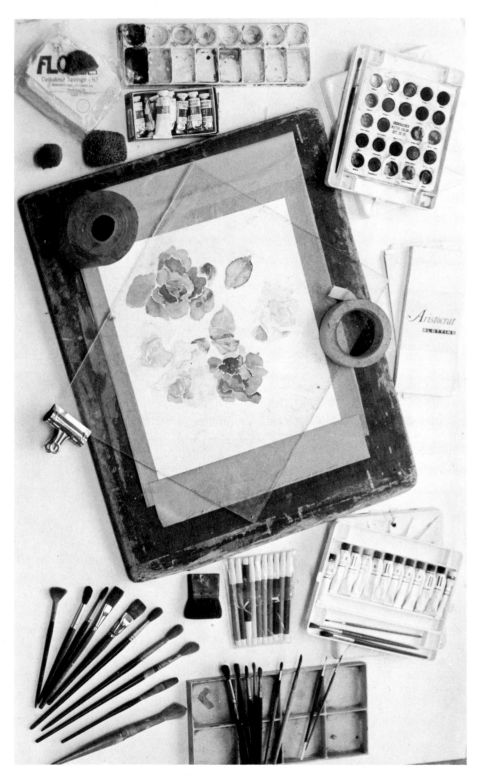

Assortment of tools and materials
needed to carry out watercolor painting projects.

HOW PIGMENTS ARE MANUFACTURED

Unlike pure colors that are viewed optically, artists' colors, referred to as *pigments*, are tangible, having both chemistry and body. Organic powdered pigments are found in nature in the form of berries, plants, and animals. These are to be distinguished from the mineral pigments, which are derived from rocky deposits in the earth. There are also artificial colors which do not occur in nature and are produced by chemical processes, among them the phthalocyanine dye colors such as thalo blue and thalo green.

Watercolor is a type of paint made when these powdered colors or dyes are mixed with a glue, called *gum arabic*, until an emulsion is formed. In the manufacture of watercolor paints the pigments are ground to an extremely fine texture in a watery solution of the gum arabic. Once this has been done, watercolor paints may be diluted with as much water as you like and still adhere perfectly to the paper. The adhesiveness of the gum is what binds the color to the paper, so that the paper absorbs and holds the particles of pigment in its surface ridges. The holding or binding action of the paper is naturally less when watercolor paints are piled up or applied thickly. The paint will have a tendency to crack unless the paper is of a very rigid type. The glue emulsion becomes transparent with the addition of water, but it can be made opaque when it is combined with white paint.

Before attempting to paint with watercolors you should have at least one year's experience in drawing, because the watercolor technique often requires drawing and painting simultaneously. The next logical step, after you have developed drawing skills, is to examine the tools needed for painting pictures with watercolors.

In addition to papers, you will need brushes, a set of cake watercolors in a box or tubes of paint, palettes, a drawing board, sponges, blotters, a pane of glass, and, last but not least, clear water; anything else is superfluous.

TOOLS AND MATERIALS

Painting Surfaces

Painting surfaces play a great role in the effects you achieve. For general practice use a student-grade watercolor paper pad. Buy all four surface types—smooth, medium rough, rough, and extra rough.

Fill each sheet with a loose drawing of any subject you like, and then cover your drawing with practice washes in a variety of strokes. In this way you will be getting firsthand knowledge of the effects that can be achieved on each type of paper. Plan to use many sheets

Lucia painting out of doors—(Photo by Lee Sievan) a wonderful way to spend an afternoon.

of paper, because learning to create different effects is a valuable part of your training. When you feel you have done enough of these preliminary exercises, you can begin to invest in the better-quality, handmade papers.

Blocks and pads of fine paper are convenient when you are working outdoors. They come in all sizes from 6″ × 9″ to 18″ × 24″, usually in the lighter weights, from 72 pounds to 140 pounds. A pad is like a notebook, hinged on only one side with a metal spiral binding or with a glue binding. A block, on the other hand, is bound on all four sides. From a little opening on the upper edge, use a table knife to cut all around the edge when the picture is dry.

For your experimenting, paint on each of the different-surfaced papers to see how each can contribute to the textural effects you want and which paper suits your temperament the best.

Papers. The method of making papers, whether by hand or machine, has not changed much since the Chinese began making them over 2000 years ago. It starts with collecting and cutting up cotton or linen rags, soaking them with water until they become a liquid pulp, and then pouring the pulp into a sieve-like mold. The mold is shaken until the excess water is removed and the fibers settle to form a sheet. The sheet is pressed between two pieces of felt and left to dry. The result is a sheet of rag paper, permanent and durable, one that will not discolor or disintegrate with age. This is still the basic method used today in the making of art paper, with improvements made by individual manufacturers.

The best papers are those 100%-rag-content papers which have a permanent "whiteness." Papers imported from England, France, and Italy excel, because they are made of the very best rag stock, following time-tested craftsmanship handed down from father to son. They have a long life, are extremely tough in texture, and cannot be matched by machine-made papers. They are available in four different surfaces: hot pressed or H.P., which is smooth; cold pressed or C.P., which is medium rough; R., which is rough; and

R.R., which is very rough. They usually come in a standard size, 22″ × 30″. You can buy them in single sheets and can cut them down into smaller sizes for less expensive experimenting.

Perhaps the best all-around surface for watercolor work is the medium-rough cold-pressed paper, because it has an unequal surface grain that is suitable for the making of washes. For fine brushwork the smooth hot pressed papers are to be preferred. The heavily grained very rough surface is splendid for bold dry-brush effects and ideal for outdoor sketching.

One of the many advantages of good-quality papers is that they dry quickly. The machine-made papers have a mechanical grid-like look. They are made from a combination of wood pulp and rag, and the cheaper ones are made from wood pulp alone. Cheaper papers are not durable, and they sometimes turn yellow and often crumble apart as they age.

Watercolor paper has both a wrong and a right side. Hold the sheet up to the light and you will discover a watermark, which is the paper's name, facing you. Reading it from left to right gives you the working surface and the top of the paper, which is usually superior to the reverse side. You can use the reverse side when experimenting, but be sure to use the correct side for your serious work.

Weights of Papers. Good watercolor papers generally come in three different weights (or thicknesses), from the flimsy 72-pound weight to the thick and heavy 300-pound weight. (The weight by pound means the weight of a ream—500 sheets—of a given size of paper.) The greater the weight of the paper, the more expensive it is; paper is sold by the pound. With heavier paper you avoid the soaking and stretching process necessary to prevent wrinkling produced by puddling water when you apply paint. If you do not have time to stretch paper, you will have to use the heavy 300-pound paper.

The chief advantage of working on heavy paper is the flexibility achieved by not having to fasten these sturdy papers down to a board

while you are working, and you are therefore better able to control the washes. Because the paper dries quickly, you can flip it over and use the reverse side if you should make a mistake and want to start over. Also, papers come in large enough sizes that you may economically cut them down to make smaller sizes.

Many of the heavier papers are covered with a sizing made with starch. This sizing must be sponged off before painting. You will find that after the paper has dried your pigments adhere more firmly, and have a better bite and that the color remains close to what it was when you first applied it. Many painters use a hair dryer to hurry the drying process.

The most reputable firms making handmade watercolor paper are:

Arches, watercolor and spiral sketch books. They come in all weights. Arches En-Taut-Cas paper, large sizes hot and cold pressed, and rough. (Made in France.)

RWS (Royal Watercolor Society) cold and rough pressed papers, 90- and 140-pound weights, watercolor papers. (Made in England.)

Machine-made papers by Strathmore, an American firm, are also recommended.

Keep in mind that a paper made by a reputable manufacturer, however lightweight it is, has the same ingredients as the heaviest. If it is properly stretched, it will provide an excellent permanent surface on which to paint.

Mounting and Stretching Paper. Lightweight papers need to be mounted on cardboard to prevent wrinkling caused by temperature changes. Watercolor papers that can be purchased already mounted have two great advantages: they remain flat throughout the painting process, and they are easy to mat and frame. However, they are costly, and if you have the time, it is cheaper to mount your own.

Do not confuse mounted paper with illustration board, which tends to have a smooth surface and is not suitable for watercolor washes, because it absorbs the water and causes the board to warp. Eggshell board, which has a distinct pebbly surface and is usually used as a mat board, is suitable only when the quick-sketching, direct technique of dry brush is used. This type of board will not stand overwashing.

To mount lightweight paper, first moisten the selected sheet, either with a sponge or by soaking it in a bathtub or a large sink until it is limp. Next, spread a water-soluble glue such as bookbinder's paste, drawing-board paste, or diluted glue evenly all over the back of the paper. Lay the paper paste-side down on heavy mounting board that has been previously dampened. Place a sheet of clean paper over it and scrape, roll, or brush it vigorously enough to force all air from between the paper and the mount. Be sure to form a uniform adhesion.

Finally, weight the paper down with a drawing board loaded with heavy books to dry flat, which usually takes several hours. Be careful—the mount may buckle if the weight is removed too soon.

Stretching paper is preferred by many painters; it serves the same purpose and is less costly than mounting. Unless you work on very heavy paper or are using the dry-brush technique, in which very little water is used, you will be painting under quite a handicap if the paper has not first been stretched. Wet paint produces creases and buckling on unstretched paper; pigment particles tend to settle into hills and valleys on the wet paper; if you do not redistribute or brush out your washes as you work (an irritating interruption), they will dry there and, in the finished work, will show the location of each original wet crease.

To stretch watercolor paper on a frame, you should use a good quality paper of medium weight, else it may pull apart or split as it dries. In stretching, only the edges are fastened down. Of several methods the most simple procedure is the following:

1. Put together four stretcher strips, the kind sold for stretching canvas. Your frame should be at least 2 inches smaller than the paper, all around the edge.

2. Soak the paper in a bathtub or large sink until it becomes soft and pliable.

3. Lay the paper flat on a clean level surface and center the frame upon it, leaving a uniform margin of paper all around.

4. Working one edge at a time, thumbtack or staple down this margin to the side edges of the frame.

5. Trim away any extra paper. (For a stronger job you can also fasten the paper to the back of the frame, but you will need larger margins.)

Stretching paper on a frame is a must when stretching large sheets, because a great deal of tension is exerted during the drying. As it dries, the paper shrinks as tight as a drum, when it is ready for painting. While you are working, the paper will buckle each time you wet it, but it will flatten out again when dry. Thinner papers will buckle more easily. Be-

cause the finished painting will wrinkle badly if it is cut away from the frame too soon, it must be allowed to dry for several hours before you cut it away.

A second system is to use a ⅛-in.-thick upson board (formerly called beaverboard), a good 1 inch larger all around than your paper. Spread your wet watercolor paper onto the board, push out all the air bubbles, sponge up excess water, and then tape it around the edges with a good commercial brown paper tape made with animal glue (masking tape will not work). Let paper and tape dry, and you are ready to start painting.

When the painting is finished, give it ample time to dry—overnight is best. Stretched paper is deceptive, because even though it feels dry to your hand, it may still contain enough moisture to buckle badly when it is cut away. Do not release it on a damp, humid day unless

Stretching watercolor paper on a frame is a **must** for painting on large sheets, because the paper shrinks when drying. Use a good quality paper of medium weight or it may pull apart or split as it dries. In stretching, only the edges are fastened down.

1—Assemble four stretcher strips, the kind used for canvas. The frame should be two inches smaller than the paper all around the edge.

2—Before stretching, soak the paper in a bathtub or large sink until it becomes soft and pliable.

3—Lay paper down flat and center the frame over it, leaving a uniform margin all around.

4—Working one edge at a time, staple down the margin to the side edges of the frame.

5—Trim away any extra paper.

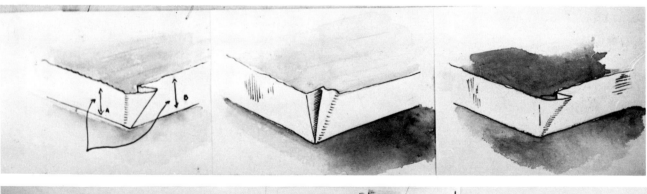

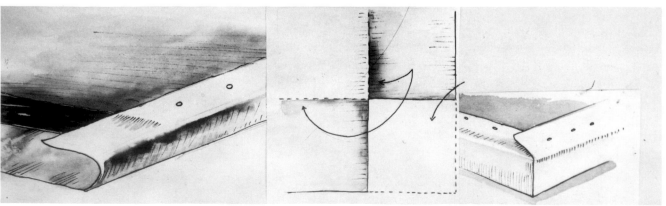

you use a hair dryer on it first. The cutting may be done with a single-edge razor blade or knife by following around the sheet continuously, starting on the long side. Avoid cutting one end and then the opposite end, for this sets up a tension that might tear the paper.

Brushes

Do not buy poor or cheap brushes, for you cannot possibly do good work with brushes that have no snap or are constantly shedding their hairs.

Sable Hair Brushes—the Rounds. The best and most costly brushes, of course, are the sable hairs, excellent brushes if you can afford them. Sable has fine resilience—the ability to snap back to its original shape—even when very wet. While painting, when you shake out the brush violently to get rid of excess water, it will regain its point.

The round sables are numbered from the smallest, #1, up through #12, the largest. The hairs are shaped in the round and come to a fine, needle-like point. The rounds are excellent for outlining and painting details and for fluid brush work.

Flat or chisel-shaped brushes are best used in painting large washes by turning the brush on its side, and in putting in fine lines, by using the sharp corner or the full width of the brush.

Camel, Oxhair, and Japanese Bamboo Handle Brushes. These brushes do the work just as well as those made of sable hair, and the cost is much more reasonable. Although they have all the sparkle and bounce of sables, you have to pick them more carefully when buying. Test each one for springiness and bounce-back qualities. All brushes come with starch in them to hold the hairs in place in the store. Ask for a glass of water to wash the brush out and then see if the hairs hold their shape when wet. Oxhair, if carefully chosen and cared for properly, can be excellent.

Bristle brushes are quite stiff and are generally used for oil painting, tempera, and acrylics. In watercolor they are mainly used to lighten small areas, to soften edges and, when you wish, to scrub out a mistake or two, which can be done by wetting the brush, scrubbing very gently, and immediately blotting up the water with a tissue or blotter. You will need only one bristle brush; a #5 "bright" is a good, all-purpose size.

Lettering Brushes. Lettering brushes are similar to the flats. The difference is that they come in very narrow widths and have long, slim bristles about an inch long. You can get all sorts of interesting effects with them by learning to twist, turn, drag, and squash the brush against the paper. After many practice exercises you will get to know exactly what each will do. You will not need more than five good lettering brushes in painting watercolors, although you may want to add more. The basic five are: three flats, in sizes of 1½, 1, and ⅝ inches; one round size #8; and one #4 rigger, a long slim-haired brush about 1 inch, perfect for achieving all sorts of linear effects.

Care of Brushes. Good brushes will last a long time if you take proper care of them. Rinse them frequently as you paint, and wash them thoroughly with a mild soap and warm water before you put them away. Shake each brush out. Do not squeeze the hairs but shape them gently to their original form with your

Care of brushes. Good brushes will last a long time if you take proper care of them. Rinse them frequently as you paint and wash them thoroughly with a mild soap and warm water before you put them away. Shake out each brush and shape the hairs gently with your finger. Place them upright in a jar to dry.

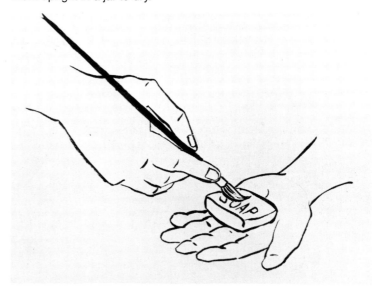

fingers. Place them upright in a jar to dry. When they are not in use, store them in a box or drawer where they will not be cramped. It helps to put in a mothball or two during the summer months—moths will always go after your most expensive brush. Any jar with a screw top (if tall enough) is also fine for storing brushes.

Sponges

All kinds of sponges are suitable for painting purposes, including the ordinary artificial ones. You can use a sponge to wash down a large sheet of paper to remove the starch sizing. Sponges can also pick up excess water, especially where it puddles along the edge of handmade papers, to prevent the water from working its way back into the picture and spoiling your washes. The sponge can serve to lighten dark areas or even to soak up any unwanted washes. You can produce all sorts of textures by dipping the sponge into thick paint and patting it into the paper.

Keep two or three sponges in your kit, a clean one for sponging down clean paper and another for special effects. For pigment application or for picking up highlights, you may find sponge brushes very useful. They are small with quill handles or large with wooden handles and nickeled ferrules.

Knives and Single-Edge Razor Blades

The main function of the knife is to cut paper and to sharpen pencils to get a variety of edges, but it also plays a role in the finishing of a picture. After the painting is dry, all sorts of fine, hairline details may be scratched out. Highlights, thin lines, and mistakes, if lightly scratched out, can give an added sparkle to the finished picture.

Single-edge razor blades are necessary for sharpening thick pencils to get different types of points for the lead and also to shave surface color off the paper when you wish to render special texture effects.

Blotters

Blotters are a necessary tool when painting washes and when you need to get rid of excess color on your brush without washing it all out by dipping it into water. You can also use the blotter edge for picking up any unwanted wet color in the picture.

Miscellaneous Supplies

Rags, paper towels, and cleansing tissues are all handy items to have in case of emergencies. Assorted pencils, erasers, clips, and brown paper tape are a must.

Watercolor Paints

Current watercolor paints come in two main types. Both have advantages, depending on your situation. The first, preferred by most beginners, is the dry variety that comes in cakes in a watercolor box. The second type, preferred by the majority of professional painters, is the moist paint that comes in tubes.

Cake Colors: The Color Box. The advantage in using watercolor sets containing cake colors is that you save time in setting up as you start to paint. Equipped with your watercolor box, a pad of paper, a few brushes, and a jar containing water, you are immediately ready to start to paint. Color boxes are most practical when working outdoors or in the classroom or when doing brilliant work on small paintings in which great quantities of pigment are not needed. If you put a few drops of clean water over each color cake before starting to paint, the water will soften the pigment, making it easy to use.

Here in the United States Grumbacher, Inc., and in England Winsor and Newton manufacture fine watercolor boxes with cake colors set in small pans. The use of the cake colors creates a relaxed mood for the painter, who is free to concentrate solely on the act of paint-

ing, without the bother of frequently having to squeeze out more color.

Cake colors are useful if you are not painting every day, because they retain their freshness indefinitely. If you are diligent about washing out your box after each use, the colors will not become muddied by the adjacent cakes, and your box will be fresh and brilliant, ready for your next painting session.

Moist Tube Colors. Unlike the dry cake colors in your watercolor set, tube colors are moist and are marvellous for painting a large picture in which bold, strong color will be used. Their advantage over the cake colors is that each color comes from the tube clean and fresh, but you do have to take time out to prepare your palette by squeezing out a sufficient amount of color each time you begin a painting. Grumbacher, Inc., and Winsor and Newton manufacture a superior product.

Whichever type of color you use, cake or tube, it is important to remember that considerable water must be added, depending on the depth of the tone you want. For dark or brilliant hues, relatively little water is needed. For most light tints you dilute with larger amounts of water. It is a good idea to learn as much as possible about the actual paints. To accomplish this end it is best to carry out a set of exercises geared to give you experience in their use. You will find that the more experimenting you do, the more control you will acquire in handling the different watercolor techniques.

An important quality that distinguishes a watercolor from other media is the transparency achieved by thinning color with water, so that the paper shows through. Another is letting the colors create "accidental" effects.

Once the techniques are mastered, it is possible to transfer what you have learned to the use of other water-based media such as gouache, tempera, and casein.

Transparency. Although the colors are all basically transparent, some are more opaque than others, as indicated on the list. You will discover this for yourself as you paint with them. Most watercolors are about 10% lighter

when they dry. An exception is Payne's gray, which dries 50% lighter, and it is best to confine its use to the light areas of your picture. You can mix your own beautiful warm gray by combining ultramarine blue with burnt sienna. To get a cold gray, mix black with lots of water and a little thalo blue.

DEGREE OF TRANSPARENCY

Alizarin crimson	very transparent
Burnt sienna	transparent
Cadmium red light	slightly opaque
Cadmium yellow deep	slightly opaque
Cerulean blue	slightly opaque
Cobalt blue	very transparent
Crimson lake	very transparent
Emerald green	slightly opaque
Hooker's green	very transparent
Ivory black	very transparent
Lamp black	very transparent
Lemon yellow	slightly opaque
New gamboge	very transparent
Payne's gray	very transparent
Raw umber	transparent
Rose madder	very transparent
Sap green	very transparent
Terre verte (green earth)	transparent
Thalo blue	very transparent
Thalo green	very transparent
Ultramarine blue	slightly opaque
Vermilion	slightly opaque
Viridian	very transparent

These colors will stay bright and clear if they are not exposed to direct sunlight. Of course, the more fastidious painter will avoid using colors that are not marked "permanent" by any reliable paint manufacturer, because these will tend to fade with time. You may wish to have other types on hand for aesthetic reasons, but it is a good idea to work with the permanent colors and thus avoid unnecessary problems.

The following group of colors are very lovely to look at but are of no real practical use in achieving painterly effects. These colors have

little solidity, and it is almost impossible to get any opaque effects with them, because they have very little pigment quality or body substance. When they are mixed with a little white, the resulting mixtures are lovely, subtle undertone versions of their original hues. Because they are transparent, they are really best suited for the technique of overpainting and glazing. Here is a list you might like to experiment with.

Crimson lake produces a mauve undertone.

Alizarin crimson has a strong pink undertone.

Rose madder has an undertone that is a very gentle pink.

Green earth produces a wet grass or moss color.

Sap green has a mustard-green cast.

Transparent gold ochre has a golden-yellow undertone.

TECHNIQUES

The advantages of working in transparent watercolors vary with the temperament of the painter using them. There is no question that watercolors are used to best advantage when free, delicate, jewel-like effects are sought. One need only look at the paintings of John Marin, Paul Cézanne, and Winslow Homer to have this observation borne out.

One of the reasons for the extensive use of this medium is that it is a quick technique. Labored overpainting spoils the work, and beautiful color transparencies are achieved simply by using the white of the paper as a color. Watercolors are very suitable when working outdoors, in small work areas, in schools in which limitations of equipment sometimes raise a problem, and in commercial illustration and design work in which quick, spontaneous effects are often sought.

It is difficult to handle painting without first acquiring the skills of drawing and composition, especially if you wish to express specific ideas. In watercolor techniques there are two distinct types. Each has many variations, but essentially all methods may be classified as being in either the *opaque* or the *transparent* category. Here are the basic characteristics of each.

The Transparent Watercolors

In transparent painting the "accident" is part of the painting process. Once this idea is thoroughly accepted, it will help you to relax and enjoy the act of painting in this medium. By "accident" we mean that the flow of color from your brush onto the usually wet paper proves to have a mind of its own. You must learn to be flexible in going along with what is happening on the paper with the flow of your watery washes. Learning to control what the colors do comes with practice. Most painters find watercolor painting a challenging and exciting way of working: exciting, because watercolor moves, crawls, and resists control; challenging, because you have to learn how to control and guide it.

Here is the primary rule to remember: The white of the paper is your only white, and therefore the composition must be planned so that the paper is allowed to show through whenever you want white to be present.

The best procedure in handling a watercolor is first to sketch in your picture idea lightly in pencil or to paint it in with a light, neutral-colored wash, for you will rely very little on a careful underdrawing. The real work will be done while you are painting. The drawing is done with your brush as the picture develops.

In architectural renderings or commercial illustration, in which the design must be accurate to the subject, you first have to make a very careful drawing, and then you tint or color this underdrawing. However, what we are primarily concerned with here is work produced by creative artists whose paintings are meant to express feelings, dreams, moods, and ideas; the "accidents" are incorporated into the picture. Never forget as you work along that the quick applications of a series of

transparent washes are what create the spontaneous quality of the finished work.

Remember also that for a watercolor to have a transparent look it must allow any "underneath" color to show through, even when a second wash is placed over it. For example, a red over yellow will appear orange, and yellow on top of blue will produce green. As mentioned, the white of the paper is your only white, and consequently while working with transparent color you must plan to paint around any highlight area.

Opaque Effects

Roughly defined, watercolor is any pigment that is soluble in water, whether it is opaque or transparent, and water is used to paint it. The term *opaque watercolor*, however, covers a large area. *Gouache* is made opaque with the addition of white paint; *casein* with a milk-curd emulsion; *tempera* with an egg-white emulsion; and *acrylics* with a plastic emulsion. All are water-based media, and all are opaque, although for special effects they can be made transparent. Because they are more opaque than transparent, to achieve different textures they are handled very much as you would handle oil paint, in that you mix opaque white with the colors to get different tonalities. For example, to make a color lighter, you add white, thus making it opaque and solid enough to cover whatever is underneath it.

You may sometimes wish to use opaque and transparent colors in the same picture, which can be accomplished by adding a little opaque white to all your watercolor washes. But in doing so you will be defeating one of the purposes of working in watercolors, the chief characteristic of which is the pure transparent and spontaneous effect achieved only with the application of transparent washes.

Before you begin using watercolor paints, review the descriptive terms that apply to the quality characteristics of the different watercolor paper surfaces. This is important, because knowing them will be of great help when selecting the correct paper to use for your pictures.

Project: DIFFERENT BRUSH EFFECTS

TOOLS AND MATERIALS:
 Sable or oxhair or synthetic brushes, assorted
 sizes, both rounds and flats
 Set of cake watercolors
 Three sheets of watercolor paper, one each of
 hot-pressed smooth, cold-pressed
 medium-rough, and rough
 Blotters
 Sponge
 Jar of clear, cold water.

Be systematic. Use the rounds first, then the flats, going in size from large to small. First practice with your brush loaded with wet color and later with very little color. Note that if you gently wipe the brush or run it across a blotter to get rid of excess color you will get very "dry broken-line" brush strokes.

For a starter, prepare to use different brushes. Copy all the brush strokes and marks pictured, using all three types of watercolor papers to paint on.

1. Drop a little water over the cake of black in your paint box.

Brushes. The **flat** or **chisel-shaped** watercolor brushes are best for painting large washes. The **rounds** come to a fine needlepoint. They are excellent for outlining, for fluid linear work, and for painting detail.

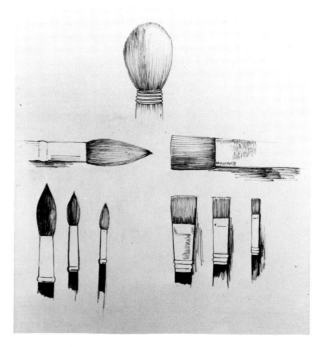

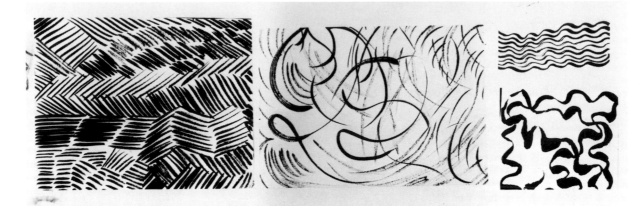

Practicing brush strokes. This picture, and the two on the opposite page show a variety of strokes and lines made with the different brushes. Experiment with all of yours before painting a picture. In order to achieve best results, do a set of practice exercises using different brushes so as to test the type of brush mark each one makes. Use either sable or ox hairs of all sizes.

2. Using the different-sized brushes in sequence, make brush strokes on the cold-pressed medium-rough paper.

3. Dip the brush again into the color and paint on the hot-pressed, smooth paper.

4. Now dip the brush again into the color and make brush strokes on the rough paper. Compare the three papers, noting how the brush stroking differs because of the textures of the papers.

5. Fill up several pages. When you think you have the feel of watercolor you can proceed to do the projects outlined in the following pages.

For a dry-brush practice exercise, fill up a sheet of paper with dry-brush work.

Dry-brush work is usually done with a minimum amount of water in your color. You simply place your colors with sharp brush strokes directly onto the paper, which contains no previously made drawing or sketch. The strokes may vary in width from a hairline to an inch or more. They may also vary greatly in length and direction—some long, some short, some straight, some curved, some wavy. Brush lines may also be sharp, soft, broken, graded, or uniform. The surface of the paper you are using can be used to show contrasts of textures. The amount of thinning caused when more water is added to your color and when you have dried out the color on the brush by running it over or across the blotter also can create contrasts of textures.

Project: DRY BRUSH

SUBJECT: A rocky landscape

ILLUSTRATION REFERENCE: Marin, *The Little House, Stonington, Maine* (color section, page 32)

TOOLS AND MATERIALS:
16″ × 20″ cold-pressed, medium-rough watercolor paper
Assorted sizes sable hair, pointed round brushes
Set of cake watercolors
Blotters
Jar of clear, cold water

Make several preliminary sketches of a rocky hillside, planning the compositions to

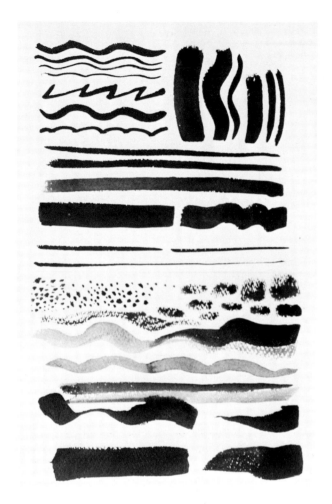

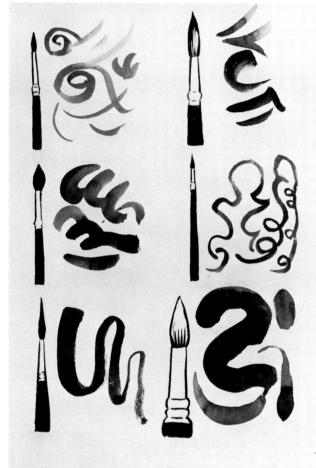

create a variety of forms in overall pattern-like arrangements. Select the one you like best and transfer it onto your good watercolor paper.

In this painting of a rocky landscape you will be mainly concerned with using juxtaposed dry-brush strokes. You will very seldom do an entire picture with the dry-brush technique, because it is used only in specific areas in which textural effects are needed, like rocky hillsides or perhaps the weathered wood siding of a barn in your landscape.

1. With fairly wet paint, put in all the large areas first.

2. As the brush begins to run out of paint or when the paint is rather thick, you will get a ragged, broken stroke, particularly if the paper is rough.

3. Use your color sparingly in the foreground areas, allowing the white of the paper to show through as much as possible.

4. Paint in "architectural" formations to your rocks with the edge of a wet brush, then rub the brush across a blotter and pass it over the parts of the picture requiring textural effects. You can use charcoal to further accent parts of the picture, especially the darker areas. The finished effect should be that of a spontaneously painted rocky landscape.

The Flat Wash

Painting with washes differs from applying the color with dabs, dots, or various kinds of lines. It is really the basic method of

watercolor painting, since the brush is employed to convey liquid paint to the paper.

This *wash* is allowed to flow under the control of the brush over large areas on the paper until the limits of the picture area are reached. Before laying in a flat wash, mix more than you think you are going to need to cover the area to be painted, using a small cup for mixing. The aim is to coat the area with a uniform tone. To get a perfectly flat wash, prewet the paper and let it dry a little. The paper is ready as soon as the shine disappears. While the paper is still damp the wash can be started. Tilt or incline your drawing board just enough to permit the wash to flow slowly. Dip a large and sharply pointed brush into the color, give it a shake or two over the cup, run it lightly over your blotter to get rid of any surplus wash, and then:

A. Gently put brush to paper, starting at the upper left corner of the area that is to be painted (if you are right-handed and vice versa if you are left-handed).

B. Next, stroke it to the right, dipping the brush again into your color as often as necessary to retain a wet puddle.

C. Start your second stroke immediately under the one you just made, so that the point of the brush touches the lower edge of the established puddle, allowing it to flow down naturally. Maintain a wet puddle at all times. Keep brushing on the wash, one stroke directly under the other until you have finished the area.

D. To finish off the wash (that is, when you approach the lower boundary edge) take up any surplus paint with the tip of your brush and run it across the blotter. If you fail to do this, the puddle made by your last stroke will seep back into the already painted area and form a blotch.

For a really well-painted wash, much depends on the size of the area to be painted. It is easy enough to run a satisfactory flat wash of a few inches in size and quite another to cover successfully a large area, such as an entire sky in your picture. Therefore, to acquire this skill, you should practice this exercise repeatedly.

The Very Dark Washes

You may sometimes wish to vary the flat wash to create very dark tones. The painting procedure is the same as with a flat wash, except that you are using more pigment.

By first mixing a large enough quantity of your wash (use a cup to mix it in) you will have enough paint to cover a large area, without the risk of running short of color while you are painting. Mix it in the cup until it is exactly the color, value, and fluidity you wish. Sample it on a piece of scrap paper, and let it dry to see

The flat wash. In painting a flat wash the aim is to coat an area with a **uniform** tone. Before laying in a flat wash, mix more than you think you are going to need to cover the area that is to be painted. Use a small cup and mix more than you think you will be needing.

Dry brush work is done with a minimum amount of water in your color. Brush lines may be sharp, or soft, showing contrasts of textures of paper surfaces. Dry off excess color on the brush by running it across a blotter.

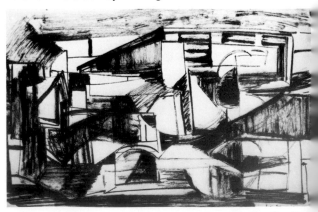

if it does what you had in mind. By using the cup method, you arrive at exactly what you want before painting.

Avoid going back over the dark wash after it dries. Because the dark wash contains more pigment, your brush will tend to pick up color from the paper if you go over it, and the flat effect will be spoiled.

The Graded Wash

The surface texture of the paper is important in the graded-wash technique. Because the aim is to achieve gradual tonalities, make a series of graded washes of all of the colors in your box. The sample washes need not be large in area; in fact, 2-inch squares will do. Before applying the color, first dampen with clear water the spot you intend to paint. You will find that this softens the graduation process considerably.

Project: THE TRANSPARENT FLAT WASH

SUBJECT: A cityscape

ILLUSTRATION REFERENCE: A. Salemme, *The Crowd* (color section, page 28)

TOOLS AND MATERIALS:
 Set of cake colors
 Assorted brushes, sable, oxhair, flats and
 rounds
 Cold-pressed, medium-rough watercolor paper
 Small cups for mixing washes
 Sponge
 Blotters
 Jar of clear, cold water

In doing this project, in which you will be carrying out a pictorial idea, the flat sides of city buildings afford you ample opportunity to put your experience of painting flat transparent washes to the test.

1. Make a number of preliminary sketches of a street scene in pencil or charcoal. Select the one that appeals to you most and redraw it on your good cold-pressed, medium-rough watercolor paper. The pencil lines should be barely visible, so that they do not show through the colors as you paint. Start by placing a row of buildings that are silhouetted against a cloudless sky. Then decide where the source of light is to be, one that will produce a light side and a dark side for each building. Plan the composition to include three sections—a sky area on the top space, buildings in the center running in a band across the page, and a sidewalk or street in the bottom section. You may also wish to include a few figures walking on the sidewalk.

2. Paint in the largest areas first. Use a large brush to convey a large puddle of liquid paint to the paper. Add paint, a brushful at a time as needed, or reduce the amount of paint by picking it up with a dry brush and wiping off the brush on a blotter. Repeat in this manner until you reach the limits of the area.

3. When the paint in the large areas is dry, fill in the progressively smaller areas with

Graded wash. Controlling the flow of color and water at one sitting. The more water you add to your color, the lighter each succesive stroke becomes.

smaller brushes. Be sure that adjacent areas are completely dry before you begin on the middle-range and smaller areas. Be careful not to have the different washes run into each other, or the colors will get muddy. Save your boldest colors for the foreground areas, because this is how you will effect a feeling of depth and distance in the composition.

4. As you get more practice, you will develop individual procedures and techniques, but experience has shown the value of proceeding from large areas to smaller areas and then to details of windows, doorways, or figures. Do not overdo the details, which are to be painted in as a final step when the picture *is completely dry*.

Project: GRADED WASH

SUBJECT: A country scene using graded washes

ILLUSTRATION REFERENCE: L. Salemme, *Volcanic Landscape*

TOOLS AND MATERIALS:
 Assorted brushes, sable or oxhairs, rounds and flats
 Cold-pressed medium-rough watercolor paper
 Set of cake watercolors
 Blotters
 Sponge
 Box of cleansing tissues
 Jar of clear, cold water

The medium-rough cold-pressed watercolor paper is the suitable one for making graded washes, because it has an unequal surface grain.

Graded washes going either from dark toward lighter tones or from light toward darker can be painted in various ways that you can practice before doing this project. One way is to work on a dry paper. Dip your brush into the color and start off with a dark bold stroke. Then add more clear water to each stroke as you come down the sheet. The increase in water added to the pigment each time makes the color lighter with each successive stroke. Another way, especially useful when you have to paint around intricate shapes such as treetops, edges of buildings, or petals of flowers, is to paint around the edges of each shape with a very light wash until you clear the wash by brushing it all across the paper, adding more pigment with each pass of the brush until you reach the top. Finish off by taking up any excess water with the tip of your brush and running the brush across the blotter.

Because colors differ considerably, some being more transparent than others, you should get to know what each is capable of producing in intensity and value.

1. Make a few preliminary rough sketches of an imaginary or remembered landscape on a drawing pad. Select the sketch you like best

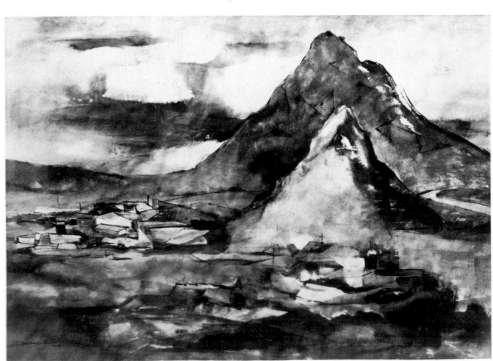

Lucia Salemme, *Volcanic Landscape*.
Mingling. Drop two or more colors from your brush onto the paper and permit them to flow into one another. Use the colors full strength, mixing them a little at a time with water to make them lighter as you paint along, until the picture is completed. Give a transparent look to your watercolor painting by allowing any "underneath" color to show through.

and redraw it on your good watercolor paper. If you find it helpful to use a photograph of a scene, follow the same procedure. Modify or subtract from the scene according to your impressions and feelings, because most photographs contain more than you would really want to include. Arrange your composition into four sections: the top for the sky area, the next for shapes in the far distance, the section underneath suggesting the middle distance, and the bottom for the foreground shapes.

2. Now put in the subject matter—distant hills, field or meadow, rivers, or sandy beach.

3. Then indicate details such as houses, people, bridges, trees, or rock formations. Include "in-between" spaces for separating the more concrete features of your landscape.

4. Your aim is to give each one of the four sections a distinct overall tonal value. Every feature in the landscape must be graded according to the tonal value of the area in which it appears. First, paint in the sky and clouds, using definitely outlined cloud shapes; paint around them with a light-colored wash and then brush it clear across the paper.

5. To have mountains or trees appear to be in the far distance, use colors that you have made "weak" with the addition of clear water. Weak, pale colors will suggest deep space.

6. Because the middle distance usually includes your painting's center of interest, create it with care, selecting fairly focused colors. These colors usually have very little water added to them.

7. In the bottom section, the foreground, you can use all your boldest colors, strong in hue and clear in detail.

Your finished picture will represent a fine rendering of a landscape painted in graded washes.

Mario Cooper, *Cormorant Domain*. Watercolor on paper.
To render sparkling whites in a composition, first make a careful drawing of the subject with faint, barely visible pencil strokes. Then block out all the areas that are to remain white, using either a stencil, miskit or by simply **not** putting any paint into the spaces that are to remain light.

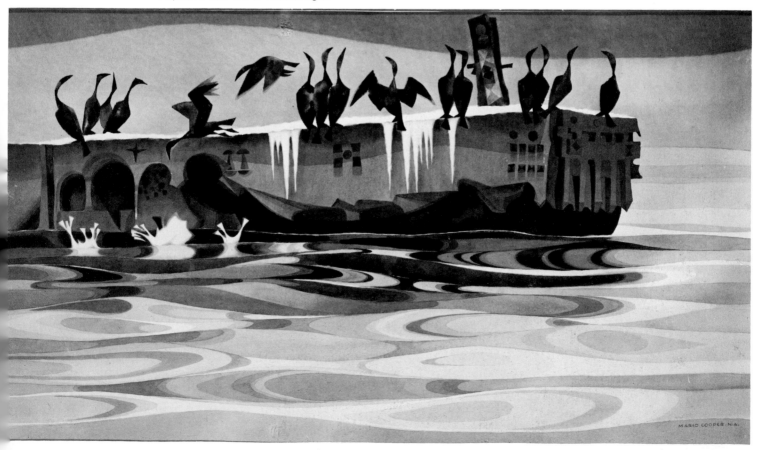

Project: OMITTING EDGES

SUBJECT: Seascape

ILLUSTRATION REFERENCE: Cooper, *Cormorant Domain*; L. Salemme, *The Chinese Poster* (color section, page 28)

TOOLS AND MATERIALS:
Hot-pressed, smooth paper (If you use the thinner 72-pound or 140-pound paper, it must be stretched to avoid water puddles and wrinkles. If you do not have time to stretch paper, you mut use the heavy 300-pound hot-pressed watercolor paper.)
Moist colors in tubes, full palette
Enamel or plastic palette with recessed grooves
Sable or oxhair brushes, flats and rounds, assorted sizes.
Ink eraser
Masking tape
Single-edge razor blade
Blotters
Box of cleansing tissues
Jar of Miskit (made by M. Grumbacher)
Jar of clear, cold water

There are several techniques for *omitting edges* and blocking out parts of the picture while you are painting in larger areas. Here are some methods for accomplishing this end:

1. First is the old reliable method of not putting any paint in areas that you want to remain white.

2. Another method is to blot out unwanted color while the paint is still wet, using a sponge, tissue, or blotter.

3. Unwanted paint can be erased or scratched out with a single-edge razor blade after the picture has dried completely (usually overnight).

4. You can also cut out stencils or paper masks of the spaces you want to remain untouched by color. You fasten the stencils down with rubber cement or use masking tape cut to fit the space.

5. A product manufactured by M. Grumbacher, Inc., called Miskit, comes in liquid form and is used to block out areas when painting backgrounds. First you paint Miskit over the areas to be blocked out. Then you paint in your background, going directly over the blocked areas. When the paint has dried, you remove the Miskit by peeling it off with your fingertips. The original paper surface is intact, untouched by color.

Work requiring much detail is best accomplished on paper with a smooth surface. Before starting this project, study the two watercolors reproduced here and note how the whites of the paper to suggest light have been rendered.

Plan your composition of a marine subject by drawing a series of preliminary rough sketches in pencil or charcoal. The subject can be a composite of remembered scenes relating to the sea or of images derived from several favorite photographs. Select a subject that will require white spaces in the composition. For example, include sailboats, figures on a beach, or white foam in a seascape.

1. Using faint, barely visible brush marks, sketch in your composition onto the surface of the watercolor paper.

2. Block out all the areas that are to remain white. Use masking tape, stencils, or Miskit.

3. Boldly wash in all the large spaces. Paint freely over the small areas that you have blocked out, because the color will not take where the paper is covered or coated.

4. Wait a half hour or so until the color has dried. Then remove your masking tape or Miskit by picking up an edge with the fingertips and peel it off. The original paper surface is intact, untouched by color.

5. You are now ready to paint in the details and to pick up the drawing wherever you feel your subject needs clarifying.

Try painting another version of the same subject, but do not mask out areas. Wait until your picture has completely dried, and then use either a razor blade or an ink eraser to remove color.

Next, paint a third picture, this time while the paint is still wet, blotting out with a sponge or tissues any color in areas that you wish to appear lighter than surrounding areas.

Lucia Salemme, *Lower Manhattan*. Watercolor.
When you are working on a rough textured paper, you can scrape or **scratch out color** in order to get lighter tonalities. The white spaces are what liven up a picture.

Leave spaces untouched where you want sparkling highlights.

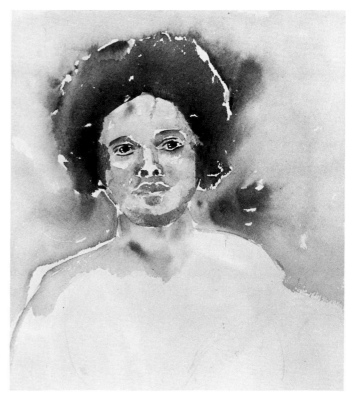

After a picture is completely dry, highlights can either be rubbed out with an eraser or scratched out witha safety-edge razor blade.

While the picture is still wet, unwanted paint
can be lifted out with the edge of a blotter.

Vincent Van Gogh, *Boats at Saintes-Maries*.
Gray and black ink.
(Justin K. Thannhauser Collection, The Solomon R.
Guggenheim Foundation, New York.)

There are many ways of handling the brush:
with the tip alone, on its side, and combining
very thin watery ink in the full part of the brush
with heavy black ink on its tip for making
varied brush strokes. Many effects are
possible with different papers.

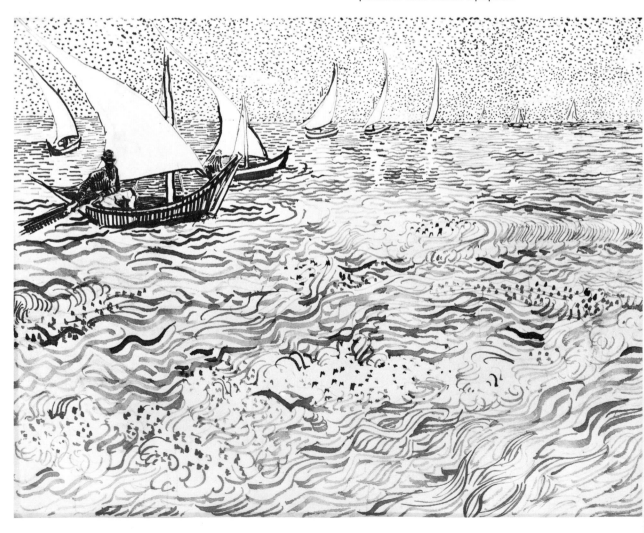

Another product that performs the same service is called Moon Mask. You simply paint all white areas in the composition with gray Moon Mask, allow a few minutes for it to dry, and then proceed with the painting. Another is called Maskoid. It leaves whites crisp, soft, and clean. You apply it by brush for broad areas, by pen for more delicate rendering. Both products are made by Marc Moon Studios, Dept. AA, 505 W. Portage Trail Ext., Cuyahoga Falls, Ohio 44223.

All five of these methods are recommended, depending on the particular problems of each picture you work on. Your own judgment on which to use where is best. Do some experimenting with each.

Wet-in-Wet

Wet-in-wet simply means that the color is brushed onto paper that is already wet. It is referred to by painters as the *soft or wet-surface* method. There are several ways of achieving these effects. One way is to wet the paper lightly with a sponge. This method is fine for painting the large areas in your picture, such as the sky or a field, where you do not have to paint around anything needing a hard edge.

Let us now do some exercises to depict skies, fields, fruit, and drapery. Start by sketching in the subject so that your pencil lines are barely visible, and then wet the paper. Next, paint a fairly flat wash onto the wet paper, then *immediately* come back in with dark pigment and let it run where it wants to go.

If you wait too long before brushing the darks into the wash you will get sharp, hard edges to your dark colors. Study your large passages carefully, and plan exactly what you intend to do before you put brush to paper. When you have decided, plunge in and hope for the best. If you fill up many practice sheets, you will become fairly familiar with just what happens under all kinds of conditions.

The Streaky Wash

And now to paint a more carefree, spontaneous subject of an all-over pattern of abstract shapes in yet another wet-paper technique.

Flow clear water with a brush over your paper, and while the paper is still wet, drop in your dark pigment at the top. Pick up one corner of the sheet and let the dark flow as far as you wish; when you lay the paper down flat the action will stop. The results will be a series of streaks that you can change by manipulating the paper, causing the streaks to blend together. It's fun to see how many times the patterns will change.

Many watercolorists enjoy the method of mingling colors by painting on a soaking-wet paper placed on a pane of glass or a sheet of Plexiglas or Lucite. This procedure eliminates the necessity of fastening the paper to a frame or board, making it easier to manipulate the paper to guide the flow of color into interesting directions.

Abstractions in which free-flowing color is the goal and imaginative landscape compositions make ideal subjects for this method of painting. You do not have to prepare a preliminary sketch, as you will be painting with flowing colors, working in the abstract shapes and images while the color is still wet.

Working with Wet Paper over a Sheet of Glass or Lucite

The artist either sketches in the subject lightly while the watercolor paper is still dry or paints it in after the paper has been moistened. A wet blanket of blotting paper is laid on a horizontal sheet of glass, Lucite, or Plexiglas. The paper is heavily dampened with water and laid on top of the wet blotter and glass. The larger washes are applied to the paper while it is still damp. They merge and spread, with many interesting accidental effects. As the paper dries, all the other images and finer details are added.

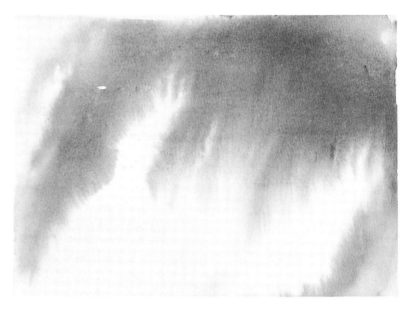

The streaky wash is the more spontaneous method of watercolor work. Brush on clear water over paper, and while it is still wet, drop some pigment on the upper part. Pick up one corner of the sheet and let the color flow where it will or as far as you wish; when you lay the paper flat down, the action will stop while the surface is drying.

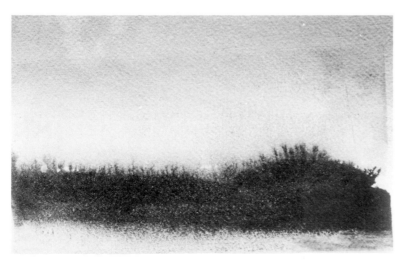

By manipulating the paper, you can cause the streaks to blend together.

The colors must be used in their strongest values, because they are less vivid when they dry, producing what is called the washed-out look. Therefore, a great deal of daring is essential.

Working on Dry Paper with Mingled Color

Mingling your colors is simply allowing them to run into one another while they are still in the wet state. This technique is used when you wish to achieve a variety of hues and intensities, especially sunset skies and cloud formations in a landscape. The mingling is done directly on the paper.

One procedure for mingling is to drop two or more colors from your brush onto the paper and permit the colors to flow into one another. Control the flow of pigment either with your brush or by tilting your board to allow some areas to mix more than others. Allow the colors to be full strength in some areas; in others mix them only a little; in still others, make them lighter by adding more water.

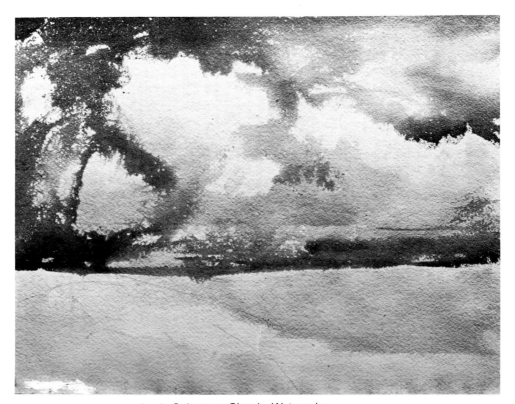

Lucia Salemme, *Clouds*. Watercolor.
You can render billowing **clouds** in sky areas by not painting in any color in the areas themselves. In the space around them however, all sorts of tonal variations are permissible.

Project: WET-IN-WET

SUBJECT: Still life

TOOLS AND MATERIALS:
- Set of cake watercolors
- Sheet of hot-pressed, smooth 140-pound watercolor paper
- Drawing board
- Brown paper tape
- Sable or oxhair brushes, rounds and flats, assorted sizes
- Blotters
- Sponge
- Box of cleansing tissues
- Large jar of clear, cold water

1. Start by selecting one each of apples, oranges, pears, bananas, or other fruit.

2. Place them in an interesting arrangement over a draped tablecloth of a contrasting color such as blue or violet.

3. Sketch in your composition with a light pencil.

4. Wet the paper lightly with a sponge.

5. Apply paint to all the larger areas of back-ground drapery. Then continue on to the smaller shapes of the fruits, being careful to leave a space when placing a new color next to the one you have just painted. If you don't, the colors will run into each other. Also, be sure to change the water in your jar frequently; working with clear water is what keeps your picture from getting muddy.

6. Try not to get *too much* water and paint in your brush when you come back into an already painted wet area.

7. When working on really soaking-wet paper, all action is much slower. If you wet the paper only on the surface the colors take less time to dry, as does the paper. To hasten the drying process you can use a hair dryer.

8. If you wish to have sharp edges to your objects, lay your wash onto completely dry paper and then add your dark break-ins to this wet wash. Come back in with great speed, as your underwash dries even more rapidly than paper sponged with just clear water.

When you have finished, do another version of the still life by changing the arrangement of

While paint is still wet, use facial tissues or a soft sponge to blot out any unwanted color.

the objects on the table, as that is the only way you will paint as many pictures as you can. Get the *feel* of working with watercolors and you will find that your daring will become almost automatic.

Project: COLOR MINGLING

SUBJECT: Sky at sunset

ILLUSTRATION REFERENCE: L. Salemme, *Cape Split, Maine*

TOOLS AND MATERIALS:
Set of cake watercolors
Drawing board
Sheet of hot-pressed, smooth 140-pound watercolor paper
Brown paper tape
Sable or oxhair brushes, assorted
Blotters
Sponge
Cleansing tissues
Jar of clear, cold water

Brush one color directly next to or under the first one while it is still wet. The artist can tilt the board to control the running or "bleeding" of one color into another, picking up unwanted color with a clean blotter. A sunset sky with billowing cloud formations is an ideal subject for a color-mingling study.

1. Start by sectioning off the paper so that the top two-thirds is used for the sky area. Work with a light pencil to sketch in the cloud formations. Keep the sketching down to a minimum, because you will rely on the mingling of the colors to indicate the imagery.

2. The bottom third of the paper is the foreground. Here you may be very definite about what you put down. You can sketch in a frieze consisting of rooftops, trees, or hills. Select the scene that suits your fancy most. Again, sketch in your images with a light pencil.

3. Completely wet the paper, either by immersing it in a tub of water or by soaking it with a sponge, and proceed to paint the sky area.

4. Wait until the paper is fairly dry before painting in the foreground, because here you will be requiring more control of the color. Try

several versions of this idea—before you know it, your sense of daring will become stronger.

Opaque Effects with Gouache

Gouache painting is a technique dating back to the Old Masters. The colors have been ground in water and mingled with a binder prepared from gum arabic. It is popular with many of today's painters because it is a quick, warm medium, ideally suited for rendering quick impressions, while allowing overpainting when subtle effects are required. The characteristic look of a gouache painting is the dry matte quality of the colors. Do not confuse plain, everyday poster colors with gouache, or watercolors from tubes that you have mixed with Chinese white. These by comparison are drab, flat colors without any life or warmth. Furthermore, the paint will in time flake and chip.

The technique calls for thick application of paint, which allows the artist great freedom in achieving textural effects quickly without too much preparation.

A good binder is what makes gouache. The best gum arabic is made from either the acacia or senegal plant. When you buy your paints, check with your supplier to see that your colors are made with these products. Winsor and Newton Designers Superfine Gouache colors are used by most professional gouache painters, and I suggest you use them too.

Avoid painting on boards; they contain considerable filler or glue, and you will find your paint sliding. The glue prevents gouache color from penetrating fully and adhering to the surface; it will scratch off easily. Also, because boards are rigid, they are easily affected by changes in temperature, which causes buckling; and that in turn will cause any thick color to crack off. If you can afford it, use only the best unmounted pure linen fibre paper for gouache work. In selecting paper, use only the linen with a slight suggestion of "tooth." For the actual painting, it is not necessary to glue the paper to a board or frame as you do for

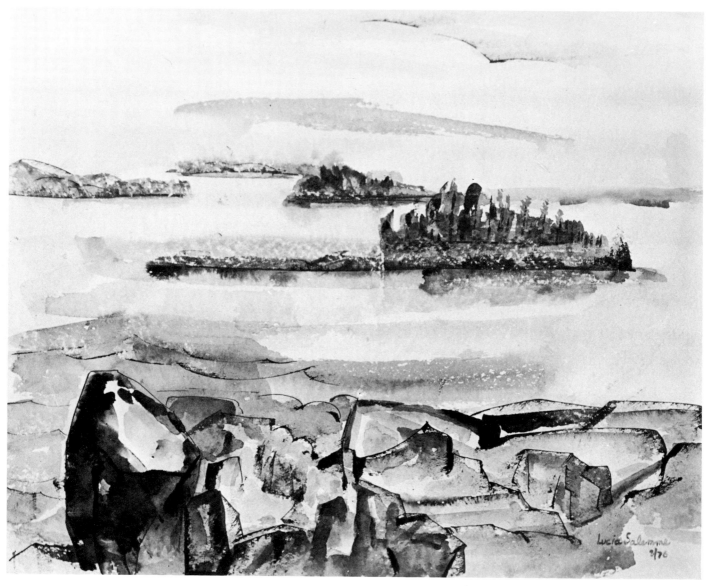

Lucia Salemme, *Cape Split, Maine.*
Watercolor on paper.
Mingling. In mingling, one color is brushed
directly next to (or under) the one already
there while it is still wet. The paper can be
tilted to control the running or "bleeding" of
one color into another. Pick up any unwanted
painted with a blotter, tissue, or soft sponge.

Lucia Salemme, *Small Town*. Gouache painting on white
paper.
The traditional method of using opaque colors is to apply
thick coats of paint onto a clear white surface.

watercolor painting. For gouache, simply tack the paper to a drawing board, using enough tacks to keep the paper taut. The paper may buckle slightly at the start, but as you continue to paint you will find that it tightens up.

Bristle brushes of the short, square variety are best when using gouache paints.

You should learn some of the problems and techniques of this medium. Do a series of sample applications of your gouache colors singly to get acquainted with them. Paint small patches of each color. Although this is an opaque technique, you gradually build up to the impasto state by beginning the picture with a series of light-colored washes. Keep a large supply of clean brushes on hand, because clean brushes are a necessity in gouache painting.

Try to finish your picture in one sitting. Do the most important portions as quickly as you can, leaving details to be done later. It is always best to work wet-on-wet. If the paint is allowed to dry, reworking is difficult, because the colors dry to an almost enamel-like surface that does not absorb any fresh paint. Many colors "sink in" and become rather flat, but you can brush a watercolor varnish on your gouache painting after it has dried for about four months. The varnish will bring back its original brilliance and will retain luster. This is a harmless procedure since the varnish is made up of a small quantity of bleached beeswax, a solution of a synthetic resin, and some purified petroleum spirit. The varnish dries with a matte finish that will both preserve it and protect the sparkle of your gouache painting. This product is called Winton Mat Varnish and is made by Winsor & Newton Inc. This, of course, is the alternate method of preserving work done on paper. The best is to mat and frame the picture under glass in an airtight frame.

Lucia Salemme, *In the Country.*
Graded washes, going from light toward dark or dark toward lighter tones, can be achieved in various ways. One way is to work on rough surfaced, dry paper.

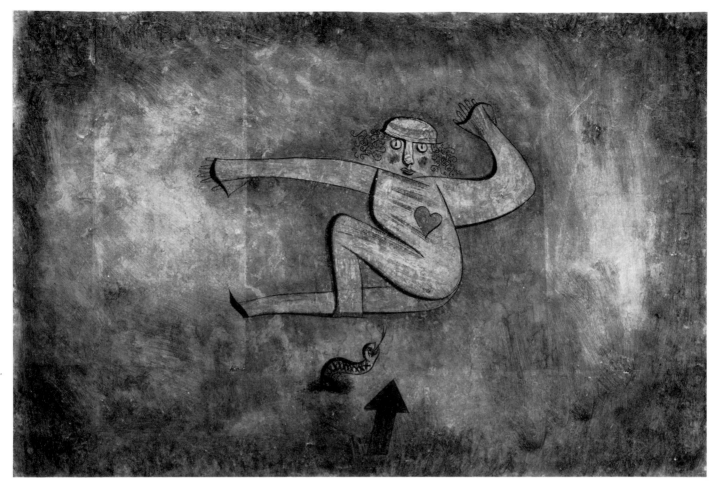

Paul Klee, *Serpent*. 1923 Gouache, ink, collage.
(Former collection of The Solomon R. Guggenheim Museum, New York.)
Combined media. Once the underlay of opaque gouache color has dried, it is safe to superimpose any number of additional media to bring the picture to completion. Colored inks, pastels and collage are the most popular.

Project: GOUACHE

SUBJECT: Figure in room interior

ILLUSTRATION REFERENCE: L. Salemme,
 Portrait of Louisa Calder in Saché Kitchen;
 Contemplation; Two-Stages (color section,
 pages 29 and 31)

TOOLS AND MATERIALS:
 Large tube of Chinese white
 Designer superfine gouache colors
 Drawing board
 Thumbtacks
 Cold-pressed, medium-rough watercolor paper
 Enamel or plastic palette with grooves
 Jar of clear, cold water

In a gouache painting it is not advisable to apply impasto applications of pigment at the outset, because the paint will peel off when it dries. The best method is to build up to the impasto state gradually by a series of color washes superimposed over each other.

1. Begin by making a good drawing of the room interior with figure.

2. Then wash in a slight white tone over the large areas of the composition which is usually the background space. Paint around the smaller areas (the face, hands, and figure).

3. Build up the different colors of the smaller objects gradually, starting with thin watery versions of each color, leaving the painting in of the highlight areas for the last. Plan to continue painting your gouache so that it is finished in one sitting. Do not allow it to dry over a long period before you rework it. As the paint hardens, it will not absorb any fresh

Pablo Picasso, *Young Acrobat and Child* (*Two Harlequins*). Gouache on gray cardboard.
(The Justin K. Thannhauser Collection, The Solomon R. Guggenheim Foundation, New York.)

Transparent and opaque together. To use transparent and opaque color together in the same picture, add a little opaque white to all your watercolor washes. Picasso demonstrates how to combine the two in one picture: transparent washes are put down in the large areas and opaque gouache where three-dimensional qualities are needed.

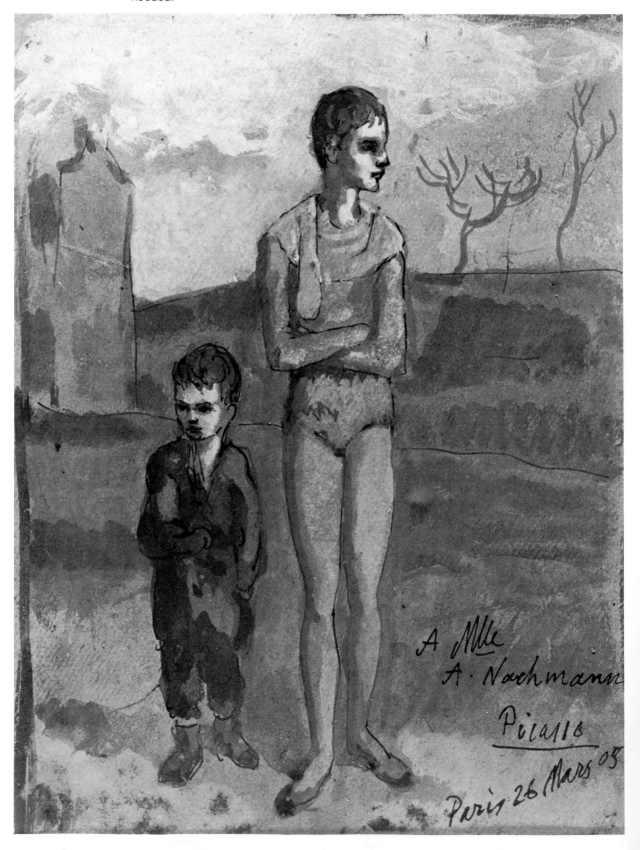

paint, and what little fresh paint that does adhere will most likely flake off as it dries.

4. After the colors in the large areas have dried, you can begin building them up further with more paints until the desired color is achieved.

5. Paint in all the details of highlights last, like the facial features, hands, hair, and whatever small objects there are in the room. You may wish to overpaint or superimpose in some areas, but only in small areas, because too much may cause pigment to flake off when it has dried.

6. You may occasionally wish to brighten a color after the gouache is finished. It is permissible to apply a little pastel, provided that the area to be covered is not too large. Blend the pastel in with the fingers.

7. Many colors when wet are very bright and then "sink in," becoming rather flat when dry. Some painters have found that by brushing on a watercolor varnish after the picture has been allowed to thoroughly dry for about four months, the original brilliance and luster are brought back.

But the best method of protecting a work done on paper is to mat and frame it under glass in an airtight frame. If this is not possible, the next best is to cover it with the watercolor varnish.

Project: TEMPERA

SUBJECT: Country scene

ILLUSTRATION REFERENCE: A. Wyeth, *Dodge's Ridge* (color section, page 29)

TOOLS AND MATERIALS:
 One egg
 Color pigments in dry powder state (should be ground in water with a muller on a glass palette and kept in small covered jars)
 Brushes: assorted sizes, sable hair
 Masonite panel, 18″ × 24″
 Acrylic gesso
 Palette, either glass, porcelain, or paper

In tempera painting the preparation of the masonite panel is essential. This is done by applying four coats of the acrylic gesso. The first coat is brushed on in horizontal strokes, the next with vertical brush strokes, then again with horizontal stroking and finishing with a coat of vertical strokes. It is best to work on a glass palette with a sheet of white paper underneath.

In this type of painting the yolk of the egg is your medium, and if you want the medium to be thinner, dilute it with a little water. Any unused egg yolk can be kept in a closed jar in the refrigerator for one week. To prepare this medium, separate the yolk from the white of the egg, and then gently pick up the yolk with the thumb and forefinger. Puncture the thin membrane from the bottom and release the liquid into the jar and discard the membrane. The medium is what you have in the jar. Now you are all set to paint in tempera.

1. First make a good drawing of a country scene. Include whatever features you consider characteristic of a country setting—clouds, hills, fields, trees, barns, people working, cows, and the like.

2. Starting with thin linear brush strokes of green earth color, gradually begin to build up color areas. This will be the underpainting.

3. Use a warm pink color for the second layer of brush strokes, modeling with fine brush lines. The combination of warm over cool color creates a glowing, luminous surface.

4. To give the painting an extra glow, paint in all the details by using vivid color, first with strokes of yellow, then with strokes of bright red placed over the yellow.

In tempera painting the pictorial forms need to build up in stages with individual brush-stroking. The work is done on the smooth, gesso-covered masonite panel over a good underdrawing. The tones are created by starting with a thin coat of cool color, gradually building up progressive color layers with warmer hues, usually pink. The linear modeling is done from the center of each form, the direction of the brush stroke going in the direction of the cloud, rock, tree, hill or barn that is being painted.

Part Seven

OIL PAINTING

Detailed descriptions of all the equipment needed for painting in oils should be studied carefully so that you thoroughly understand what is needed both for obtaining your best results and to give you clearer insights in the rendering of the projects. It is most important to keep in mind that each work session should be planned so that you have enough time set aside for the execution of your ideas and that you have adequate studio space to work in without interruption.

WORK PLACE

When you first start to paint it is a good idea to find one room in your home where you can set up an easel and keep your work and supplies permanently. Almost any room can be made perfectly workable as long as it is private, for this is where you dream up your ideas and where you make them tangible. It is where you experiment with new art forms that someday may become your lifework. Plan your work area carefully to create an environment conducive to private thoughts.

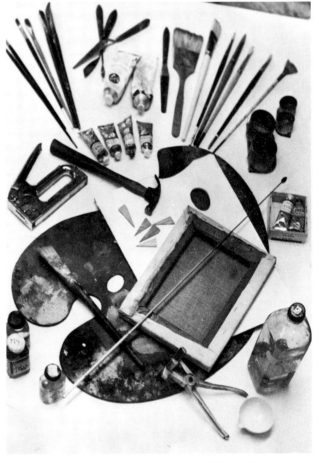

Some of the tools and materials you will be using in carrying out the oil painting projects.

The first step in setting up a proper work area is to select a room with a good light. The ideal room has a natural north light. Failing that, you can install light fixtures to create almost any kind of environment you desire. Most painters prefer the natural north light, because it affords a steady light, free from streams of sunlight and strong shadows. This even lighting may seem cold, but it is desirable, especially if you are working from a posed model or a still-life setup for which an unchanging light source is essential. Today many artists also rely on electrical lighting in the form of daylight lamps and reflectors to light up their work areas. An ordinary room has an advantage over a studio with a north window in that objects and people look more natural in a lived-in room, which they seldom can in the cold, north-lit studio. It is a matter of choice.

TOOLS AND MATERIALS

The Easel

After deciding where you will work, you will need an assortment of basic equipment. Very important is a good, sturdy easel. It should be rigid.

Work Table

You will need a table next to the easel to keep all your materials at hand. An old television table on wheels is ideal for holding your palette, paints, and brushes.

One compact painting cabinet on the market is made to hold your palette on the top with two drawers for brushes and tubes of paint. Its door opens into the bottom half of this cabinet with shelves to hold large cans, rags, and extra supplies. It is on wheels, so you can easily

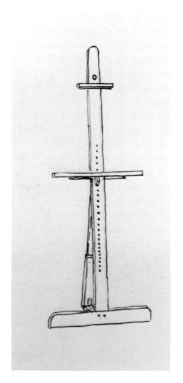
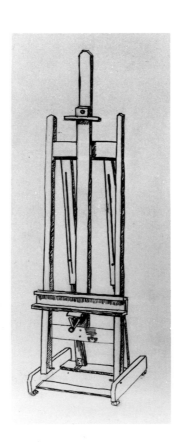
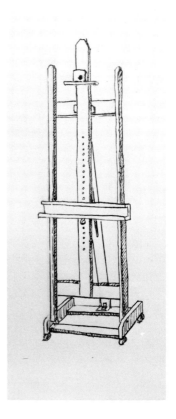

Very important is a **good, sturdy easel.** Choose the one that best suits your individual needs.

push it about the studio to any painting position.

You can make a work table from a large panel of ½-inch plywood placed on two wooden sawhorses. This table is good for holding sketches and your assortment of brushes and media or anything else you may be needing for your work.

Several 3-foot-high stools are good for either sitting at your easel or holding your palette.

The Paint Box

A good paint box for storing your tubes of oil color make it possible for you to have all your supplies on hand. At a moment's notice you can take it with you when you wish to paint away from your studio. All kinds of boxes on the market can be purchased in any art supply store. They are usually partitioned for tubes, media, and brushes, and their lids have grooved channels for holding canvas boards and palette.

Many boxes are made of wood, and their prices vary according to how they are finished. You may finish the least expensive box yourself simply by sandpapering and staining the wood and then varnishing it. However, the metal hardware of the higher priced boxes makes them sturdier, and all-metal ones are the strongest. If you feel you will be traveling a lot with your box, either for outdoor painting or on trips back and forth to different studios, the all-metal box is the best.

Tin Palette Cups. Tin palette cups clip onto your palette to hold turpentine or linseed oil. Palette cups fitted with screw-on caps to prevent spilling are ideal for outdoor sketch trips. They clamp onto the palette and are 2 inches in diameter.

Heavy-Duty Canvas Pliers. Heavy-duty canvas pliers are made with a hammer jaw, which acts as a lever when a strong pull is required. These pliers measure 8¾ inches in length, and the width of the jaw is 3½ inches. They weigh about 18 ounces.

For extra-heavy duty and long life, you can buy canvas-stretching pliers that act as both a hammer and pliers.

A variety of medium cups for holding turpentine, linseed oil or medium.

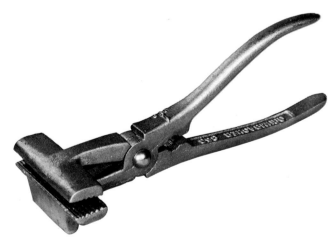

Heavy duty canvas pliers are made with a hammer jaw, which acts as a lever when a strong pull is required.

Pins and Clips. Canvas pins are used for holding wet canvases or panels apart. They are made of double-pointed steel pins through a plastic or wooden base.

Strong spring-controlled canvas separator clips allow you to carry two wet canvases face to face without touching them together.

Mahl Sticks. Many artists working on wet canvases use mahl sticks to rest the painting hand to avoid smudging the newly painted areas. It also steadies the hand when doing delicate work. Made of sturdy lightweight aluminum, they are well balanced and come in three 10-inch threaded sections that slide in and out of each other to obtain the desired length.

Composition Aids. Object rests such as small end tables or model stands and shadowboxes are used when you wish to light up your posed model or still life to get more dramatic light-and-dark effects. You can easily make your own shadowboxes by cutting away two sides from a cardboard carton. Fabric thrown over the box can provide a desirable color for your background.

How you light up your subject is most important. Shades and shadows are elements of composition that must be distributed as effectively as the objects. In fact, the compositional arrangement is largely determined by the shapes and values of light-and-shadow areas and edges.

You can set up cardboards to catch light and reflect it onto the objects much as photographers might do in portrait work. The cardboard or cloth acts as a reflector, throwing back light on certain surfaces. If it is of colored material, it modifies the color effect of the entire grouping.

You can make your own viewfinder from a 3″ × 5″ piece of black cardboard by cutting out a 1-inch-square window in the center. By holding it at arm's length, you can easily look through it to select a landscape view to paint from. You may also use it before starting a figure or portrait, to decide how much of the pose and background you wish to put into your composition.

Painting Knives. Painting knives for direct knife-painting techniques come in a variety of sizes and shapes. Although some artists like to have a large collection, you can reduce the number to a basic few. Here are three:

Trowel-shaped knife with a wooden handle and a 3½-inch pointed blade

Squat 2-inch trowel with a rounded tip

Flat, straight blade for mixing

Knives are a favorite tool for artists because they require very little care, needing simply to be wiped clean on a rag at the end of the painting session. Most knives are made from tempered steel and are therefore extremely flexible.

Palettes. A favorite palette for beginners is the disposable, all-purpose palette pad. It fits in all paint boxes and contains about 50 oil-proof and watercolor sheets, 12″ × 16″. These

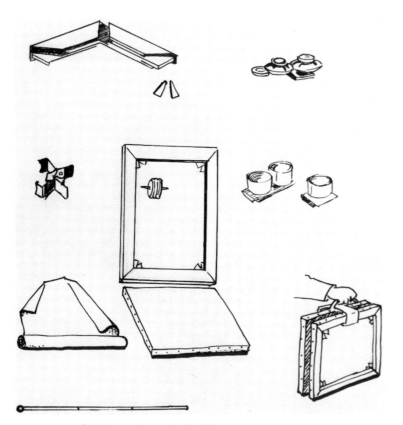

Basic equipment: stretchers, canvas clip, two-pronged pin, stretched canvas, roll of canvas, mahl stick, and canvas carrier.

View finder. Cut out a one inch square window in the center of a 3″ x 5″ piece of black cardboard. When it is held up and looked through, it makes the selection of an interesting view much easier.

Shadowbox for holding still life set-up. You can easily make a shadowbox out of a corrugated cardboard carton. Cut away two of its sides, and place the still-life object inside it. The aim is to catch and reflect light and shadows onto the still life.

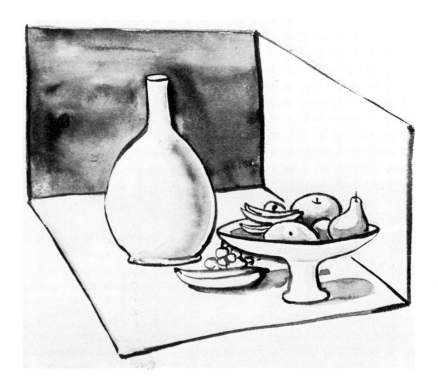

disposable sheets give you a clean fresh surface for each painting session and eliminate messy scraping and cleaning or working on dirty, caked-up surfaces. Simply peel off the used sheet, and a new palette is ready. Also on the market is a palette made of specially processed stronger sheets that supply a sturdier surface to mix your paints on.

Professionals prefer wooden palettes, because you can better evaluate the hues you mix on the warm brown surface of the wood. The most popular is the oblong palette made of mahogany plywood. A specially polished sur-

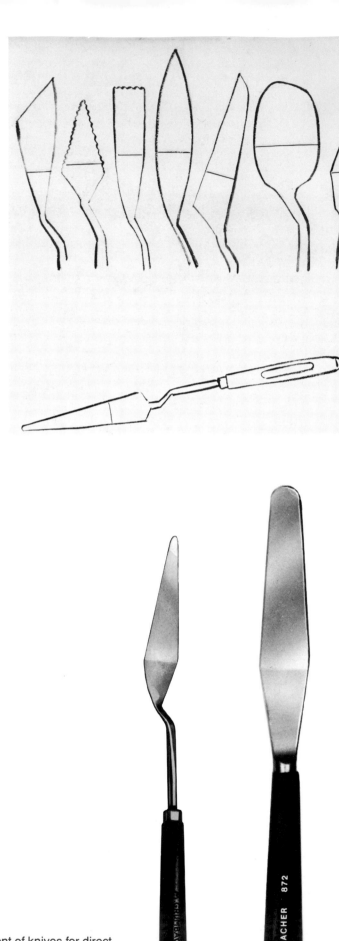

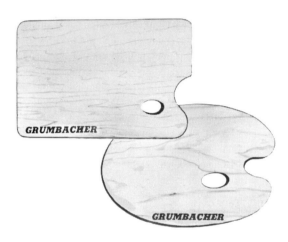

Palettes. The disposable paper palettes for beginners, wooden ones that fit in all paint boxes, and the most expensive—those that balance onto your arm are available in art supply stores.

Painting knives. An assortment of knives for direct palette-knife painting. Some artists like to have a large collection, but the basic two are:
The **trowel-shaped** knife with a pointed blade used only for painting.
The long **flat-blade** knife for mixing colors and rough scraping.

face is also available. The most expensive is a palette that the painter balances on the arm. It is made of selected mahogany plywood, free of blemishes. The back is reinforced for support. To lessen strain on the artist's thumb, the hole is placed to ensure perfect balance; this shape is the result of careful research. This palette has three coats of a hard finish that is resistant to the oils, varnishes, and turpentine usually used by artists. This finish is only used on the surface of the arm palette.

Brushes: Bristle and Sable

Brushes are especially important to the success of oil painting. Because inexpensive brushes in the long run prove to be a waste of money, buy only the best. You will not need many, and given good care they will last a long time. Brushes come in all sizes and shapes. Compare the different brushes your dealer has in stock. Artists' preferences differ, and your choice will depend on your method of working. Your experience will eventually dictate which brush you will use where, after you have first experimented with each one. Bear in mind that brushes are the chief tools of your profession or avocation.

Most bristle brushes are made from hog hair. Manufacturers vary in the way they number their brushes. It is sensible to buy according to size rather than number: extra large, large, medium, and small. The more expensive brushes will not produce a fuzzy stroke or shed their bristles. High-quality bristles curve from both ends of the ferrule toward the middle; the bristles in the middle are straight. A brush built in this manner allows for the greater precision necessary in portrait painting. The cheaper brushes have bristles that are narrow at the ferrule and wider at the tip, giving a fuzzy and loose brush stroke; they are useful for free spontaneous painting.

Bristle brushes are about 150 years old. In their present, up-to-date appearance they have a flat ferrule (the Old Masters' brushes were oval) that forces the painter to handle them on the broad side of the bristles' body. The flat brush is the right brush for underpainting,

Brushes come in all sizes and shapes. The ones you choose to work with will depend on your method of working after you have experimented with each one. Buy them according to size rather than number; extra large, large, medium and small. There are three basic types made from both bristles and sable hairs, the flats, the brights and the rounds.

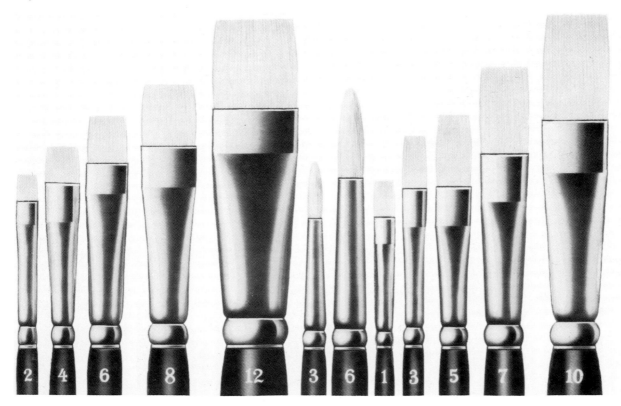

because of the rhythmic stroke you get from it when painting on rigid surfaces and panels.

There are three basic types of brushes made from both bristle and sable hairs: the flats, the brights, and the rounds.

The flats possess longer bristles that allow for a more fluid brush stroke and do very well in underpainting and also to blend the oil colors.

The brights have a shorter body of bristles that allows for more vigorous brush work. They are efficient for transferring large amounts of paint to the canvas, making them the right type for painting large areas.

The rounds have a round body of bristles. When the bristles are short, they work well for painting on rigid surfaces such as masonite or canvas boards. When the bristles are long, they easily become ragged from painting on large canvases, and the fuzzy marks they then produce are ideal when mingling colors.

Sable-hair brushes for oil painting also come in flats, brights, and rounds. The hairs on a good sable-hair brush should be uniform and should, at all times, keep a sharp point. They are expensive, but they can produce all sorts of flamboyant brush strokes, because they are springy, flexible, and resilient to touch. The smaller brushes allow for maximum control and are ideal for portraiture. Because the small brush requires frequent reloading with fresh paint, it is best for areas that call for careful work. The larger brushes hold more paint and can be used not only for applying paint to the canvas, but also for producing draftsmanlike delineations. The smallest sable brush is called the *liner*; it is used mainly for signing pictures and for extremely small details. The next smallest is the *script-liner*, which produces hairline details. The sable-hair brushes are used when some really smooth and delicate blending is desired.

Good brushes will give many years of service. After painting, you should rinse your brushes in gum turpentine or a turpentine substitute, wipe them thoroughly, and then wash them with a mild soap and warm water. Shake each one out, and then squeeze it so that it assumes its natural shape.

For drying brushes, stand them in a jar, with the bristles exposed to the air. Let them dry overnight before using them again. If an old brush starts to loosen, it can sometimes be fixed by hammering the ferrule. Do not throw out used brushes, because you will be able to use them for scumbling and glazing.

PAINTING SURFACES

Anything that can be painted on is referred to as a support. It is either a canvas or some form of panel. Good-quality canvas can be bought already primed and stretched, but that is expensive. Panels are cheaper, but the choice between panels or canvas is a matter of taste. If you are planning to use lots of paint with a palette-knife technique, panels are stronger and cheaper. Masonite panels or canvas boards, which are more rigid, afford excellent support for heavy impasto paint. Many artists use $\frac{1}{8}$-inch masonite panels, that have resistance and can take much manipulating during rough work with sand and other vehicles.

Fabrics

When starting a new painting, you can best select the canvas by knowing something about the textile from which canvas is made. The fabrics commonly used for canvas consist of threads that interlace at right angles, a method of weaving that produces the tightest canvas, because the threads are closely entwined.

Artists' canvas is woven from the fibers of flax, hemp, or cotton. Flax produces a fine linen fabric, the one chiefly used to make canvas for the painting of easel pictures. Hemp produces a coarse fiber about 2 yards long which is used to weave fabrics that are even and strong. This fiber is especially well suited to the larger canvases. The large paintings of Veronese, Tintoretto, and others are painted on canvas made from hemp fiber.

Cotton, when closely woven, is as good as linen. It is suitable mostly for smaller sizes.

Most manufacturers make an all-purpose canvas, which takes oils as well as acrylics. This canvas is double primed with acrylic polymer gesso, producing a flexible, nonyellowing white surface. Colors applied to this surface retain their brilliance and do not "sink in."

Imported Belgian and Irish Linen. Like many other people, you may wish to prepare your own canvas. You will need a strong 100% cotton or linen (unbleached) fabric of a heavy weight and close weave. You can prepare it for painting (after stretching it onto stretcher strips, as described in the next section) by giving it a sizing of rabbit-skin glue and then priming it with flake white thinned with turpentine. This method assures you of getting the best possible support for your paintings. Cotton and linen come in a variety of weaves, and you can select the one you like best.

When you are in a hurry, unprepared cotton duck canvas can be primed by painting the stretched surface with Utrecht's New Temp Gesso directly onto the unprepared canvas. It can also be primed by the method described above.

If you do not have the studio space or time to prime your own canvas, buy the ready primed, which is much more expensive. It is available at all art supply stores. Canvas cotton duck is what most beginners use. It comes in either single-prime or double-prime rolls of 6 yards or more, in widths commonly ranging from 36 inches to 72 inches. For very large canvases or murals canvas comes in widths of 84, 92, 120 and 144 inches.

Stretcher Strips

Stretchers are wooden strips 1¾ inches wide that come in different lengths for making the frames on which the canvas is to be stretched. Lengths range from 8 inches to 60 inches. For the larger-size canvases, use heavy-duty strips of 2½ inch width. They are necessary where more rigid support is needed and come in lengths ranging from 24 inches to 84 inches.

To make a stretcher, the first step is to decide what size picture you wish to paint. Then select the suitable strips to put together to make the desired size. For example, for a 20″ × 24″ canvas, two 20-inch and two 24-inch strips are needed. Each strip has grooved openings so that they can be easily joined. After you have put the different lengths of stretchers together, cut a piece of canvas about 2 inches wider than the outer edge of the put-together stretcher frame.

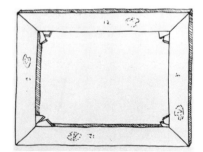

Stretchers are wooden strips for making the frames on which canvas is to be stretched. They come in interchangeable sizes, ranging from 8″ to 60″.

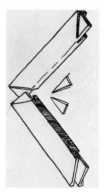

Primed Canvas Stretching Procedure

Wait for a damp, rainy day to stretch canvas, but if this is not possible, slightly dampen the back of a canvas with a sponge dipped in water. Lay the piece of cut canvas on a low table or the floor and place the stretcher on top of it, making sure that the bevelled side of the wooden strip goes next to the canvas. Center it so that the weave runs parallel to the sides of the stretcher frame.

Begin by first tacking or stapling the canvas to the center of each side of the frame, stretching it evenly all around by pulling it over the wood strips and placing tacks or staples on the

edges. Repeat on the opposite side and then to the other two sides, pulling the canvas tightly before fastening with a tack about every 2 inches from the center to the short sides. When you come to the corners, overlap the canvas into a firm fold, and staple or tack it into place. Your stretched canvas should be tight as a drum, but if there are any wrinkles, you may use keys for wedges to tighten up the canvas. By placing a key or wedge into the opening in the inside corners of the frame and carefully tapping them with a small hammer to "separate" the joint, the canvas will become as tight as a drum.

Stretching Raw Canvas

The following method is used to stretch raw canvas before the gesso size is applied to it:

1. First, decide the size of picture to be painted and select the suitable length stretcher strips.

2. Assemble stretcher strips firmly together into a rectangle. Check with a carpenter's square to see if the corners are correctly joined. Use standard 1¾-inch-wide strips for sizes up to 40 inches and extra-heavy 2½-inch-wide strips for larger works. When using larger sizes, it is wise to reinforce the stretchers with a crossbrace to prevent any twisting caused by shrinking of the canvas during the drying of the wet glue size. The usual way to crossbrace the stretchers is to place a strip of wood snugly in the shorter inside distance between the stretchers and to connect with steel mending strips fastened with screws. One crossbrace will allow you to key out at least two sides to tighten up the unprepared canvas.

3. Lay the canvas on a low table and place stretchers face down over it. Center it so that the weave is parallel to the side. Tack or staple on the canvas to prevent distorting its shape while it is being stretched.

4. Cut the canvas at least 1½ inches larger than the stretcher size on every side. Begin attaching the canvas by pulling it over strips and by placing tacks in the center of the short side.

5. Pull the canvas tightly toward the corner of the short side and tack it down. Repeat on the opposite corner of the same side. The canvas is now fastened with three tacks.

6. Stretch the canvas from the opposite short side. Pull tightly from the center and

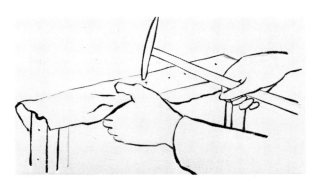

Canvas stretching procedure: First cut the canvas so that it is at least 1-1/2″ larger than the stretcher size on all four sizes. Then place the canvas on a low table or on the floor. Next, place the assembled stretchers on the canvas and staple or tack down the canvas to the stretcher at the center. Begin from the middle. Pull the canvas tightly toward the corner and tack it down.

fasten with a tack. Then pull one corner at a time in a direction away from the center of the stretcher and away from the opposite side.

7. Now start stretching and nailing tacks approximately every 2 inches out from the center of the short sides.

8. Repeat the same procedure for the longer sides.

9. Leave the corners free until the end, then fold the canvas and place tacks in the wider part of the stretcher joint at alternate ends of the bars.

Any wrinkles will disappear, because the canvas will tighten up after the gesso has dried.

SIZING AND PRIMING

The texture of the surface you paint on is so important that you should prepare your own if you have the time. When you are learning to paint you must realize the paramount importance of the ground on your canvas. Only by experimenting can you find your ideal surface—smooth or rough. An unsympathetic surface can be quite a detriment and can affect your performance in painting a picture right from the first brush stroke. Instead of the paint's flowing easily, it seems to fight you all the way. Some canvas boards or panels seem to drink up the paint, and no matter how solidly you work, the surface always appears flat. Instead of painting a picture, you find yourself using all your good paint to build up an added priming.

Unprimed linen or cotton canvas can be prepared in two ways. The one frequently used today is a new product manufactured by Utrecht, called New Tempo Gesso, especially to be used on unprimed canvas. It comes in cans and is ready to apply with a flat 3-inch nylon brush directly on the unprepared canvas. It dries in a matter of hours, and the canvas is ready for painting with oils.

The second is the traditional method. The canvas is sized with a glue solution and is then coated with flake white. This combination has to dry for at least ten days before you can paint on it. When using this method it is advisable to prepare a number of canvases at one time, so that you have a supply in readiness as you have a need for them.

Making Glue Size

To make the glue solution, begin by buying the granulated form of rabbit-skin glue. Make only enough for one day's use, because it cannot be stored. To prepare a batch of glue, heat a quart of water (don't let it boil). Turn off the heat and add six tablespoons of glue little by little, stirring each addition of glue until it

The gesso primer is used only on boards or masonite panels. The purpose of a primed surface is to protect the finished picture from outside elements that may penetrate the surface of the panel. Since the primer is elastic it enables the canvas to yield to actions created by the different layers of colors during their drying process. This yielding of the primer is what later on prevents cracks in the dried, finished picture.

The glue size. Heat a quart of water (don't let it boil) and add six tablespoons of granulated rabbit-skin glue, a little at a time, stirring until the glue is dissolved. Apply the glue size to the canvas with a large nylon brush about three inches wide and allow it to dry for about two hours. If the surface is a little rough, rub it down with fine-grained sandpaper, then apply a second coat of the size. When dry, the canvas is ready to be primed.

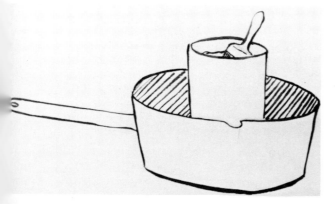

is dissolved. Apply this size to the surface of the canvas with a sponge or a large nylon brush about 3 inches wide. Avoid missing any areas by working on one spot at a time, going back and forth, first in one direction, then in another. Let it remain in a well-heated room, and the canvas will be dry in about two hours. If it is a little rough, rub some fine-grained sandpaper very lightly over the whole surface. Next, apply a second application of the size in the same way. When it has dried, the canvas is ready to be primed.

Priming with Gesso Ground

The purpose of a primer is to protect the picture from any destructive elements that may penetrate to the surface of the canvas. The elasticity of the primer enables the canvas to yield to actions created by the different layers of colors during their drying process. This yielding of the primer is what later on prevents cracks in the finished picture after it has dried.

Artists enjoy painting on a primed surface, because it is attractive to paint on. The colors are made more transparent by the white ground shining through, helping to keep the picture luminous.

Gesso is the oldest and most traditional of primers. It should not be used on canvas, because it is more brittle than white lead. You use it only on well-sized boards or masonite panels. Before today's new products were in-

vented artists first gave the board or panel a coat of glue size. Some gesso was mixed into the remaining liquid glue size until it was the consistency of cream; while the size was still warm, the mixture was brushed onto the canvas. A panel being gessoed may need a second coat after the first one dries, since it is more absorbent than other primers. Because gesso primers are made from white chalk powder with a glue size, they are not injurious to colors and are permanent.

You can get some interesting textures by sticking pieces of burlap and linen of different weaves onto the panels together with the size and primer.

Priming with Oil

When oil priming a canvas, a white-lead paint is often used, because it contains very little oil. The priming determines how absorbent the canvas will be, depending on how thick or thin the primer is.

For a matte finish (that is, when you wish your paint to dry flat rather than shiny), use a thin primer. You can thin it with turpentine. A thin primer can be used only on very fine, closely woven linen that primer cannot seep through.

For a glossy effect or when you wish your paint to dry with a sheen, you use a thick primer that makes the canvas less absorbent. Use a canvas that has a coarse, loose weave and primer of a thick consistency.

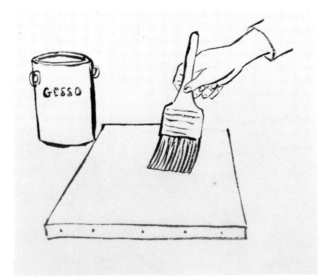

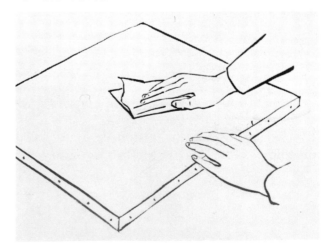

A canvas being gessoed may need a second coat after the first one dries.

MEDIUMS

An oil painting medium is a liquid that, when added to tube colors, alters their consistency and brushing properties. It is made from a balanced mixture of an oily ingredient (linseed oil), a resinous ingredient (copal varnish), and a dilutent (turpentine) or thinner. The proper painting medium will enable you to use a variety of painterly effects, will increase the brightness of your colors, and will in no way affect the durability of the finished painting.

Today, painting mediums come in a variety of laboratory-tested forms. They are manufactured by reputable dealers and are readily available in art supply stores.

You will be able to use the medium to paint in thick or thin paint applications in the impasto, scumbling, or glazing techniques, so your brush can run freely with the flow of your ideas. The supreme example of this ease of execution can be seen in the work of the great master Rubens and painters of the French Academy, Georges de la Tour and Nicholas Poussin, in the seventeenth century, when paintings of the human figure reached their peak of popularity.

The Uses of Mediums

Oils and pigments that have oil for a base are at their peak of natural adhesion when used as they come from the tube. The more they are exposed to the open air on the palette, the less their adhesiveness. To retain the natural glueyness of the paint, to make for permanent adhesion, one should always use fresh paint and avoid leaving large remnants of color on the palette. Because the colors straight from the tube are too stiff for effective manipulation, we resort to the use of mediums such as turpentine, linseed oil, and either standoil or copal varnish.

Turpentine, if used profusely, destroys the binding properties of oil. Therefore, use rectified turpentine only to thin or extend your oil color when you first begin your painting. It produces a matte surface that, from the viewpoint of permanence, is undesirable, because flat surfaces collect dust and are impossible to clean. This is the main reason that turpentine is used only to begin or to block in the shapes of composition.

When you are ready to apply the second coat or successive layers of color and when you wish colors to flow or blend into each other, use a painting medium made by combining one-third linseed oil, one-third rectified turpentine, and either one-third copal varnish or one-third standoil. Using this medium to extend your oil paints will give you the glossy surface that is the chief characteristic of a painting done with oils. This glossy surface indicates that the pigments are properly bound by the oil medium, and when dry, the surface is smoother and more resistent to atmospheric attacks. (Reject Damar and mastic varnishes. These are resin based and too soft to clean properly, and thus they endanger the permanence of the painting.)

Use copal varnish or standoil thinned with rectified turpentine when glazing or overpainting, because these do not yellow or crack. When dry they produce an enamel-like finish that enhances the tone values of your painting and promotes the fusion of colors. The heavy medium also permits frequent overpainting without impairing permanence, and the paint film it leaves improves the drying capacity.

Cobalt drier is a liquid that promotes drying in oil paints. It should be added to colors as well as to the medium. One or two drops of this powerful drier added to a mixture of 1 inch of paint and one drop to a teaspoonful of the medium will make the painting dry in a matter of hours. Apply paint that has been mixed with the cobalt drier to your canvas in thin coats, or it will dry quickly on the surface and remain wet underneath for a long time.

Mediums Available Today

It is useful to experiment with a new painting medium by mixing varying proportions with the oil paints and applying it to practice

Titian, *Venus and Adonis*.
(National Gallery of Art, Washington, D.C.,
Widener Collection.)

Oil painting mediums. We give tribute
to the masters of the past who were
the first to invent formulas for oil
painting mediums. The exact
proportions of the ingredients they
used are unknown, but approximations
of them are the basis for the mediums
in use today.

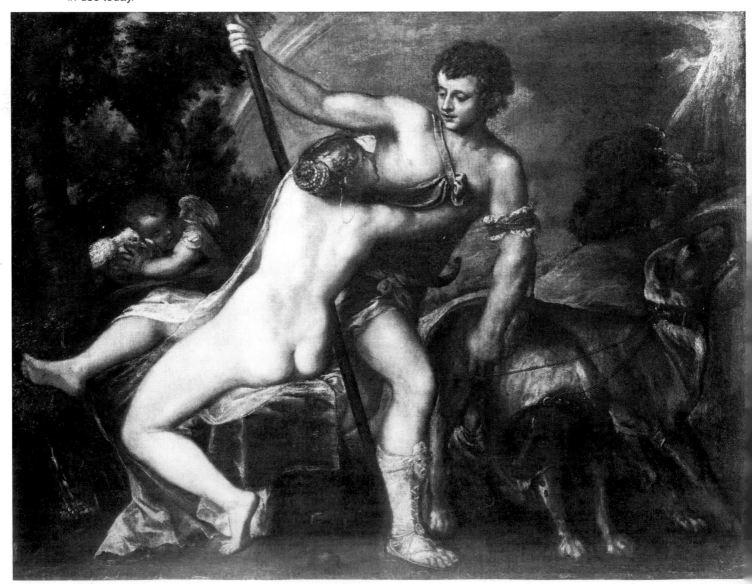

Barbara Adrian, *Judgment of Heracles*. Oil on canvas.
(Collection: Butler Institute of American Art, Youngstown, Ohio.)

The oil-based painting medium used on a primed canvas. Apply one coat of Chardin rabbit-skin glue-size onto a raw linen canvas and allow it to dry. Follow with one coat of lead white paint. When the paint has dried, sand down the surface with fine sandpaper. Repeat with a second coat of lead white, allow to dry, and before beginning to paint the actual picture **sand it again.** Miss Adrian's painting medium has an oil and varnish base which is thinned down with rectified turpentine while painting and she uses it sparingly to best preserve the finished painting.

canvases with different kinds of brushes and palette knives.

Good mediums are available in all art stores. For glazing, you may use copal painting medium (made by Weber Paints). It has lots of resin, is very elastic, and is used mostly for glazing and wet-in-wet techniques when it has been thinned with refined turpentine. You may also use Meglip (made by Winsor and Newton), which is made from a mixture of strong drying oil and strong double mastic varnish. It is sometimes called painter's butter.

For palette knife techniques use Oleopasto (made by Winsor and Newton), a translucent, jellylike medium for impasto painting. It extends the paint and is quick drying and noncracking. It dries uniformly in a semigloss and is more durable than a paint film. It is very suitable for work that will be exposed outdoors. It can be varnished in the normal way.

For the velatura effect use Opal Medium (made by Weber Paints), a useful medium when a matte effect is desired. It is made from beeswax and refined turpentine.

For the alla prima technique, use Res-N-Gel (made by Utrecht). It provides a buttery brush stroke that is retained when the paint dries. It holds defined details and it also accelerates drying.

The following medium, which you can make yourself, is good for almost any style of painting. Combine 1 fluid ounce of standoil (the resinous ingredient), 1 fluid ounce of linseed oil (the oily ingredient), 5 fluid ounces of rectified turpentine (pure spirits), and a few drops of cobalt drier (use an eye dropper). In crease the drier a few drops at a time, sparingly, if a faster drying is wanted.

All mediums, no matter what mixture is used, should be used sparingly and lean. In this way color never changes, and paintings are preserved. Use an oil- and varnish-based painting medium.

Project: PAINTING ON MASONITE PANEL WITH AN OIL- AND VARNISH-BASED PAINTING MEDIUM

TOOLS AND MATERIALS:
 One quart raw cold-pressed oil (available in
 health food stores)
 7½% white lead in powder form
 1 pound mastic varnish crystals
 Rectified turpentine

The raw cold-pressed oil is mixed with 7½% lead powder and cooked until it becomes transparent, then allowed to cool. The mastic crystals are then added and cooked until they dissolve. When the mixture has cooled, the buttery medium needs to be squeezed into a clear, new tube that can be purchased in any art supply store. The rectified turpentine is used to thin it while painting.

Project: PREPARING THE GROUNDS FOR MASONITE (OR ANY OTHER NONABSORBENT SURFACE)

TOOLS AND MATERIALS:
 Chardin rabbit-skin glue mixed with water
 Gesso—made with whiting and chalk
 Zinc white oil paint
 Masonite panel—16″ × 20″

The panel is given one coat of glue size, followed with a coat of gesso (not the commercial plastic acrylic but the old gilders gesso, made by mixing together whiting and chalk). To add brightness, the masonite panel is then given a coat of zinc white. The last step is to give the panel another coat of glue size for insulation purposes.

Project: PAINTING ON A *PRIMED CANVAS* WITH AN *OIL*-BASED PAINTING MEDIUM

TOOLS AND MATERIALS:
 Stretched raw linen canvas 16″ × 20″
 Chardin rabbit-skin glue
 Lead white
 Fine-grained sandpaper

Rembrandt Van Ryn, *Self Portrait*.
(National Gallery of Art, Washington, D.C.,
Andrew W. Mellon Collection.)

Underpainting. Oil paint from the tube
is stiff and buttery and retains brush
marks, but when used with a medium
the colors flow easily from the brush.
Start underpainting with **dark tones**
smoothly brushed on, with paint that
has been thinned with the oil medium.
After it has dried, paint additional
colors over the dark base as they can
remain visible and function as part of
the finished picture. Use very **thick**
paint for the light-toned areas as they
retain their brilliance even after other
colors are glazed over them. Use **thin**
paint when working in the dark
shadowy areas, as this helps create
the illusion of depth.

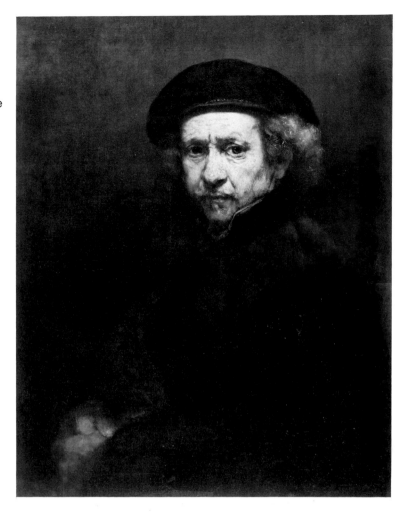

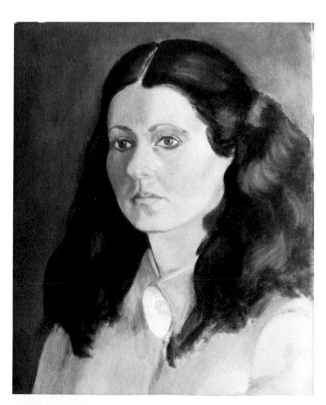

Mai Gebara Rashid, *Self portrait: Study*. Oil on canvas.
A flat paint quality. For flat surfaces, smooth, closely
woven canvas is needed. Start painting by dipping the
brush into the painting medium and then loading it with
color. Apply the color in small, smooth brush strokes. The
medium should be used sparingly. Remember, the aim
here is to render smooth surface textures.

Give the raw canvas one coat of glue size and allow to dry. Then apply one coat of lead white and when dry, sand down the surface and repeat with a second coat of lead white. Allow to dry, and sand it again before starting to paint your picture.

CHOOSING YOUR COLORS

All the oil colors for sale in art supply stores are not the same in price and quality. A manufacturer makes a cheaper tube of color for students simply by putting less pigment in the formula, making the paint weaker in color strength and therefore less expensive to manufacture. The pigment amount is reduced in two ways: by substituting inexpensive fillers or by having an excessive amount of oil vehicle.

Each pigment requires its own proper minimum of vehicle to produce a permanent union between the pigment particles and its oil vehicle. Less oil than the proper minimum may produce an impermanent paint film on the canvas of a finished picture that will make it become brittle and disintegrate with age. Too much oil vehicle may produce color that will be weak and impermanent. It is desirable to buy reputable brands, in which the formula has the proper maximum of the highest-grade pure pigment and the proper minimum of vehicle.

All artists have their own likes and dislikes and their own favorite colors. For a start, you might begin with a range such as the colors listed here. All these colors are permanent.

Flake white	Alizarin crimson
Titanium white	Raw umber
Lemon yellow	Ultramarine blue
Cadmium yellow	Cerulean blue
Yellow ochre	Viridian
Raw sienna	Ivory black
Cobalt violet	Lamp black
Cadmium red	

You may add as many colors as you like to your palette. If you buy a new tube, you should check the manufacturer's list to see if it is permanent. In preparing your palette for painting, squeeze out the colors in the same order all the time, so that you come to know where they are as instinctively as a typist knows the keyboard. Keep things orderly, as do other workmen who know where their tools are and keep them in good condition. In the same way you can keep an orderly paint box.

There are many practical advantages in using oil paints besides their great flexibility and range of tone and colors. They are ideal in making alterations at any stage with comparative ease. (The water-based media dry more quickly, making it difficult to move the paint about as you can with oils.)

The standard size most artists use in oil colors is the studio-size tube, about 4 inches in length and containing 1.25 fluid ounces. The whites come in 1-pound tubes. Because there are so many brands of colors on the market, the choice rests with you. Most students use Pre-tested, made by Grumbacher; these are good as well as moderately priced. Professional artists prefer Winson and Newton, Grumbacher Finest, Blockx, and Utrecht.

You will also need rectified turpentine, standoil, linseed oil, and a turpentine substitute for cleaning brushes. Do not buy little bottles; large quantities work out to be much cheaper.

HOW COLORS ARE MADE

Oil colors have different characteristics, quite distinct from one another. Their opacity, transparency, and color strengths furnish you with a variety of means to secure your effects, and you can choose for yourself which colors to put on your palette. Today your choices are many, as numerous as the companies manufacturing and selling artists' materials. If you know how they are made, it should be easier to know what to look for and how to make selections.

Artists' oil colors are made by mixing a fine quality linseed oil with dry color pigments. Pigments are derived from vegetables and minerals from which the coloring matter is extracted. Pigments do not dissolve in oil or in any other liquid, but when the mixture is ground with strong friction in powerful mills, the pigment becomes dispersed uniformly throughout the mixture. Some artists complain that overgrinding by these machines creates a loss of body and character, and they add sand to some of their pigments to get back what has been lost.

Highest-quality oil colors are composed of pure pigments of the best grade and are expertly ground in specially refined linseed oil. As sold in tubes, oil colors are soft pastes usually described as lean paint. Second-quality, third-grade, or student colors are inferior and less well ground; they contain cheaper pigments and are reduced or loaded with colorless fillers. It is inadvisable to use the cheaper colors, because they will not give permanent results.

Today artists have at their disposal colors many times more brilliant and more enduring than those of the past, and if the colors are properly used, their work will last as long as those of the Old Masters. Paintings are subject to certain conditions of physics and chemistry. If you expect your work to last, high standards must prevail for your materials.

The major principle and concern of the artist in painting with oils is that there be a permanent adhesion between the different paint layers and secure adhesion to the canvas. The factor most vital to the long life of the work and the one that ensures against cracking and flaking or the dulling of colors is the "fat over lean" principle. As explained earlier, this means using turpentine to thin or extend color on starting a painting, and when continuing it at the second sitting, using linseed oil or an oil-based medium.

A completed painting is composed of paint layers that have dried well. When all the layers have the same degree of flexibility, they will act as a unit while drying and will expand and contract together according to temperature and humidity variations. If one layer is more brittle than the underlayer, the action of the brittle layer over the more flexible layer will cause flaking and cracks in the surface.

Flake white mixed into a color will reduce the original high oil content of the total. Flake white is preferable, because it is more durable and dries faster than any other white.

Many manufacturers of artists' colors classify their colors according to degrees of permanence. For example, Winsor and Newton classifies as follows:

AA —Absolutely permanent colors
A —Durable colors
B —Moderately durable colors
C —Fugitive colors

Colors in classes AA and A constitute Winsor and Newton's "Selected List," the labels being marked in red with the letters "SL." You should, of course, read the labels carefully and follow the directions the manufacturer specifies.

All manufacturers put out fine color charts, and you should try to obtain some. Although the color charts provide a quick guide to the colors, they cannot compare with seeing the colors from the tube. The actual colors possess qualities that can never be accurately photographed and must be seen to be properly evaluated.

The Whites

There can be no question that the different whites a painter uses affect the color mixing. A painter should know all about those available to ensure purity of color and freedom from subsequent yellowing. All whites except two are ground in refined poppyseed and linseed oils. Foundation white and underpainting white are ground in linseed oil alone. They may be safely mixed with all colors, but if they are used for underpainting, colors should be applied either wet in wet or after the

underpainting is thoroughly dry. Cracking of the superimposed paint layers may result if this advice is ignored.

There are a great number of white oil paints on the market, most of them with only slight variations from the four major ones, which are these:

Permalba, made by F. Weber Co., is the purest, because it is dispersed in the finest oils. It does not contain any lead, will not discolor with age, and remains unaffected on exposure to light. It is noted for excellent brushing and mixing qualities and yields tints of exceptional warm brilliance. Permalba white is a mixture of zinc and titanium.

Zinc white, on the other hand, has a cold cast and is most effective when painting with cool colors such as blues and greens for seascapes and wintry landscapes. Zinc white is slower drying and is often used in glazing, because it has less covering power. Since it dries slowly, a drying medium should be added to it. Large areas covered with zinc white tend to become brittle and may crack; it is best used in small pictures.

Flake and cremnitz whites are called "white lead," because they are basically made with carbonate of lead ground in pure linseed oil. Lead is a time-tested canvas primer and painting white. It dries rapidly and produces tough and durable paint layers. These are warm whites; their tinting strengths are strong, allowing for lovely warm tonalities, especially when painting portraits. However, they must be used cautiously, because the lead they contain makes them poisonous and dangerous if the pigment should get into an open skin cut. Wash your hands thoroughly after each use of these whites.

Titanium white is the most durable and is preferred by many painters. It is made from titanium oxide and is ground in a number of different oils and poppyseed oil. Titanium is the whitest of all the whites. It will not crack, discolor, or affect other pigments in their mixtures. It has exceptional covering power, brilliance, and permanence; its cool cast is ideal for the painting of all subjects.

There are two whites on the market that are not mixed with other colors but are used primarily for sizing: One is foundation white, which is used for priming unsized canvas. The other is underpainting white, which is quick drying, has excellent texture, and is very useful as the underpainting on which glazes can be applied without any delays. Both of these whites are ground in linseed oil.

The Blacks

The blacker and less tinged with brown a black pigment is, the more permanent it is. When nuances of warm blacks are required, it is better to mix such tones from ivory black and ultramarine blue, because all the others turn into a dirty gray.

Ivory black is made from charred animal bones and horns. It is the deepest and purest of all the blacks and is the quickest to dry. It can be used in all techniques. When used by itself, it may crack, but not when mixed slightly with other colors. When it has dried, it has a glossy finish.

Lamp black is the most permanent of the blacks. It is charcoal which is freed from soot and oil. Lamp black is usually used for drawing purposes in underpainting. It has a matte finish when dry.

Vine black is made from plant and vegetable charcoal. It has a slight brownish tinge and is useful when warm tones are needed.

If at all possible, try to visit some paint manufacturing plants to see the buckets of colors being mixed and being put into tubes. You will get a first-hand look at the color selections of each company at the same time. You will then be able to see for yourself how much they differ from one another. Each individual manufacturer chooses a balanced chart of all the colors, based on the ability of each color to mix well with the other colors. For example, some manufacturers may produce as many as six cadmiums, instead of the normal

three (light, medium, dark) for there is a vast range from light red-orange to red-purple. There are quite a few painters who do not like to do any mixing, and they buy the numerous shades put out by the different suppliers. But it really is more exciting, as well as practical, to do your own mixing. Once you have studied the pigments for yourself, you should come up with a permanent palette of colors distinctly your own.

QUALITY OF PAINT AND BASIC PRINCIPLES

You should now memorize the basic principles involving painting with oil color.

1. Oil paints are formulated from organic and inorganic pigments combined with a binding vehicle (made from a mixture of linseed oil and varnishes).

2. Oil colors are opaque; that is, they hide the surface on which they are painted. However, there are some colors that are transparent, varying in degrees of hiding power. With these colors, such as alizarin crimson and green earth, the opaque quality will predominate when mixed with white or other, more opaque colors.

3. Oil paint as it comes from the tube is stiff and buttery and when brushed out retains the brush marks. Thick impastos, stippling, visible brush strokes with all types of brushes and knives are possible, and when used with a painting medium, it can be made more fluid and pliable.

4. As far as permanency is concerned, there is the time-tested method of using "fat over lean" to rely on. "Fat over lean" simply means that the picture is made up of layer upon layer of pigment and that the first coat is made lean when it is thinned out with turpentine. All the successive layers will be fat, since either linseed oil or an oil-based paint medium is used to thin and extend the paint.

Your paintings will remain permanent if you keep in mind that the fat colors are more flexible; therefore, they must always be painted over the lean. There is a positive adhesion between each layer, because the lean layer is more absorbent. The adhesion between the oily layer of color and the lean one is slower, because oil color is slick and less absorbent.

5. A painting begins to crack and to deteriorate only when one layer of paint is more brittle than its underlying one or when the different layers of paint do not have the same flexibility. When they do have the same flexibility, they act as a unit while the contracting and expanding (caused by variations of the room temperature) are taking place. Therefore, think fat over lean. Use turpentine only on the first layer, saving the less absorbent slick oil color for all the later stages.

6. As far as color is concerned, get into the habit of using the darker ones over the lighter. This is always more desirable simply because it takes less effort to darken a color than it does to make it lighter once it has been put onto the canvas. It is also the best way to keep a clean palette.

The way in which you use your materials has a strong effect on the color qualities you achieve. Therefore, it is good to have at your disposal as many techniques as possible to solve the varied problems you will encounter. Because each subject presents its own special problem, your ability to reach solutions will depend on selecting the technique best suited to it. You should know which materials to use while in the throes of painting, without having to interrupt the flow of your creative energies in looking for tools. When you have mastered the different techniques you can use them one at a time or in combination with each other and in any appropriate situation without having to think too much about it. You will be free to use these techniques when you like, where you like, and how you like—getting the maximum use of your paints. Each of the following oil technique projects includes a description of the painting method to be practiced, along with a list of all the required equipment suitable for that technique; also a

Lisa M. Specht, *Gladiolas*. Oil on canvas.
(Collection of the artist)

Fat over lean. The picture is made up of layer upon layer of pigment. The first coat is made "lean" when thinned out with rectified turpentine. All the successive layers will be "fat" since either linseed oil or an oil-based paint medium is used for extending the colors. The rule to remember in painting with oil is: **Use fat over lean**.

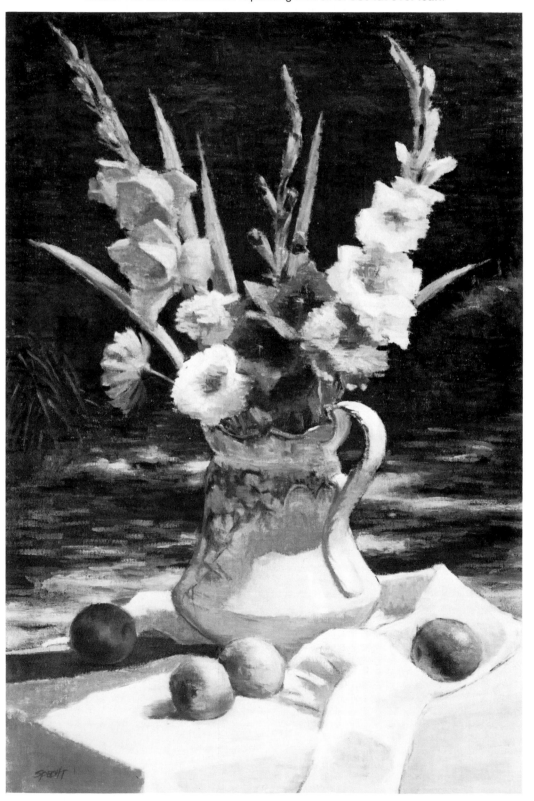

suggested pictorial subject that is accompanied with step-by-step instructions for carrying out the project. The reproductions shown with each project are meant to both inspire as well as guide you on to the highest possible achievements.

Project: GRISAILLE

SUBJECT: A draped figure

ILLUSTRATION REFERENCE: Antonio Salemme, *Portrait of Attilio Salemme*

TOOLS AND MATERIALS:
 Smooth-surface canvas, 20″ × 24″
 Bristle brushes: flats, assorted sizes
 Burnt umber
 Turpentine
 Oil painting medium
 Two medium cups
 Flat-blade palette knife for mixing
 Clean palette

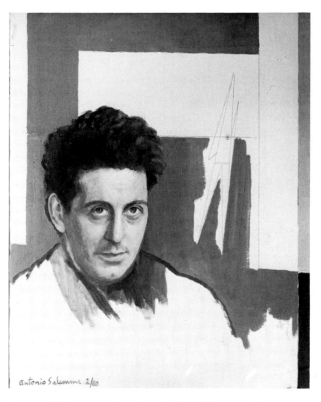

Antonio Salemme, *Portrait of Attilio Salemme,* from a photograph. Oil on canvas.
(Family collection)

A grisaille is a carefully executed under-painting in different tones of burnt-umber or gray in which the three-dimensional aspect of the subject is clearly rendered. This effect is accomplished with careful modeling of the forms in a full range of tones.

A grisaille is the underpainting that establishes the brightness pattern as well as the three-dimensional quality of the forms in your composition. This three-dimensional effect is accomplished by careful modeling of the forms with a full range of muted umber tones that have been previously mixed. The umber tones should range from very dark, almost black values, up through different middle values, and finally on to the bright, light ones.

Prepare your palette with a series of at least seven different tones, using just burnt umber and white in your mixtures. Painting forms that have volume in these graded tones, you achieve the three-dimensional quality. The Old Masters always started their paintings using burnt umber in a procedure much like the one described here.

1. The model should wear a garment that clings softly to different areas of the body. Arrange to have a definite source of light directing its rays onto the model so that the facial features, garment folds, shadow areas, and highlights are clearly visible.

2. Mix seven different tones of paint onto your clean palette, ranging them from dark umber (mixed with a little black) to very light umber (mixed with white).

3. By adding some turpentine to your darkest tones, make a thin wash. (Use this to block in your composition carefully. Use a soft rag to wipe out any mistakes.)

4. Develop this preliminary rendition of the composition by systematically building up each feature with the different shades of umber tones you previously mixed. The forms should be painted with gradations that clearly illustrate the volume of each. This is best accomplished with tones that show careful transitions from dark to light for each shape in the picture.

5. Accent all highlight areas with pure white.

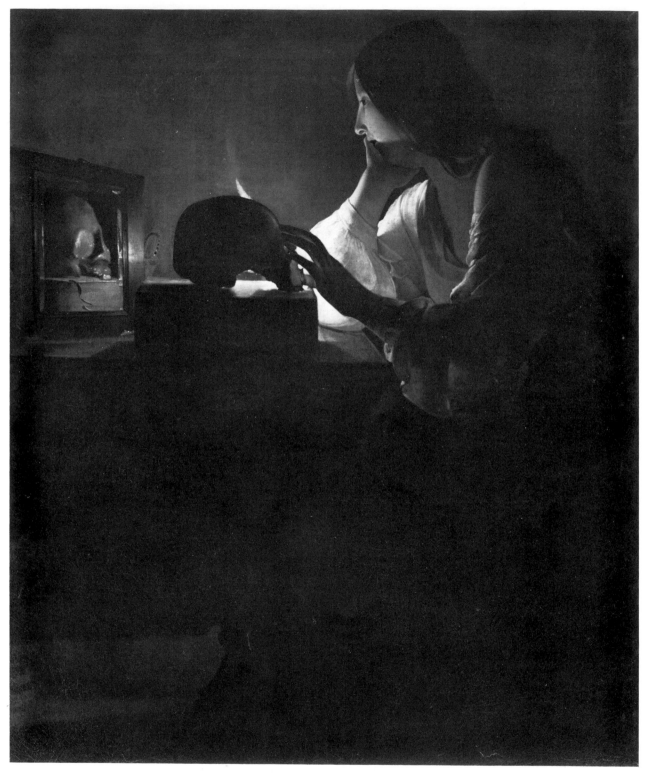

Georges de La Tour, *Repentant Magdalen*.
(National Gallery of Art, Washington, D.C., Ailsa Mellon Bruce Fund.)

Chiaroscuro. Chiaroscuro is the way the lights and darks in a composition are arranged and balanced in a contrasting fashion.

Project: CHIAROSCURO

SUBJECT: Landscape by moonlight

ILLUSTRATION REFERENCE: De La Tour,
 Repentant Magdalen: L. Salemme, *Skyline*

TOOLS AND MATERIALS:
 Medium-rough textured canvas, 20″ × 24″
 Assorted sizes, bristle brushes—flats
 Oil colors—titanium white, ivory black
 Painting medium made from rectified
 turpentine, linseed oil, and standoil (one part
 each)
 Palette knife, flat blade for mixing paint
 Clean palette
 Medium-soft charcoal

Chiaroscuro is an Italian term describing the way you arrange and balance the lights and shadows in your painting. To balance your lights and darks successfully, think in terms of black, white, and gray values. To understand the chiaroscuro idea, it is best to see the areas to be painted without their color, considering them instead in terms of a black-and-white value scale. Therefore, allow yourself plenty of time in which to prepare your palette with as many grays as you can mix before you start to paint your picture. You should come up with at least seven different gradations of gray simply by adding a little more black to the white paint for each successive gray. Transfer these seven grays, along with some pure white and black, onto the upper edge of your clean palette. You now have nine mounds of paint to work with.

(You will be using the alla prima method of painting for this project. Refer to page 182 for description.)

1. Make a detailed drawing of a city skyline in a moonlit landscape. Draw directly on the canvas with some medium-soft charcoal. Section the composition so that one-quarter is for the sky area, where a dramatic light is to come from. Fill in the remaining space with rooftop formations as seen in a frieze of buildings. Sketch in large roofs adjacent to small ones, to have a variety of proportions in the picture.

2. Indicate where the light is coming from (the moon, stars, or beacon lights in the sky). This sharp opposition of the light and dark areas is what creates the interesting chiaroscuro effect on your picture.

3. Block in all the extremely light areas first; follow by painting in all the strong blacks and dark gray areas; then in sequence, the other grays beginning with the lightest. See how often you can change their values by adding a little black to each gray.

4. Into the areas you have just painted, you can brush or work additional colors suitable to the subject. Because you are using the alla prima technique, the whole painting may be resolved in this one sitting, since no overpainting is required.

5. If you have distributed the extreme dark and light areas properly, you will have created a very dramatic and romantic mood, which is what this method of painting is most noted for.

Project: GLAZING

SUBJECT: Portrait of a brunette

ILLUSTRATION REFERENCE: Vermeer,
 A Woman Holding a Balance

TOOLS AND MATERIALS:
 Gel or glazing medium. To make 2 ounces of
 medium use ⅓ rectified turpentine, ⅓
 linseed oil, and ⅓ standoil mixed with 1
 teaspoon of cobalt drier.
 Smooth-surface stretched canvas, 24″ × 18″
 Burnt umber
 Flake white
 Ivory black
 Titanium white
 Naples yellow
 Alizarin crimson
 Cadmium red
 Ultramarine blue
 Green earth
 Sable brushes, flats—assorted sizes

M. Grumbacher, Inc., puts out a colorless oil medium called Gel that can be mixed with oil colors, making them transparent but retaining all the hue characteristics and texture of the tube color. You can use either this preparation or the oil medium you make yourself.

For a painting using the glazing technique, select a fairly smooth canvas or one with a fine tooth.

THREE STAGES IN A CHIAROSCURO PAINTING

Lucia Salemme, *Skyline*. Oil on canvas.

A detailed drawing of a moonlit city skyline is drawn directly onto the canvas. The space is sectioned so that one part is for the sky, where a dramatic light is to come from, and the remaining spaces are filled with building façades, the small buildings next to tall ones. The strong black areas are blocked in, then the dark grays, with the extreme lights left for the last. Colors are applied at the third stage. They can either be brushed into the wet paint in the alla-prima technique where brush strokes go in the natural direction of the shape being painted, each shape having a different direction; or the colors can be glazed on after the chiaroscuro stage has completely dried.

1. Prime your canvas with a coat of flake white. If you are in a hurry, you can substitute a product called underpainting white MG, made by M. Grumbacher, Inc., which dries in two to four hours. The coat of white is necessary to guarantee the transparent effects that are the chief characteristics of this technique.

Allow your primed canvas to dry thoroughly. You can hasten the drying process by working in a well-ventilated room or outdoors, but give the canvas at least a two-week drying period if you have not used the quick-drying MG.

2. The next step is to start the painting. First, select your brunette model, preferably one requiring lots of modeling.

3. On your already-primed, dry canvas make a monochrome drawing of the subject, using your burnt umber.

This underpainting should be carefully planned. The paint should be applied with impasto of varying smooth and thick brush strokes. Use tones of burnt umber, adding white to lighten tones and ultramarine blue for any dark tones. This underpainting is important, because it is the base on which all the glazing is to be done. The dark tones must be allowed to show through where the shadow areas are the deepest, and the lighter areas must have applications of thick white paint.

4. When you have finished with the underpainting of your subject, it is time to concentrate on the background. Most painters cover this space with a dark-toned wash of burnt umber mixed with ultramarine blue, mingling the background through to the deep values of the hair (remember, you are painting a brunette!), and then allowing the picture to dry for several days.

5. To glaze, you paint thin, transparent layers of color one over the other, covering the modeled forms that you have already painted on the canvas. You must now prepare the transparent colors. You will use a glazing medium to thin the colors.

To thin your colors to obtain transparencies, you'll need two medium cups, one holding rectified turpentine and the other holding your glazing medium. In this technique your chief problem is knowing how long it will take for the different layers of paint to dry, because you cannot apply a new coat of paint until the one underneath is thoroughly dry. To overcome this problem, add a few drops of cobalt drier to the colors as well as to the medium. One or two drops of this powerful drier added to 1 inch of paint, or from one drop to one teaspoonful added to the medium, will make the colors dry in a matter of hours.

By superimposing one transparent color over another, new colors are created. The primary rule about color in glazing is that you start off by painting in the light colors first, gradually adding each successive color of a darker tone. The rule to remember is: dark colors over light colors. The whites underneath will show through the glazes that you place in sequence one over the other. Where you wish areas to appear to recede and shapes in the shadow areas to look darkest, allow whatever dark tones you have previously painted to remain unglazed.

6. Begin with the mixing of a flesh tone. Bear in mind that there really is no standard flesh tone. This color depends on where the person is sitting—indoors or outdoors in shade or in bright light—and on whatever colors are reflected by the skin from the setting. Start with a basic flesh tone, which is a mixture of titanium white with some Naples yellow and a drop of alizarin crimson.

Thin this mixture with rectified turpentine, and paint the entire face and neck, covering any shadow areas previously painted. (Some of the dark tones should show through.) Allow to dry.

7. Wash a thin coat of Naples yellow (mixed with your oil medium this time) over the entire face and neck area. Allow to dry.

8. Next day, paint a very thin wash of rose madder thinned with your mixed oil medium over the entire face so that the under colors show through. Allow to dry.

9. Apply a thin coat of cerulean blue thinned with your oil medium in the modeled areas on the light side of the face.

10. Apply a very thin coat of ultramarine

blue thinned with your glazing medium over the areas on the dark shadow side of the face. Allow to dry.

11. Use green earth to paint shadows in the whites of the eyes, nostrils, and corners of the mouth. Thin with medium if necessary. Also, paint the light side of the hair with burnt umber mixed with yellow ochre. Allow to dry.

12. Use raw umber to paint in the pupils and eyebrows. The dark side of the hair should have ultramarine blue and a little black added to the umber. Allow to dry.

13. You have now arrived at the final stage. You may use some of the lighter colors wherever you think necessary, probably in the highlights. Also, you are now allowed to use more opaque variations of your colors to complete the picture. Let me warn you not to be too heavy-handed and to be very selective in your tonal values. Not only are there many tones of each color, but effects vary according to their surroundings, especially according to the neighboring values of whatever color they are placed next to. Judge wisely. Work with a light touch, and wipe off any excess color with a very soft rag.

The finished picture should sparkle with luminous variations of your different colors!

In reviewing all that we have discussed on the preceding pages, it is important to emphasize that glazing involves the superimposing of transparent layers of colors, appled one on top of the other, only after the undercoat is completely dry.

Each additionul color must be thinned sufficiently so that the layer underneath can be seen through the glaze. A glaze is like a piece of colored gelatin held over another colored area, creating a third and more subtle color. To glaze with maximum success, it is best to use colors of a darker value over the lighter colors. This time-tested principle is the only one that works for this technique.

The final and total effect of the glazing technique is a painting of unsurpassed translucence and luminosity. Since all the modeling has been done previously, in the initial painting-in of your subject, you are free to concentrate completely on beautiful tonalities.

Along with the many obvious qualities and lovely results obtained from the glazing method of painting, artists and restorers put it to very practical use when they wish to retouch deteriorated areas in old pictures. The rule here is to retouch with glazes that match the underpainting. Oil colors darken as they dry, but in glazing the darkening is counteracted by the transparency of the glaze.

Project: WET-IN-WET

SUBJECT: Landscape in a rainy-day atmosphere

ILLUSTRATION REFERENCE: Turner, *Keelman Heaving in Coals by Moonlight* (color section, page 22)

TOOLS AND MATERIALS:
Smooth-surfaced canvas, 24″ × 30″
Bristle brushes, brights, assorted sizes
Oil painting medium
Zinc white
Ivory black
Raw umber
Prussian blue
Lemon yellow
Cadmium red

The term wet-in-wet speaks for itself, in that you can work or blend additional colors into color already on the canvas. For guidance you need only to think of painters who mastered this direct painting technique: William Mallard Turner, who blended colors into each other to achieve his poetic and mystic effects, and John Marin, who applied his paint in brilliant and definite brush strokes.

In this direct method of painting the underlying layers of paint have little influence on the final appearance of the work, which depends on the opaque quality of the final layer.

In this technique, color brilliance is obtained from the color itself, as emphasized or subdued by the colors painted in the surrounding areas and by its place within the composition. This quality of color brilliance can be achieved only in the direct wet-in-wet technique.

Jan Vermeer, *A Woman Holding a Balance.* Oil.
(National Gallery of Art, Washington, D.C., Widener Collection.)

Glazing. Use a smooth-textured canvas and paint a careful monochromatic study of the model. As a medium for glazing you will need a mixture of stand-oil and rectified turpentine. A drop of copal varnish will hasten the drying process. Some colors such as alizarin crimson and green earth are lovely to look at but have little solidity. These colors have no practical use by themselves, but when mixed with a little white paint, they yield subtle undertone versions of their originating hues. Some of these are superimposed over the preliminary sketch of the subject. To glaze, use the light-hued colors first and the darker ones after the first have completely dried.

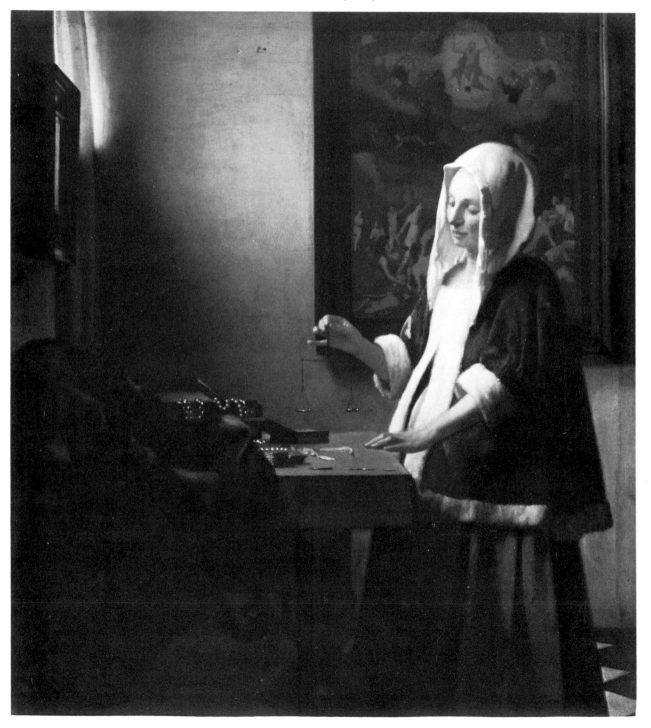

You can create many atmospheric effects with the wet-in-wet technique. By atmosphere we mean the colors immediately surrounding your main subject. This, of course, depends on the type of light you are depicting. For example, should you be painting a landscape, your choice of color is determined by the weather and the time of day. Therefore, if outdoors, the atmospheric colors would be quite different than the ones you would use when painting a bouquet of flowers indoors.

At the very outset of your painting session it is necessary to determine the time of day and season of the year you wish to depict. If it is to be early morning or late afternoon and outdoors, the light will most likely be sharp and clear, calling for a high-keyed palette of light greens, blues, reds, and yellows. The forms will cast slanting shadows, and the light-and-dark compositional masses will be clearly defined. This interplay of the gentle shapes of cast shadows combined with the definite lights and darks of the subject give you an excellent opportunity to use the wet-in-wet technique in the rendering of your idea.

Here are a few rules to be guided by when you wish to express certain atmospheric effects in the wet-in-wet technique. The base colors to use when you wish to paint a rainy-day atmosphere are grays, purples, and neutralized versions of the three primary colors, red, yellow, and blue.

A sharp clear day: Cerulean blue, cadmium red, lemon yellow, ultramarine, violet (for shadows), permanent green light, and titanium white.

Sunrise and sunset: Brilliant pinks, pastel oranges, blues, and violet.

Room interiors: Ivory black, yellow ochre, or burnt umber combined with muted versions of whatever the colors the furnishings happen to be.

Let us put these rules to the test by painting a landscape in a rainy-day atmosphere for a starter.

1. First, mix an atmospheric color that will serve as your ground or base value for the subject. Combine white, a little ultramarine blue, and some raw umber and mix them together thoroughly. This mixture is the traditional ground color the masters used. This grayish-brown color was called the bistre.

2. Paint this mixture over the entire canvas. Of course, any color of your own choosing may also serve as your atmospheric ground color.

3. Next, using a small brush dipped in the blue, sketch in the features of the landscape, such as the distant hills, a road, trees, and houses.

4. Next, paint in all the very dark areas, using a mixture of blue and raw umber and a little black.

5. Then paint in all the light areas by working pure white into the wet base color already there.

6. As a final step, paint in all the details in whatever colors they happen to be, gently blending these shades into the base color.

The finished picture should be a very gentle rendering of a landscape on a rainy day, achieved by having first painted the entire picture surface with its appropriate atmosphere color.

Project: UNDERPAINTING

SUBJECT: Portrait

ILLUSTRATION REFERENCE: A. Salemme, *Self-Portrait*; L. Salemme, *Three Steps in Painting a Portrait* (color section, page 23)

TOOLS AND MATERIALS:
Smooth-textured canvas, 25″ × 20″
Assorted sizes, bristle brushes—filberts
Oil colors—titanium white, raw sienna, burnt umber, and ultramarine blue
Additional colors—choice of full palette
Painting medium—one part each of standoil, linseed oil, rectified turpentine
Clean palette
Lots of rags or paper towels

Underpainting means that dark tones show through colors that are painted over them and

remain visible to function as part of the finished picture.

1. The first step, of course, in doing a portrait is to pose the model. Plan the placement of the subject by deciding what you want to include and what you want to leave out in your picture. Unlike a camera, which captures everything about the subject, you as an artist, are free to select and reject parts of whatever you are viewing. When you have analyzed the pose, decide what size of canvas would be suitable. A 25" × 20" canvas is suggested, because a portrait usually calls for just the head and shoulders of your subject.

2. Before you start to paint, first consider the areas without their color, seeing them only in terms of values; plan the value scale carefully. Know where your light areas and dark areas are to be, what the source of light is, and whether the background is to be darker or lighter than the model. Study the shapes to see what shadows they cast. You are ready to paint only after you have resolved all four of these points.

3. Mix the white, burnt umber, and raw sienna together, then thin the mixture with rectified turpentine and use it to make a careful drawing of the model. You can easily wipe off any mistakes with a rag dipped in clean turpentine.

4. In the light-to-dark underpainting method, begin with a light-toned painting, using colors liberally tinted with white paint. Next, apply darker colors over this underpainting, darkening the values as you proceed toward the finishing of the portrait. Keep track of the direction of the light, because it should be consistent. A sharp opposition of lights and darks will give interest to your subject.

5. Particularly useful is the underpainting in the shadow areas of your picture. These dark areas are painted chiefly with earth colors mixed with ultramarine blue. You'll find that little or no overpainting is necessary where you have applied the dark colors first. Such areas must be painted smoothly with little or no texture.

6. While the paint is still wet, gently blend in the additional colors, taking care not to disturb the values already established in your underpainting.

7. The areas representing the source of light, however, should be applied in impasto over the light areas of the underdrawing. Thinly applied light paint layers will not remain permanent, because any underpaint will eventually show through. The rule therefore is: use very thick paint in the light areas to allow the light colors to retain their brilliance, and thin coats to overpaint the dark areas.

8. Complete the portrait by painting in the skin tones. You can mix a basic skin tone by combining white, Naples yellow, and a touch of alizarin crimson. Superimpose the various shapes where they are needed on any drapery and the background shapes. Finally, you should make any desired corrections and carefully paint in details and accents where needed.

Attilio Salemme, *Self Portrait*. Oil on canvas.
(Collection of Lucia A. Salemme.)

The flesh tones of the face have been modified by blending some of the background color into the shadow side of the face and some of the flesh tone into the background color. This interchange helps create the illusion that both areas are present in the same atmosphere.

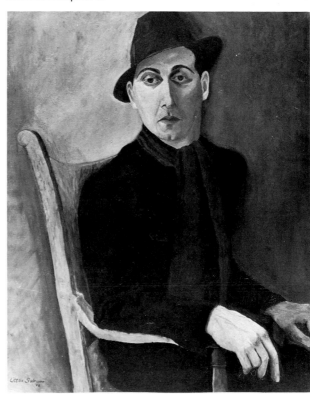

Project: **ALLA PRIMA**

SUBJECT: A still life

ILLUSTRATION REFERENCE: Manet, *Still Life with Melon and Peaches*

TOOLS AND MATERIALS:
 Stretched canvas, 24″ × 30″
 Oil painting medium
 Full palette of oil colors
 Bristle brushes, filberts, assorted sizes

The term alla prima means to apply all the colors in one sitting, utilizing dexterous brushwork to render textures and value relationships.

A. To paint a still life, set up an uncluttered group of fruits.

1. Do a line drawing of the subject directly onto the blank canvas. The entire painting is to be finished in one continuous operation, manipulating the pigment in thick applications to the canvas. There is no overpainting after the first layer is dry.

2. You are now ready to start using the alla prima technique. Prepare your palette of colors, having them ready so that you can carefully apply unmuddied paint.

3. Apply the light and pale-toned colors first, thinning the paint with oil painting medium, manipulating the pigment so that each stroke leaves its mark.

4. Follow with the more vivid colors, modeling them into the lighter colors with strokes that go in the direction of the form or shape

Edouard Manet, *Still Life with Melon and Peaches*. Oil on canvas.
(National Gallery of Art, Washington, D.C., Eugene and Agnes Meyer Gift 1960.)

Alla prima. Cover the area being painted with a color of your choice and, while this color is still wet work in additional colors using a visible brush stroke. The direction of the stroke is determined by the natural shape of the form being painted.

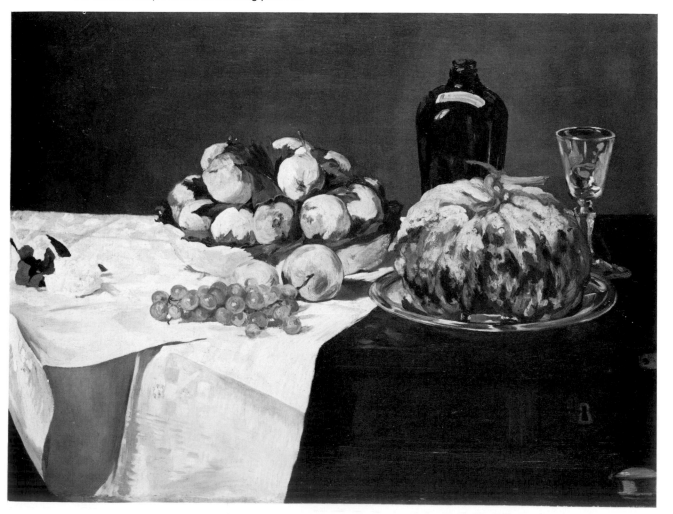

being painted. Paint the dark areas, doing all your modeling with visible brush stroking, always going in the natural direction of the shape being painted. You have now established the value scale.

5. The last step is to touch up any ragged edges so that the forms do not overlap. Apply the details with a small, pointed sable brush.

Your finished painting should have all the spontaneous quality that this technique is noted for.

B. Many artists work from memory, but a photograph of a skyline will do. Decide first on the time of day you are planning to render. If it is to be twilight, you will be working in a minor key and should select a palette made up of muted values. If, on the other hand, you wish to paint an early afternoon scene, your subject calls for lighter versions of your colors and a palette of high-key values are needed.

Remember, the object of this exercise is to paint a spontaneous version of a scene, completing it in one sitting. For a subject, you might use buildings arranged in an overall pattern.

1. First, sketch in a group of buildings so that tall vertical skyscrapers break up the space in the upper half of the canvas. In front of or beneath these, sketch in several horizontal ones.

2. Paint in the surfaces of each building with colors that are different from one another.

3. Next, study the colors you have just painted and note how one color differs from another and the chromatic intensity of each. Decide where you want the darks to be placed in the composition. To create a darkened version of the original color work a darker color into it.

4. Work some white into the sides of the buildings catching the light. Now paint in all the midtones.

5. For a final dramatic effect you can even add some black to the colors on the shadow sides of each building, in order to sharpen the different degrees of light and dark of the colors.

Painting from Sketches Done Out of Doors

In painting a landscape when you are in your studio, you may wish to work from some favorite watercolor sketches previously painted out of doors. Select one you like best and use it as the study for a serious oil on canvas where the alla prima technique would be suitably used. Study the illustration on page 30 to see how this idea was worked out.

Project: **POINTILLISM**

SUBJECT: Country scene by the sea

ILLUSTRATION REFERENCE: Seurat, *Peasant with Hoe*; *Les Grues et la Percee*; Monet, *Banks of the Seine, Vetheuil*; L. Salemme, *City Panel*; *Study of Pointillist Principle* (color section, page 24)

TOOLS AND MATERIALS:
Canvas board, 18″ × 24″
About ten small bristle brushes, one for each color
Colors: Lemon yellow
 Cadmium yellow
 Yellow ochre
 Cadmium red
 Alizarin crimson
 Cerulean blue
 Ultramarine blue
 Cobalt blue
 Cobalt violet
 Titanium white
 Ivory black
Roll of paper towels

It is not always necessary to mix the colors you need on the palette. By properly putting one color alongside another on the painting surface, you ensure that these colors will be mixed visually when viewed from a distance. This phenomenon is best exemplified by the pointillist technique. Here the mixtures are optical. The Pointillist broke up tones into their constituent elements, and the resulting optical mixtures produced far more intense luminosities than the same pigments mixed

on the palette. The pointillists referred to this as the *art of divisionism* because they split or divided complementary colors into the two primary components. For example, instead of using a green, they used the two colors that make green, blue and yellow, applying the paint in tiny strokes as close together as possible. When viewed at a distance, the yellow and blue dots seem to blend into green. (See color section, page 24.)

Because sea and landscape subjects lend themselves admirably to this pointillistic method of painting, let's do a country scene by the sea.

1. Loosely sketch in your subject, dividing the space into three sections for land, sea, and sky.

2. In small dots, paint in all the large spaces first: sky, hills, water. To paint the sky, work from the top of your canvas down, to avoid smudging any wet areas as you work along. Use a separate brush for each color, so that you can quickly interchange the various colors in each area.

3. You'll need a separate brush for each clean color. To get the light tone of a color, add tiny white dots to the area. Add similar black dots for shadows.

4. To suggest an orange color, paint in a grouping of alternating yellow and red dots, interspersed with tiny white dots where you wish to lighten the color and black dots where you want a darker orange.

5. Similarly, for the effect of green fields, paint a mixture of small yellow and blue dots.

6. To get the effect of purple, paint a mixture of red dots and then blue dots onto the space.

7. Now, fill in smaller areas such as trees, boats, houses, or figures.

8. Lastly, paint in the details or final accents, using a small brush to paint in the solid patches wherever necessary.

When the finished painting is viewed at a distance, you'll note that yellow and blue dots seem to blend, making green; the red and blue dots seem to be violet; and the yellow and red dots make orange. The overall effect is fresh and vibrant.

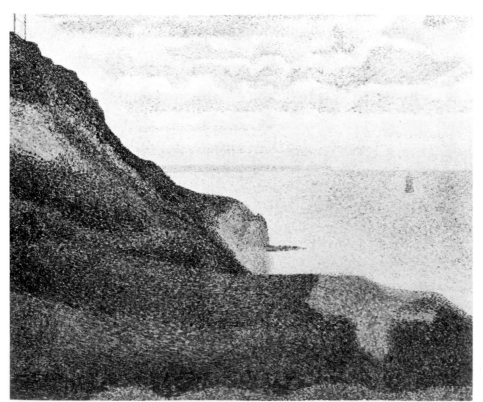

Georges Seurat, *Seascape at Port-en-Bessin, Normandy*. Oil on canvas. (National Gallery of Art, Washington, D.C. Gift of Averell Harriman Foundation in memory of Marie N. Harriman.)

Pointillism. A fine example of Seurat's remarkable pointillist technique where, by breaking up color tones into their constituent elements, he produces a luminous optical mixture far more intense than those mixed on the palette. The colors are applied in small dabs or dots with a small brush.

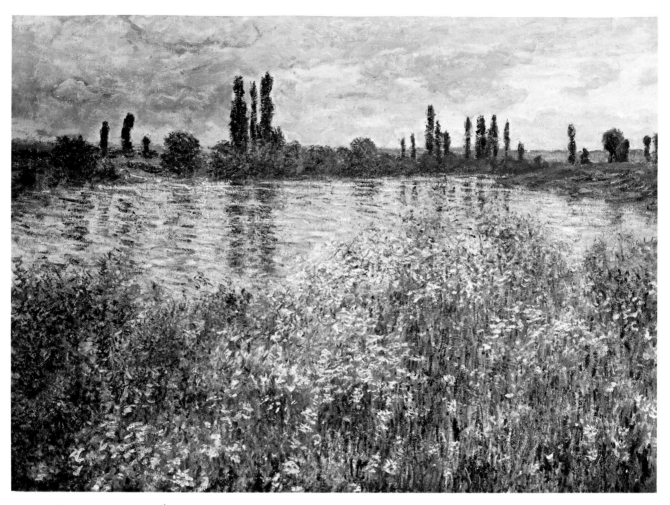

Claude Monet, *Banks of the Seine, Vetheuil*.
(National Gallery of Art, Washington, D.C., Chester Dale Collection.)

A modified version of the pointillist technique in which one is aware of the textural quality of each element in an overall pattern.

Georges Seurat,
Peasant With Hoe.
Canvas.
(The Solomon R. Guggenheim
Museum, New York)

By placing numerous brush strokes of bright colors side by side, you will be following much of the same system used by this French Impressionist. This method is a **variation of pointillism** where flat color is applied in small dabs or dots of paint to achieve different atmospheric color affects.

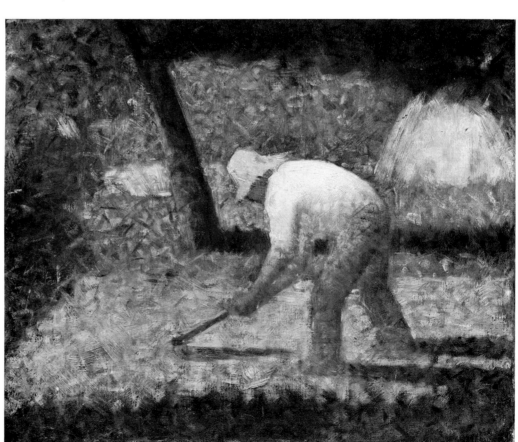

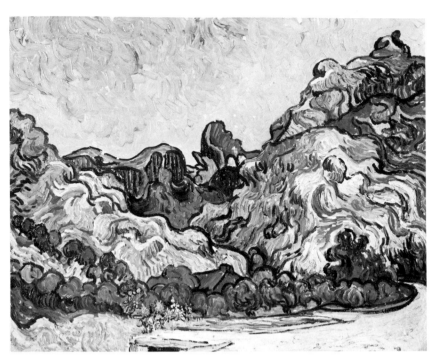

Vincent Van Gogh, *Mountains at Saint-Remy*. Oil
on canvas.
(The Justin K. Thannhauser Collection, The Solomon R.
Guggenheim Foundation, New York City.)

Impasto. The application of thick paint layers by
squeezing color from the tube directly onto the canvas or
by modeling the paint with a brush or palette knife, is how
raised, visible brush strokes are created.

Project: **IMPASTO**

SUBJECT: Landscape with barn buildings

ILLUSTRATION REFERENCE: Van Gogh,
 Mountains at Saint-Remy

TOOLS AND MATERIALS:
 18″ × 24″ rough-surfaced canvas
 Bristle brushes, brights, assorted sizes
 Full palette of colors
 Flat-blade palette knife for mixing
 Roll of paper towels

Being a painter means venturing into the
dazzling world of pure color, and using the
impasto method is a recommended first step
toward this goal. Impasto means applying
heavily raised paint layers by either squeezing
color from the tube directly onto the canvas or
by modeling it with a brush to create visible
brush strokes. To achieve a rough-textured ef-
fect, first select a firm, rough-textured canvas
and a set of bristle brushes. A suitable subject
for this technique is a landscape, because the
rendering of the different forms affords you
ample opportunity to concentrate on surfaces
with trees, grasses, rocks, distant hills,
houses, and barns. You can work from mem-
ory, a photograph, or at the scene itself.

1. Sketch the scene directly onto the canvas,
keep the composition uncluttered, separating
the picture surface into four sections.

2. The top section, of course, is the sky area,
showing some cloud formations where broad
flat brush stroking can be used. For the sec-
tion under the sky, show hills or mountains,
and paint this far distance area with light, deli-
cate colors, using semirough brushwork.

3. Under these, in the middle distance place
some trees, barns, or houses, and apply the
paint with more visible brush strokes, using

muted colors. In the bottom section, which is the foreground area, you may have figures, rock formation, or hedges. Use very thick applications of paint, brushed on boldly with strong dramatic colors.

4. Because you use your colors without adding a medium, the paint consistency will be uniform.

Do a second painting. This time make it an abstract version of a landscape.

1. Before starting to paint, mix large amounts of color on the palette.

2. Scoop up the color with your knife and place it on the area in the composition where you think it will look best. Then with a brush stroke it into place, having the brush go in the natural direction of the shape being painted.

3. Use plenty of paint—by applying large amounts of color onto the canvas, the desired thick, three-dimensional effects are achieved.

Project: **SMOOTH TEXTURES**

SUBJECT: Smooth-surfaced objects found in nature

ILLUSTRATION REFERENCE: Ingres, *Madame Moitessier* (color section, page 26); Rembrandt, *Portrait of a Lady with an Ostrich-Feather Fan*

TOOLS AND MATERIALS:
12 smooth-surfaced canvas boards 10″ × 12″
Full assortment of colors
Clean palette
Sable-hair brushes, flats—assorted sizes
Roll of paper towels
Oil painting medium
Cups
Rectified turpentine

To learn how to render the surface textures of smooth objects, it is best to study the real thing whenever possible. Because these are basically all smooth surfaced, use only the soft

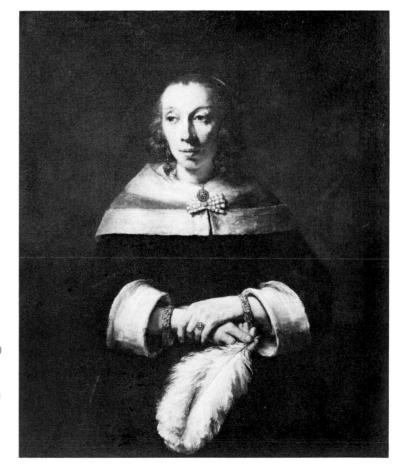

Rembrandt Van Ryn, *Portrait of a Lady with an Ostrich-Feather Fan*. Oil on canvas.
(National Gallery of Art, Washington, D.C., Widener Collection, 1942.)

Varied textures. Note the intricate manner in which the textures of the feather fan, jewelry, fabric, and lace are rendered in detail, when compared with the fairly smooth surfaces of the face and the hands of the subject.

sables to paint with. Do one painting each of the following—fruits, seashell, flowers, foliage, pebbles, and pearls.

Use your remaining canvases to paint one each of the different features of a posed model—eyes, nose (with both light and shadowy skin tones), hair, drapery, feathers, and jewelry.

1. Make a careful drawing of the smooth-surfaced object directly onto the canvas.

2. Paint in the largest areas of the composition first with an overall ground color.

3. Try to paint exactly what you see, referring to the subject frequently.

4. Paint with flat thin applications of paint, doing any blending while the paint is still wet.

5. Superimpose whatever details are necessary, having the brush go in the natural direction of the object being rendered. When finished you should have at least six paintings of smooth-textured objects.

Project: ROUGH TEXTURES

SUBJECT: Rough-surfaced objects found in nature

ILLUSTRATION REFERENCE: V. Salemme, *The Shore at Night* (color section, page 23)

TOOLS AND MATERIALS:
 Full assortment of colors
 Flat-blade palette knife
 Trowel-shaped palette knife
 Small-bristle hair brushes
 Roll of paper towels
 Clean palette
 6 canvas boards 10″ × 12″

Make a selection of any objects you can find with a rough surface—sand, rocks, tree bark, pine cones, pineapples, starfish.

Do a series of small paintings (using your small-bristle hair brushes or small trowel-shaped painting knife) of a still-life setup of some of the rough-textured objects you have collected.

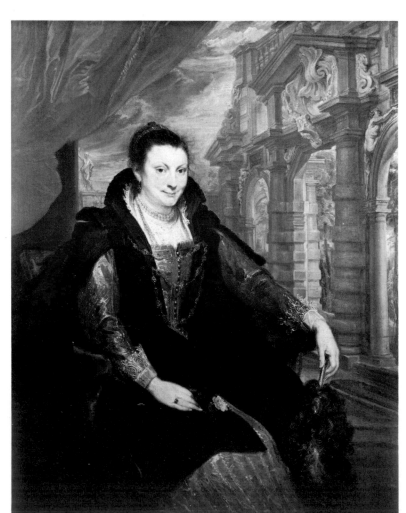

Sir Anthony van Dyck, *Isabella Brant*. Oil on canvas.
(National Gallery of Art, Washington, D.C. Andrew W. Mellon Collection.)

Textured surfaces made fluid with superimposed paint layers. To paint the lustrous color and sheen of fine fabrics you should study the fabrics by themselves in a still life and as they appear on a posed model.

When we talk of producing textures, we mean rendering objects in a way that makes their surfaces look different from one another. There is a marked difference between a piece of cloth and a chunk of granite or a field of corn. The textural difference helps us to distinguish linen from burlap or sandstone from granite. When you portray different surfaces, consider the substance that the object is made of. The best way to learn how to render textures is to study the real things and to show the difference in your painting. Think of these paintings as a series of important studies that will help you to do your larger works.

Project: LUSTROUS EFFECTS

SUBJECT: Still life—satin drapery

ILLUSTRATION REFERENCE: Sargent, *Betty Wertheimer* (color section, page 23); Van Dyck, *Isabella Brant*

TOOLS AND MATERIALS:
Smooth-surface canvas, 18″ × 24″
Sable brushes, assorted sizes
Cadmium red light
Cadmium red medium
Aliziran crimson
Veridian green
Raw umber
Titanium white

You will occasionally be called on to render smooth, lustrous effects, mainly in portrait and still-life subjects. For practice I suggest you drape a piece of satin fabric over the back of a chair, so that it falls into interesting folds.

Limit your palette to colors within the same family (for example, all the reds), using soft sable brushes to achieve the soft, smooth brushwork.

1. The first step is to carefully sketch in your subject so that you can keep track of the folds in the material.

2. Using a subdued color (green with a gray mixed into it), paint in the background spaces.

3. Paint in each fold of the drapery.

4. Using smooth, flat brush strokes, paint in the shadow areas or the darks of the drapery,

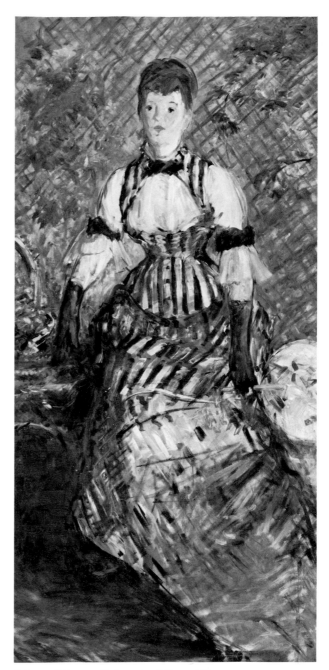

Edouard Manet, *Before the Mirror*. Oil on canvas.
(The Justin K. Thannhauser Collection, The Solomon R. Guggenheim Foundation, New York.)

Crosshatching. Different textures in crosshatched patterns are rendered in a network of brushstrokes carefully applied. Each area relates to the adjacent one because there are no small details to distract you.

mixing the alizarin crimson and a little black with the cadmium red.

5. Next, superimpose pure and vibrant pink tones over the colors, which will indicate the the light area.

6. And last, a very thin, almost pure white line with some cadmium red added to show the extreme highlight in the shining fabric.

Project: **TEXTURES FOR ARCHITECTURAL SETTINGS**

SUBJECT: Street scene showing brick, wood, and stone buildings

ILLUSTRATION REFERENCE: L. Salemme, *Imprisoned Dream of a Side Street*; A. Salemme, *View from the Window*

TOOLS AND MATERIALS:
 20″ × 24″ smooth-canvas
 Full assortment of oils
 Brushes—assorted sizes
 Oil base medium
 Clean palette
 Paper towels

To render the surfaces of different types of architecture, select a subject encompassing these various kinds of textures.

1. In your preliminary sketch, show a row of different, varied structures—one made of bricks, one of wood, and another of stucco. Also put in a stone wall, windows and shutters, wrought-iron balconies, and a lamp post or two.

2. Use a large brush to paint in the large background spaces. Make smooth brush strokes, with few or no apparent ridges remaining on the canvas.

3. Then, taking one building at a time, apply

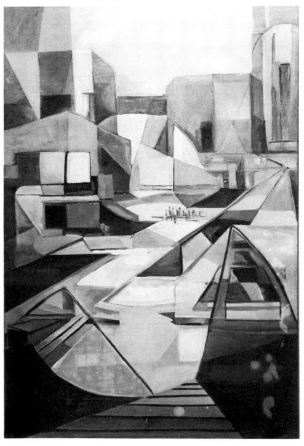

Lucia Salemme, *Imprisoned Dream of a Side Street*. Oil on canvas.
Architectural textures can be suggested poetically with a well designed composition.

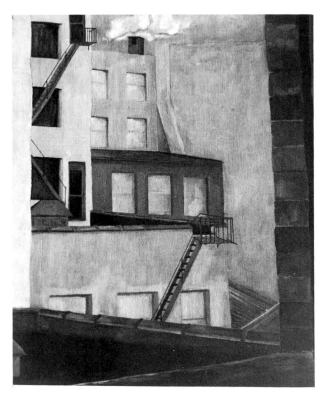

Attilio Salemme, *View From the Window—1940*. Oil on canvas.
(Private Collection.)

The linear rendition of the setting is the important factor. Think of the physical quality of each of the elements of the architectural world: concrete, glass, steel, brick, tar, and wood. Then, taking one building at a time, apply the colors with smooth brush strokes that leave no ridges. You need not be photographic, as long as you convey an approximation of the textures of the different surfaces.

the colors with medium-sized sable brushes, rendering accurately the surface textures of each building. Use your judgment to choose an appropriate size of brush for each. A small sable brush for painting in the final details is preferable. Use little or no medium with your colors, and paint with smooth brush strokes, with few or no ridges.

This exercise should give you an opportunity to work out a carefully detailed, literal subject, in which you can develop your perception and the ability to render texture in an architectural scene.

Use a full palette of colors along with your medium.

Project: **DIFFERENT TEXTURES IN A LANDSCAPE**

SUBJECT: Country scene

ILLUSTRATION REFERENCE: Renoir, *Oarsmen at Chatou*; Cezanne, *Le Château Noir*

TOOLS AND MATERIALS:
Rough-surfaced canvas 20″ × 24″
Canvas board 15″ × 20″
Full palette of colors
Bristle brushes, assorted sizes
Oil base medium
Clean palette
Trowel-shaped painting knife
Paper towels

Pierre Auguste Renoir, *Oarsmen at Chatou*. Oil on canvas.
(National Gallery of Art, Washington, D.C., Sam A. Lewishon Gift.)

Textures in nature subjects. Varied brush strokes capture the holiday spirit of the different elements in the scene.

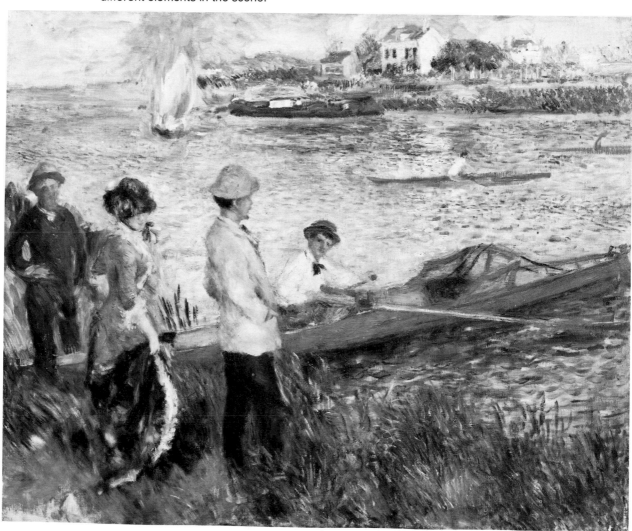

To achieve a rough-textured effect, first select a firm, rough-textured canvas and a set of bristle brushes, using the paint as it comes from the tube. A suitable subject for this experiment is a landscape, because the rendering of the different forms affords you ample opportunity to concentrate on surfaces—trees, grasses, rocks, distant hills, houses, and barns. You can work from memory or from a previously made drawing of the scene. Keep the composition uncluttered, separating the picture surface into four sections.

As before, the top section is a sky area, showing cloud formations where flat brush stroking is used. For the section under the sky show some hills or mountains in the far distance. Paint this area with light, delicate colors in semi-rough brushwork. Under these, in the middle distance of the landscape, put in trees, barns, or houses. Apply the paint in a more visible brush stroke, using muted variations of the normal colors. In the bottom section, which is the foreground area where you may have figures, rock formation, or hedges, use thick applications of paint boldly and with strong dramatic colors.

Use your paint without adding a medium to it, so that the paint consistency is uniform.

Do a second version of this idea, this time working outdoors on the scene or, if this is inconvenient, from a photograph. For this second painting use a palette knife to apply the paint and work on canvas board instead of canvas, keeping to the same procedure as the first exercise. Canvas board offers a firmer surface and is more adaptable to knife work.

Project: FLAT PAINT APPLICATION

SUBJECT: Still life with smooth-surfaced objects

ILLUSTRATION REFERENCE: A. Salemme, *Guitar with Chinese Horse*; Matisse, *Apples on Pink Tablecloth*; Avery, *Upper Pasture*

TOOLS AND MATERIALS:
 Smooth-surfaced, close-weave tablecloth
 canvas, 24″ × 30″
 Sable-hair brushes, assorted sizes
 Full palette of colors
 Oil painting medium
 Turpentine
 Roll of paper towels
 Cups

In learning how to produce a flat-paint quality, it is important to select a proper smooth-surfaced canvas on which to do your painting. A closely woven linen is the best for this purpose.

For subject matter, plan an uncluttered composition of a still-life arrangement made up of objects that have smooth surface textures such as drapery, wine bottles, fruits, and any others that you find appealing.

1. Make some preliminary drawings. Break up the picture plane into interesting flat patterns, because very little modeling is to take place. Select the one you like best and redraw it onto your clean canvas.

2. Prepare your palette before you start to paint by squeezing out all the colors in the still-life setup. Then mix the variations and different tonalities and place them onto the palette along with the mass toned colors.

3. Start your painting by first applying color to the largest area in the composition. Dip the brush first into the medium and then into the suitable color. Apply the paint to the canvas in small, smooth brush strokes, Do not use too much medium. It is used merely to make the paint more pliable, so that you may extend it without leaving visible brush strokes and ridges. Remember, the aim of this project is to create, smooth, uncluttered, flat textures in a harmonious rendering of your subject.

Project: SCUMBLING

SUBJECT: Country landscape

ILLUSTRATION REFERENCE: Ryder, *Jonah* (color section, page 25)

TOOLS AND MATERIALS:
 Full palette of colors
 Rough-surfaced canvas, 20″ × 24″
 Bristle brushes, filberts, assorted sizes
 Soft rags

Scumbling is the technique of dry brushing thick paint into dry surfaces, dragging the

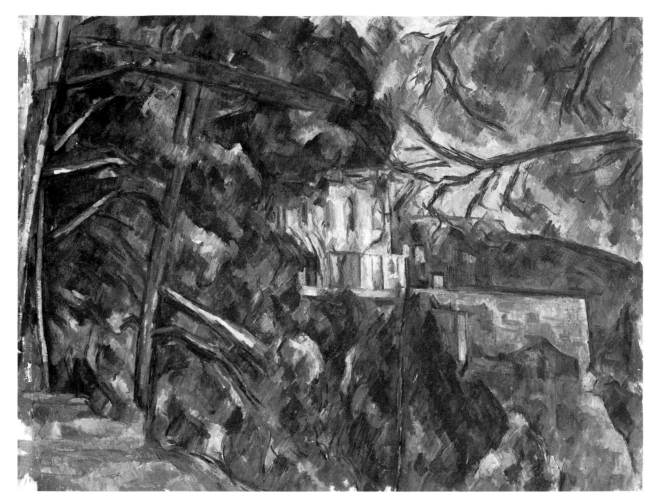

Paul Cezanne, *Le Château Noir.* Oil on canvas.
(National Gallery of Art, Washington, D.C., Sam A. Lewishon Gift.)

Cezanne has created **tensions** between the different planes and masses in his composition by having the color, forms and brush strokes mutually affect each other. Altering any one of these parts would disrupt the chain reaction of their movements.

brush back and forth from subject to background.

In addition, you can scrape and scratch off paint to reveal the painting underneath. By scratching the surface with the edge of your palette knife, you get fine lines. Scumbling is always done over a dry painting; that is, the paint must be dry underneath. Experiment with some of your old paintings.

Scumbling affects color by producing a broken surface. You can give your painting a very beautiful, archaic look by dragging a new color over an old one, allowing some of the original color to show through. Unlike glazing, in which a darker color is painted over the light one under it, in scumbling an interesting effect is produced by scumbling a white or lighter color over a previously painted darker area. You can also soften or subdue a strong color, cover unwanted details, and get interesting textures by patting on the color with old bristle brushes.

For scumbling, use the less oily colors, because transparent colors such as alizarin crimson and green earth are not appropriate to this technique.

1. In scumbling a country landscape first make a few drawings and select the best one for your painting. Decide whether you wish your picture to be vertical or horizontal. If you wish height, hold the canvas vertically; if width, rest it horizontally. Arrange the shapes in the composition—mountains, sky, trees, houses—in what you feel is an interesting

composition. Think of the canvas as a plan that you can arrange and rearrange as you like, just as you arrange objects on a table. Avoid having too many things of the same size or shape. Do not put in too much or too little, and have the space around each of the shapes act as part of the composition.

2. Roughly sketch in your subject. Paint in all the large masses such as sky, meadow, and the foreground area.

3. Superimpose the middle-sized spaces such as trees, barns or houses, and figures. While the paint is wet, gently wipe off some of the color so that the underlying color shows through.

4. Introduce accidental shadow areas, atmospheric effects, or textural elements. Paint in details with a small brush. Apply paint in solid patches wherever needed.

5. When the colors have dried sufficiently, usually in about three weeks, you will be ready for the second stage, which is scumbling with rags. Take a small piece of the soft rag and gently rub a transparent lighter mood color over the whole picture surface—say, a brownish gray-blue for a poetic mood. Then, while the paint is still wet, rub off the parts you do not like, so that the color areas and details underneath are revealed.

Milton Avery, *Upper Pasture*. Oil on canvas.
(Private collection)

Untextured color planes
create a quiet poetic effect.

Henri Matisse, *Still Life: Apples on Pink Tablecloth*. Oil on canvas.
(National Gallery of Art, Washington, D.C., Chester Dale Collection, 1962.)

Flat paint application. Where you do flat brushwork, it is essential to use a painting **medium.** The brush is first dipped into the medium and then into the color, after which it is applied to the canvas in small, smooth strokes with a sable-hair brush. Do not use too much medium, just enough to make the paint more pliable.

Attilio Salemme, *Guitar with Chinese Horse*. Oil on canvas.
(Private collection)

Flat paint quality achieved with visible brush strokes. Even though the paint is applied with flat brush work, the ridges left by each stroke are visible. The juxtaposition of different tonalities painted with little or no modeling is what gives form and shape to all the objects in the composition.

Project: SCUMBLING

SUBJECT: Reworking one of your old paintings

TOOLS AND MATERIALS:
 One of your old paintings, completely dry
 Old bristle brushes, assorted sizes
 Oil colors

Study the subject on your old canvas to see how you can improve it. Remember the aim in this exercise is to explore the scumbling technique as a means of retrieving an old canvas and making it into something interesting.

Dip your brush in a favorite color, and run the brush on some old newspapers you place next to your palette to get rid of excess oil in the paint.

The object here is not to radically change what has already been stated in this old painting, but to accent whatever is there that you consider worthwhile improving. This can be done with the additional application of new colors, which you use sparingly so that you do not eradicate your previous statement.

Project: PALETTE KNIFE

SUBJECT: Abstract landscape

ILLUSTRATION REFERENCE: L. Salemme,
 Columbine

TOOLS AND MATERIALS:
 Stretched canvas or canvas board, 24″ × 30″
 Full palette of colors
 Paper palette
 Roll of paper towels
 Flat-blade palette knife
 Trowel-shape palette knife
 1 medium-size bristle hair brush

In juxtaposing strokes, you use color in its purest sense—no black and white, just color. One clear color is put next to another to create the illusion of dark and light. The Post-impressionists and, later, the Pointillists used this method.

In this project you will place the color onto the canvas with the palette knife. With the knife you can squeeze, spread, or tap tiny and broad dabs of clear color directly onto the surface, and you can use the edge of the knife to make thin lines. Experiment to see which method you prefer. There are as many styles of palette-knife painting as of penmanship.

Many types of palette knives are sold in art supply stores to suit the tastes of individual artists. Try them and choose the one you prefer. I recommend a knife that has a 3-inch blade, tapering to a fine point at the tip. This knife takes care of most painting problems.

The technique of palette-knife painting is sometimes called the *impasto* technique. It's characterized chiefly by the raised paint ridges that create an additional dimension on the flat surface of the canvas. The thickness of the paint suggests a link between the flat, two-dimensional surface of the brushed painting and three-dimensional sculpture. You should note that the raised ridges of the paint dabs catch the light and cast shadows on themselves, creating the feeling of volume.

There are several advantages in using the palette knife, the main one being that it is possible for you to work long hours while the painting is wet. You are able to start and finish a picture in one sitting simply by placing stroke next to stroke.

You can maintain a clean, orderly canvas and render a clear, crisp image of your subject, as long as you wipe the knife clean after each color is used. (You would be surprised how quickly things can get out of hand if you do not get into the habit of wiping the knife!)

The palette-knife technique is best suited to expressing mysterious, romantic effects. The accidental effects it produces are part of the fun. You are free to work a play of cool colors against warm. A word of caution about edges: a hard edge will make your subject look mechanical, so use the sharp edges only if you want attention without mystery. Of course, the reverse is true when you are seeking softer and more poetic effects.

1. Start by making some preliminary drawings of an abstract composition from memory. Select the one you like best and paint it with a

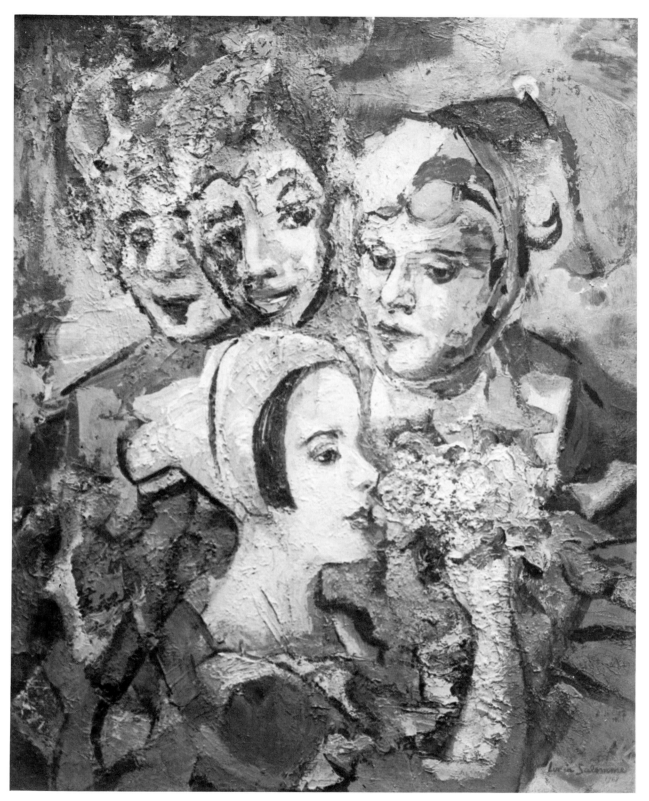

Lucia Salemme, *Columbine*. Oil on board.
Palette knife work. First sketch the subject in a bold,
dark color, which should serve as part of the composition.
With the trowel-shaped palette knife, spread or tap on
small dabs of color. Use the edge of the blade for making
long thin lines.

wash of bold, dark color onto your clean canvas.

2. Prepare your palette for painting by mixing all the colors you intend using. Mix ample amounts of each, because you will be using much more paint in this method of painting than when using brushes.

3. Using your trowel-shaped painting knife, apply paint to the large areas first. Put down a large dab of color with the flat part of the blade, then extend the strokes in a consistent direction, so that you always have visible ridges. Be careful to not blot out the bold lines of your drawing.

4. Next, juxtapose contrasting colors, playing light against dark, cool against warm, complements next to primaries. You should have a festival of colors. Use a patchwork of colors for sky, hills, lakes, and houses, painting each in its own fresh color. Each will enhance the other. These units of color painted in a broader version of the pointillist technique (that is, large visible dabs of paint) will determine the ultimate unity of the composition.

Palette-knife painting is no technique for the timid, so paint bravely! If you make a mistake, you can easily scoop it off with your flat knife.

2. Place canvas on the floor, and hold stick wet with a color over the canvas. Allow paint to drip onto the canvas. Control the flow with swift arm and body movements over the canvas, creating a compositional design in this manner.

3. Begin with the light-hued colors, gradually using the darker colors so that they are alongside each other. Avoid having the colors overlap; you may build up too many thick paint layers if you do, running the risk of the paint cracking and peeling off the canvas in a matter of years.

In this technique, it is better not to have a picture plan. The success depends on a spontaneous application of the flow of paint from stick to canvas surface. You can vary this method of spontaneous painting by pouring color that has been greatly thinned directly onto the canvas.

This can be an untidy process if you are working at home! As an alternative, you might try working out-of-doors or in a basement, where you do not have to be concerned with keeping the floors clean. Of course, a loft studio is the ideal working area for this technique.

Project: SPONTANEOUS PAINTING

SUBJECT: Free-form abstraction

ILLUSTRATION REFERENCE: Pollock, *Ocean Greyness*

TOOLS AND MATERIALS:
Unsized cotton canvas 30″ × 40″
Oil paint in cans, (e.g., small size Benjamin Moore) all colors
A dozen sticks, one for each color, about 18 inches long
Gum turpentine
Lots of rags

1. Immerse one stick in each can of liquid paint so that each will be ready whenever you wish to use a color.

Builtup Spontaneous Layers of Color: Barbara Schaeffer, *Portrait of an Urn*

Layer upon layer of textures are made by pouring and squeezing out colors from plastic squeeze bottles. This is a spontaneous method of painting in which the three-dimensional surface is created with brushing and working the paint with the hands, letting one layer to dry thoroughly before applying the next. Tools consist of double-primed canvas which is stretched on a heavy-duty sturdy frame, brushes, various buckets and squeeze bottles for drawing and pouring and your own hands for applying the paint. You can use tube colors, dry pigments mixed with linseed oil and cobalt varnish.

Jackson Pollock, *Ocean Greyness*.
Oil on canvas.
(The Solomon R. Guggenheim Museum.)

Drip, pour, and stain. Intuition as well
as spontaneity play a major role in this
type of painting. The canvas is placed
down flat and colors are either poured
or dripped over it so that they merge or
superimpose on one another. The
artist's sensations are the subject.

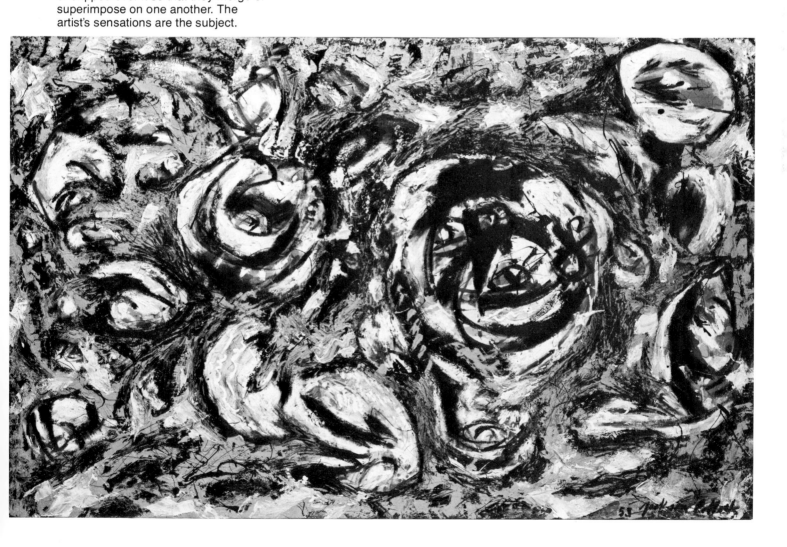

Barbara Schaeffer, *Portrait of an Urn*. Oil on canvas.
Three-dimensional effects with paint layers. A
spontaneous method of painting where the three-
dimensional surface is created by building up color areas
with paint squeezed from plastic bottles. Layer upon layer
of textures are made by pouring, brushing, and working
the paint with the hands; letting one layer dry thoroughly
before applying the next. Tools and materials are: double-
primed canvas stretched on a heavy-duty sturdy frame,
brushes, buckets and squeeze bottles for drawing,
pouring, and applying the paint. The paint itself is a
mixture of tube colors and dry pigments that are ground
and mixed with linseed oil and copal varnish.

Project: VELATURA

SUBJECT: Figure in a landscape

ILLUSTRATION REFERENCE: L. Salemme, *As Light Sweeps Across the Sea* (color section, page 20)

TOOLS AND MATERIALS:
Stretched medium-rough canvas, 30" × 40"
Full palette of colors
Oil painting medium
New-Temp Gesso, Utrecht
Bristle brushes, rounds, assorted sizes

The velatura technique is ideal for creating veil-like, ephemeral, airy effects when you want to express poetic moods. The velatura quality is arrived at by adding glazing medium to the color until it is of a paste-like consistency, halfway between impasto and glaze.

Velatura calls for a dry, matte surface texture. To achieve this you must give your canvas an undercoat of quick-drying white. New-Temp Gesso, a product made by Utrecht, is recommended. One coat is usually sufficient. When this undercoat is dry, much of the oil has been removed, leaving you with a dry, matte surface over which velatura glazes may suitably be painted.

1. Plan a fairly large picture and select a good drawing to enlarge onto your canvas.

2. Model your subject in varying tones and textures of a light neutral color. Raw umber or raw sienna is fine. Paint your dark areas thinly and the light areas with a slightly thicker application of paint. You will create a more three-dimensional quality that adds depth to the picture when the modeling is done with visible brush strokes, that is, covering the light value areas with very thick brush strokes of a light neutral color and the dark areas with applications of thinned color. Then, when you superimpose a velatura color, the thinly painted darks come through as shadowy receding tonalities, whereas the more thickly painted light areas, having more texture, will appear to be advancing.

3. When the underpainting is completely dry, you are ready to use the velatura, paste-like versions of all your colors. Paint these directly over the picture areas, so that a spontaneous effect is created. This involves knowing exactly where you wish a given color to appear, to avoid reworking as much as possible.

4. Place the colors on your palette. First, mix the tones you will be needing, then thin them with your medium, so that when applied to the canvas there will be no visible brush stroke. This direct method of painting allows for little or no overpainting. What you first apply is what should remain, assuring you of a fresh and spontaneous effect.

Project: VISIBLE BRUSH STROKES

SUBJECT: Rock formations in a seascape

ILLUSTRATION REFERENCE: Homer, *High Cliff, Coast of Maine* (color section, page 25)

TOOLS AND MATERIALS:
Medium-hard charcoal
Medium-rough textured cotton canvas,
20" × 24"
Bristle brushes, assorted sizes—flats
Full palette of colors
Painting medium made from one part each of turpentine, linseed oil and standoil
Palette knife, flat blade for mixing purposes
Clean palette
Roll of paper towels

1. The first step is to make a detailed drawing of rock formations, drawing with medium-hard charcoal directly onto the canvas. Section the compositional space so that one-quarter is for the sky area. The remaining area is for rock formations, as seen in rockbound coastlines. Sketch in large rocks adjacent to smaller ones, so as to have a variety of proportions in the picture.

2. Indicate where the light is emanating from so that you will know where to place shadows.

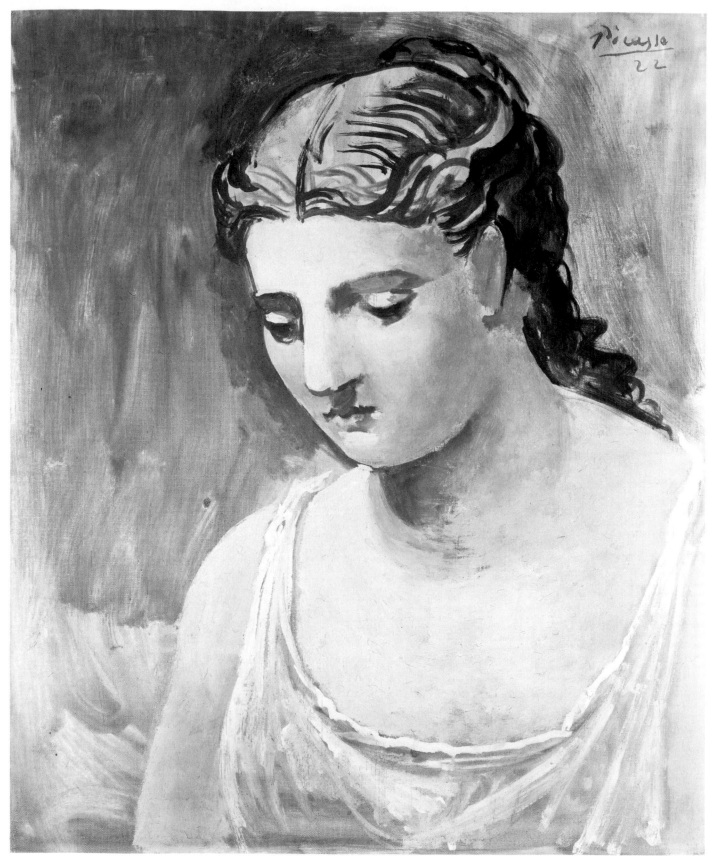

Pablo Picasso, *Classical Head*.
(National Gallery of Art, Washington, D.C. Chester Dale Collection.)

The three-dimensional quality is rendered with subdued
modeling in order to capture the acrhaic mood of a
classic portrait.

3. Block in all the extreme light areas first, then paint in all the strong dark areas. In sequences add all the other colors, beginning with the lightest and then, by adding a little black to each, see how often you can change their values.

4. Because you are painting with visible brush strokes, the whole painting can be resolved in one sitting, since no overpainting is required.

5. Load your brush with color suitable in intensity to the area being worked on, and apply it in the natural direction of the form you are painting.

6. Be generous with the amount of paint you use, because a thick paint load on the brush is what creates the visible brush stroke.

ACRYLICS

During the past 75 years many discoveries and inventions in the manufacture of synthetics, lacquers, and dyes have finally led to the development of the plastic paints known today as acrylics. Many of our leading painters are using acrylics since they are fast-drying and durable and solve those two most pressing problems painters have always had to contend with.

The main drawback of oil paint has always been that during the drying its linseed oil vehicle changes from a liquid to a solid and in the process becomes an entirely different substance. Furthermore, because oils lack adhesiveness, when the finished picture dries, it becomes porous and brittle, is subject to cracking, and eventually deteriorates. In contrast, acrylics remain stable and are not subject to further chemical changes as they dry. Unlike oils, which dry by oxidation, acrylics dry by evaporation. Once they have dried, no other chemical process within the paint film takes place to crack or darken the painted surface.

Acrylics are soluble in water as they come from the tube or jar, but they become completely insoluble as soon as the water evaporates. As a result, overpainting can proceed in a few minutes without affecting the condition of the paint beneath or its durability. The entire painting process—from priming a raw canvas with a gesso ground, sanding the ground, painting the picture with as many layers of colors as you like, and applying a coat of varnish—can be done in the space of one day.

Acrylics are water-emulsion paints made with dry, powdered pigments and a combination of plastic resins. In the manufacture of the paints, colored pigments, plasticizers, and wetting agents are added to plastic polymer materials in granular or emulsified form, the end product being this newest of all painting media for artists—acrylic paint.

Acrylics first appeared on the market in 1947. Many scientific tests have proven that **205**

they are all they are claimed to be—that they are fast drying, do not peel or crack, and do not with time change or fade in color value in any way.

Acrylic paints employ the same resins as those used in such plastic products as Lucite and Plexiglas, and they possess the same brilliance, durability, and depth—the typical look of all plastic products.

There are two types of acrylics. One is Magna, made with an acrylic resin that is miscible with oils and turpentine. Magna is an acrylic resin that, when suspended in a suitable solvent-like turpentine, forms a substance that can then be applied to any paintable surface—paper, wood, plaster, or canvas. The resin becomes part of the surface as the solvent evaporates. There is no long drying process, because no chemical reaction takes place. The resin is chemically inert and therefore stable. Magna may be used with oil; it speeds the drying time of the oil. After 20 years of tests Magna has proved to be most durable and will not yellow even in direct sunlight. Magna is made by Bocour Artists Colors, Inc.

The other acrylic type is a polymer emulsion that can be thinned with water. These colors are easily manipulated, have excellent adhesion, and are permanent. The most popular and best-known brands of the polymers are: Aqua-tec made by Bocour Artists Colors, Inc. Hyplar made by M. Grumbacher, Inc., Liquitex made by Permanent Pigments, Inc.

Acrylics are especially useful in the commercial art field, where speed of execution and durability are a primary concern. They are advantageous for paintings destined to be hung in public places and exposed to drastic changes in temperature.

To further the comparison between acrylics and oils, we go to the final look of both media. Oils have a rich, moist, velvety texture, and when dry they have a glossy finish. Acrylics, on the other hand, are crisp in texture and dry with a dull, matte finish.

TOOLS AND MATERIALS

Painting Surfaces

For acrylic painting, rigid supports such as masonite panels are excellent; such ordinary surfaces as canvas, paper, china, glass, and Lucite can also be used. When acrylic paints are used on porous surfaces like Celotex, plywood, plaster, and masonry, several priming coats of gesso must be applied to close the pores before painting begins. When extremely rough surfaces are desired, many artists add marble dust, gravel, or sand to the gesso to create the desired textures.

Brushes

In brushes, bristles, sable, and nylon are all useful. You can use either inexpensive versions of these or stiffer, tougher substitutes like sabeline and high-grade oxhair. The white sable brushes made by Robert Simmons, Inc., are most suitable for both linear and wash rendering. These brushes are made with a synthetic fiber which performs like the traditional red sable hair. They are excellent for basic uses, and are easier to clean, last longer, and are priced considerably lower. M. Grumbacher, Inc. also makes brushes with synthetic bristles.

Before starting to paint, plan to select the right brush for the area to be painted. Consider the texture of the support you will work on and the type of brush mark you wish to make. For example, flat-bristle brushes are suitable for covering large areas on porous grounds. The rounds should be used when scrubbing on color with the scumbling technique. The flat sables are used when smooth textures are required in blending on glazes and applying varnishes. Very stiff bristles are used when you wish to make visible brush strokes.

While painting with acrylics the brushes must be kept wet at all times to avoid having

paint harden on the bristles. You can ruin many a good brush if you let the paint harden on it—and it does not take very long. As soon as a painting session is over, brushes must be cleaned thoroughly with soap and water—all the acrylic paint must be removed, or the brushes will dry hard. If this should happen, the brushes may be reconditioned by using the manufacturer's recommended acrylic remover or solvent for removing dried paint films.

Palettes

Aluminum foil, plastic saucers, and disposable paper palettes may all be used as palettes, but the best is a sheet of Lucite or Plexiglas or a flat piece of glass. These last serve very well for paint mixing, and they are practical when you wish to remove dried paint. You simply submerge the glass in water for a short time and strip the paint from the surface.

In setting the palette it is best to put out only as much paint as you think you are going to use in the painting session, adding more colors as they are needed. Because paints are workable only while moist, add a bit of water periodically as the colors thicken. Once they have hardened, they cannot be reworked.

Medium

The liquid binding medium is a concentrated acrylic emulsion. The binding medium is important because acrylics, which come in an opaque state, require a medium that permits a good deal of color visibility from one layer to another, especially when glazing. The medium, which comes in both tubes and jars, becomes completely clear when dry and has the same consistency as the color.

Gloss medium is a milky plastic emulsion that dries clear. When this milky medium is added to the tube color, the pasty tube paint dissolves in the medium to form a thick fluid that is the consistency of honey. This medium has a faint white tone when wet, but when dry it becomes as transparent as a pure watercolor wash. Yet it dries with a luminous, inner light, and this is its chief characteristic. This medium makes it possible for you to apply paint with a soft sable brush in a smooth coat, but it is thick enough when applied with a stiff bristle brush to make distinct, textured strokes. You can also rebrush a wet passage before it dries without fear of muddying the color. It is also useful when you want thinner paint layers; the trick is to thin your paint first with water, then add a brushful of the medium to get the consistency just right. Therefore, keep a glass of water next to the jar of medium.

Matte medium dries to a nonglossy finish similar to the look of watercolor. It contains an inert substance that removes the shine out of the paint. When wet it looks like milk, but it dries clear and matte. It is difficult to tell the difference between gloss and matte when wet; the difference shows up only when the picture dries. Gloss medium seems to add luminosity to your colors, in the same way that a layer of varnish gives more gloss to an oil painting. Matte surfaces, however, create subtle and delicate atmospheric effects.

Gel Medium

Gel medium is thick and pasty and comes in a tube like the paint. When squeezed, it has the same cloudy, milky look as the matte and gloss media. When gel dries it, too, is clear. Mixed with tube color, gel keeps the paint stiff and buttery for impasto painting and supplies you with a heavy buildup of color, making lots of rough visible brush and knife work possible.

All sorts of raised brush strokes are possible when one of these gels is added to colors. It is a thick, concentrated acrylic emulsion similar

to the liquid acrylic binding medium. It is flexible and dries like a film, fitting acrylics for a variety of techniques, including transparent washes, delicate brush delineations, raised brush strokes, and heavy impasto effects. When gel is mixed with the colors, it increases their transparency without changing their consistencies, brush characteristics, or hue. Furthermore, brush strokes and palette knife textures are retained. The mixture may be used under, with, or over other colors for creating dimensional effects. Because gel has a slower drying action than the medium, it allows for easier manipulation of the color when blended effects are required. This emulsion is labeled under different names by individual paint manufacturers, but all are essentially the same product.

Jel is made by Bocour Artists Colors, Inc; Hygel is made by M. Grumbacher, Inc.; and Gel is made by Permanent Pigments, Inc.

Gesso

Gesso is used in the preparation of the grounds on plaster walls, unprimed canvas, or any other porous surface. It is a ready-made product used to coat or prime a painting surface without using a preliminary sealer. Because it contains titanium white, it is nonyellowing. It is adhesive, because it has been combined with acrylic polymer emulsion. It is applied with a brush or roller on any clean, nonoily surface; when it dries, it is completely resistant to oil and water. When a very smooth surface texture is needed, gesso can be thinned with water and applied in several coats. Each coat should be sandpapered after it dries to be ready for paint. Many artists apply sand or gravel to the gesso as it dries to create a base for subsequent color layers and new textural surfaces. The gesso is used directly from the can without dilution, and colors may be added to make tinted grounds.

Varnishes

Unlike oil varnishes that dry by oxidation, acrylic varnishes dry by evaporation. Such varnishes may be applied minutes after the painting is finished, not months later, as with oils. The varnish comes in three forms: matte, gloss-medium, and gloss, and each can be used according to the finish the individual artist requires for the painting just completed. For example, gloss varnish is crystal clear and can also be used as a medium for the colors, increasing their adhesive qualities as well as making them glossy. When applied to a finished painting, it coats the surface with a luminous sheen. When a matte varnish is used as a medium for painting, it changes the semimatte quality to a flatter quality, coating the surface of a dried finished picture with a soft matte film. Both matte and gloss varnishes are available in spray cans.

Works on paper do not really need the protection of the varnishes, since they should be exhibited under glass. However, varnishes can be used on works that have been painted on canvas and masonite.

Acrylic medium and acrylic varnish are almost alike—they both come in matte and gloss. They should always be diluted half-and-half with water. Brushed on straight from the bottle, these varnishes, especially the matte, sometimes dry to a faintly cloudy film. Diluting it with water eliminates the problem.

Retarders

Several manufacturers produce retarders to slow down the drying time of acrylic paint when stroking and restroking shadows to get the correct soft transitions from dark to light. Retarders work well only with thick paint. Too much restroking may create muddy color, so use the retarder sparingly.

Modeling Paste

Modeling paste comes in cans and has the consistency of putty or clay. It is a mixture of acrylic emulsion and some granular substance like marble dust. When mixed with acrylic color, you will get the thickest paint you have ever seen, with amazing three-dimensional surfaces. Other intriguing effects can be created for various textured painting surfaces. For example, you can tint the paste with a color, trowel it onto a sheet of untempered masonite, and texture the wet paste to make a delicate "mold" or impression of the fabric's surface. You can then paint on it or press onto it any other textured vehicle like wood, seashells, or wood bark to leave its imprint into the wet paste. *To color wet modeling paste*, the thick acrylic paint is the best to use, because the dry paste is not absorbent enough for fluid washes. Furthermore, leveling and nonleveling for achieving impasto and relief effects can be easily accomplished by using modeling paste, because it is a ready-to-use paste made with a latex emulsion and ground marble. While wet it can be shaped and textured; when dry it can be cut, carved, and sanded. It is best to paint on a hard surface like masonite or a well-supported canvas, because the modeling paste makes the colors heavy while drying. When modeling paste is mixed with acrylic colors the paints become more adhesive and dry more matte. The built-in driers can be controlled by the individual artist according to the needs of the moment from a slow-drying action to medium or fast. When dry, the paste becomes resistent to both water and oil.

TECHNIQUES

When you first begin to use acrylics you will in all likelihood imitate older media such as oil, tempera, or watercolor, but if you acquaint yourself with the advantages of acrylics by experimenting with them, these synthetic paints will reveal many new possibilities. Keep in mind that they are made of plastic and that plastics have three distinct physical characteristics: transparency, body, and adhesiveness. Certain painting techniques are best suited to acrylics, including flat-paint application with no surface textures, palette-knife effects with raised and lowered visible strokes, scumbling, glazing, and impasto for three-dimensional effects.

Flat Application of Paint with No Surface Textures

Acrylics are ideally suited to rendering flat, untextured surfaces with clean, sharp edges. The colors are used as they come straight from the tubes, with little or no water added to them. It is best to paint on an unprimed canvas that has a slight tooth to it, because this will give the paint surface a slightly textured look when dry. (See color section, page 38.)

Flat applications of paint can be used to best advantage when painting abstract, geometric themes with shapes that have a hard edge. In this method of using acrylics, masking tape is placed along the outside edge of the shape that is to be painted. Then the desired color for that one area is squeezed onto the palette and applied onto the canvas in flat, smooth, untextured brush strokes. Stay within the edge of the masking tape. Some painters color right over the tape, removing it when the color has dried to reveal a clean, sharp edge. Since the colors dry in a matter of minutes, it is a simple process: Paint the larger areas first, place tape along the edge of the next shape, and then proceed with the painting.

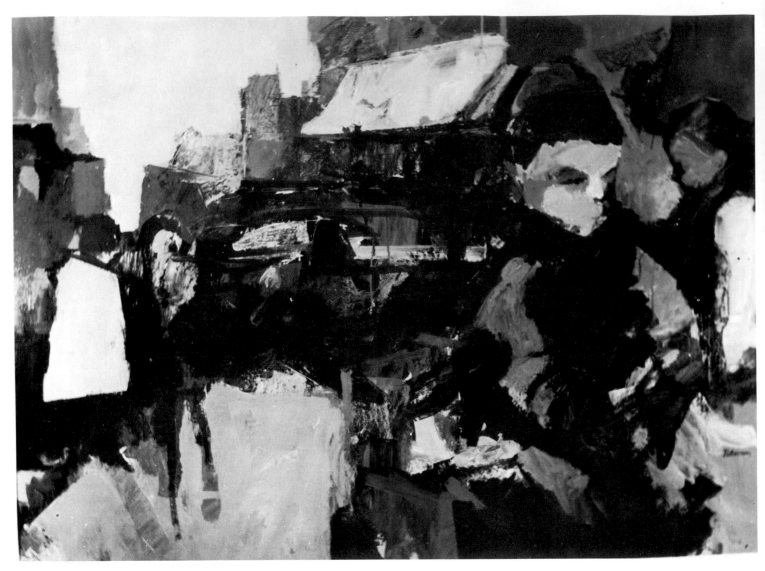

Daniel Dickerson, *Crosstown Complex*. Acrylics.
(Private collection)

Fluid brushwork. Acrylics have transparency, body, and adhesiveness, three characteristics that are considered to be a bonus by most painters. They can be handled in a manner similar to oils and gouache making it possible to organize the composition with much fluidity.

Project: FLAT SURFACE TEXTURES

SUBJECT: Abstract composition with no surface
 textures

ILLUSTRATION REFERENCE: Barnet, *The Three
 Brothers* (color section, page 37);
 Bolotowsky, *Abstraction in Three Reds*

TOOLS AND MATERIALS:
 Canvas, unprimed, semi-rough texture,
 24″ × 30″
 Acrylic paints, assorted colors
 Set of sable-hair brushes, assorted sizes
 Glass palette
 Jar of water for cleaning brushes

Flat Application: Hard Edge

1. On a separate sheet of paper, make some
sketches of shapes that have a hard edge.
Make them of varied sizes that interact with
one another in the composition. Select the
drawing you like best, planning beforehand
the placement of the colors. Working with col-
ors that are in the same family is always pleas-
ing.

2. Transfer your sketch onto the canvas,
using pencil and ruler to get straight edges.

3. Attach strips of masking tape along the
outside edge of the shapes before starting to
paint.

4. Use one color at a time as you need it.
Squeeze it onto the palette, and apply it to the
area with smooth, flat, untextured brush
strokes. Color up to or over the tape; when the
paint is dry (in a matter of minutes), pull the
tape from the canvas to reveal the clean, sharp
edge.

5. Paint the large areas first, repeating the
procedure until you have covered all the areas.

6. Should you wish to overpaint any area,
isolate the color layer with a coat of varnish,
and when it has dried, apply your new color.

Ilya Bolotowsky, *Abstraction in Three Reds* 1979.
Acrylic on canvas.
(Private collection)

Flat surface textures. Acrylic paints possess "leveling"
characteristics which make them ideal for the flat textures
of abstract painting. As an added advantage elaborate
precision edges are possible since the brush does not
leave any paint ridges.

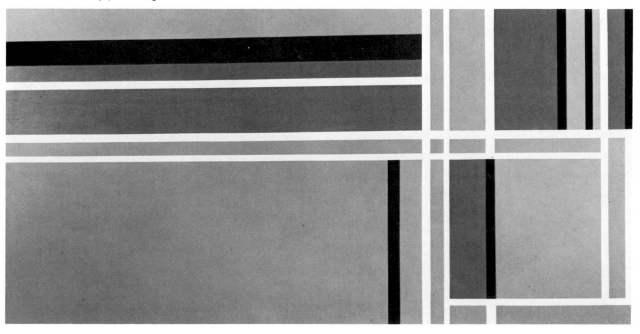

7. The last step is to varnish the finished picture with matte varnish for a matte finish or with the gloss for a lustrous sheen.

Palette-Knife Technique

The aim of the palette-knife painting is to create visible strokes with the colors. Unlike other water-based paints, acrylics have body and are solid after they have dried, making it possible to build up thick bodies of paint when used with a palette knife. Tests have proved that these heavy paint applications will not crack or peel.

Acrylic paints may be made heavier and thicker by adding gel, a thick emulsion that produces sparkling, three-dimensional impasto effects, thick brush strokes, and palette-knife textures. Its best feature is that it dries clear and does not interfere with the values of the colors. With the addition of gel, flat color areas and smaller mosaic-like shapes of color can be painted with the palette knife very easily because the paint will dry rapidly. For this reason the work of painting can be done in a swift and spontaneous manner, and the picture can be finished in one setting.

You can prepare your glass palette for painting by placing a sheet of white paper under it. Squeeze out all your colors along with some of the gel and mix each color with some of the gel as you use it. This will make the paint thicker and heavier so that you can use the flat-blade knife to mix it with. Then with the trowel-shaped knife you can apply color directly onto the canvas, using bold, thick applications of paint. To get intermediate color tones, mix them first on the glass palette, and then apply them to the canvas. Do not forget to add the gel. Since the acrylic colors dry quickly, you are able to overpaint as many additional color layers you like. To paint the smaller areas, the trowel-shaped palette knife is used. Follow the natural shape of the object being painted for the proper direction that the knife strokes are to take. Scrape away any unwanted areas.

The particular advantage of using the palette-knife technique with acrylics is its ability to achieve raised and lowered paint strokes in quick succession with color that dries as you paint along. This quick drying permits you to accent the volume of the forms being painted simply by stroking the paint so that its direction matches the natural direction of the form being worked on. Paint a tree trunk in the direction that it is growing; paint a flower from its center out; paint grass in up-and-down strokes.

To raise the level of each stroke or pat you make with the knife, simply mix the gel into the color being used until a thick paste is formed. This enables you to produce dynamic dimensional effects. (You will know that the paint is thick enough when it can be moved easily with your knife.)

For finishing touches and color accents, pure white and black paint are used. This is best done by applying the paint with the long edge of the trowel-shaped painting knife to make thin lines for refining any delicate forms. Acrylic colors dry to a matte finish, requiring no final varnish. If you should wish to have a glossy finish, cover the surface of the picture with gloss varnish.

Project: PALETTE KNIFE TECHNIQUE

SUBJECT: Country scene

ILLUSTRATION REFERENCE: Penney, *Jivation* (color section, page 39)

TOOLS AND MATERIALS:
Drawing pencil, 6B
Canvas board, 20" × 24"
Drawing paper, 20" × 24"
Glass palette with sheet of white paper under it
Gel
Flat-blade mixing knife, 3 inches long
Trowel-shaped palette knife, about 3 inches long

1. Make some preliminary drawings of a country scene, using features that will give

you an opportunity to render raised and lowered visible strokes. Include billowing clouds, distant hills, rock formations, trees, and an old barn or two. Select the composition you like best, and sketch it with your pencil onto the canvas board.

2. Squeeze out all your colors, along with the gel, onto the glass palette.

3. To thicken the paints, mix them with the gel.

4. Apply the paint boldly on the larger areas, using the trowel-shaped palette knife. To get different intermediate tones, mix the colors on the palette before applying them to the canvas. Because acrylic colors dry rapidly, you are able to overpaint with as many additional layers of colors as you like.

5. To reveal an underlying color, remove the upper layer with the flat-blade mixing knife.

6. Use the tip of the trowel-shaped palette knife to paint the smaller areas. Follow the natural shape of the object being painted, to assure yourself of establishing a vibrating dimensional quality in your landscape.

7. For the finishing touches and color accents, use pure white and black paint. Apply the paint with the long edge of the trowel-shaped palette knife to make thin lines to identify any of the more delicate forms.

SCUMBLING TECHNIQUE

As you know, scumbling means scrubbing color into a dry surface by dragging the brush back and forth from subject to background, so that some of the ground color shows through. The scumbling technique is used when you wish to create poetic, mysterious effects.

To scumble acrylic paints, old bristle brushes are used to apply paint in a scrubbing

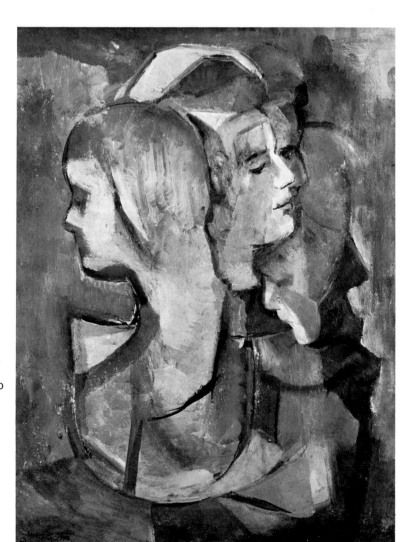

Lucia Salemme, *Young Love*. Acrylic on canvas.
(Collection Sam Nerevsky, N.Y.)

Scumbling. In order to use the scumbling technique your colors must have body and should maintain a uniform consistency. By mixing gel into the paint, you can lay down one color over another so that some of it shows through in irregular textures.

motion, allowing previously applied paint layers to show through. A poetic, archaic look is the final result, because some of what was underneath is always visible, suggesting mysterious unspoken ideas.

In the scumbling method of painting the colors must have body and maintain a uniform drying power during painting. Mixing gel into the paints ensures just that.

An unprimed canvas with two coats of gesso is the best surface for scumbling. Start by painting in all the largest areas, using an old bristle brush to scrub the paint onto the canvas in a circular direction. While the paint is still moist do some blending by adding gel to your colors. Allow the paint to dry, then scumble or rub a darker-toned color over what is already there. You are now at the intermediate state, at which both the dark and the light tones have been alternately used. In a semi-scumbling technique you paint in additional colors that you thin with matte painting medium, again allowing some of the underneath colors to come through. Now the advantages of working with acrylics becomes evident, because the paint areas dry in minutes, and new areas can be scumbled over them almost immediately. At this point you can begin to overpaint, that is, you can perk up the already painted areas with undiluted color, making them even thicker by mixing them with either white or black. In the final stage, you can begin to use more transparent washes of your colors to obtain glazes by using the gloss painting medium mixed into the color. These thin glazes will produce a lustrous surface created from the many layers of colors that have been used. For the final detail work a small sable brush is good for painting in any detailed solid color areas. Apply highlights by scumbling one of the brighter opaque colors wherever you feel that they are needed. To complete the painting, apply two thinned-with-water coats of matte varnish with a 2-inch sign painters' brush.

Project: **SCUMBLING**

SUBJECT: Objects in a still life

ILLUSTRATION REFERENCE: L. Salemme, *Young Love*

TOOLS AND MATERIALS:
 Assortment of still-life objects
 Stretched unprimed canvas 24″ × 30″
 Old used bristle brushes, flats and rounds, assorted sizes
 Sable-hair brush, #3
 Gel
 Matte painting medium
 Gesso
 Sign-writer's brush, 2 inches
 Glass palette
 Two jars of clear water

1. In setting up your still-life arrangement, select objects you feel are particularly poetic—an old teapot, a vase, a book, or a musical instrument. Set them on a table near your easel and make several drawings of the group. Select the drawing you like best and set it aside.

2. Before starting to paint you should cover the unprimed canvas with two coats of gesso.

3. Paint in all the larger areas first, and use an old bristle brush to scrub on the colors. This will establish the general mood of the picture.

4. While the paint is still moist, do some blending by adding gel to the colors.

5. Allow the paint to dry, then scumble or rub darker-toned colors over what is already there.

6. You are now at the intermediate stage in which both the dark and the light tones have been alternately used. Paint in additional colors that you have first thinned with matte painting medium, again allowing some of the colors underneath to come through.

7. Now you can begin to overpaint. You can perk up the already painted areas with undiluted color, making them even thicker by mixing the paint with white or black or another color.

8. Lay down more transparent washes of your colors mixed into the color. These thin glazes will preserve the lustrous surface created by the many layers of colors previously scumbled on the canvas.

9. Try the #3 sable brush to paint in any detailed solid color area. Apply highlights by scumbling an opaque bright color whereever you feel it is needed.

10. You can now varnish your finished picture, if you wish. With your 2-inch signwriter's brush apply two thinned-with-water coats of matte varnish, and your picture is ready to be framed.

GLAZING TRANSPARENT EFFECTS

Because acrylic paints are plastic, they are completely transparent, and this makes them a perfect medium for the glazing technique. You can apply thin transparent glazes by thinning the paint with water or with acrylic painting mediums, which come in gloss, matte, or gel. When you apply the varnish after each one of the glazes, one glaze is built up over the other like layers of colored cellophane. The clear varnish will separate each glaze and build up a film of thick colored paint. In the finished picture this color film produces an eerie inner brilliance that is very beautiful.

Prepare unprimed canvas for painting by giving it two coats of gesso. Then water down one of the light-hued colors to make a thin wash and apply it onto the canvas. Paint successive layers with progressively darker-hued colors, using less water each time you paint.

Try out the different mediums one at a time and study their effects. For example, make one glaze with gloss medium, one with matte, and one with gel. As you approach the final glazes, use the colors as they come straight from the tube, with no water or medium added.

Project: TRANSPARENT EFFECTS WITH GLAZING

SUBJECT: Flower abstraction

ILLUSTRATION REFERENCE: L. Salemme, *My Garden* (color section, page 37)

TOOLS AND MATERIALS:
 Full palette of acrylic colors
 Bristle and sable-hair brushes, assorted sizes
 Painting mediums, matte and gloss
 Gel
 Unprimed canvas, 18″ × 24″
 Jar of acrylic gesso
 Two jars of clear water

1. Prepare your unprimed canvas for painting by giving it two coats of gesso.

2. Make some sketches of an individual flower, one that has interesting petal forms—such as a tiger lily, gardenia, or tulip—utilizing the leaf and stems as a secondary motif.

3. Select the sketch you like best, and redraw it onto the canvas (you can use a pencil).

4. Thin each color as you use it, either with one of the mediums or with just plain water using all the lighter-hued colors in the beginning paint layers. Because acrylic paints are plastics, they are completely transparent, and you can build one layer over the other, like layers of colored cellophane.

5. As you approach the final glazes, use the colors as they come straight from the tube. Be careful not to cover all the translucent effects you have worked so hard to achieve.

Here is a project exercise that I suggest you do just for a little fun and to practice using the acrylics in a more lighthearted manner.

Project: WATERCOLOR METHOD

SUBJECT: Landscape

TOOLS AND MATERIALS:
 Heavy water color paper or illustration boards
 Full palette of colors
 Pointed sable brushes

The aim is to achieve transparent effects in a spontaneous, carefree handling of the paints.

1. Prepare paper by giving it a coat of acrylic gesso.

2. Use some method of painting as the traditional watercolor technique.

3. Dilute the paints with water and matte medium by dipping the brush first in one, then in the other.

4. For final details and highlights, titanium white, used sparingly, is effective.

IMPASTO FOR THREE-DIMENSIONAL EFFECTS

All sorts of dimensional effects are possible with acrylics, especially when modeling paste is worked into the gesso ground while the gesso is still in a wet state. Heavily raised impastos are created by building up the paint levels with modeling paste and relief effects by scooping out the modeled paint layers. Painting on a rigid surface such as masonite is a must when using modeling paste. Doing a mural on a plaster wall or outdoors on a cement wall presents no problems, because, obviously, these walls are sufficiently rigid.

The area to be painted on must be primed with at least five coats of gesso. An uneven texture made with irregular brush stroking is advisable. You can apply the acrylic modeling paste over the gessoed surface to create additional textures. Marble dust added to the paste will extend the colors while you are painting. At this stage you are ready to transfer a previously made sketch onto the masonite panel. Black acrylic paint thinned with water will make the paint more fluid for drawing on the uneven surface of the gessoed panel. Keep the sketch simple, and draw with bold, sweeping lines to just suggest the pictorial idea. You can paint the details at the final stage. Keep applying additional thinned-down colors with an old brush to create thin films of paint and continue to scrub on color over color, creating as many surfaces and textures

as you like. Finally apply carefully painted-in highlights and details and one coat of thin matte varnish to seal the paint layers.

Another method for achieving the uneven surfaces of the impasto effects is to combine a variety of textured materials to a can of clear acrylic. To do this, mix a quantity of clear acrylic with all kinds of textured materials such as powdered cork, sawdust, ground glass, whiting, marble dust, or other similar materials to make a paste-like material. Use an empty can or other receptacle. You now have a "putty."

You will need a full palette of acrylic colors, palette knife, trowel, bristle brushes, untempered masonite panel. Rigid surfaces such as masonite or plywood are best for impasto painting. Draw the pictorial idea onto the panel. Apply the putty to the rigid surface of your masonite panel in any irregular manner you like, using a trowel-shaped palette knife to create your uneven surface. The putty can also be mixed directly into the colors. The areas to appear in the foreground should be molded in high relief, the areas in the distance painted with the colors alone, but add some putty to the color of the middle distance areas. Color the background areas with pigment that comes straight from the tube. The forms in the middle-distance areas first should be painted with the darks, then the middle tones, and last the light tones and highlights. In the foreground a considerable amount of putty should be added to the colors.

Project: IMPASTO FOR THREE-DIMENSIONAL EFFECTS

SUBJECT: Figure group

ILLUSTRATION REFERENCE: D'Alessio, *The Guitar Enthusiast*

TOOLS AND MATERIALS:
Masonite panel, 20″ × 24″
Worn bristle brushes, assorted sizes
Trowel-shaped palette knife
Flat-blade palette knife

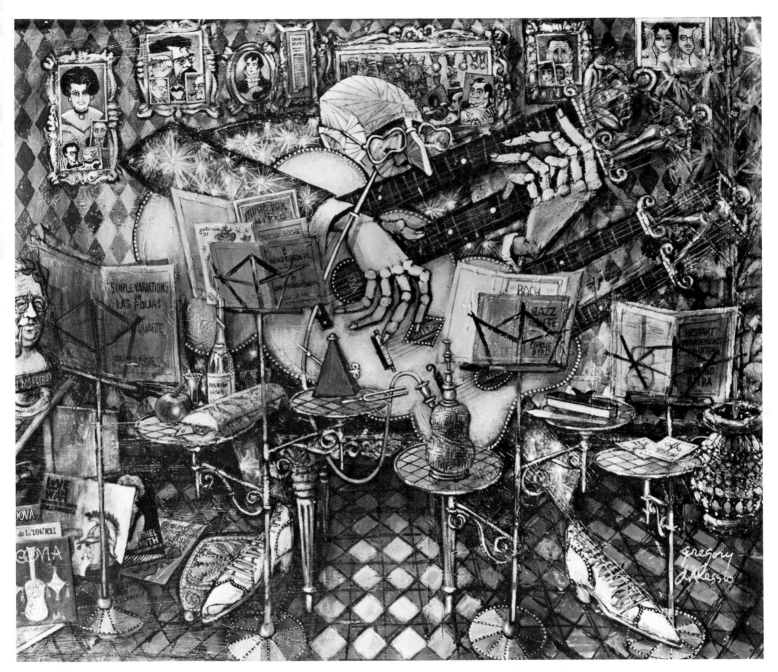

Gregory d'Alessio, *The Guitar Enthusiast*. Acrylic on canvas.
(Collection of George Perutz, Dallas, Texas.)

Acrylics may be used to great advantage when rendering realistic subjects. They are especially well suited when transparency, body, and adhesiveness are required for visual effects in small areas.

Janice Bowman, *White on White*. Acrylic on masonite.
(Collection of the artist)

Relief painting. Sculptural effects are achieved with
acrylic paint combined with any textured materials that
can be easily molded into the paste, such as sawdust,
cloth, straws or bits of wood.

Gesso
Modeling paste
Marble dust
Matte varnish
Glass palette on sheet of white paper
Two jars of clear water

1. Make some carefully planned sketches in which lowered and raised surfaces are to be the underlying elements of the composition. Select the sketch you like best and put it aside.

2. Apply at least five coats of gesso to the masonite panel. While applying the gesso, you can also develop your impasto areas. Referring to your sketch, apply the acrylic modeling paste to mold raised levels in your composition with a large brush or palette knife. If you wish, the paste can be further extended by adding marble dust to it.

3. Redraw the previously made sketch onto the panel. Using black acrylic paint, thinned down with water to make it more fluid for drawing, outline your pictorial idea in sweeping bold lines over the uneven surface of your panel. Keep the drawing simple and uncomplicated.

4. You are now ready to color in your picture. In preparation, thin all the colors with water, and with a worn round bristle brush, scrub the different colors well into the uneven surfaces, so that a thin color film covers each area.

5. Keep applying additional thinned-down colors, scrubbing color over color, in this way creating a multitude of new colors. At this point you are free to enjoy the act of just painting. You no longer have to be concerned about textures, because you have resolved that problem.

6. Using a firm small round, bristle brush, outline all the pictorial features with an opaque color.

7. To bring key areas into focus, paint in all the highlights and details with care.

8. Apply a thin coat of matte varnish to seal the surface of your picture.

Project: RELIEF METHOD

SUBJECT: Abstract composition

ILLUSTRATION REFERENCE: Bowman, *White on White*

TOOLS AND MATERIALS:
 Masonite or plywood panel
 Bristle brushes
 Palette knife
 Full palette of colors
 Polymer medium
 Plaster of Paris
 Fabric
 Bits of wood

Here is an additional exercise in three-dimensional painting which you may wish to experience doing.

The aim of relief painting is to achieve sculptural effects. For a subject do an abstract landscape.

1. Mix the medium and plaster with enough water to make a paste.

2. Apply paste to support, and set fabrics and bits of wood into paste to suggest landscape elements.

3. Apply your paints as in a traditional oil painting.

4. Superimpose succeeding washes of thin acrylic paint to build up a surface of glazes of many colors.

5. Make a putty of your own by sawing or scraping Celotex (which makes a good sawdust) and mix the sawdust with clear lacquer. Use this putty for rendering relief shapes with high surfaces and many interesting textures on your picture.

COLLAGE AND MIXED MEDIA

odern techniques of collage and mixed media represent a unique contribution to the visual arts. Although each technique was used in ancient Japan, Persia, and Europe by artists wishing to achieve *trompe l'oeil* effects, these techniques really came into their own in major art movements only in the twentieth century. Among the first to make major advances were Georges Braque, Pablo Picasso, Juan Gris, Paul Klee, and Kurt Schwitters. With collage and mixed media these creative painters transformed the most ordinary materials into objects of mystery and great beauty.

The name *collage* is derived from *collé*, the French word for glue. Usually, the best collages are those that use a minimum of materials. Making a collage involves selecting, cutting up, putting together, and pasting down pieces of paper or almost any other material that pleases you. All you need are a variety of personal odds and ends, some old magazines, a pair of scissors, and glue.

The result may depend on accidental elements, as you feel your way along to see what happens and hoping for the best. You can also make collages that are planned and controlled from a beginning, drawing to a carefully executed ending. Experiment with different materials in series of practice exercises, but first study what other artists have achieved.

TOOLS AND MATERIALS

The basic tools you will need for making collages and mixed media pictures are simple! Good sharp cutting tools, such as scissors, single-edge razor blades, and an X-acto knife and various blades. You will also need pins, masking tape, and cellophane tape to fasten objects to a support. Two brushes for applying glue, one small and one large, and several palette knives, both spatula and trowel-shaped, are necessary, as are palettes made of paper, masonite, or glass.

Supports

It is important to have a fairly rigid support to which you can attach the elements of your pictorial idea. The ones most suitable for collage are canvas boards, upson boards, and hard cardboards. For *mixed media* you will need more rigid supports, such as masonite or plywood panels.

Primers

In preparing the surface for a collage ground you may use a water-based underpainting white or a casein-colored primer. For the mixed media the water-based or oil-based gesso or an acrylic varnish, either matte or gloss, is best.

Adhesives

The most important item of all in doing collage and mixed-media work is a suitable glue. Quite a few are on the market. Choose the most durable one that is practical for your needs. For heavier dimensional work, the white glues are best, such as: Elmer's or Sobo as well as epoxy cement. For paper work the acrylic emulsions or gel are best. For gluing small, hard-to-get-at areas, you may wish to use an adhesive spray.

Suitable Materials for Collage

In selecting materials for your collage, choose only those that both please and inspire you. The best collage is made up of many personal bits of printed and colored papers. Heavy watercolor and drawing papers, wax paper, art deco papers, construction paper, tissue papers, and cellophane and gelatin sheets of all colors are useful. Oriental rice papers in plain and patterned surfaces and gold and silver metallic papers and aluminum foil add other effects. Look especially for printed papers that have some reference to your theme—old letters, clippings, labels, photographs in color and black and white, tickets, stamps, posters, and reproductions of fine art.

Suitable Materials for Mixed Media

All sorts of dimensional vehicles are appropriate for mixed media, such as parts of living things found in nature—seed pods, seaweed, herbs, wood bark, grasses, leaves, flowers, hair, fur, feathers, coral, pearls, and shells—and minerals such as copper, silver, gold, tin, glass, gravel, stones, pebbles, and sand. Manufactured materials include parts of furniture, china, crockery, phonograph rec-

Some tools and materials to use in making a collage.
The tools needed for making collages, mixed media, and assemblages are simple. You will need a sharp cutting tool, pins, small nails, hammer, masking tape, glue, masonite panels, illustration board, paints, primers, and, most important of all, many pieces of paper and fabrics that you personally feel are suitable for the media.

ords, clock parts, corrugated boards, pipes, tubing, wire mesh, coins, buttons, corks, and beads. Especially useful are textured fabrics such as lace, linen, burlap, satin, velvet, leather, synthetic fibers, and plastics.

These are just suggestions; the most interesting will inevitably be the ones that you yourself discover and decide to use in your own individual way.

TECHNIQUES FOR COLLAGE AND MIXED MEDIA

Collage and mixed-media works are similar in that they both involve working with an assortment of tangible materials that must be fastened onto a rigid support. The major difference between them is that a collage is rendered with mostly flat materials, whereas a mixed-media work generally calls for the use of more-dimensional objects and materials.

The problem of attaching these materials so that they adhere satisfactorily to the support is what should primarily concern you. It should be solved in a manner that will not disturb the quality of your idea. Knowing about and experimenting with different techniques by doing a series of practice exercises should be a great help.

There are four basic collage categories, each having a specific rendering technique.

1. The flat-plane collage requires only papers and thin fabric.

2. The textured-surface collage uses all sorts of different-textured cloth, fur, and feathers as well as all types of organic materials found in nature.

3. Transparent effects are created with tissue papers, celluloid, and sheets of colored gelatins and plastics.

4. Three-dimensional effects are made with modeling paste, plaster, wax, and all manner of tangible materials.

Each type of collage is produced in a series of steps that will be described in a general way here. Note the variations due to materials. Of course, your subject will also affect the emphasis you give each step.

The Flat-Plane Collage

The flat-plane collage calls for no surface textures. The aim is to create flat, hard-edge surface effects that render the pictorial idea, with all sorts of printed matter as the vehicle. Henri Matisse and Paul Klee are among the masters of this technique.

After choosing a subject idea, spread out all sorts of printed material, along with sheets of colored construction paper, and select the most pleasing and appropriate material. Guided by the selection of materials, make one or more sketches of the pictorial idea, using the materials in hand.

Plan a color scheme that will express the theme, using the different papers for color.

Anne Ryan, *Small oval*. Collage mounted on Howell paper.
(Courtesy of Andre Emmerich Gallery, New York.)

Mixed flat-surfaced work permits you to use all types of materials including felt strips which you can cut up into abstract shapes.

The next step is to transfer the best sketch onto a canvas board. Then cut the papers into shapes and patterns that correspond to the sketch. Hard-edged shapes are cut with the X-acto knife.

Preparing the support with an adhesive is the principal concern when doing a collage. The simplest procedure, of course, is to cover the entire surface with brushed-on paper glue. The entire surface may be moistened with an acrylic emulsion of gel. When working in smaller areas, the proper procedure is to use a small brush dipped in glue or a spray adhesive.

Transparent Effects with Cut Paper

Cut-paper work, limited to scissors, paper, and paste, obliges you to interpret the shapes of the composition in a simplified manner, reducing each object to its basic shape, with details eliminated. Pictorial ideas should be interpreted simply and clearly.

Project: FLAT-PLANE COLLAGE

SUBJECT: Portrait of a room

ILLUSTRATION REFERENCE: A. Salemme, *Ipso-Facto and a Little X*

TOOLS AND MATERIALS:
 Can of spray fixative
 Canvas board, 18″ × 24″
 Scissors
 X-acto knife and blades
 Acrylic emulsion
 Pins
 Masking tape

All sorts of personal printed paper matter—picture postcards, old letters, colored reproductions, clippings, labels, tickets, music sheets, and stamps.

1. Make a good drawing of your idea for portraying a room, either a real room or an imagined one.

2. Transfer your drawing onto the canvas board, drawing with a pencil.

3. Prepare the printed "material on paper" that you plan to use in the collage, by cutting,

crumpling, and wetting it into shapes that coincide with your sketch. You can achieve many subtle tonalities with papers by immersing and crumpling them in acrylic emulsion (allow about an hour for drying time) and overlapping them to raise their surfaces for new and subtle color effects. You may also wish to alter the color of papers by scorching them over a burning match (holding the paper over a sink) or moistening them with melted wax (from colored crayons). You may also change the surface of the papers by first rubbing them through stencils of mesh or lace.

4. Arrange picture fragments onto canvas board and place them according to your sketch; pin or tape them in place.

5. Paste the background pieces on first; in sequence, add all the remaining cutouts, saving for the last those that are to appear on the surface areas.

6. As a final step, spray the collage with fixative.

7. If you wish to frame your finished collage, the most suitable method is to put it under glass. This will be the best way to preserve the different papers and cloth fragments that are in the collage.

Colored papers, Oriental rice papers, tissue papers, and gelatin sheets are suitable for transparent effects. A preliminary sketch is not necessary, but it can be made. Start by cutting up different-toned papers to establish the lights and darks of the picture.

After all the shapes are cut out, arrange them on a support board. The color of different surfaces can be varied by superimposing different-colored tissues or gelatins over one another. You can experiment with papers that contrast with each other in tone and color, such as brown wrapping paper and colored tissue paper. Large shapes can be cut out to represent a background space. For more neutral-toned effects, you may use newspaper. Paper shapes can be glued down as you go along, the darker-toned ones fastened down first, adding and superimposing the bright-colored papers next, and ending up with the light-colored and more-transparent papers last.

Project: **TRANSPARENT EFFECTS WITH CUT PAPER**

SUBJECT: Still life with bottles

ILLUSTRATION REFERENCE: Ryan,
Small Oval

TOOLS AND MATERIALS:
Colored tissue papers, Oriental rice papers,
 gelatin sheets
Canvas board, 18″ × 24″
Pins
Acrylic emulsion for gluing
Scissors

1. On a separate sheet of drawing paper, make a preliminary sketch of a still life of wine bottles, apples, oranges, and lemons.

2. Cut or tear tissues to desired shapes and decide whether they are to be pasted down flat or crumpled or crushed to make interesting surfaces.

3. Change the colors of the tissues by superimposing them. Of course, yellow over blue tissue makes green; red over yellow makes orange; blue over red makes violet. Superimposing a sheet of light green over strips of red, yellow, and blue tissues creates a variety of tones. For added tonal effects draw, paint, and tear the tissues. To fade and bleed colors, immerse tissues in either water or wax.

Ronald Fisher, *Many Surfaces 1972*. String and fabric collage.
Experimenting with different materials helps you to evolve effects that are uniquely your own.

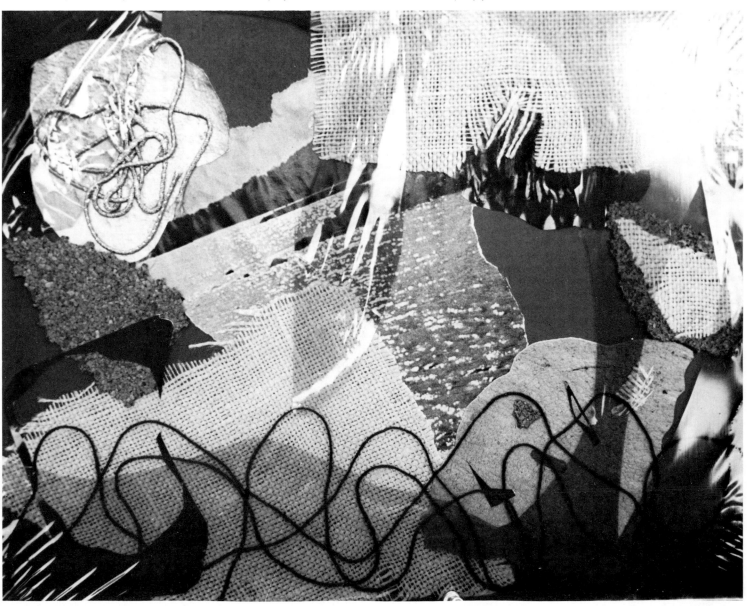

4. Cut, tear, and mold papers. By immersion of tissues in wax or acrylic emulsion you will be able to mold tissues into varied raised shapes. Move them about on the support board until a satisfactory compositional arrangement has been arrived at.

5. Pin tissues into place.

Textured-Surface Collage

A textured-surface collage is made with all sorts of textured fabrics, fur, and feather fragments, as well as any materials found in nature, including dried grasses, leaves, bark, and flowers. These materials may be used as one finds them, or their colors can be changed by various means. Many artists like to fade fabrics by immersing them briefly in laundry bleach, achieve mildewed effects by leaving them out of doors in damp weather, and change colors by pouring colored melted wax over the objects or on the panel support. They may also try placing transparent gelatins over the base materials.

Experimenting with different materials helps you to create effects that are uniquely your own. Therefore, try using whatever materials you find interesting and see what you can come up with.

Project: TEXTURED-SURFACE COLLAGE

SUBJECT: A poetic mood in an abstract
 composition

ILLUSTRATION REFERENCE: Manso, *Summer's
 Day 1968* (color section, page 40)

TOOLS AND MATERIALS:
 All types of materials that offer textural variety,
 such as lace, burlap, satin, velvet, old leather
 gloves, straw matting, string, rope, fur, bark,
 dried flowers, leaves
 Masonite panel, 18″ × 24″
 White glue
 Acrylic emulsion
 Scissors
 Masking tape

1. Look over all your scraps and remnants of cloth to see what they suggest to you.

2. On a separate sheet of paper, prepare a drawing of the sizes and shapes of the pieces of materials you plan to use in your collage.

3. Cut the materials into varied shapes and sizes to match your sketch.

4. Unravel edges of fabrics to reveal their weave and to loosen threads.

5. Immerse the cloth in glue so that you will be able to mold it into varied shapes.

6. Place your cloth pieces on the masonite panel according to your sketch plan.

7. Rearrange and move the pieces about to elaborate on your original composition.

8. Fasten down each fabric piece with a piece of masking tape.

9. Without disturbing your compositional arrangement, glue each piece separately, pasting down the background pieces first and adding in sequence all the remaining fragments, saving for the last step those that are to appear on the surface.

THREE-DIMENSIONAL EFFECTS

The subject or idea of a three-dimensional collage should always reflect the artist's affection for the materials used. Collecting and selecting them requires much thought and care, as they are the real subject of a collage. Finding beauty in commonplace materials reflects the artist's taste and ability. These choices are what is of interest to viewers of collages.

A three-dimensional collage looks best on a small scale, where the objects used may be seen close up without much trouble. It is always a good idea to work from a predetermined design or composition. The artist redraws the preliminary sketch onto a panel before beginning to attach the tangible materials previously selected, which can range from buttons to matchsticks or bottlecaps, so long as they have a special interest or appeal.

The background area materials are first placed and then glued on. Next, the other objects are glued on in layers, attaching first

Attilio Salemme, *Ipso-Facto and a Little X.* Paper collage.
The flat-plane collage. Only flat papers, photographs,
thin fabrics with no surface textures are required to do a
flat-plane collage, as the aim is to create even-textured
hard-edge surface effects.

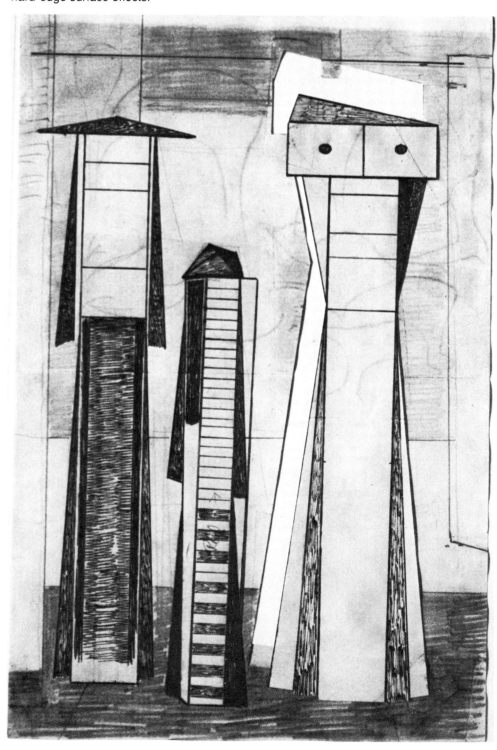

Joseph Cornell, *The Red Box with Glass Door: Les Petites Filles Modeles*. Pasted on all the sides of box.
(Collection of Mrs. Attilio Salemme.)

Three-dimensional assemblage. To construct a three-dimensional object you can use cigar boxes, glass, metals, or any tangible, firm materials you can think of. You may use nails, cement, thread, or wire for assembling purposes. Some artists drill holes from the back of the panel and insert screws to hold heavier pieces of materials in place. Many beautiful effects can be achieved by pasting cut up fabrics or pictures to the object you make. Joseph Cornell used red velvet to line his painted-red box and black-and-white cut up illustrations to decorate the outside areas.

Arthur G. Dove, *Rope, Chiffon and Iron*.
(Terry Dintenfass Gallery, Inc., New York.)

Poetic effects become more powerful when delicate
materials are used together with more rugged materials.

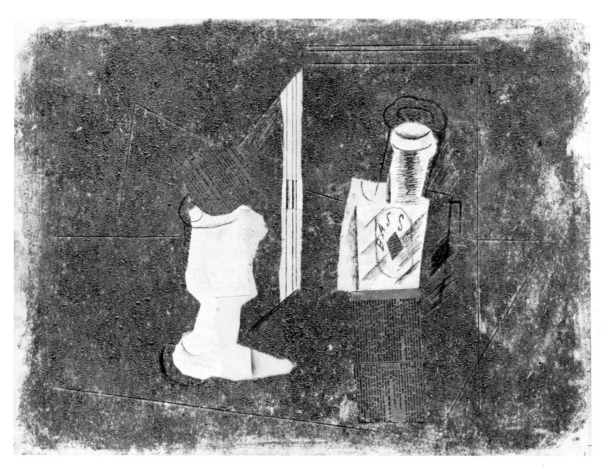

Pablo Picasso, *Glass and a Bottle of Bass*. Pencil, gouache, sawdust, and
collage on board.
(Collection the Solomon R. Guggenheim Museum, New York.)

Textural effects are best achieved with the use of uncluttered shapes in the
composition. The simpler the subject matter the more visible is the vehicle that is
used to render surface qualities.

those that lie behind the ones closer to the surface, leaving the protruding top objects as the very last to be attached.

There is no limit to the variety of shapes, colors, and patterns that can be superimposed to create extraordinary and radiant effects in several dimensions. Many variations will undoubtedly occur to you as you do the more three-dimensional work.

Project: DIMENSIONAL EFFECTS ACHIEVED WITH TANGIBLE OBJECTS

SUBJECT: Commonplace objects used in a poetic manner

ILLUSTRATION REFERENCE: Schwitters, *Merz 163, with Woman Sweating* (color section, page 40)

TOOLS AND MATERIALS:
Use any small tangible objects that have personal meaning for you, be they pieces of bark, wire, mesh, rope, glass, or plastic or gelatins, clock parts, buttons, beads, matchsticks, or bottlecaps
Masonite or wood panel, 16″ × 20″
Epoxy cement
Nails, screws
Small hammer, screwdriver
Wire cutter
Hacksaw
Tape

1. On a separate sheet of drawing paper make a sketch of a composition idea that reflects a poetic interpretation of your materials.

2. Prepare the objects you plan to use by trimming them into appropriate shapes to coincide with your sketch.

3. Saw, cut, or break materials into disproportionate, interesting shapes. Sandpaper and polish any ragged edges.

4. Place materials on support according to your sketch.

5. Fasten each piece down with nails or epoxy.

6. Paste the background pieces on first, and add in sequences all the other pieces, saving for the very last those that are on the surface. If you like, you can add color with acrylic paints to some parts of the construction.

MIXED MEDIA

A mixed-media work generally calls for the use of dimensional objects and materials. The problem that concerns you most is how to attach the materials and objects onto a durable support. The three basic mixed-media categories are as follows:

1. *Flat mixed-media work* permits you to use all types of painting media and techniques, as well as combining printed or photographed flat material all together in one picture. These materials can be fastened to the picture support with Elmer's or Sobo glue or simply patted onto the wet, painted surfaces and allowed to dry along with the paint it is lying on.

2. *Three-dimensional constructions* are made from parts of boxes, mirrors, metal, or any other thing that has volume. How you attach these objects to a masonite or plywood panel so that it then will be held firmly in place permanently is, again, your chief concern. Epoxy cement and nails may be used for the purpose. Some artists drill holes from the back of the panel and insert screws to hold the heavier pieces in place.

3. *Ready-mades* are assemblages of man-made objects as well as parts of found objects. These objects may be used in the same state you found them or sanded down and broken up so that only parts or pieces of them are used. How you put them together so that they adhere permanently to the support is the important last step. This may involve the use of carpentry tools as well as physical brawn—it all depends on just how complex your project is to be and how ingenious you are in gluing, sawing, sanding, painting, polishing and hammering.

But whatever method you do employ, keep in mind that understatement is at all time the best policy. Again, note the variations due to materials. Your subject should also determine how you emphasize each step.

Project Subject: A three-dimensional construction made with a combination of dimensional materials, for example, cigar boxes, metal candy boxes, seashells, mirrors, heavy

fabric swatches, and photographed clippings. These may be painted with acrylics, oils, pastels, or inks.

The goal is to use combined media so that their colors and forms all play a part in creating the desired three-dimensional final effect.

Project: MIXED-MEDIA CONSTRUCTION

SUBJECT: A three-dimensional construction

ILLUSTRATION REFERENCE: Cornell, *The Red Box with Glass Door; Les Petites Filles Modeles*

TOOLS AND MATERIALS:
 Hinged boxes of all kinds
 Unusual fabrics—damask, satin, velvet
 Printed line drawings and engravings
 Colored photographs
 Stamps, seals, decals
 Small nails and screws
 Small hammer, screwdriver
 Sandpaper
 Glue or epoxy
 Scissors, single-edged razor blade

1. Select the materials you wish to use in your construction and have a definite plan on how you will use them. Make some sketches.

2. Cut or tear fabric pieces and printed paper matter into desired shapes for attaching to box interior and sides, or on other parts of the construction.

3. Brush on a coat of glue on parts of construction where the fabrics and papers are to go and then press them into place.

4. On the outside areas of construction or box, glue on whatever elements you have selected to use there.

Since your construction is probably made up mostly of vehicles that have volume, they have to be fastened carefully onto the support. Use the glue to attach any soft materials, but either nail, staple or screw down the heavier ones.

Look for and collect interesting parts of furniture, crockery, china, phonograph records, clock parts, old toys, plexiglass, jewels, colored stones or anything that appeals to you.

Because you may be working with three-dimensional objects, you may not need a support. In that case your own expertise and ingenuity in assembling the different parts of your ready-mades will suffice. Just keep your goal in mind, which is to provoke surprise in your viewers by finding new and exciting ways of using your ready-mades. This is the one technique that invites you to be as outrageous as you like, but do keep things under control, or your finished work will become too cluttered and congested. Once again, understatement is always the best policy.

An assemblage is more like a construction in the sculptural sense of the word, since the forms come forward in high reliefs. They are often high enough so that you are able to see the sides of each form, creating a natural effect of volume and depth.

Project: ASSEMBLAGE OF FOUND OBJECTS AND READY-MADES

SUBJECT: Look for and collect interesting parts of furniture, crockery, china, phonograph records, clock parts, old toys, plexiglass, jewels, colored stones or anything that appeals to you.

ILLUSTRATION REFERENCE: Dove, *Rope, Chiffon and Iron*

TOOLS AND MATERIALS:
 Nails, screws, nuts, bolts
 Hammer
 Screwdriver
 Hacksaw
 Epoxy
 Sandpaper
 Acrylic paints and brushes

1. Plan your compositional concept by first making a series of sketches.

2. Saw, cut, or break ready-mades to suit your selected sketch.

3. Sandpaper, polish, or color surfaces to suit your ideas.

4. Fasten together the different parts of your construction using nails, screws, bolts, or epoxy where needed in order to form permanent joinings.

GLOSSARY

In the painter's language words sometimes have specialized meaning. Even the painter is not always consistent. Many of the words can have a variety of meanings. For example, shade, tone, tint, and value are terms difficult to pin down. Don't be surprised if the lingo of the art world sometimes differs with your dictionary. Here are some terms used in this book that you may wish to refer to from time to time.

Acrylic—A plastic-based opaque pigment.

Adhesive—Glue.

Alla prima—The method of covering the ground of canvas with a color and, while this ground color is still wet, superimposing all the other colors in thick visible strokes.

Analogous colors—Colors in the same family, such as yellow, red, orange, Indian red, and burnt sienna.

Atmospheric effects—Are arrived at with the gradual toning down of intense color areas and having them fade into adjoining colors.

Black oil—Linseed oil or walnut oil that has been brought to a boil and cooked until it turns black.

Block—A paper pad with a glue binding on all four sides.

Brilliance—The degrees of brightness in colors, ranging from the maximum brilliance of white paint to the zero brilliance of black.

Brush stroke—The way an individual painter applies paint to the canvas; often referred to as the painter's handwriting.

Casein—Water-based color that has been made opaque with a milk curd emulsion.

Cast shadow—The dark area resulting when a source of light has been intercepted.

Chroma—The degree of light the color releases, or the degree of its brilliance. Also how one color differs from another.

Cold press—Watercolor paper with a *medium-rough* surface, sometimes labeled C.P.

Color perspective—The illusion of distance or deep space created with color alone.

Color spectrum—The basic colors: red, orange, yellow, green, blue, and violet, from which any number of additional variations can be mixed.

Complementaries—Colors that are directly opposite to each other on the spectrum color wheel: for example, red and green, yellow and violet, blue and orange.

Composition—How the artist puts the components of a picture together so that the drawn and colored shapes relate to and balance each other.

Cool colors—Most blues, grays, and greens, because they suggest cool places such as water, sky, ice.

Crosshatching—Painting two sets of parallel lines that intersect, as in a grid.

Design—The style or pattern in which the picture is put together; also the art of arranging things.

235

Dry brush—The term given to the ragged, broken line that is created when one begins to run out of paint.

Earth colors—The earliest colors known to man, prepared from various ores and oxides found in the earth. Permanent and inexpensive, they are found in all countries.

Even-textured paint—Smooth-surface brush application with paint that has been extended with a painting medium.

Form—The shape given to the outside edge of a visual concept such as the shape of a vase, figure, cloud, fruit, or tree.

Fresco—Gesso or white chalk powder that has been mixed with a glue size. Also, painting done on a freshly laid wet surface of plaster that has been mixed with a glue size.

Gel—A thick oil varnish medium used for glazing and colors; also a thick concentrated synthetic emulsion used with acrylics.

Gelatine glue—Dried purified glue, dissolved in hot water, producing a "size" that is easy to use.

Gesso—A composition of lime, sand, and water. The Italian term for plaster and chalk.

Glaze—Any transparent coat of paint superimposed over a dry coat of paint so that the undercolor filters through. In a painting, thin glaze is placed in sequences over an already modeled subject to achieve certain effects.

Glycolin—A synthetic substance that retards drying of acrylic paint.

Gouache—A general name for opaque watercolors (showcard, poster, and designer colors).

Gradation—A single color that has been gradually mingled with water or white to create a lighter or darker value.

Grayed down—The neutral, muted variation of a pure color made by mixing a little black, raw umber or its complement to the color to be muted.

Grisaille—A carefully executed drawing or underpainting that clearly renders the three-dimensional aspect of the forms in the picture.

Gum arabic—An adhesive product made from tropical trees that produces a watercolor medium of good balanced qualities. Gum of the cherry tree, used as a binder for gouache pigment.

Halftone—The middle values of a color when it is mixed with black. Also, in printing, the reproduction of a photograph in continuous tone by shooting through a screen; the pattern of different size "dots" yields the illusion of continuous tone.

High key—The use of all the top-tone colors in a painting.

Highlight—The lightest area of a picture.

Hot pressed—Watercolor paper with a smooth surface, sometimes labeled H.P.

Hue—Another word for *color*, it sometimes implies a lighter version of a color.

Impasto—A thick application of paint, often with a palette knife.

Intensity—The strength of a color.

Line—The outside edges of forms. Lines are also directional; up, down, sideways, and undulating.

Linear work—Placing the pigment with sharp-edged brush strokes.

Litharge—A fused form of powdered lead ore.

Mass tone—The pure quality of color as it comes from the tube or jar.

Matte—A dull surface quality.

Medium—The substance added to pigments—oil, water, casein, wax—which makes them more fluid or more adhesive and can hasten or retard their drying. Also means the material through which the artist expresses ideas, such as clay, marble, paints, pastels, or graphics.

Midtone—The middle value of a color, made by mixing a color with its complement and a little black, for example, red mixed with a little green and black.

Mineral colors—Paints prepared from mineral or metallic substances, such as cadmium and cobalt. They are permanent and are the most expensive group of artists' paints.

Mingling—Allowing colors freely to run into one another.

Minor key—A painting in the dark or half-toned colors, also referred to as low key, the opposite of high key.

Modeling paste—An emulsion made from a mixture of latex and ground marble.

Monochrome—A painting done in shades of one color. Opposite of polychrome.

Negative space—Area surrounding the main subject or idea of the composition.

Oil colors or Oils—Oil-based opaque pigments.

Opacity—The quality of a paint that does not allow anything underneath it to show through in a painting. The opposite of transparency.

Opalescent—Halfway between transparent and opaque.

Pad—A notebook hinged on only one side with either a glue or spiral binding.

Paint quality—The character of the physical surface of the painting.

Palette—A tablet or any flat surface on which the artist mixes paints. Also may refer to the typical set of colors an artist uses.

Pentimento—Old paint on canvas, as it ages, sometimes becomes transparent, making it possible to see the original drawing or sketch under the paint. This is called "pentimento" because the painter "repented" or changed his mind.

Pigment—The coloring matter in powder form used in paints.

Plaster—(Or its Italian term "*gesso*") a composition of lime, sand, and water.

Plasticity—The tension created in a painting between one element and another of the composition when the lines, colors, and forms mutually affect each other To alter any one of these parts would disrupt the chain reaction of their movement.

Pointillism—A school of painting within the Impressionist movement. The pointillist painter juxtaposed small brush strokes of pure colors so that from a distance the eye did the mixing to produce various color effects.

Polychrome—Anything painted in several colors, the opposite of monochrome.

Polymer—Plastic.

Positive space—Solid space in the picture that is making the statement (e.g., the face in a portrait).

Primaries—Red, yellow, and blue.

Pure black—The total absence of color.

Pure white—Intensified light.

R.—Term applied to a paper surface meaning "rough."

R.R.—Term applied to surface of paper meaning "extra rough."

Resin—Glue made from animals or vegetables.

Rough textures—Oil-painting technique using visible brush strokes with paint as it comes from the tube.

Saturation—The full strength or intensity of a color.

Scumbling—Applying almost dry paint in a scrubbing motion on the canvas surface so as to allow previously applied paint layers to show through. Lighter colors over the darks is the rule, the opposite of the glazing technique.

Secondary color—The three colors made from mixing the primaries: *orange* (red and yellow); *green* (yellow and blue); *voilet* (blue and red).

Shade—A darker version of a color, used for creating the illustration or depth or roundness of a form.

Siccative—A glue made from burnt bones and vitriol.

Size, sizing—A weak coat of either glue, starch, or gesso to cover surface of paper or canvas before it is painted on. For example, glue size, gesso size.

Smooth-surface textures—Even brush strokes made with oily paint.

Solvent—Any thinner that dissolves paint, such as water for gouache, watercolors, and acrylics; turpentine and mineral spirits for oil paints.

Source of light—The place or spot in a composition from which the light is coming.

Support—Anything that can be painted on. It can be canvas or any type of panel.

Technique—The way you use or apply the paint or the way you use your tools.

Tempera—Water-based paint, made with an egg-white emulsion.

Three-dimensional—The height, width, and depth of the forms in the painting, to illustrate visual perspective.

Tint—A light value of a color.

Tone—Different values of a color.

Top tone—The color after it is diluted with water or when mixed with white paint.

Transparency—The quality of allowing light to pass. Opposite of opacity. Certain oil colors are naturally somewhat transparent, such as rose madder, alizarin crimson, and green earth. All colors can be made transparent by adding a glazing medium.

Two-dimensional—The height and width of the forms and spaces within the composition; the height and width of the flat surface of canvas.

Underpainting—A coat of gesso or quick-drying white paint (called underpainting white) that, when painted on the canvas and allowed to dry thoroughly, removes much of the oil. An undercoat of flake white is fine for glazing. Also means the first sketch the artist paints on his canvas before adding all the subsequent layers of paint.

Undertone—The color when mixed with white.

Value—The colors as they go in scale from their lightest toward white and their darkest toward black. Tint is a *light value* of a color; tone, *different values* of a color; and shade is a *darker value* of a color.

Velatura—A glaze containing some white paint or a light opaque color as opposed to a pure glaze diluted only with the medium or varnish.

Viscous—Having a glutinous consistancy; sticky.

Warm colors—The colors that suggest heat, fire, or flames. Reds and yellows are the warmest hues.

Wash—A highly fluid application of color.

Watercolors—Transparent pigments, the same as aquarelles, made with a mixture of pigments and gum arabic. Soluble in water.

Wet-in-wet—Blending and working one color into another while both are still wet.

INDEX

239